SHALLAN!

EDWARD SHERIFF CURTIS: Visions of a Vanishing Race

EDWARD SHERIFF CURTIS VISIONS of a VANISHING RACE

Text by FLORENCE CURTIS GRAYBILL and VICTOR BOESEN

Introduction by Harold Curtis Photographs Prepared by Jean-Antony du Lac

To Beth Curtis Magnuson and To Jane Jordan Browne

Copyright © 1976 by Florence Curtis Graybill and Victor Boesen Introduction copyright © 1986 by Harold Curtis

The material on pages 78-79 is reprinted from *Westways*, copyright © 1974 by the Automobile Club of Southern California.

All rights reserved. No part of this work may be reproduced or transmitted in any form or by any means, electronic or mechanical, including photocopying, recording, or any information storage and retrieval system, without permission in writing from the publisher. All requests for permission to reproduce material from this work should be directed to Multimedia Product Development Co., 410 South Michigan Avenue, Chicago, Illinois 60605.

Published in 1994 by

Promontory Press A division of Budget Book Service, Inc. 386 Park Avenue South New York, NY 10016

Promontory Press is a registered trademark of Budget Book Service, Inc.

Published by arrangement with Multimedia Product Development, Inc. Library of Congress Catalog Card Number: 86-15218

ISBN: 0-88394-089-2

Printed in the United States of America.

Acknowledgements

Many hands helped us bring together the information in this book—we are grateful to all. Our first thanks go to Harold Curtis and Katherine (Billy) Curtis Ingram.

We especially want to mention librarian Ruth M. Christensen of the Southwest Museum, who provided us with the forty-four-year correspondence between Curtis and his editor, Frederick Webb Hodge, director of the museum for nearly a quarter-century after his work with Curtis, until his retirement at ninety-one. This correspondence, beginning in 1903 and ending in 1947, had never before been published. Indeed, its existence was unknown even to members of Curtis' own family.

Thanks also to Renate Hayum, History Department, Seattle Public Library; Andrew F. Johnson, University of Washington Libraries; Beverly Russell, Chief Librarian, Seattle *Times;* Newspaper Reference Library, Spokane, Washington; Amy E. Levin, Reference Librarian, Smithsonian Institution Libraries, Washington, D.C.; Manford E. Magnuson; and Angus McMillan.

Our sources include Curtis' log of his Far North, and final, field trip, in 1927; his daughter Beth's log on the early part of the same trip; material from notes taken by Florence Curtis Graybill in conversations with her father, as well as her own account of her summer in the field with him, in 1923; Curtis' letters late in his life to Harriet Leitch of the Seattle Public Library; Curtis' Western Indians: The Life and Works of Edward S. Curtis, by Ralph Andrews; Portraits from North American Indian Life, Edward S. Curtis, edited and with Introductions by A. D. Coleman and T. C. McLuhan; The North American Indians, A Selection of Photographs by Edward S. Curtis, text compiled with an Introduction by Joseph Epes Brown; A Quarter-Century in Photography, by Edward L. Wilson; The Vanishing Race, by Joseph K. Dixon; volumes of Curtis' original The North American Indian and his Indian Days of the Long Ago; photo portfolios of the E. H. Harriman expedition to Alaska; Will Soule, Indian Photographer at Fort Sill, 1869-1874, by Russell E. Belous and Robert A. Weinstein; One Hundred Years of Photographic History, by Coke Van Deren; Bury My Heart at Wounded Knee, by Dee Brown; The Columbia Encyclopedia; The Encyclopaedia Britannica; numerous newspapers and periodicals.

Introduction

by Harold Curtis

One April day in 1906, soon after the Seattle schools were out for the summer, my mother received a letter from my father asking her to bring along the three Curtis children — Florence, Beth, and me — and join him on the Navaho reservation in Arizona. San Francisco was still smoking from the earthquake as we passed through on the way to Gallup, New Mexico, where my father met us at the station with a Studebaker spring wagon for the overland trip to Canyon de Chelly in the heart of Navaho country.

Every summer thereafter, as he worked to create *The North American Indian*, I was with my father in the field as a member of the crew, as cook and general Pooh-Bah of the camp. When school ended, he would send me a railroad ticket, or the money for it, to come and sign on to whatever reservation he was on at the time. Throughout these summers, my father was a good companion and a good teacher. He left it more or less up to you to decide what to do and how to do it. I think he always figured you were more likely to keep out of trouble if you learned the hard way.

Although I was quite young when I began spending my summers with my father, Indians and Indian reservations were not strange to me. For years my father had taken me along on visits to various tribes in the Puget Sound area, and to the Nez Perces in Montana. I believe I was only seven, in fact, when I met Chief Joseph.

I had already learned to cook at home, out of necessity. My mother was a "joiner" and gave a lot of time to other children, leaving her own to fend for themselves. So, as the eldest, I did most of the cooking for my sisters and myself and sort of kept house.

In addition to cooking, my responsibilities in camp included keeping watch over the horses, our only link with civilization 150 miles away or more. There were six horses, four to pull the wagon and two to ride, tied behind. We tied them up at night just beyond the stake ropes of our tents, and then lay half awake listening for the rest of the night as they moved about, cropping the grass.

But the Indians were the world's best horse thieves. Carrying gunny sacks to muffle the hoofs, they could get away with a half-dozen horses even though you were sleeping inches away — which is just what they did one night in Canyon de Chelly. The next morning, there we were — the whole Curtis entourage, the womenfolk and hired help as well as my father and I — marooned in the middle of Indian country.

After a few days, an Indian drifted into camp and sat around on his haunches, saying nothing. In due course he let it be known that he might be able to find the missing horses for \$150. My father carried a number of bank sacks filled with silver dollars to pay the Indians for posing, a dollar each time. He gave the Indian a sack full of dollars, and in no time at all we had the horses back. They were grazing the whole time in a green little side canyon nearby with an entrance so narrow it was almost invisible.

The next summer's work took us to the Sioux reservation in South Dakota. My mother and I rode the train to Alliance, Nebraska, to meet W. E. Myers, my father's right-hand man, with the wagon for the rest of the trip to Pine Ridge. In weeks of travel across the prairies (still marked by buffalo trails though the buffalo had been gone since 1880), we saw not a single fence and only one homesteader's cabin, built of cottonwood logs and sod.

At the Niobrara River we took the wheels off the wagon and put them inside, then wrapped the bed in a tarpaulin, making a boat out of it. We tied a rope to the front and had the horses pull it across, with me aboard one of the horses. As we reached deep water, I slipped out of the saddle and dashed water in their faces to keep them from drifting downstream.

At Pine Ridge my budding career as all-purpose factorum of the Curtis camp was interrupted by typhoid fever. I was delirious for weeks, but my mother nursed me through it. I don't know where she got the experience, but I would never have pulled out of it without her.

Sickness was not our largest concern, however. Simply traveling across country with the added burden of my father's photographic equipment proved hardship enough. We lived in 8-by-8-foot single-pole sheepherder tents with the floors sewed in to keep the rattlesnakes out. The tents were prone to blow down, mostly at night while we were sleeping it seemed. The studio tent, twelve feet square with six-foot side walls, was usually the first to go. (It was specially made with a top that could be rolled back on both sides to adjust the light. Many of the best pictures in *The North American Indian* were actually taken under studio conditions.) At the first blow, we took away the poles and let the tent collapse flat on the ground, covering the camera equipment inside.

The glass plates were stored in the safest place we could find, the wagon. My father wore a big canvas jacket — rather like a hunter's — with a lot of pockets that he kept filled with plate holders. Also hidden in his jacket was a .30 caliber Colt automatic pistol, which he had occasion to use only once, to my knowledge. He picked up a hitchhiker in Oregon who suddenly put a hand on the wheel. My father relaxed the hold with a bullet in his wrist, tying him up for the sheriff at Grant's Pass.

Our drinking water came from water holes that were often miles apart and befouled by livestock. In Canyon de Chelly, where the water table was only six inches down, the Indians shoveled out holes a few feet wide to drink from and then drove their cattle over them. Boiling the water didn't always seem enough to make it harmless.

In the Southwest, the flies were so thick that it was tricky getting the food from the dish to our mouths without swallowing flies along with it. Sometimes one of us stood by to shoo the flies away while the others ate. And there was no good way to store food. Refrigeration hadn't been invented, we couldn't lock it up, and on the prairies there were no trees to stash it in. Any food left over was likely to be stolen by starving Indian dogs and skunks. Between listening for these marauders and Indian horse thieves, there was never really any sound sleep in the camp.

Our inability to keep food at least assured us that what we had was fresh, since its

procurement was a daily concern. Some days our luck getting food was better than others, but rarely so good as the morning in Montana when I rode into Browning to pick up the mail and supplies.

"Where can I get some meat?" I asked the man at the trading post.

He pointed to a doorway. "Cut off anything you want," he said.

Behind the door hung a quarter of beef. I eyed the steaks at the end. "How much for the steaks?" I asked.

"All cut same price — ten cents a pound."

I rode away with all the T-bone steaks in the house, and that night we feasted.

When we were camped near streams we had fish, sometimes trout or salmon three times a day. My father became a connoisseur of Chinook from the Columbia River, which is possibly the richest of the Chinooks. He claimed he could tell from the taste how many hours it had been out of water.

My father's stamina amazed me. The Chief, as everyone called him, was the last to bed at night and first up in the morning. Working by acetylene lamps hanging from the roof of the tent, he wrote until eleven or twelve o'clock each night. At dawn he was up lighting the fire under the coffee pot on the grate and rousing the rest of the camp. I don't think he ever slept more than three hours a night. He managed to endure all the hardships — the tents blowing down, the flies, the dogs, the nightly watches and still keep alert for the day's work of photographing and interviewing the Indians, coordinating the shots, listening to their histories, songs, and legends.

In addition to his mastery of the wilderness, he was an accomplished seaman, having battled many an Arctic storm. The violence of these storms could wreak havoc on a small boat, and many times he survived by the skin of his teeth. For one whose only previous boating experience had been on the lakes of Minnesota rowing his preacher father on his ministerial calls, he had a remarkable understanding of rough water.

And then there was always the problem of money. Up until the time of the arrangement with J. P. Morgan in 1906, the money to support the Indian work came exclusively from the family studio in Seattle plus what my father made lecturing. Sometimes money was so tight we nearly starved to death.

This would have been a trying way of life for any family, and mine was no exception. Things were not going well at home for my parents. My father was rarely there — in the summer he was in the field taking pictures and collecting information for *The North American Indian*; in the winter he was in New York trying to get it published or traveling the lecture circuit to earn money to keep the work going. As a result, my mother felt abandoned.

When divorce was in the offing, my father decided to send me away to prep school. Through the good offices of Theodore Roosevelt, he enrolled me at the Hill School in Pottstown, Pennsylvania. Living in the East while I completed prep school and college at Yale, I saw a great deal of my father in the winter months, getting to know him in circumstances altogether different from those of the field in the summer. There I saw a side of my father far removed from the backwoods of Minnesota where he had grown up. As far as I knew, he had only completed sixth grade, yet on the lecture platform, the Chief handled himself like one born to it. He grew up working with his hands, and before he came west he bossed a gang of muleskinners laying the roadbed for the Great Northern railroad. In fact, he once told me that the reason he took up photography (building his first camera from instructions printed in the *Seattle Post-Intelligencer*) was that it was easier than cutting wood for a living. But in spite of this background, he managed to move easily in the top social circles. He was a sartorial dandy, and even with his large frame — six feet two inches, 180 pounds — he wore clothes well. He was a weekend regular at the Roosevelt home at Oyster Bay, and his friends were the Robert Morris family, the Hamiltons, and their ilk. But then he could just as easily go back to a reservation and sit in a circle of Indians as one of them. He could do anything, was at home in any circle. He was the best man I ever knew.

Text Photographs

The captions to all of Curtis' photographs in the text section and the descriptions in the List of Portfolio Photographs in the back of the book are either his own or have been taken from his writings in the *North American Indian* volumes.

Princess Angeline 8

The Clam Digger 11 Edward S. Curtis in a Kutenai canoe 11 Black Eagle—Assiniboin 14 The Three Chiefs—Piegan 15 The Vanishing Race—Navaho 18 An Oasis in the Bad Lands 18 Chief Joseph—Nez Percé 19 Geronimo—Apache 19 Mrs. Nicholas Longworth (Alice Roosevelt) 21 Theodore Roosevelt 21 The Scout—Apache 22 The Storm—Apache 23 Sacred Buckskin—Apache 25 The Curtis trail wagon in Navaho country 26 Florence Curtis at Cañon de Chelly 26 The Blanket Weaver—Navaho 27 The Curtis camp in Walapai-land 28

Edward S. Curtis on the move 29 Slow Bull-Ogalala Sioux 32 Custer's Crow scouts 33 Sioux Camp 33 Return of the Scouts—Cheyenne 33 Mandan Bullboat 37 Upshaw—Apsaroke 39 Sacred Mandan Turtles 40 A little Oto 42 A Cheyenne child 42 Innocence (an Umtilla) 43 A Wichita dancer 43 Jicarilla Maiden 46 Jicarilla Chief—Apache 47 Apsaroke Mother and Child 50 Hidatsa Mother and Child 51 Sisters—Apsaroke 53 Sun Dance Encampment—Piegan 54 In the Lodge—Piegan 55 Day-dreams—Piegan 55 Author's Camp Among the Spokan 57 Yakima Boy 60 On the Beach—Chinook 60

The Fisherman—Wishham 63
Carved Posts at Alert Bay 63
George Hunt at Fort Rupert 66
Octopus Catcher—Kwakiutl 66
The Fire-drill—Koskimo 66
A Nakoaktok Chief's Daughter—Kwakiutl 71
A Bridal Group—Kwakiutl 71
Typical Nez Percé 72
Basket Maker—Skokomish 75
Puget Sound Baskets 75
The Weaver—Hopi 75
Snake Dancers Entering the Plaza—Hopi 78
Awaiting the Return of the Snake Racers—Hopi 79
A Visitor—Hopi 83
Kachina Dolls—Hopi 83
Walpi 84
A Washo Gem 84
Obsidian-Bearer, White Deerskin Dance—Hupa 85
Hupa Mother and Child 85
Hupa Purses and Money 85

Evening on the Columbia 60

Florence Curtis and two Indian guides 88

Florence Curtis at camp near Ukiah 88

Klamath Child 89

Hupa Woman in Primitive Costume 89

Grinding Medicine-Zuñi 90

Aíyowits!a-Cochiti 91

Tsí'yone ("Flying")—Sia 91

Drying Pottery 93

Pottery Burners at Santa Clara 93

Chipewyan Tipi Among the Aspens 94

Blackfoot Cookery 95

Blackfoot Woman 96

Beth Curtis in Alaska 98

King Island Village from the Sea 99

Drilling Ivory—King Island 100

Boys in Kaiak—Nunivak 102

Kiaiak Frame—Nunivak 102

The Drummer—Nunivak 103

Ceremonial Mask—Nunivak 104

Noatak Child 107

Drying Walrus Hide—Diomede 108

Cutting Up a Beluga Whale—Kotzebue 109

The great changes in practically every phase of the Indian's life that have taken place, especially within recent years, have been such that had the time for collecting much of the material, both descriptive and illustrative, herein recorded, been delayed, it would have been lost forever. The passing of every old man or woman means the passing of some tradition, some knowledge of sacred rites possessed by no other; consequently the information that is to be gathered, for the benefit of future generations, respecting the mode of life of one of the great races of mankind, must be collected at once or the opportunity will be lost for all time. It is this need that has inspired the present task.

> Edward S. Curtis From his foreword to Volume 1, *The North American Indian*, 1907

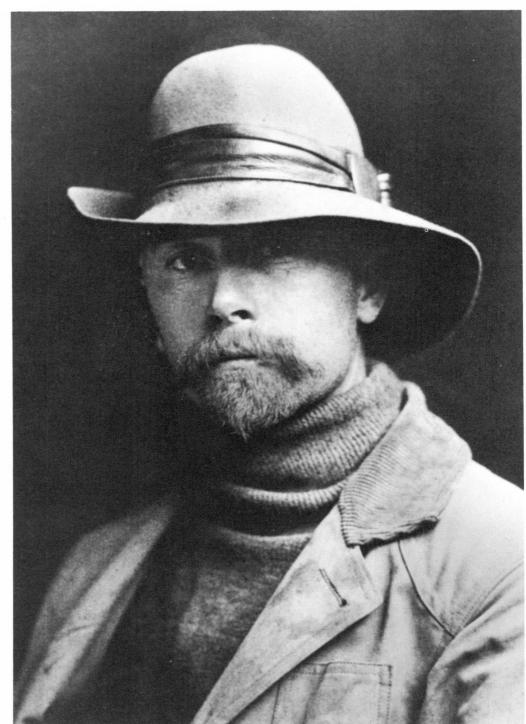

Foreword

In the summer of 1923 when I was twenty-four, Father called long distance: "Could your husband spare you for a couple of months? I will be working with the Indians of northern California and could use your assistance." My husband was understanding and it was arranged. I left Seattle by train and met Father at Williams, California. In the cool of the morning we traveled westward by small car toward the coastal range, mountains we would cross seven times during that season on trails widened sufficiently to be called roads.

Father's dedication to producing an illustrated history of the North American Indian meant the family had to be satisfied with brief visits at home. These were always such very special occasions. And then there were times when he took one or two of us with him for the summer season. Now I was to be the lucky one—he was to be my wonderful companion and would share with me his vast knowledge of the outdoor world in which he lived so many months of the year.

It was this summer that I first became aware of Father's remarkable rapport with the Indians. We set up camp under cottonwood trees near a village where there were Indians of many tribes speaking six distinct languages. Young and old, they came to this area to pick beans, working in temperatures well over 100 degrees to earn a small wage.

According to his usual plan Father worked with an Indian interpreter, one with authority, a chief or medicine man. Father's assistant, Mr. Myers, had already been in the area, gathering data. Father would work on the ethnographic notes which would go in the volume on these Indians and would make photographs.

Communication with the Indians was very restrained. No one warmly welcomed us, yet I sensed a feeling of friendliness. Our camp was open to all. I remember when a young girl rushed into camp telling us her grandmother was very ill and asking us to come. The elderly woman was stretched out on the earthen floor of a small hut. She had been picking beans all day under a torrid sun. Father expressed deep sympathy and we left. Out of earshot I asked, "Shouldn't we go for help?" "No, my dear," he said. "I believe that is for them to decide."

The next day the young girl came again to our camp, her face now wreathed in smiles. "Grandmother is much better. The white doctor came and he could not help, but our medicine man knew what to do." Slowly I began to understand. Accepting the Indians and their beliefs, Father made no effort to influence or change their way of life.

I remember another incident that happened when we were invited to dinner in town at the home of a scientist and his wife. Afterward, walking to the car, I asked Father, "That religious rite the doctor questioned you about which he has been trying to learn for so many years, isn't that the one you were told about just today?" He was startled by my question. "How did you know?" "Just a hunch," I said. "In only a few days you've learned something he had been trying to discover for many years and yet you did not tell him." "Well, no doubt I was just lucky." "Lucky and modest as well," I answered, which made him laugh.

I recall Father saying, "The Indian knows instantly when he is despised." Sensitive of mind and heart, he recognized the Indians' true qualities. They, in turn, revealed to him some of their innermost thoughts, which were usually concealed from the white man.

That summer, I watched him making pictures with a new appreciation of what was involved. He always insisted that the Indians he photographed should be dressed like Indians, and if there was a background scene it had to contain a vital part of their life or land. As I watched him make the close-ups of those proud Indian heads, their armor of hostility seemed to slowly dissolve before my eyes. They were looking at a man who understood and cared. They felt the warmth of his friendship, and in turn he was their friend.

It is gratifying to me that Father is finally winning the recognition he himself was certain would eventually come. It has long been my desire to contribute in my own way to this recognition, and I hope that through this book, I have done so.

> FLORENCE CURTIS GRAYBILL Laguna Hills, California April 1976

The Photographer and His Equipment

Edward S. Curtis, photographer, like all great artists, succeeded in making his process invisible. So complete was his mastery of craft and so sensitive his perceptions, so secure was he in his technique and so trusting his subjects, that the viewer-as many have noted-feels able to enter into the very lives of the people he portrayed. All the more reason, in this age of everyone-a-photographer, to wonder for a moment about the basic tools used by this remarkable man as he traveled from tribe to tribe for three decades. "What camera," the question goes, "did he use?" The answer, of course, is "Many." While Curtis did employ numerous cameras over the years, ranging from a 14 x 17 inch glass plate behemoth taken along on his first voyage to Alaska before the turn of the century, to a 6 x 8 inch sheet film reflex model used on his final journey to the same place in 1927, the $6\frac{1}{2} \times 8\frac{1}{2}$ inch dry-plate view camera seemed to suit him best. Time and again, "The Chief"-as his colleagues affectionately referred to him-turned to the favored old Reversible-Back Premo, and it would appear that a high percentage of Curtis' 40,000 exposures were made with this fine mahogany, brass, and leather instrument. Introduced in 1897, the Premo boasted a Victor Rapid Rectilinear Lens and an iris diaphragm shutter, and offered other controls important to the photographer in the field: rising and sliding front, rack and pinion focusing, and double swing back in which, as the name of the camera implies, the position of the plate could be changed from horizontal to vertical while the camera remained on the tripod. An added advantage was that the camera, being relatively light in weight, could be hand-held as the situation arose-the typical shutter speed of 1/25 of a second generally posing no insurmountable problems. And that, for Curtis, was essentially it, insofar as basic photographic tools were concerned; there were no exposure meters, no filters, no gadgets; just a camera, tripod, focusing cloth, and film.

Development of the exposed plates in a pyro developer usually was accomplished in a tent at night, with work prints made the following day on printing-out-paper or, sometimes, on ferroprussiate (blueprint) paper exposed to the sun in a printing frame. Names and other identifying data would then be scrawled across the faces and backs of the work prints, and Curtis would sometimes scribble special instructions to his studio associates in Seattle. (One photograph of a young man racing by on a horse revealed a blurry object dangling from a rope and evidently slapping against the flank of the animal as it galloped along. Curtis drew a circle around the object with his pen and wrote, "Make this look like a chicken." Of course, it *was* a chicken—on its way to the cooking pot, no doubt—but Curtis wanted it to *look* like a chicken, and so instructed his studio. Retouching was a tool to be utilized as needed.)

—Jean-Antony du Lac

HE CURTIS STUDIO in Seattle was where society girls went to have their portraits made in the late 1890's, tradition had it. A portrait by Curtis gave them "glamour." But if they were drawn also by the aristocratic person of the young proprietor, six feet two, athletic, and with a well-trimmed Vandyke beard, they were usually disappointed.

More often than not, Edward Sheriff Curtis was away taking pictures of Indians. Curtis' fascination with Indians as subject matter began when he came on Princess Angeline, aged daughter of Chief Sealth (whose name somehow came out Seattle when it was given to the city), digging clams near the shack where she lived on Puget Sound. "I paid the princess a dollar for each picture I made," Curtis recalled a long time afterward. "This seemed to please her greatly and she indicated that she preferred to spend her time having pictures taken to digging clams."

Indian subjects appealed to him further after he visited the Tulalip reservation one morning, hired the Indian policeman and his wife for the day, and made many photographs. He went back another day and made some more. He gained the confidence of the Indians, he explained, by saying "We, not you. In other words, I worked with them and not at them."

After taking pictures of the Indians for three seasons, he entered three—*The Clam Digger*, his very first; *Homeward*; and *The Mussel Gatherer*—in the National Photographic Exhibition and won the grand prize. Sent on a tour of the world, the prize-winning pictures took prizes wherever they went, one a solid gold medal.

Curtis achieved these results with a massive 14 x 17 view camera, using glass plates. He had bought the camera from a prospector heading for the California gold fields who needed a grubstake. Not that there weren't more sophisticated cameras to be had. Modern photography had been heralded a good many years before, in 1880, when George Eastman introduced the dry plate, bringing exposure time down to a fraction of a second.

Edison's invention of the electric light also had given a boost to photography by dispensing with the need for a skylight. Now the studio could be brought down to the ground floor, precluding the need to ride an elevator or climb the stairs.

Photography became so popular in the 1880's that artists, among them John Singer Sargent and James McNeill Whistler, put aside brush and palette to experiment with the camera as a means of self-expression—as David Octavius Hill, the well-known Scottish portrait artist, had done long before with a far more primitive camera, using it for three years before returning to his easel.

Then came Eastman's Kodak, the first handy, hand-held camera. With a fixed focus, it took circular pictures $2^{1/2}$ inches in diameter and carried a roll of 100 exposures. Photography became a craze rivaled only by that of the bicycle. "There was a fan in every family," observed *Scientific American* in 1896. For those who couldn't afford to buy a camera, manuals were published showing them how to make their own, much as in the natal days of radio, in the early 1920's, many built the "wireless" themselves.

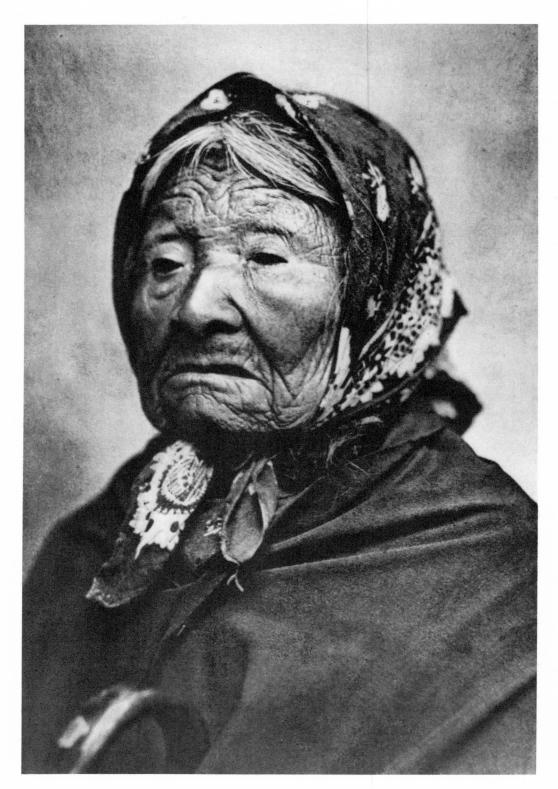

Curtis' first camera he made himself, guided by a borrowed manual. He fitted a wooden box inside another, mounting at the front a stereopticon lens which his father had brought home from the Civil War. There wasn't much money in the Curtis family. Johnson Curtis was a hardscrabble farmer and part-time preacher, who took young Edward, the second of his four children, with him to help on the paddles when he set out by canoe each autumn to call on his parishioners, scattered through hundreds of square miles of the Minnesota woods, holding church services and performing marriages and baptisms along the way. No small part of the recompense father and son brought home for these services each time was a flour sackful of delicious smoked leg of muskrat.

Curtis used to tell of the time when all the family had to eat for a couple of weeks was boiled potatoes—always boiled because there was no grease to change off to fries. In the midst of this depletion, the presiding elder of the local church rode up on his horse unexpectedly one afternoon, near dinner time. Mrs. Curtis called young Edward and said, "We can't just give the elder boiled potatoes. Is that old snapping turtle still down by the creek?"

Princess Angeline. This aged woman, daughter of the chief Siahl (Seattle), was for many years a familiar figure on the streets of Seattle.

When he had finished off the turtle, the guest said, appreciatively, "That was one of the most delicious meals I've ever had. What was that meat?"

Told what it was, he became ill.

Taking pictures in his spare time with his homemade camera, Edward worked a year or so in a St. Paul photographic gallery, gaining experience in printing and coating. Then he tried running his own shop, but this failed because having their pictures taken was far from the most pressing need of the struggling residents of his small backwoods community. Edward put away his camera, and though not yet eighteen, found a job bossing 250 French-Canadians on the Soo Line railroad.

The following year, 1887, the Curtis family moved to Washington Territory for the elder Curtis' health, homesteading at the south end of Puget Sound, near what is now Port Orchard. Among the attractions of the new country for Edward were the daughters of the Phillips family, living nearby. In 1892 he married Clara Phillips, who was bright, well-read, a good conversationalist, and shared Edward's love for this great, scenic land of the Northwest—but not his interest in photography.

The same year he was married, Curtis bought a photo studio at 614 Second Avenue, Seattle, for \$150. Henry Guptil put up the money, Curtis buying him out two years later. "Curtis and Guptil," as the place was first known, specialized in "family portraits," and in sepia prints of Curtis' Indian pictures. Little by little it acquired status as the place where the elite went to have their pictures taken, in particular young ladies of the social register.

As the absentee proprietor roamed with his camera ever farther afield from Seattle, he took pictures not only of Indians but of the scenery as well. A rich source of scenic views was 14,000-foot Mt. Rainier with its lakes and mirrored images of peaks, forests, and flowers. Curtis became a skilled alpinist. With his camera and heavy pack of glass plates, he sometimes led others to the top, on one occasion 108 Kiwanians.

He put in a good part of two summers taking pictures on Rainier. "On the second season a party of scientificos came to study the mountain," Curtis wrote in 1951 to Harriet Leitch of the Seattle Public Library, who had asked him for information about his life. "A couple of times they got lost. I managed to get them to my camp where I thawed them out and bedded [them] down. Following that I acted as their guide in giving the mountain the once-over."

The "scientificos" were all men of eminence. They included Dr. C. Hart Merriam, physician and naturalist, who was chief of the United States Biological Survey; and Gifford Pinchot, chief of the Division of Forestry (later the Forest Service, Department of Agriculture), later governor of Pennsylvania, a pioneer conservationist and writer about trees. A third in the group was George Bird Grinnell, editor of *Forest and Stream* and well-known for his books about the Plains Indians, as well as a conservationist and naturalist.

The upshot of Curtis' chance encounter with the VIP's on the mountain in 1898 was that he was invited by railroad magnate E. H. Harriman to go along as official

photographer on an expedition to Alaska the following summer. The roster of scientists accompanying Harriman, who first had in mind merely a family excursion but was persuaded to turn the trip into a full-fledged scientific expedition by the men Curtis met on Rainier, read like a *Who's Who* of science. Among them were naturalists John Muir and John Burroughs, who spent most of the time in heated argument with each other.

Muir later wrote that one of the most exciting moments of the entire expedition was provided by Curtis and his assistant as they took pictures from a small canvas canoe under the face of Muir Glacier. As the others watched from a hill, a big chunk of the glacier broke off and plunged into the water. The boat, already riding precariously low from the weight of the two men and their equipment, vanished. It reappeared on the crest of a wave, only to be lost to view once more as a second chunk of ice roared into Glacier Bay. The watchers on the hill turned away, convinced they had seen a tragedy.

Between them, Curtis and his assistant, D. G. Inverarity, made more than 5,000 photographs during the journey, which covered 9,000 miles and took the voyagers to the edge of Siberia. "The summer days in Alaska are long on both ends, and Mr. Harriman urged that I make use of all the daylight," Curtis wrote Miss Leitch.

HE SUMMER after the Harriman expedition, Curtis visited the Blackfoot Indians of Montana, as guest of George Bird Grinnell. Grinnell, who had spent each summer for the past twenty years among these Indians, was becoming known as "Father of the Blackfoot People." It was a pivotal experience for Curtis as he and Grinnell sat astride their horses on a high bluff looking out over a vast plain where the Indians were gathering for their annual sun dance, on the Piegan Reservation. Never before had he seen so many Indians at one time.

"The sight of that great encampment of prairie Indians was unforgettable," he recalled years afterward when he briefly yielded to members of his family who wanted him to write about his life. "Neither house nor fence marred the landscape. The broad, undulating prairie stretching toward the Little Rockies, miles to the west, was carpeted with tipis. The Blood and Blackfeet from Canada were also arriving for a visit with their fellow Algonquin."

He described the scene further—men and women riding horses, some traveling by wagon; camp equipment, personal effects, babies and pups hauled by travois, the transport device consisting of two poles held together by a frame and drawn by a horse.

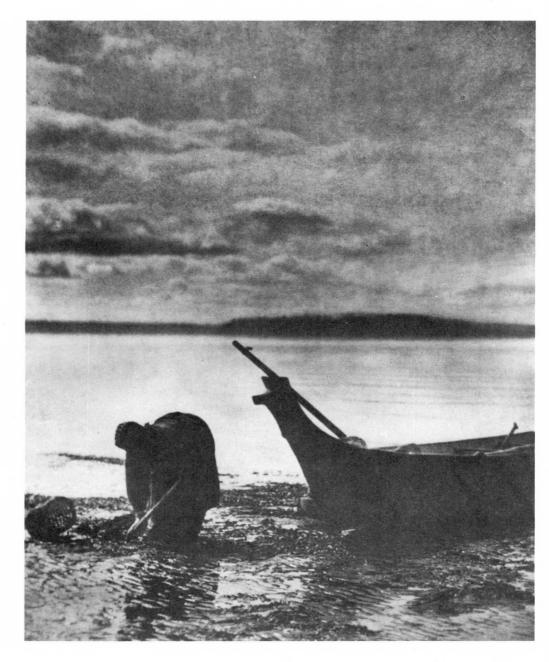

The Clam Digger. Clams are an important food to those who live in the vicinity of the clam beds; to others they are a comparative luxury obtained by barter. The implement of the digger is a wooden dibble.

Edward S. Curtis in a Kutenai canoe, probably around 1904.

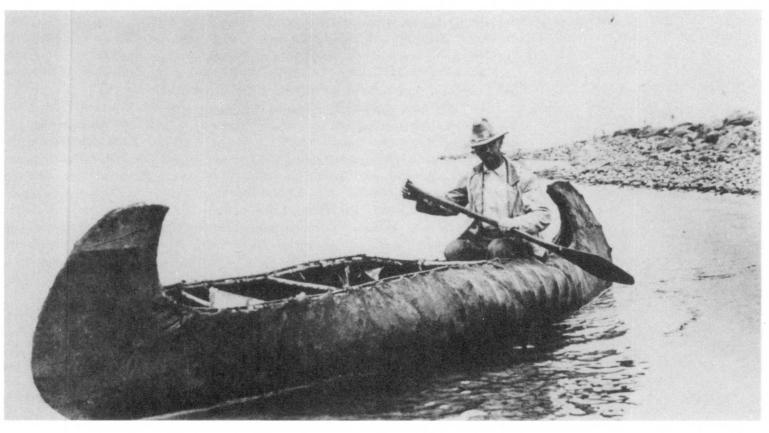

"It made a very deep impression on him," Florence Curtis Graybill remembered. "He often spoke of it afterward. To most people it would have been just a bunch of Indians. To him it was something that soon would never be seen again."

The Indians east of the Mississippi were already considered to have passed out of sight, without any true documentation of their way of life having been made. In the West, as the tide of empire crept inexorably toward the Pacific, the settlers generally went along with the view of General Philip Sheridan, "The only good Indian is a dead Indian."

The red man had little heart left for the fight after Wounded Knee, the My Lai of the day, when some 300 unarmed men, women, and children were slaughtered by the United States Cavalry. Throughout the West, he had been swindled, debauched, murdered, and massacred. And the missionaries had been abroad for some time now, seeking to make Christians out of these heathens.

The day was fast arriving, Curtis saw, when the Indian of old would be no more; his was a vanishing race.

Ten days after he had sat with Grinnell overlooking the scene on the Montana prairie, Curtis was at work with his camera among the Hopi in southern Arizona. There had been others before him who made pictures of the Indians. Among these was George Catlin, lawyer and painter, of Wilkes-Barre, Pennsylvania, who went west in 1832 to paint the red man. Catlin became so absorbed in what he was doing that he gave up his law practice and stayed twenty-five years. In 1850 Henry Schoolcraft, of Mackinac Island, Michigan, published six volumes about Indians, illustrated with steel engravings from drawings by army captain Seth Eastman.

The first man to make his pictures by camera, apparently, was William Henry Jackson, of Denver. Traveling in a buggy fitted with a darkroom, Jackson shot pictures of Indians, wagon trains, Pony Express riders, and other such subjects of the West. Will Soule, who photographed the Indians around Fort Sill, Oklahoma; and Adam Clark Vroman, who favored photos of the Indians of the Southwest, were two others prominent on the list of those who preceded Curtis in catching the Indian on film. "Shadow catchers," the Indians called them.

But Curtis stood alone in that he went about it systematically, and with a comprehensive plan. He had in mind making "a photographic history of the American Indian," as he later described it, recording him on film before he gave way too much to the white man's culture. With each picture he planned a descriptive title, telling something about the tribe represented.

In the summer of 1904, Curtis was encouraged in his plan by President Theodore Roosevelt, who had invited him to Sagamore Hill, the Roosevelt summer home, at Oyster Bay, New York, to photograph the family. Roosevelt had seen Curtis' pictures of the winner in the most-beautiful-child-in-America contest, published in the *Ladies' Home Journal*.

Roosevelt had spent a great deal of time in Indian country, as a resident of his Elkhorn Ranch in the Dakota Badlands, and was a champion of the Indians. He ad-

mired the folder of Indian pictures Curtis had brought along and listened attentively as Curtis told what he had in mind. "I'll do all I can to help," TR replied enthusiastically when Curtis finished.

At this point, however, Curtis had no thought of the ultimate dimensions of what he had set out to do. He could never have foreseen that the work he had begun in the heat of the southwestern desert would end in a screaming storm above the Arctic Circle thirty years later, that he would study more than 80 tribes, from Mexico to Alaska, taking more than 40,000 photographs, making over 10,000 recordings on wax cylinders, and writing hundreds of thousands of words, all comprising an ethnological masterwork without equal. He could not have guessed that it would consume his life: There would be no vacations, indeed hardly a weekend off, but sixteen hours of work a day, seven days a week year after year as he passed from young man to old.

"Following the Indian's form of naming man I would be termed The Man Who Never Took Time to Play," Curtis wrote when he was eighty-three.

One thing Curtis did know in those beginning days, though: the kind of job he was going to do. "I made one resolve, that the pictures should be made according to the best of modern methods and of a size that the face might be studied as the Indian's own flesh. And above all, none of these pictures would admit anything which betokened civilization, whether in an article of dress or landscapes or objects on the ground. These pictures were to be transcriptions for future generations that they might behold the Indian as nearly lifelike as possible as he moved about before he ever saw a paleface or knew there was anything human or in nature other than what he himself had seen."

It didn't always go well at first, mostly because Curtis was as ignorant about the Indians as everybody else. They shot at him. They crowded in front of his lens. A drunken Indian on a horse nearly rode him down. One threw handsful of dirt at the camera—whereupon Curtis drew his knife and rushed the offender.

By showing he was no coward, by acting naturally, by making friends with Indian children and dogs, and most of all, by learning the Indian point of view about himself and about the white man—whom he regarded as his inferior—Curtis won respect.

One thing worked for him subconsciously. "An Indian is like an animal or a little child," he once said. "They instinctively know whether you like them—or if you're patronizing them. They knew I liked them and was trying to do something for them."

When the work had been underway fourteen years, Curtis told a *New York Times* reporter, in 1911, "Many of them are not only willing but anxious to help. They have grasped the idea that this is to be a permanent memorial of their race, and it appeals to their imagination. Word passes from tribe to tribe. . . . A tribe that I have visited and studied lets another tribe know that after the present generation has passed away men will know from this record what they were like, and what they did, and the second tribe doesn't want to be left out.

13

"Tribes that I won't reach for four or five years yet, have sent me word asking me

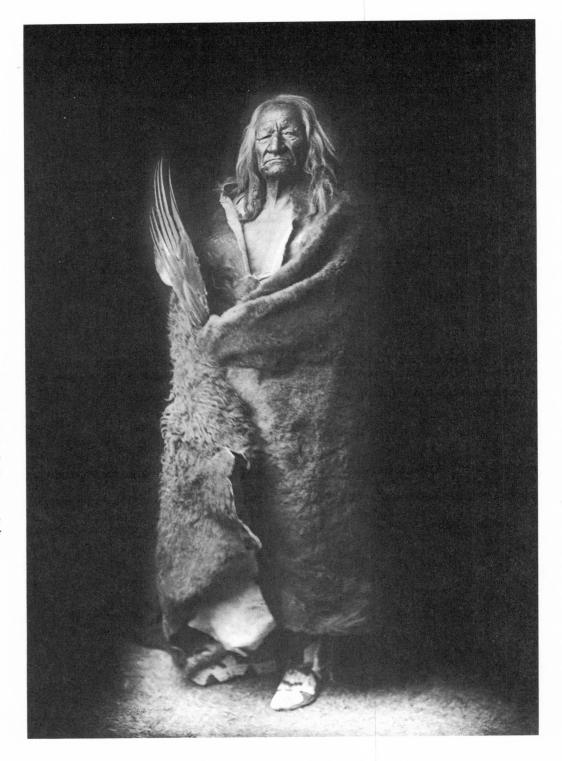

Black Eagle—Assiniboin. Born in 1834 on the Missouri, below Williston, North Dakota. He was only thirteen years of age when he first went to war, and on this and on the next two occasions he gained no honors. On his fourth excursion he was more successful, alone capturing six horses of the Yanktonai. Black Eagle led war-parties three times. He married at the age of eighteen.

> to come and see them. Where they haven't hit upon the idea themselves I suggest it to them. I say, 'Such and such a tribe will be in this record and you won't. Your children will try to find you in it and won't be able, and they will think you didn't amount to anything at all, while the other tribe will be thought to be big people.'"

> This approach finally moved Chief Black Eagle of the Assiniboin, a seamy-faced tribal elder of ninety years, who all his life had refused to tell the paleface a word about his nation. After having been belligerent and noncommittal all day toward Curtis, denying him even a picture, the old chief showed up in Curtis' tent at three o'clock in the morning, giving the sleeping man quite a start as he laid a hand on his shoulder, and said, "I want the book to have something in it about Black Eagle."

"There will be if you'll tell me something to write," Curtis answered. Black Eagle's boycott was over.

On one occasion the elements intervened on Curtis' behalf. With his interpreter he had ridden for hours in wet, raw weather to hear about a secret ceremony from an old priest who had promised to reveal all there was to tell. Curtis soon realized that the priest was holding out on him, giving him only parts of the story.

Curtis stopped the proceedings. "Your gods will be angry with you because you lied to me," he scolded. There came a timely flash of lightning followed by a clap of

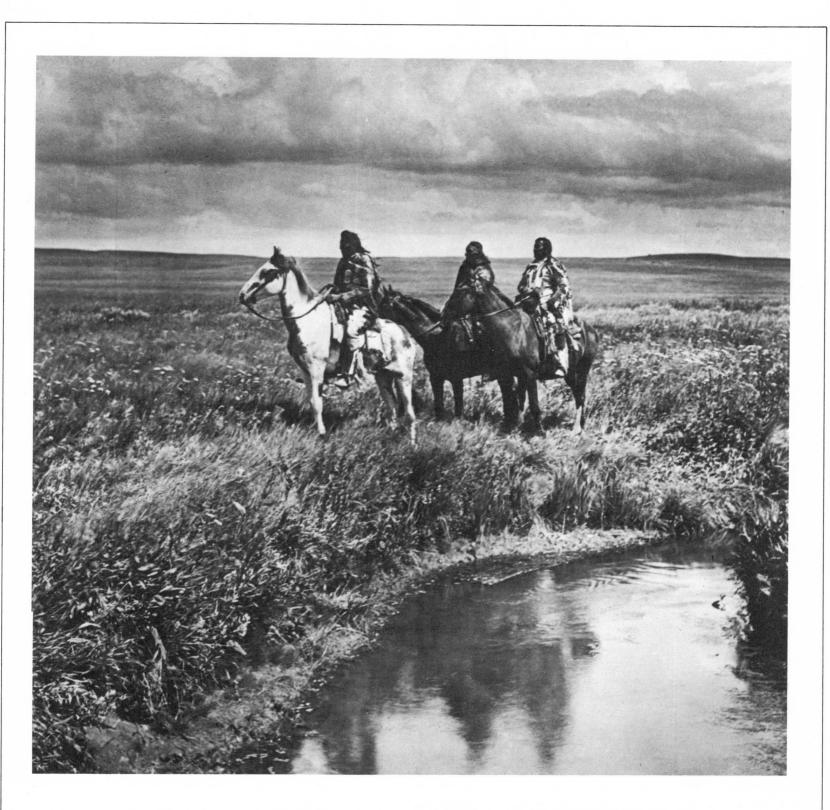

The Three Chiefs—Piegan. Three proud old leaders of their people. A picture of the primal upland prairies with their waving grass and limpid streams. A glimpse of the life and conditions which are on the verge of extinction. thunder. "See," Curtis said, "they are angry. They know you lied to me."

The priest grabbed a sacred white buffalo robe and mounted to the roof of the lodge. Waving the robe at the heavens as the storm gathered, he made an impassioned invocation to the divine ones to forgive him, his harangue frequently lost in peals of thunder. He then gave Curtis the full and straight story he was after.

The key to the Indians' confidence, Curtis found, was religion. He understood why they held back on this topic. "Even the cultivated man of civilization is loath to open the inner sanctum of his soul to the inquisitive," he told an interviewer for the Washington *Star* in 1908. "If educated people object to such self-exhibition, what can be expected of the primitive man who from the first has been told that his gods are fictitious, and that his superstitions . . . are wrong and childish."

Curtis studied comparative religion, accumulating an extensive library in this field which he kept with him to the end of his life. Well grounded in the subject, he could talk freely about it. If the conversation was slow to start, he would say something which he knew was wrong, provoking a correction. The Indian would explain why it was wrong—and it went on from there.

The Indians came to sense that in Curtis they had a friend who understood with them "that all things are the works of the Great Spirit," as Black Elk of the Oglala

Sioux put it in his prayer. "We should know that He is within all things: the trees, the grasses, the rivers, the mountains, and all the four-legged animals, and the winged peoples. . . ."

Thus, Theodore Roosevelt could write in his foreword to the volumes, "Mr. Curtis . . . has been able to do what no other man has ever done. . . . [He has] caught glimpses . . . into that strange spiritual and mental life of [the Indians]—from whose innermost recesses all white men are forever barred."

Curtis survived many hazards, and it came to be believed that he carried a rabbit's foot of uncommon power. One early incident occurred as he worked one afternoon in the killer heat of a summer day in the Southern California desert, near Palm Springs, photographing the Cahuilla Indians.

"I was so engrossed in my task I must have stayed too long in the sun," he wrote in the grudging memoirs which he never completed. "The next I remembered was waking up in the early dawn in a garden oasis. The area was surrounded by a picket fence with a vulture on almost every fence post. The stench was horrible. Frankly, I wasn't at all sure I was really alive."

The owner of the place presented himself, explaining that Curtis' Indian guide had found him in the desert the day before, unconscious from a sunstroke. The owner now had a reciprocal favor to ask of Curtis: Would he help him build a coffin for his wife, who had died of an illness during the night and whose rapidly putrefying body accounted for the smell and the vultures.

"We put together a crude box as rapidly as possible, constantly battling the vultures," Curtis wrote. "We placed his wife in the box, which we then lifted into the buckboard, and started on our difficult trek to Banning, some twenty miles away, where was located the nearest undertaker. Unfortunately, the box did not shut out the odor that traveled with us. There were no paved roads, and the dust and heat made the distance seem interminable."

As Curtis got into his project, his zeal grew. "The longer I work at this collection of pictures, the more certain I feel of their great value," he wrote to Frederick Webb Hodge, of the Bureau of American Ethnology at the Smithsonian Institution in Washington, D.C., on October 28, 1904. Curtis had just completed a long visit among the Navaho and Apache in the Southwest.

He was learning something else as well, he indicated in his letter to Hodge: "The only question now, in my mind, is, will I be able to keep at it long enough . . . doing it in a thorough way is enormously expensive and I am finding it rather difficult to give as much time to the work as I would like."

In December, friends in Seattle hired Christensen's Hall so Curtis could show the public some of the photographs he had. The response was enthusiastic.

Of *The Three Chiefs*, showing three horsemen of the Piegan tribe in Montana scanning the horizon, the Seattle *Times* said, "This picture is so remarkable in its lines of composition that we marvel how the artistic requirements could be accomplished with the camera."

The Vanishing Race, a column of mounted Indians retreating at day's end toward the dark opening of a canyon, possessed "a haunting mysticism rarely found in pictures," the *Times* commented, a response that would be heard many times about this picture as the years passed.

Ironically, Curtis had been afraid the picture might be too dark when he brought the plate to his Seattle studio. "I'll make it come out," he was assured by A. F. Muhr, the genius in charge of the darkroom.

Curtis was honor guest for dinner at Seattle's exclusive Rainier Club, making a big hit as he showed 150 slides of his photographs and told how he got them. When news accounts of the Seattle event reached Portland, the Mazamas invited him to come there and put on his show at the White Temple. Again, he was warmly received. "It is surely an educational work of unique and remarkable value which should be enjoyed by all public school pupils, teachers, students of American history and the public generally," the *Oregonian* reported. Curtis' fame was spreading.

Early in 1905, at the suggestion of Erastus Brainard, lobbyist for the state of Washington, Curtis took a selection of his pictures to Washington, D.C., where E. H. Harriman helped him set up an exhibit at the fashionable Washington Club. This was followed by another show at Dolly Madison's old home, the equally elegant Cosmos Club.

Gifford Pinchot, one of the men Curtis had rescued on Mt. Rainier half a dozen years before, had him to dinner at his home, remarking of his pictures, "I certainly have seen no such collection anywhere in the world." Curtis also was invited to speak at the National Academy of Sciences, no small honor for a man whose formal education stopped at grammar school.

While in Washington, Curtis ran into another old friend as well. Indian Affairs Commissioner Francis Leupp asked him to photograph a group of Indians on hand for the inauguration of Theodore Roosevelt. As Curtis approached them in a light rain on the White House lawn to set up his camera, an Indian wrapped in a red blanket stepped forward, opened the blanket, and enfolded Curtis within it. It was Geronimo, the one-time Apache terror of the plains, one of five chiefs invited to ride in the inaugural parade.

In New York, members of the "four hundred" came in force to see his exhibit in the grand ballroom of the Waldorf-Astoria—Mrs. Jay Gould, Mrs. Frederick W. Vanderbilt, Mrs. Douglas Robinson, sister of the president—but left Curtis to pay the \$1,300 tab for the rental of the hall. Happily, the patrons also bought his photographs, at least saving him from financial embarrassment.

At the close of his Waldorf show, Curtis shipped his pictures to the Lewis and Clark Fair at Portland, where again they were a hit. "The present day life of every people in this big world is shown," noted the *Oregonian*, "but the exhibit which will mean more than any other to the American and his history a thousand years from now is a little group of Indian photographs which occupies a quiet corner in the attic of the forestry building."

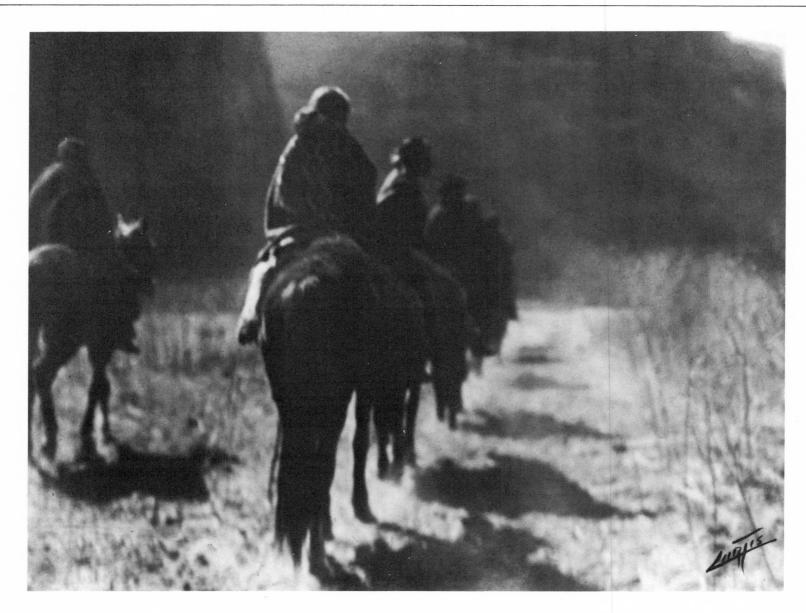

The Vanishing Race—Navaho. The thought which this picture is meant to convey is that the Indians as a race, already shorn of their tribal strength and stripped of their primitive dress, are passing into the darkness of an unknown future. Feeling that the picture expressed so much of the thought that inspired his entire work, Curtis chose it as the first of the photographs to be included in *The North American Indian* portfolios.

> An Oasis in the Bad Lands. This picture was made in the heart of the Bad Lands of South Dakota. The subject is the sub-chief Red Hawk. He was born in 1854. His first war-party was in 1864 under Crazy Horse, against troops. He led an unsuccessful war-party at twenty-two against the Shoshoni. He was engaged in twenty battles, many with troops, among them the Custer fight of 1876.

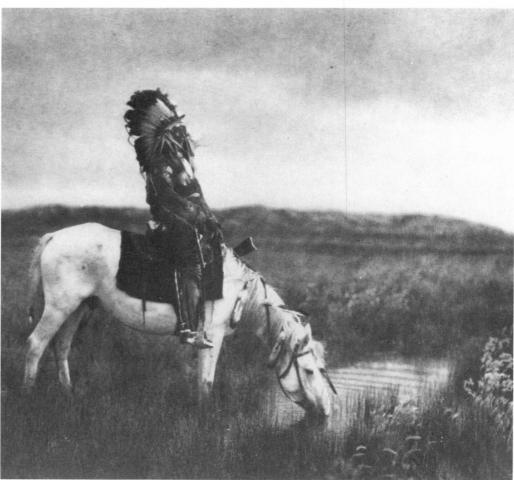

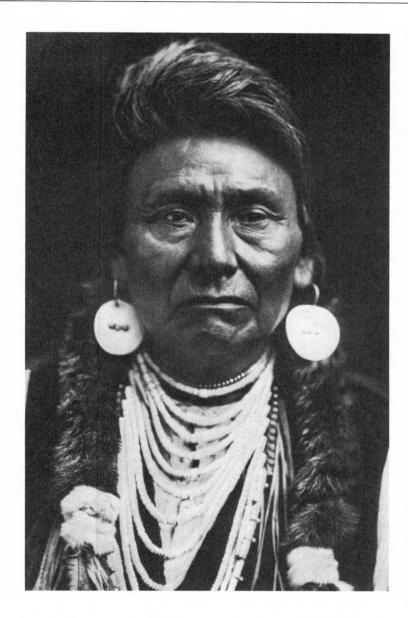

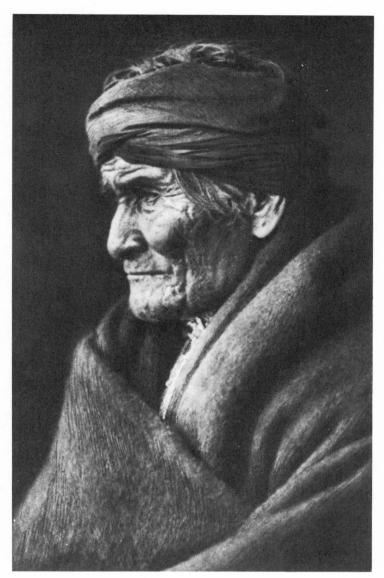

ABOVE: Chief Joseph—Nez Percé. The name of Chief Joseph is better known than that of any other Northwestern Indian. To him popular opinion has given the credit of conducting a remarkable strategic movement from Idaho to northern Montana in the flight of the Nez Percés in 1877.

ABOVE RIGHT: Geronimo—Apache. This portrait of the historical old Apache was made in March 1905. According to Geronimo's calculation he was at that time seventy-six years of age, thus making the year of his birth 1829. The picture was taken at Carlisle, Pennsylvania, the day before the inauguration of President Roosevelt, Geronimo being one of the warriors who took part in the inaugural parade at Washington. He appreciated the honor of being one of those chosen for this occasion, and the catching of his features while the old warrior was in a retrospective mood was most fortunate.

Returning west as the summer of 1905 came on, Curtis visited the Sioux in South Dakota. With Chief Red Hawk and twenty of the chief's followers escorting him, Curtis explored the Badlands, some fifty miles north of Wounded Knee. It was on this occasion that he took one of his most famous pictures, *An Oasis in the Badlands*, showing Red Hawk watering his horse on the prairie.

At the end of his stay among them, Curtis promised to come back and give a feast for his Indian hosts of the summer. In return it was understood that with Chief Red Hawk in charge, they would set up an old-time Sioux camp for Curtis' camera and enact some of their ancient rites and customs, with no clothes or other trappings of the white man showing.

Also, at Nespelem, Washington, during the summer of 1905—on June 20—Curtis helped rebury his friend, Chief Joseph, the great Nez Percé leader, with whom Curtis had spent much time while gathering his story for Volume 8. Joseph had died in September of the year before, of a heart ailment, and had been buried in a temporary grave while the State Historical Society prepared a suitable monument, perhaps in some measure to atone for the wrongs done to him in life by the white man.

Made of marble, the monument bore Joseph's likeness along with his Indian name, Hin-mah—too-yah-lat-kekt, meaning "Thunder Rolling in the Mountains," as well as his English name.

Before the ceremonies, conducted by Edmond S. Meany, professor of history at the University of Washington, whom Joseph called "Three Knives," certain preliminaries were necessary. Curtis, who apparently had taken part in the first interment, described these to Miss Leitch forty-five years later.

"In the days of long ago," he wrote, "I helped to bury the chief twice. In order to bury him the second time we had to dig him up. I did most of the digging. It was a very hot day and the Noble Red Men said, 'Let the white men do the digging. They know how.'" ACK IN NEW YORK as winter settled over the plains, Curtis again heard his work richly praised, but by now it was clear to him that unless he found financial help, he would have to abandon the project. He wrote to President Roosevelt, asking for a testimonial which he could use in trying to raise some money.

TR responded with a laudatory letter "To Whom It May Concern," which Curtis was free to show "in talking with any man who has an interest in the subject."

Presumably using the Roosevelt letter, Curtis arranged an appointment with J. Pierpont Morgan, and in due course he found himself sitting, somewhat nervously, in the presence of the Croesus of Wall Street. Morgan listened inscrutably as Curtis talked, the story goes, then cut him off. "There are many demands on me for financial assistance," he said. "I will be unable to help you."

Curtis opened his folder and began sliding pictures across the desk. Morgan examined each carefully. "Mr. Curtis," he announced finally, "I want to see these photographs in books—the most beautiful set of books ever published."

If there was to be text along with the photographs, telling of the Indian's customs, ceremonials, beliefs, myths, religion, what he did day to day—Curtis eventually developed twenty-five cardinal points of information to explore—with all of it bound up in books, the question arose as to who should do the writing.

"You are the one to write the text," Morgan declared at once. "You know the Indians and how they live and what they are thinking."

The plans called for 20 volumes of text and pictures, to be published in a limited edition of 500 sets, each book to be accompanied by a large portfolio of Curtis' prints, all to be sold by subscription. Two kinds of paper were selected, each handmade and each the costliest to be had: imported Japanese vellum, and a special Dutch etching stock called Van Gelder. The pictures were to be hand-printed from copperplates, by John Andrew and Son, of Boston. The University Press in Cambridge was chosen as the printer.

The price was fixed at \$3,000 for the set printed on vellum, at \$3,850 for the Van Gelder. These prices, Morgan estimated, would more than meet the costs of publication. He agreed to put up \$75,000 toward Curtis' field expenses, to be paid out at the rate of \$15,000 a year for five years. In return, Morgan was to receive 25 of the \$3,000 sets, along with their matching portfolios of 500 photogravures.

Additionally, the arrangements called for Curtis to give time to promotion and sales of the work, besides his researches in the field.

It was now, too, that the decision was made to record the music and language of the Indians on Edison cylinders. This task alone grew to awesome proportions. "In the coastal states of California and Oregon we recorded more root languages than exist on the face of the globe," Curtis wrote. "In several cases [we] collected and recorded the vocabularies from the last living man knowing the words of a root language. It can safely be said that no comparable record of the words of a passing race has ever been made."

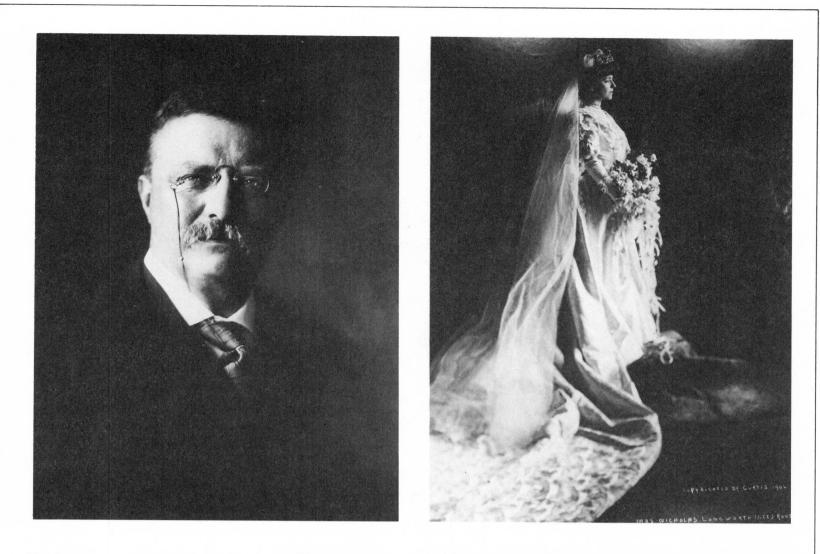

Theodore Roosevelt, taken by Curtis in 1904.

Mrs. Nicholas Longworth (Alice Roosevelt), February 1906.

The arrangements with Morgan settled, Curtis tarried in the East to photograph the wedding of Alice Roosevelt to Nicholas Longworth, the headline society event of the day, on February 17, 1906. Then he prepared to head back to the Indians.

"Will you please write me in the next few weeks, addressed to Seattle, as to any points which I may take up in the White Mountain Apache country," Curtis wrote on March 26 to Frederick Webb Hodge, who had been chosen to edit his work, at 7 per thousand words.*

"Also, if you know of an available map there in Washington which gives a good detail of that country, I wish you would have a copy mailed to me. Something on which I can check up the primitive home location of the different bands. \dots "

On April 10, Curtis had a final favor to ask of Hodge before leaving for the West. "A thought has occurred to me that there may be several times during the summer when I see some old and interesting ruin that I would like to do a little digging in," he wrote. "I have in mind the Apache country. . . . If this can be arranged in any way will you let me know."

Reaching Seattle, he found that there was still something he needed. "Once more I must bother you," he wrote Hodge apologetically on April 25, 1906, "but if you have a copy of your paper, 'The Early Navaho and Apache,' will you please send me one—?

"I am a little upset with the California calamity, and slightly delayed as part of my equipment was there and must be replaced."

The "California calamity" was, of course, the great San Francisco earthquake which took place on April 18, a week before Curtis wrote the letter. It was characteristic of him that he made only this glancing reference to the matter as it concerned him, leaving Hodge in the dark as to details. He was "one of the most genial and pleasant of men," once commented A. F. Muhr, "but he wasted few words on adventure and misadventure, except as forced by circumstances—as the time he returned from the field with the camera held together by a rope tied in a diamond cinch about it, and when this was untied the camera fell apart." This seemed to call for some explanation. His mule had fallen off a cliff, carrying the camera with it.

* How Hodge was chosen to be the editor is not recorded.

The Scout—Apache. The primitive Apache in his mountain home.

N EARLY JUNE, Curtis wrote from Holbrook, Arizona, "We are here in the Apache country, working away the best we can. I feel certain we are going to be very successful in getting a lot of splendid Apache material. Perhaps the least bit too certain of it—however, I know it's going to be a very successful effort. . . .

"By the way, is your Indian dictionary or encyclopedia in such shape that any parts of it could be sent on to me?" he asked, referring to the two-volume, 2,000page *Handbook of the American Indian* which Hodge was editing.

". . . Just at the present time this is the only thing I can think of that I want to ask you to do for me, but one thing is certain, at the time I quit the Apache Reservation, there will be a good many questions answered as to the inner life of the Apache. . . ."

Some of the questions that were answered had to do with the Apache's spiritual life. The Apache guarded this aspect of his life so closely, and he was supposed to be such a ferocious being, that many believed he had no religion.

As Curtis wrote, "The Apache Indian has been credited with such inhuman characteristics by fiction, it is difficult for a reader to picture him as extremely religious. To secure their genetic legend, I realized it would require the greatest skill and patience on my part."

Curtis approached them on the subject with pretended indifference. "I asked no questions and indicated no special interest in more than casual things."

But by keeping his eyes open as the Indians went about their daily routines, he could see that they were deeply religious. "The men rose at dawn and bathed in pools or streams that their bodies be acceptable to the gods. Each man in isolation greeted the rising sun in fervent prayer. Secretly shrines were visited and invocations made. I realized, though, if I asked a single question or displayed any curiosity as to their devotional rites, I would defeat my purpose."

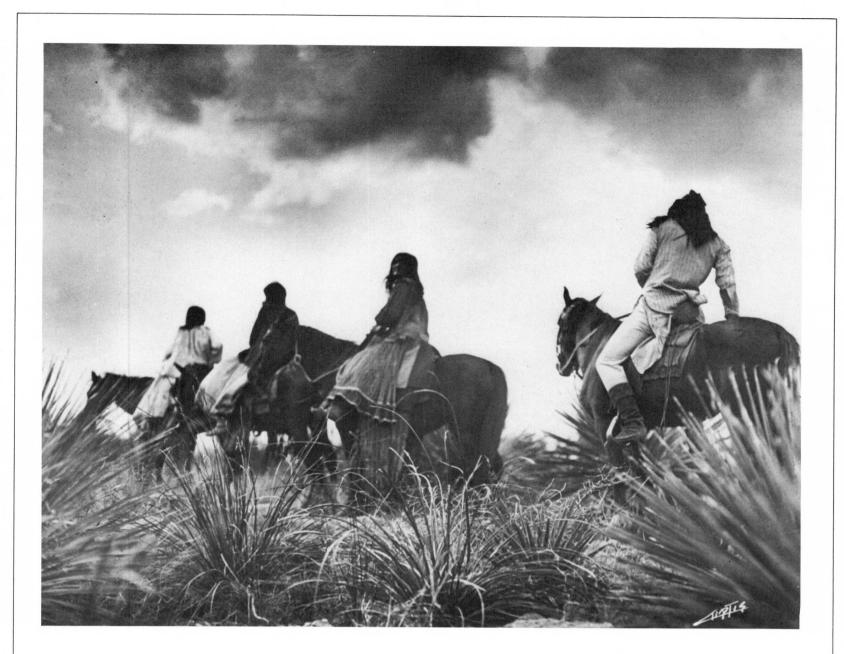

The Storm—Apache. A scene in the high mountains of Apache-land just before the breaking of a rainstorm.

Curtis' feigned lack of interest was so convincing that the Apache invited him to accompany them on a trip into the mountains to harvest mescal, a species of cactus and one of their important foods.

"That first night, with Indian courtesy, they allowed me to pick my camp site first, which I chose by the river under the shade of a walnut tree," Curtis recounted. "Around the campfire that evening we sat telling stories. I included accounts of the way other Indians lived. While they talked of the mescal gathering, I endeavored to learn the Apache story of its origin, but of that they were noncommital."

Days later, with the mescal gathered, at the cooking pit, Curtis listened closely to the ritual accompanying the lighting of the fire in the pit. "In their prayers I heard the names of the divine ones constantly repeated until I, too, knew the names of the gods of the east, west, north, and south, the sky and the earth, but I had no key to this vast storehouse of primitive thought. At least I had excellent pictures of the entire harvest and ceremony."

Back at the Apache village after the mescal harvest, Curtis went on acting as if he had no particular interest in being there, but all the while he kept his eyes and ears open. The Apache, in turn, took little notice of him, carrying on their lives in normal fashion. "Medicine men stealthily continued their devotions, husbands kept rendezvous with widows, and wives came to me expounding their daughters' charms, unable to understand why I lived alone," Curtis wrote.

In Washington next season, as he prepared to return to the Apache and pick up where he left off, he told an ethnologist friend of his eagerness to uncover the secrets of their religion.

The other's eyebrows went up. "Don't you realize you are going out to get something that doesn't exist?" he exclaimed. "The Apache has no religion."

"How do you know?" Curtis asked.

"I spent considerable time among them and they told me they had no religion."

Arriving again among the Apache in the spring of 1906, Curtis received a warm welcome, but when he told them what he wanted, thinking that by now he knew them well enough to broach the subject, the atmosphere changed. "Old friends looked the other way," Curtis wrote. "One of my former interpreters declined to have anything to do with me, declaring he was not going in search of sudden death."

Subtle attempts at bribery availed him nothing. "At the end of six weeks of patient work we had only succeeded in building up a wall of tribal reticence," Curtis wrote. "Every member of the tribe understood that no one was to talk to us and a delegation of the chiefs had visited the Indian agent in charge, demanding that I leave the reservation."

Curtis persevered. "With the greatest stealth, I approached several of the medicine men in an effort to secure even a key to the situation. A few words of information would serve as a leverage to learning more. I managed to speak with several of the foremost medicine men, but on the subject of religion they were as silent as the Sphinx."

Then Curtis learned that there was division among the medicine men, a situation that he might be able to turn to his advantage. One medicine man was Das-lan, "a very ambitious man who was promulgating a new cult which he claimed had been revealed to him by the gods," Curtis wrote. "This crafty medicine man hoped to supplant Gosh-o-ne, the present high priest."

Although Gosh-o-ne rebuffed Curtis several times, he seemed not unkindly disposed. The interpreter confided that the old man was very angry at the upstart Daslan and might finally talk. Summer was passing; it was now or never. Curtis set out to try for the last time, reaching the patriarch's camp at dawn.

"In concealment we watched the old priest emerge for his morning prayer to the sun," Curtis wrote. "At the close of his invocation we approached and once more made our plea that he tell us how the world began. Without protest or comment, he said, 'I think I will tell you that story.' Then he led us to a secluded spot among the shrubbery at the brookside. First he invoked the sun in short prayer. Then without prelude he began the story of the gods and the creation of the earth and its people." It was noon before Gosh-o-ne finished his account, filling the ears of his visitors with something never before heard by the paleface.

"That is how we learned the Apache Creation Myth," Curtis wrote. "In poetry of imagination I believe it supreme in genetic legends collected from the American Indians."

Curtis had more good fortune; he called it a "miracle." He got hold of a medicine man's prayer chart, along with a full description of all its symbolisms. "Such a chart without the description would only be interesting primitive art, but learning the functions of every character represented by figure or symbol, it became a document beyond price," he explained. "To us its greatest interest was the fact that its description confirmed in every detail the information secured from Gosh-o-ne."

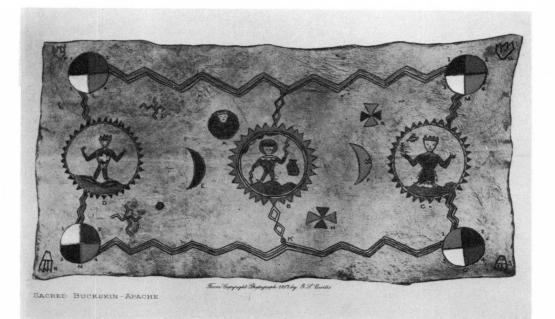

Sacred Buckskin—Apache. This medicine skin was owned by Hashke Nilnte and was considered one of the most potent belonging to any of the medicine-men. During the lifetime of Hashke Nilnte it was impossible for any white men even to look upon this wonderful "medicine." After reaching extreme age he was killed, presumably by his wife, from whom this valuable and sacred object was procured.

> Called medicine charts by the Apache, prayer charts were painted on deerskin by the medicine men, each executing his own and presumably according to his own private directions from the gods. "The one I obtained was considered the most important and potent in existence and no white man had ever been allowed to see it," Curtis wrote.

> Nor would any white man—or man of any other color, for that matter—ever know how he got the chart. "Its acquisition and cost is not mythology so is omitted," Curtis wrote mysteriously, by now seemingly tinctured with some of the Apache secrecy he had been surrounded by.

> In the early summer, having indeed learned the answers to a good many questions about the Apache, Curtis moved on to the Navaho. "I think I can say that the Apache work has been quite successful—far more than I had hoped for," he wrote Hodge on July 9.

> "If you care for it, I might furnish you something on the Apache for the *Anthropologist* [which Hodge edited] taking up some point or a general paper on the legends, mythology and religion of these people.

"I will say one thing—that there is absolutely no trace of a migration story. As far as any legend of these people is concerned, they were always where they are. Personally, I believe they are comparatively younger than the Navaho Race. There must have been a time when the two were one—not that I can find anything in the legends which tells of this, but judging from the rites of the two, the Apache shows far less age. . . .

"I have lately outlined what I would call the general introduction to the whole series of volumes," he continued, indicating the progress he was making. "I shall take time to go over it again within the next few days, taking another point or two, and then submit it to you and see what you think of it. . . ."

Curtis' stay among the Navaho was considerably more eventful than he let on. His wife and children—Harold, eleven; Beth, nine; and Florence, seven—had joined him as soon as school was out for the summer in Seattle. Curtis met them by fourhorse covered wagon at the train in Gallup, New Mexico.

The family stopped for supplies at Day's Trading Post, at St. Michael's, Arizona, camping nearby the first night. As they prepared to move on the next day, a flash flood hit, and suddenly, as the others ran for higher ground, Curtis was up to his waist in water, fighting to save his equipment. Fortunately, he carried most of it—camera, plates, other critical items—in sealed containers.

It was at Cañon de Chelly, within whose towering sandstone walls lived what was left of the Navaho after Kit Carson finished his killing and scorching among them, that tragedy threatened. It had been an enchanting time for the children, Florence remembered. They rode a burro, watched the Indians weave rugs, explored cliff dwellings of earlier residents, being careful not to desecrate "the places of the old ones."

All at once one day, the canyon became strangely deserted and quiet, the only

The Curtis trail wagon in Navaho country in 1906. From left, Charlie Day, son of the trading post owners, Edward S. Curtis, Florence Curtis, Beth Curtis, and the Navaho interpreter.

sound being the chant of medicine men, reverberating up and down. A child was being born, and the mother was having difficulty. The medicine men blamed the palefaces, camped in a grove of cottonwoods.

When the chanting finally ended, Curtis and Charlie Day, son of the trading post owners, who had grown up among the Indians and served as Curtis' interpreter, rode abruptly into camp. Working fast, they struck the tent and threw it into the wagon. They hitched up the horses, helped the youngsters scramble aboard, and fled, lashing the team as the wagon rolled through the deep sand.

The baby had been born, making it prudent to leave, for now there was the question of its survival. "If it should die," Charlie Day warned, "no power on earth can save you and your family."

Curtis never again took his entire family with him into Indian country.

Y AUTUMN 1906 he had made a great deal of headway. "I have my material for the first volume of the Apache Navaho nearly completed and the photogravure people are working on the first lot of plates," he happily wrote Hodge from Seattle on September 27.

In two more weeks he reported, "I today received the President's introduction to the volumes and as soon as I get in touch with my working force in the Southwest I shall send you certain material to look over, the President's introduction, title page, my introduction to the work and possibly the first parts of Volume 1. My plans are to use this much of the material for a prospectus, and hope to get them out by the first of the year, and of course use it in the getting of subscriptions to the work. That part of the problem is moving along as well as I could possibly hope for, in fact I feel that everything is in splendid shape and progressing rapidly.

"One question I would like to ask. I have, in thinking of a title for the book, thought of the following title, *The North American Indian*. The only question seemed to me to be, has this title been used before. Will you tell me what you think of it."

Hodge evidently replied that he liked the idea of an introduction by the president of the United States, but said nothing about Curtis' title.

There was a note of impatience in Curtis' next letter, on November 16. "As to the title of the book," he wrote, "unless something better should occur to me, I shall decide on the one previously suggested, *The North American Indian*. . . . Still, if you should think of a more fitting title, I should be only too glad to make use of it. . . ."

At the finish of almost ten months of field work for the first two volumes, Curtis

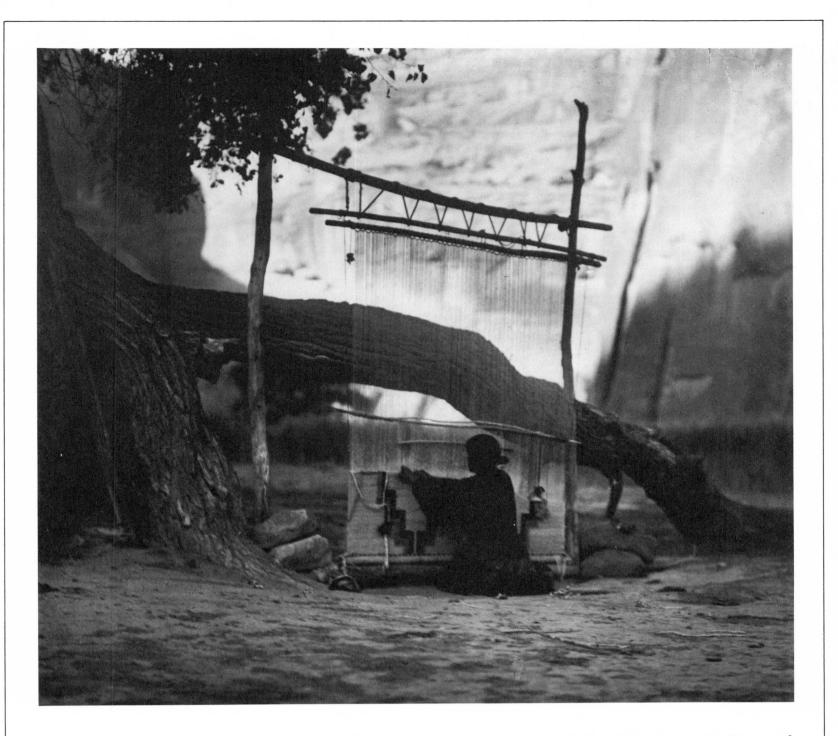

The Blanket Weaver—Navaho. In Navaho-land blanket looms are in evidence everywhere. In the winter months they are set up in the *hogans*, but during the summer they are erected outdoors under an improvised shelter, or, as in this case, beneath a tree. The simplicity of the loom and its product are here clearly shown, pictured in the early morning light under a large cottonwood. shut himself away with his three assistants, Edmond Schwinke, W. E. Myers, and William Phillips, a cousin of Mrs. Curtis, in a cabin on Puget Sound, his whereabouts unknown even to his family. For three months they worked, from eight o'clock in the morning until one the next, seven days a week, to prepare the material for publication. The day the job was done, early in 1907, Phillips headed for Boston with the manuscript to get its publication started.

Curtis himself went east soon afterward. "I am now sending you by express the first two volumes, that is, for the text proper," he wrote Hodge from New York's Hotel Belmont, March 27. "You will find system of spelling following Page 8, and opposite Page 39, Volume 1, and will find the reproduction of an *Apache medicine buckskin*. The plan is to print the different names of the deities represented in this painting on the opposite page, setting it horizontal that the reader can more easily study the matter.

"While we have said nothing in regard to this, I would suggest that it might be best that you, as editor, write a brief introduction to be included in the first volume. From the fact that there is so much material of this kind, with the President's foreward, it will probably be best to keep your matter on one page. . . ."

Curtis gave Hodge little time for reverie. A week after writing that he was sending him the manuscript, consisting of several hundred pages, he sent another letter to Hodge. "If I come to Washington the first days of the coming week, will you by that time have gone over the book matter so that we can take up a discussion of it?" he wrote, with more command then query.

The Curtis Camp in Walapai-land. So far as is known [the Walapai] have always occupied the pine-clad mountains for about a hundred miles along the southern side of the Grand Canyon in northwestern Arizona. Curtis, with no academic credentials beyond grammar school, was not necessarily inclined to leave things to those who had. "My dear Mr. Hodge," he began in a letter on June 8, 1907 (departing from his usual less formal "Dear Hodge"), "Just a word in regard to the appended material in Volumes 1 and 2, or more particularly in regard to the brief systematic summary as given in the manuscript you now have. The more I think of it the more anxious I am to carry out the summary through the entire work. To me it seems to have considerable value, and in fact, there is nothing in the different volumes that I would refer to as often as I would to this brief summing up of the different subjects, and I think other workers, both serious and superficial, will find it the same way. I am very much in hopes that you will agree with me in this.

"I shall be here at the hotel for a few days and then start for the West. I am more than pleased that you are getting along so well with the work and that we can in the near future begin to turn copy over to the printers. It is distinctly decided that Phillips will remain here all through the summer, and in that way there will be no loss of time in bringing the book together."

Then Curtis received a chilling call from the president of the United States, summoning him to the White House. "Curtis, I have had a complaint from a professor at Columbia University," TR began with characteristic directness. "Because you do not have a formal degree in ethnological research they question the validity of your work. There is only one answer. I have appointed a committee of three men whom I consider supreme authorities in our country to go over your work and render a decision. I am sure you know how I personally feel about this."

The president named the men he had selected, a trio of scientific titans: Henry Fairfield Osborn, curator of vertebrate paleontology at the American Museum of Natural History, New York; William Henry Holmes, chief of the Bureau of American Ethnology at the Smithsonian Institution, Washington; and Charles Doolittle Walcott, secretary of the Smithsonian—all with imposing records of achievement in their respective fields.

The man who had raised the issue of Curtis' competence was Dr. Franz Boaz, Columbia University's first professor of anthropology and until the previous year curator of anthropology at the American Museum of Natural History. Boaz was an authority on the Indians and had written extensively about certain tribes.

Curtis provided his judges with suitcases full of notebooks and whatever else told of his work in the field, including his Edison cylinders with their recordings of Indian music. The panel did not long keep Curtis in suspense. In a letter from Osborn, the three savants not only endorsed his work but praised it.

Nevertheless, it had been a shattering experience, and perhaps Curtis was still a little edgy when he wrote Hodge a final letter from the Belmont, June 26, 1907, before heading back to Indian country. Curtis had edited the editor's copy, and he made it clear who was to prevail.

"I have made slight changes in the introduction and am now enclosing you the

Edward S. Curtis on the move. Location and dates unknown.

29

introduction as rewritten with these changes," Curtis wrote. "They have been very slight in every way, and I hardly think that any change that I have made will conflict with your ideas, and in no case have I made any change in the construction. I am in hopes that it will be in every way satisfactory to you, and in case there are any slight changes will you please indicate in red ink and return to Phillips.

"My field address for a few weeks will be Pine Ridge, South Dakota. Any special thought that occurs to you that I should follow in the Sioux or Northern Plains work I shall be very glad to have. Mr. Myers has been at work at Pine Ridge and writes me that everything is moving along very well."

W. E. Myers, a former reporter on the Seattle *Star*, was Curtis' right-hand man. An English literature major in college, Myers possessed unusual talents as a short-hand writer, typist, speller, and phoneticist.

"To the Indians his skill in phonetics was awesome magic," Curtis wrote. "An old informant would pronounce a seven-syllable word and Myers would repeat it without a second's hesitation, which to the old Indian was magic—and so it was to me. We might spend the early part of the night listening to the Indian dance songs, and as we walked back to camp Myers would sing them."

Curtis described the working arrangement. "Most times while extracting information from the Indians, Myers sat at my left and the interpreter at my right. I led in asking questions and Myers and the interpreter prompted me if I overlooked any important points. What chance did the poor old Indian have when confronted by such a trio? "By writing all information in shorthand, we speeded the work to the utmost. I hazard the statement that our trio could do more work in a year than a lone investigator, writing in longhand and lacking phonetic skill could do in five years. . . . Also we knew nothing of labor union hours in our party. Myers neatly typed his day's collection before going to bed. In that way field notes were kept up to the minute. Our average working time for a six months' season would exceed sixteen hours per day."

If there was anything else Myers needed to know as he transcribed his notes, he dug into a tailor-made 18-by-24-inch metal trunk filled with books about the tribe they were with. It was Myers' notebooks which so speedily settled the issue raised by Franz Boaz.

No less baffling to the Indians than Myers was his mechanical counterpart, the Edison recorder, from which, as the machine played back the music, the score and words of a song were taken down.

"The singers and fellow tribesmen were awe-struck on hearing the song as repeated from what they called the magic box," Curtis wrote, adding, "The securing of some of what they termed sacred songs was exceedingly difficult. All songs were considered as the personal property of the singer, and a part of his life, to be handed on to his eldest son."

> AITING FOR CURTIS at his Pine Ridge camp were his wife and his son, Harold, who would be spending the summer vacation with him. Mrs. Curtis and the boy had come up with Myers and the rest of the Curtis party from the train station at Fort Alliance, Nebraska, traveling overland by four-horse wagon, the off-road vehicle of the day.

Providing young Harold a horse, Curtis took the boy with him on the ride to Wounded Knee, about twenty miles to the northwest. "The rattlesnakes were so thick in the grass that our horses kept shying," Harold remembered years later. "All along we saw cattle that were sick, with badly swollen heads, from snake bite."

Curtis went to Wounded Knee to keep his promise of two years before, to return and give a feast to Chief Red Hawk and his followers who had ridden with him into the South Dakota Bad Lands. He found that preparations had been made for him, but there were complications. Red Hawk had been unable to limit the guests, so that instead of twenty Indians on hand for his feast there were three hundred. Moreover, the guests included two chiefs who outranked Red Hawk. One of them, Iron Crow, had brought his own council tipi, inherited from his forefathers, and he invited Curtis into it for the big meeting with the head men.

It was a fine old tipi, held up by twenty-five lodge poles, one five feet longer than the others, with a "scalp" on the end—actually a horse's tail, the only concession to the new times. Around the sides fifty more "scalps" were arranged. All fastenings were polished rods of cherry and imitation snake rattles.

Curtis was seated at the place of honor at the back of the tipi, facing the entrance. In the ceremonies that followed, he formally told the purpose of his visit and read letters of greeting from President Roosevelt, the Great White Father in Washington, and from Indian Commissioner Leupp. Red Hawk graciously spoke of the long time they had waited for this visit from "Pazola Washte," meaning "Pretty Butte," their name for Curtis, and told how happy they were because he had kept his promise of the feast.

Iron Crow then pulled rank, interrupting the civilities. Waving for the interpreter, he declaimed that there were three hundred Indians on hand as against only two beefs; by his calculation, this wasn't going to be enough beef. Four would be more like it.

Curtis answered adroitly, assuring one and all there would be more beefs. There were "Hows" and handshaking, and all was well. But next morning, as the first procession was about to lead off for Curtis' camera, Chief Slow Bull held up a hand and launched into oratory. He, too, must have more beef. Fine, Curtis replied; he would have it. (Where Curtis was getting all the beef, or how the feast finally came out, is not known.) Then all the Indians decided to rest and smoke for the remainder of the day. Red Hawk had lost control completely.

Casually, with no show of impatience, Curtis folded his camera and left. During the night the Indians had a change of heart, and the next morning chiefs Red Hawk and Slow Bull rode into camp leading a column of warriors and saying they wanted to help their paleface friend. They reenacted old rites, refought old battles, retold the old stories. Curtis captured it all.

Sometime during the summer, too, Curtis visited the Little Bighorn battlefield, some 300 or more miles to the northwest from Pine Ridge, in Montana—though it isn't clear when or how he got there. Determined to get the facts of what happened as nearly first-hand as he could for *The North American Indian*, for days he ranged back and forth across the scene where in 1876 the Sioux wiped out General George Armstrong Custer and his entire command of 264 men. With Curtis were three Crow scouts, White Man Runs Him, Goes Ahead, and Hairy Moccasins, who had scouted for Custer.

He also went over the ground with Two Moon and a party of Cheyenne warriors, who gave him their account of what had happened. Red Hawk also rode with him and remembered the battle in remarkable detail.

To complete his research on the events at Little Bighorn, Curtis rode over the battlefield once more, this time with General Charles A. Woodruff and the three

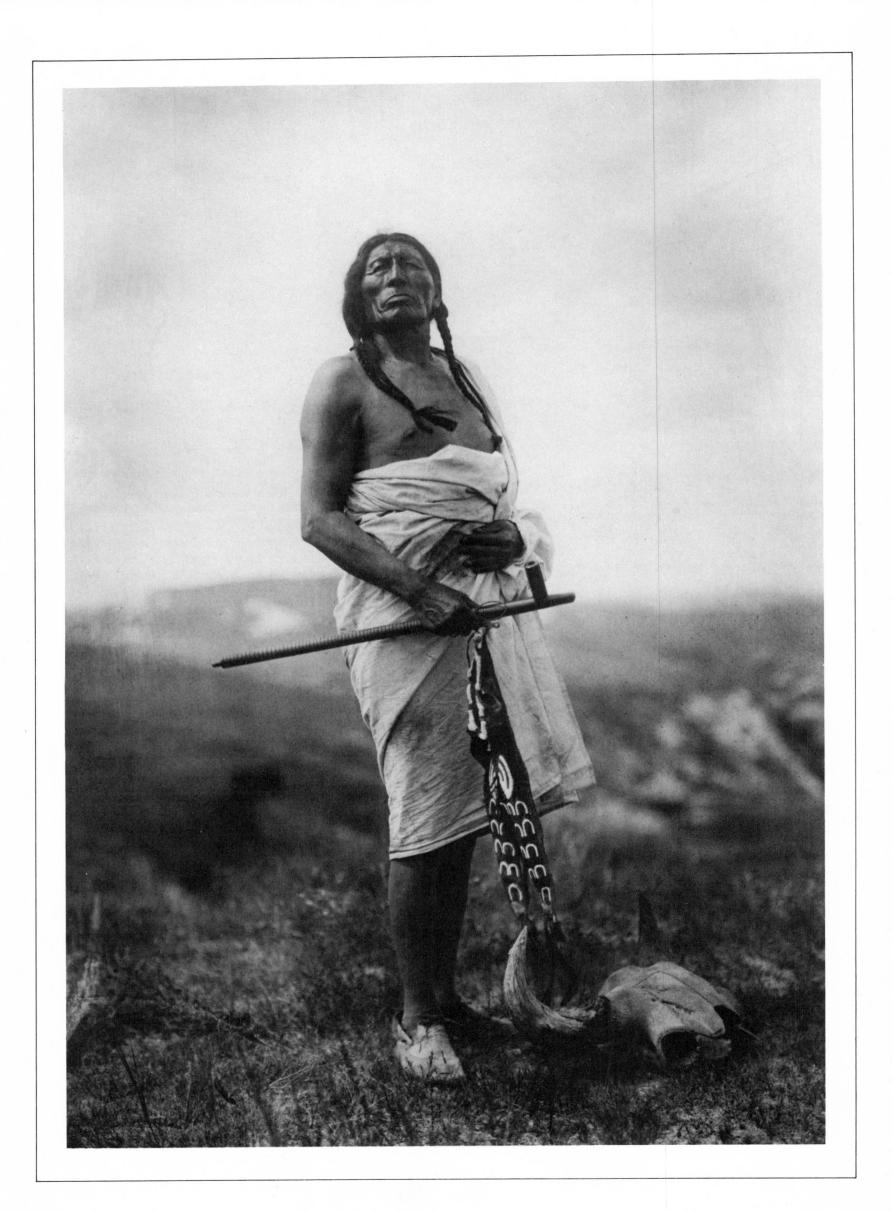

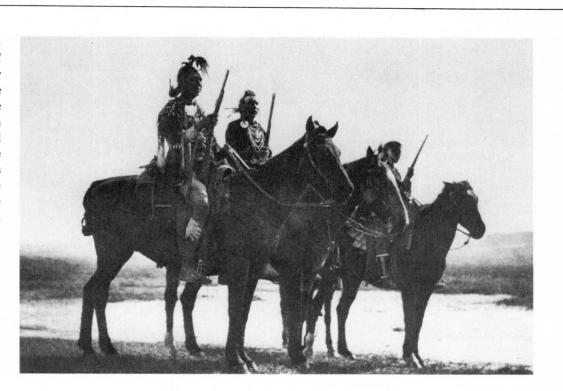

Custer's Crow Scouts: White Man Runs Him, Hairy Moccasins, and Goes Ahead. Curtis wrote, "In my close personal study of the Little Bighorn battlefield, I took with me the three Crow scouts, who, with other scouts, guided the command from the Yellowstone up the Rosebud and across from its waters to the Little Bighorn. These three men remained with Custer until he was actively engaged in the final brief fight."

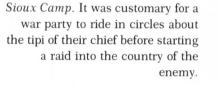

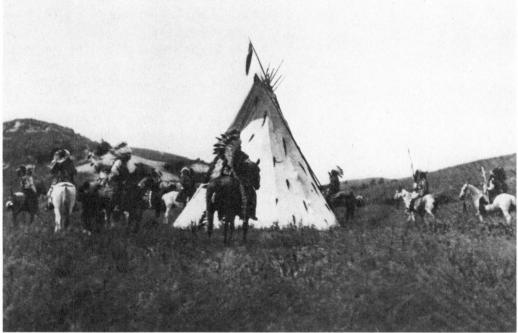

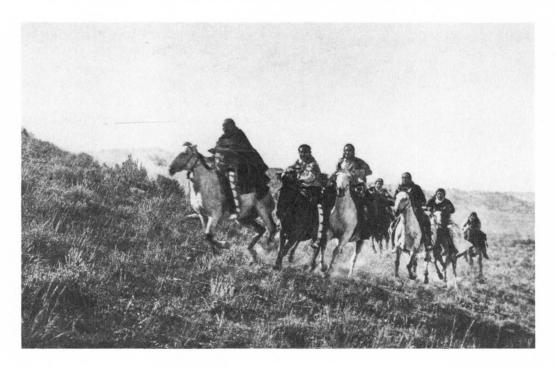

Return of the Scouts—Cheyenne. While in an external way the Cheyenne resemble the Sioux and other Plains Indians, there is a subtle independence of spirit and an attitude of superiority which is characteristically Cheyenne and shows them to be of individual mentality.

OPPOSITE: Slow Bull—Ogalala Sioux. He was born in 1844. His first war-party was at fourteen under Red Cloud against the Apsaroke. He engaged in fifty-five battles. At seventeen he captured one hundred and seventy horses from the Apsaroke. In the same year he received medicine from buffalo in a dream while he slept on a hilltop. Crow, whose testimony he wanted an experienced army officer to hear. Finally, Curtis talked to some Arikara scouts who had been with Custer, gleaning yet more valuable information.

As Curtis stayed on at Pine Ridge, the Indians began to drift into his camp to talk. The older men favored the shady side of Curtis' tent as they told their stories, revealing the broader information about their tribe which Curtis was after.

Curtis' way with the Indians made a deep impression on Professor Meany, of the University of Washington, who was with Curtis on his visit to the Sioux that summer.

Meany, who had studied the Indians in the field for years, wrote in *World's Work*, March 1908, that he had met "ethnologists, archaeologists, linguists, historians, and artists, but none of them seemed to come so close to the Indian as [Curtis]; so close that he seems a part of their life. . . . He will discuss religious topics with a group of the old men; they will pass the pipe around the circle and say, 'He is just like us, he knows about the Great Mystery.'"

As Curtis traveled about the Sioux country, his passage was often enlivened by frolicksome Indians who made mock attacks on his outfit, all intended as entertainment for their friend. It was done as in the old days, when the attacks were real. On a distant hill a small figure would appear—an Indian scout. Then, as the wagon came closer, a band of Indians came down out of nowhere at full gallop, filling the air with yells which, for many a terrified settler, had been the last mortal sound he ever heard. When the "attackers" reached shooting distance, they slipped to the far side of their mounts and began firing blanks from their rifles, for variety also shooting from under the horse's belly and between his front legs.

Round and round they galloped, firing and yelling, as if the object of all the hullaballoo were an actual enemy. Unhappily for Curtis, the commotion usually ended only when his team bolted and broke from the harness.

As the summer wore on, the strain began to tell on Harold. He felt sick, but manfully he said nothing. When he could no longer sit in the saddle, he was put to bed. His mother said it was typhoid fever; she recognized it from once having nursed Curtis through an attack.

Harold's sickbed was a rubber mattress under a cottonwood tree. Between lapses of consciousness, he was aware that his mother was giving him prairie-chicken soup and catfish soup. From time to time, his father would send an Indian in a buckboard to the nearest whistle-stop, twenty miles away, with a prescription for the conductor to have filled in Chicago. Often as not, the train thundered on through, paying no attention to the wig-wagging at the stop. Sometimes it was a week before the medicine arrived.

As the summer's work at Pine Ride ended, Curtis found time to pick up his mail. He was shocked to get news from the East that Volumes 1 and 2, supposedly well on their way to publication, were being held up. In bold, firm strokes, he fired off a letter to Hodge August 25, writing so fast that he left out words and ran sentences together.

"I had been out of touch with mail for a couple of weeks," Curtis began, "and on getting in a long-delayed lot found that the manuscripts were not yet in the hands of the printers. I certainly had a fit. \ldots

"In keeping on with the publication I must make definite statements to the bank to fail in keeping my promise there will mean failure, and I do not care at this stage of the game to have the croakers say I told you so. If it is within human effort (and I believe it is) these two volumes must be in the hands of the binders not later than October 15—I know the time is short but this is a time we have *got to* there can be no 'cants.'

"Now by all our Indian gods rush your work on the matter for the printer and get it in his hands. Then if you can not get time to do work on the proof reading and indexing let Phillips get a proof reader in Boston to help him and rush it through. I have written to Phillips to write me every three days as to progress of the work I shall by letter and wire hammer hammer at every one on the work [expenses] are heavy and this two volumes must be ready for delivery that there be something coming in to help meet them.

"My average monthly expenses this year, in the field and in bringing out the book, are to exceed four thousand five hundred—once more I beg of you to crowd the work—"

He told of Harold's illness, saying that this would cost him "the loss of a month's time and is bound to seriously affect the season's field work. I am trying to figure out a way to offset this delay and thought I might do it by skimming the work on a couple of reservations and get someone to take up the detail for me. Last spring you spoke of a man who might help me. I think he was at that time in Chicago. What do you know of him now. . . . If I am not mistaken the Ree and Mandan work is going to take a great deal of steady digging to get to the bottom of the tradition and should make a splendid piece of work. . . .

"Mrs. Curtis and I are here in camp alone with the boy. Myers and the party have gone on. Should reach the Mandan today. I will join them as soon as the boy can be taken home. . . . Now only once more let me ask you to help us all by rushing the work."

Harold was soon strong enough to travel. He and the mattress were loaded into the wagon, and Curtis drove him and his mother to the whistle-stop. The conductor accommodatingly opened two seats to make a place for the mattress for the ride to Chicago, where Mrs. Curtis bought tickets on a Pullman for a more comfortable passage on the long journey back to Seattle.

Curtis joined Myers and his crew in North Dakota, and all worked until the blizzards of early winter drove them from the field. With the first two volumes about to appear, Curtis went east to see about getting his work sold. The Panic of 1907 gripped the country, plunging it into depression. There would be fewer people with \$3,000 for a set of books.

N THE BROWN LETTERHEAD of the "Publications Office, *The North American Indian*, 437 Fifth Avenue, New York," Curtis wrote to Hodge on December 1, "Mr. Donohue, one of the subscription workers, tried last week to get the 'big book' into the John Carter Brown Library at Providence. Our good friend, Mr. Winship, wants to bar it out on their regulation rule not to put anything into the library after the date of 1800.

"I am wondering if you cannot say a good word for us to him and convince him that while we are publishing now we are covering matter so long previous to 1800 that 1800 looks very much of a youth. . . . By the time I get through with the Southwest country, I will have so much to say on that country that no library that presumes to be complete on Americana can refuse us."

By mid-December Curtis again was on his way to Indian country. Breaking his journey at St. Paul, he wrote to Hodge of a new kind of problem he had run into in Chicago the day before in calling on Edward E. Ayer. "He was extremely friendly and most enthusiastic over the pictures," Curtis wrote. "However, he was frankly skeptical as to what the text would be. He seems to have the idea firmly fixed in his mind that I plan to make it more historical than anything else and expresses considerable skepticism as to any one man doing so much—In other words he thinks I have attempted too big a task for one man, saying 'It looks to me as though you were trying to do fifty men's work.'

"I explained, as well as I could, how I was handling the several subjects and tried to show him I was not writing a history and life of the Indians from published works, but rather was simply gathering new material and bringing it together in a comprehensive way. . . .

"It has occurred to me that you are probably planning on attending the meeting of scientists at Chicago the 1st of January. If so, you could probably find opportunity to drop a good word here and there—I will have submitted to Mr. Ayer the first volume of the work by that time, which would give you a good opportunity to bring up the subject. . . .

"I will be in camp in Pryor [Montana] in a couple of days and then go to Seattle. From camp I will try to mail you a check. Phillips writes me to thank Hodge in all kinds of ways for his splendid help in rushing through the final editorial work and the 'Press' people have also been more than good fellows at this time. . .

"Try to go to Chicago if you can and wherever there is an opportunity to say a good word please do so. The work can be sold out completely without these large institutions becoming subscribers but it can be sold faster if they will give us their endorsements and there is, as you know, a little satisfaction in feeling that these men are with us. \ldots "

Curtis managed to keep going by securing several fully paid subscriptions while he was East and, in Seattle, getting a loan of \$20,000 from friends. The Morgan money simply wasn't enough. Mandan Bullboat. The Mandan bullboat was a coracle-like boat constructed by stretching a fresh buffalo-hide over a nearly hemispherical frame of willow hoops.

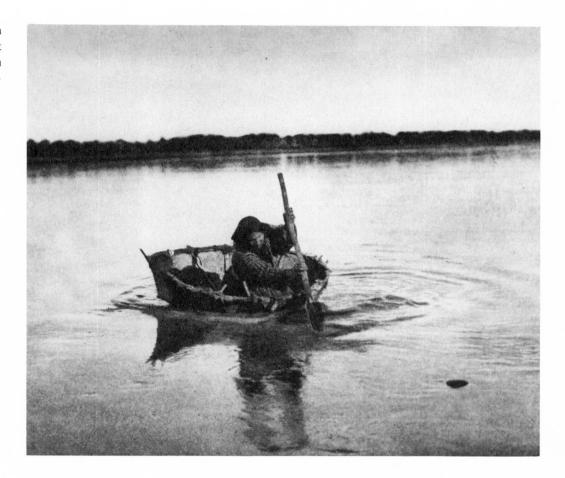

When he reached Montana, it was time to follow up on a mission initiated months before. This was to get pictures of the sacred Mandan Turtles, used by the tribe in several important ceremonies. Once live creatures but now replicas made of buffalo hide, they had never been seen by a white man. Curtis was determined to become the first to do so and not only to photograph them but also to get the legendary history behind them.

"I entrusted negotiations with the Keeper of the Turtles to Upshaw [Curtis' interpreter] knowing it required an Indian to win an Indian argument," Curtis wrote in the brief fling he took at putting his experiences on paper. "After many months, Upshaw reported that Packs Wolf, the Keeper of the Turtles, had consented to give us the information we wanted."

Packs Wolf instructed them to come to his place in early winter. He kept the Turtles in a log house near his own.

It was near zero, with snow on the ground and a polar wind whistling through the woods when Curtis and Upshaw rode up to the cabin in the twilight. "Packs Wolf

and two other medicine men, confederates in this unethical affair, were awaiting us," Curtis wrote. "After warming our chilled bodies, it was explained that preparatory to going into the House of the Túrtles, I must go through a sweat bath that my body would be purified and thus made acceptable to the Spirit People and the Turtles."

The sweatlodge was "a small, dome-shaped framework of willow wands covered with blankets, some distance from Packs Wolf's house, near the edge of a cliff. Close by was the fire for heating the rocks." Curtis disrobed in a snowbank and with the others entered the sweatlodge, taking his place beside the three medicine men and Upshaw. "We sat on our haunches with our backs to the blanket wall. Before us was a shallow pit into which an attendant dropped hot rocks. The blanket opening was lightly closed and the singing began."

At certain words of the song water was thrown on the rocks, filling the place with steam, "and instantly I forgot the chilling temperature outside," he went on. Upshaw had warned that the Indians would give him a severe test, advising that if the heat became too great Curtis should lower his head and raise an edge of the blanket for air—but not unless absolutely necessary, for it wasn't good form.

"I did not take time to explain that I had been through a few of these ordeals before," Curtis wrote, adding that "the Indians seemed to enjoy giving a white man the best sweat possible."

At the end of four songs, the blanket was lifted slightly to let in a little air. Then a new supply of hot boulders was thrown into the pit, steaming things up anew for the next round of songs. The heat that went with the fourth and final series of songs brought "the supreme test of endurance," Curtis wrote. "I almost enjoyed the polar breezes while dressing." He hoped the rising blizzard would cut down the chances of other members of the tribe intruding on his secret mission.

The crucial hour for seeing the Turtles came in the morning. "The House of the Turtles was of heavy logs," Curtis continued. "The door was locked and the windows covered. On entering we saw a large table on which was piled a heterogeneous assortment of offerings to the Sacred Turtles. There were fetishes, skins, strips of calico and flannel, pipes, plants, eagle feathers, beads and beadwork, scalps and bead pouches containing umbilical cords.

"The Keeper in a hushed voice rendered a short prayer to the Turtles, begging them not to be offended. He next removed the mass of offerings under which the Turtles were buried so that I had my first glimpse of these mysterious objects. The turtles were actually turtle drums and beautifully constructed. They were about twenty inches in length and would weigh probably twenty pounds each. The priest explained they were of great weight because each contained the spirit of a buffalo. He kept this belief alive by pretending to exert great strength in moving or lifting them."

The Turtles were covered with eagle-feather necklaces, and Curtis quickly made pictures of them. "I then asked," he wrote, "if the feathers might be removed in order to photograph them undecorated. This request occasioned considerable discussion between the Keeper and his helpers. Apparently they feared the Turtles might be of-

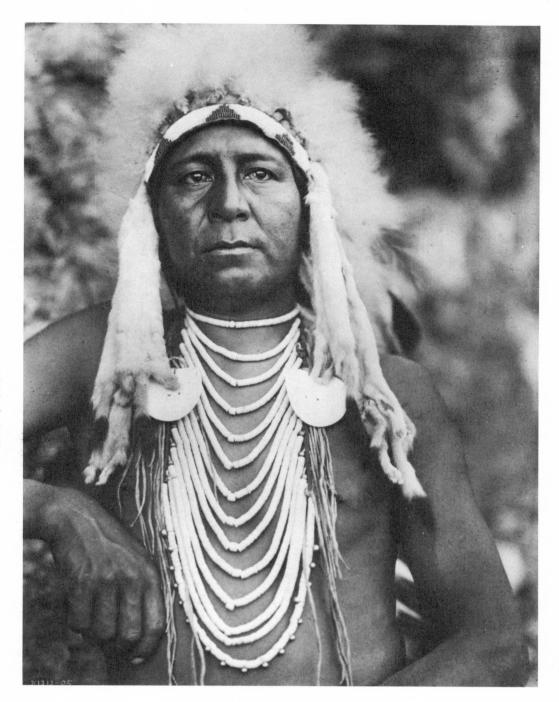

fended if left naked by removal of the decorations."

The Keeper gave a long prayer asking the Turtles' permission to grant Curtis' request. Then, as the priest soothingly talked to them, the feathers were carefully and reverently removed.

"At last, after so many months of effort, I was looking at these ancient Sacred Turtles which had been guarded well for so many years from the profane eyes of the white man," Curtis commented. "After photographing the naked turtles, I courageously asked the priest if I might move them slightly in order to obtain a better picture. To my surprise he acquiesced, but warned me against turning them over." If Curtis did that, the priest said, they would all die.

With reverence at least equal to the Indians', Curtis moved the Turtles on the table to a better light and exposed two more plates. "I was shaking like a leaf and reeking with perspiration," he wrote. "The fear of interruption before the pictures could be made was a nerve-wracking experience."

But Curtis got his pictures, although he and the others narrowly escaped discovery just after they left the House of the Turtles: Twenty-five suspicious Indians rode up on horseback. As they silently eyed him and Upshaw, he went through the motions of recording a tribal myth on an Edison cylinder, trying to look innocent.

"Obviously, they were wondering why I should return in the winter to see the Keeper of the Turtles," Curtis wrote. He tried not to show haste as he placed his camera and negatives in his saddle bags.

Upshaw—Apsaroke. An educated Apsaroke, son of Crazy Pend d'Oreille. Upshaw assisted Curtis in his field-work, collecting material treating of the northern plains tribes.

Sacred Mandan Turtles. The priests claim for these Turtledrums great weight because each contains a spirit-buffalo, a belief which they carefully keep alive in the minds of the people by pretending to exert great strength in handling them. "Granted I had paid the exorbitant price of \$500 to that avaricious priest. . . . Yet I realized there would be no time for explanations should the tribesmen be convinced of their suspicions. I knew our lives hung in the balance. My muscles seemed frozen when I lifted myself into the saddle. Urging our horses to the greatest speed, we put distance between ourselves and the Mandan."

Y JANUARY 1908 Hodge had had time to go through Volume 1, now out, and had written Curtis his impressions. Curtis replied on January 14, from Pryor, where in a mountain cabin he and his crew were busy working with the harvest of their previous summer among the Sioux.

"I am exceedingly glad to get your letter touching on several points connected with the book," Curtis began. "I quite agree with you that the Index itself should convince one that there is material in the book. You certainly did a fine piece of work on it, and it adds much to the value of the entire work. I read with special interest your words with regard to Dr. Culen [Robert Stewart Culen, director of the Brooklyn Museum]. You may be able to win him over; certainly if anyone can it is you, but I fear in attempting to do so you are using good ammunition on small game.

"The beginning of the good Doctor's critical attitude was from my failing to comprehend his personal deification. Once upon a time upon seeing him in the lobby of the Portland Hotel I stepped up to His Highness and laid my profane hand on his shoulder and spoke to him with the familiarity of an equal by saying: 'Hello, Culen, where did you come from?'

"He turned about and fixed me with an icy stare that would have done credit to Waziya, the Lakota God of the North, or chilled the sexual ambition of an eighteenyear-old Crow maiden. Later, when he reached the Day homestead in Navaho land, he spoke of the incident and said: 'Who is he that he should accost me in such a familiar manner?'

"Seriously, as an ethnologist the Doctor should confine himself to facts—. His statement that he declined a gift of the work is, I think, in error. The Board of the Brooklyn Institute did consider a purchase of the book, and he (as a member of the Board, I believe) prevented the sale.

"Also a year ago he succeeded in discouraging an individual who was at the point of buying about \$1,000 worth of the photographs for a personal collection.

"His knocking cannot reach all points—in fact, I found one institution that explained that nothing would do more to convince them that they wanted the work than to have Culen take a negative position."

As to a criticism by James Mooney, colleague of Hodge at the Bureau of American Ethnology, this merited more attention. Mooney's comments had to do with a picture titled *A Cheyenne Warrior*.

"I do not know just what the picture referred to or whether the title is one of my own, or one given by someone using the picture," Curtis wrote. "It, however, gives me a chance to say a few words on general principles of pictures and titles.

"Let us return to the title of the picture in question. It does not necessarily imply that the man is engaged in battle, or at the instant of going into the fight. An Indian of the old days was a warrior 365 days of the year, a very small part of which would be spent in actual fight. On the war raid they wore their ordinary clothing until the fight, or until the time of their medicine preparation immediately before the fight would begin. And in fact, when going into the fight they often wore clothing, particularly if it had any connection with their medicine (protective clothing). If a war party were starting out they would, on leaving their camp or village, don all their fine clothing and ride around the camp. A picture made then of them so dressed could be titled 'Warriors,' and the title is beyond just criticism.

"Saddles, homemade and bought, have been used for two generations. True, these saddles were rarely used in actual fighting, but the testimony of several tribes show that a fair percent of the men went into the fight with their saddles, particularly the younger men, and also the men who were growing old, and were not in the best of their riding years.

"I appreciate Mooney's knowledge of the Plains Indians far too well to resent his criticism, but I think in this case he has taken a super-critical attitude, presuming that the title meant to say 'This picture is of a chief dressed for the final conflict of battle,' while, as a fact, the same title could have been used for the same man while in his lodge smoking his pipe. If he meant that I should make pictures of them mounted without clothing or saddle, I agree with him that it is desirable that we get as many such pictures as can be secured."

Curtis then turned to other matters. "I am happy with the way the Lakota volume is coming together. . . . The completed text will no doubt reach you before the end of February, and the next volume, Hidatsa and Apsaroke, six weeks later, and the third volume of the year go to you by the middle of July. The reason in the delay of Volume 5 is that some of the ceremonial material cannot be obtained until the leaves are green and the birds singing again. Superstition is interesting but at times inconvenient. . . ."

In his next letter, three days later, Curtis told of some refinements he had in mind, in line with making each new volume "better than the last." Still in Pryor, he wrote, "In the future, I want to show enough of the music to give a general idea of it

4I

Few aspects of Indian life are more interesting to the casual visitor than the demeanor of the children, with their coy bashfulness, their mischievous, sparkling eyes, their doubtful hesitation just the other side of friendliness. Above LEFT: A little Oto. Above RIGHT: A Cheyenne child. OPPOSITE LEFT: Innocence (an Umtilla). OPPOSITE RIGHT: A Wichita dancer.

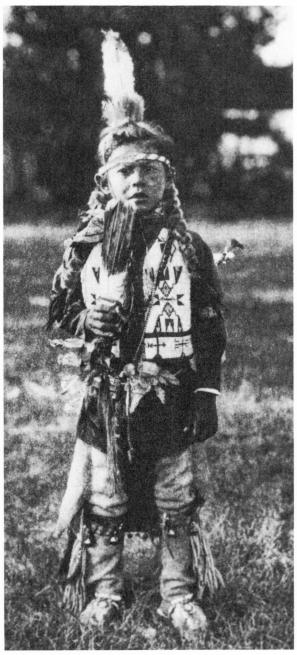

and its application in their ceremonial life.

"I had thought of printing the engraved staff of music in the body of the text in its exact position as far as the description of the ceremony is concerned. In discussing this with Mr. Myers, he seems to feel that it will hopelessly mar the page, and suggests that all music be printed in the Appendix. . . .

"I shall also discuss the matter with Orcutt, the printer, and perhaps with others, and it might be worthwhile to have a sample page made up in this way and see how it does affect its appearance.

"Another thought had been to run such music as was used in the way of a footnote, which would come in that case almost as a tail piece for the page. We have ample time to consider it, but tell me what you think."

When words of praise arrived at his camp, even from an Olympian source, Curtis seemed matter-of-fact about them. He once enclosed a laudatory letter with a brief note to Hodge. "I thought it might be worthwhile to have this with you in case you are discussing book matters with other workers," he wrote on January 28, 1908, without comment.

The letter was from Dr. Frederick Ward Putnam, Peabody Professor at Harvard University and curator of its Peabody Museum of American Archaeology and Ethnology, as well as professor of anthropology and director of the Anthropological Museum, University of California. He was also a founder of the Field Museum of Natural History in Chicago and curator of anthropology at the American Museum of Natural History in New York.

"My dear Mr. Curtis," Dr. Putnam began, "It has given me much pleasure to look over the first volume of your great work on the North American Indians, which Mr. Phillips brought out for my inspection. Everyone will be pleased with your artistic rendering of the picturesque in Indian life—a phase of the many-sided life of the Indian which has heretofore been neglected from lack of power to present it adequately. You belong to the last generation that will be granted the high privilege of studying the Indian in anything like the native state, and all future students and historians will turn to your volumes, as all ethnologists now turn to [George] Catlin's.

"Judging from the text of the first volume, you will evidently give to Americanists much valuable information which your intimate relations with the people of the various tribes enables you to impart from original sources. The critical Anthropologist will find much of importance in the full face and profile views of men and women which will be given in your series of volumes and folios of plates; and the ethnologist will fully appreciate your many views of the varied habitations of the numerous tribes living in diverse environment, with the glimpses of home life and of mysterious ceremonies.

"The gathering and saving of this information is of the utmost importance while it is yet possible, and it is indeed fortunate that this work is to be done by one who has the skill of an expert photographer and the mind and eye of an artist united with a sympathetic understanding of this much-misunderstood people. . . ."

N THE EARLY SPRING of 1908, Curtis was back in New York, setting up a publication target of three new volumes within the year. "Myers writes me that he has sent the greater part of the manuscript for Volume 3 on to you," he wrote Hodge on April 16, on the letterhead of "*The North American Indian*, written, illustrated and published by Edward S. Curtis." He went on to say, pointedly, "I had a talk with Orcutt of the University Press the other day and in reply to my question as to how fast they could do their part of the work this year they said a volume a month, provided Hodge could read proof so as to send them a bunch regularly once a week.

"I hope that they will begin on the composition about the middle of July. Will you be able to handle the proof that they can make such splendid headway?"

Hodge replied apparently in some alarm, bringing an almost unprecedented "My dear Mr. Hodge" from Curtis as he hastened to write back, on April 21. "When I spoke of Orcutt's turning out a volume a month, I did not mean that we were going to keep that up for a year, that is the time he asked to have in turning out the three volumes. Three volumes is, of course, all that I shall attempt, but my desire is to get them on the market not later than the first of January. . . . Handling the three volumes this year will certainly make you considerable work, and, at the same time, it will be financially a pretty good season for you."

As his train chuffed toward the plains once more, Curtis' mind could be free of at least one burden: the question of how his work would be received. Now that there had been several months to absorb the first two volumes, the appraisals were beginning to come in.

"Every American who sees the work will be proud that so handsome a piece of book-making has been produced in America," said Dr. Clinton Hart Merriam, who had been one of those Curtis rescued that evening on Rainier, "and every intelligent man will rejoice that ethnology and history have been enriched by such faithful and artistic records of the aboriginal inhabitants of our country."

As many would do, George Bird Grinnell singled out one picture in particular for comment, writing in *Forest and Stream*, " 'The Vanishing Race' is full of poetry and pathos, for what could be more significant than the long line of shadow figures passing into the darkening distance."

E. M. Borrojo, librarian of the Guildhall Library in London, which had been given Set No. 7 by J. Pierpont Morgan, was bemused by the attention the volumes attracted. "Although the Morgan gift has been on view only a day or two in London," he commented, "quite a number of distinguished savants have called to inspect it. The Librarian has deputized two assistant clerks to show the books to enquirers, and the array of photographs in the long passage leading to the library has already attracted considerable attention. All kinds of Indians, from papooses to full-grown 'braves' are shown, and every phase of Indian life is pictured in a way that only Morgan's millions could have made possible."

45

Henry E. Huntington, financier and railroad builder, who had paid \$50,000 for a

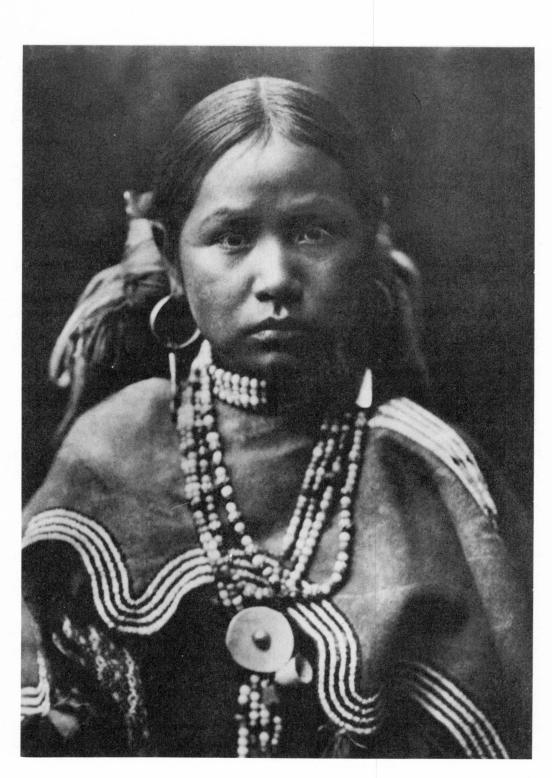

Gutenberg Bible, wrote to Curtis after subscribing to Set No. 51, for the Huntington Library at San Marino, California, "I regard it highly for its effective illustrations and its wealth of information . . . I have greatly enjoyed looking the volumes over, and am very glad to have them on my library shelves."

There must have been special satisfaction for Curtis in the words of Charles F. Lummis, librarian of the Los Angeles Public Library and founder of the city's Southwest Museum, preeminent among American Indian museums of the world. "The one director who alone objected to paying \$3,000 for your work at a time when the library was particularly hard up and had to pull in its horns even on \$1 books, has become converted and realizes at last that no respectable public library can do without such a historic record," Lummis wrote.

Lummis was himself a photographer of the Indians, having lived with and taken pictures of them for twenty years in all three Americas, as well as having recorded

Jicarilla Maiden. The typical Jicarilla woman or girl wore her hair fastened at each side of the head with a large knot of yarn or cloth.

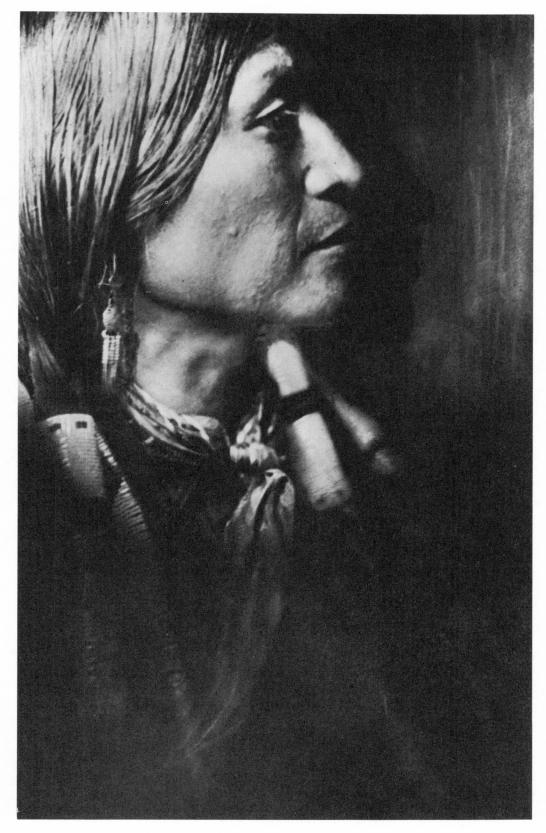

Jicarilla Chief—Apache. Generally speaking, chieftainship is hereditary, passing to the eldest son, if there be such, otherwise to a brother, on the death of the incumbent; but this rule might be set aside if public opinion was strong enough to warrant it, and the chief be selected from another family.

425 Indian songs. "But," he went on in his letter, "I frankly admit that I have never seen such successful photographs as yours. It simply makes me sorry that I am not able to subscribe to two copies." He commented that no subject "interests so many people, 6 to 60, as Indians."

There was more praise as 1908 wore on. "Lowly as they were, our original landholders deserve a monument," said Professor W. J. McGee, of the United States Bureau of American Ethnology, quoted in the Washington *Evening Star* of June 3. "Cruel as our conquest was in some respects, it deserves a record; and your great book forms both. I do not know any other general picture of the American Indians so faithful as yours—indeed, none other is nearly so vivid and accurate."

Indian Commissioner Leupp, who had studied the Indians since boyhood, wrote, "In other published works, more pretentious than this on their strictly scientific side, are gathered stores of information about our American aborigines. But Mr. Curtis' harvest has passed far beyond the statistical or encyclopedic domain; he has actually reached the heart of the Indian and has been able to look out upon the world through the Indian's own eyes. This gives so vivid a color to his writing that his readers not only absorb but actually feel the knowledge he conveys. I do not think I exaggerate the facts in saying that the most truthful conceptions of the Indian race which will ever form themselves in the mind of posterity may be drawn from this great work."

The *New York Times* commented, "Mr. Curtis has rare qualities as a photographer, alike in his recognition of the groupings, the light and shade, the points of view that make a picture as pleasing as it is truthful and in his ability to make the picture after he recognizes its value.

"His portraits are better, in the important qualities that go to make good portraits, than are the majority of current oil paintings, while in the other pictures one sees always that elusive quality which can be put into them only by an artist who sees beauty as well as material fact, and when it is all finished it will be a monumental work, marvelous for the unstinted care and labor and pains that have gone into its making, remarkable for the beauty of its final embodiment, and highly important because of its historical and ethnographic value."

To the *Literary Digest*, Curtis' work recalled John James Audubon's monumental *Birds of America*, published between 1827 and 1838. "It is not unlike that famous work in the splendor of its manufacture, the authenticity and historical value of its illustrations, or in the methods employed in the collection of the material."

"A poet as well as an artist," wrote E. P. Powell in *Unity Magazine*. "If it ever comes our turn to vacate the continent may we have as able an interpreter and as kindly and skilled an artist to preserve us for the great future."

OTHING WAS HEARD from Curtis until autumn, when he surfaced with a letter to Hodge from Minot, North Dakota, written on August 19, 1908. He indicated that his goal of three volumes for the year appeared to be well in sight—with some further heavy pushing.

"We sent you the Crow history today," Curtis wrote, "and tomorrow will probably send the Sioux history and then will have another bunch of material ready to send in a few days following that. Will get off the final manuscripts belonging to these three volumes within a week."

A week later, Hodge had already received the Crow material and written Curtis that he had mailed it back to him, having found little or nothing to change.

48

"I am more than glad that you like the Crow material," Curtis replied. "I per-

sonally feel that it is a picture of Indian life closer than will often be reached by the white man.

"When starting to work on the Hidatsa material, you will probably see at once that our plans are to make that a part of Volume 4, or the Crow volume. This, of course, means that the book will be somewhat thicker than Volumes 1 and 2. . . .

". . . I am inclined to think that Volume 5 containing Mandan, Ree and Atsina will also be above the regular thickness. We will try to avoid any of them looking like *Who's Who.*"

In a week or so, Curtis sent yet further word of progress. "I have now read and returned Sioux and Crow," he wrote, "and I believe they are in splendid shape. I have made a few slight changes in your red ink. A few of these is where the fact required it and others," he explained tactfully, "are where I failed to make myself quite clear. From that fact you got the wrong idea and attempted to make this subject more definite. In a case of this kind I modified the matter to clear up the thought originally in mind. . . ."

From North Dakota Curtis went to the Southwest. He wrote from Santa Fe, New Mexico, September 18, 1908, enigmatically addressing his letter to "F. W. Hodges, Esq." He struck out the "s," then left it in after he used it again, in his salutation: "Dear Hodges: In reply to your letter of August 31st, sent to Minot, I have closed my short piece of rather trying work here, and I am happy to say that while I think it has added a few gray hairs it also has given me splendid additional footing in the southern work."

One surmises that Hodge had made a suggestion outside the field of editing: ". . . as to mortgaging the studio, on your account, have no fear of my doing that for the simple reason that—like everything else I have or expect to have now bears more mortgages than is comfortable to contemplate. If I had an earthly thing that was not mortgaged I should immediately start out to find someone to loan me a few dollars on it right here in Santa Fe. . . ."

N NOVEMBER, after spending several autumn weeks in Seattle, "hustling things the best I can at this end," Curtis was back east again, directing the publication of volumes 3, 4, and 5, the year's quota. "I have just returned from Boston after spending a couple of days with Myers and the plate-makers," he wrote Hodge from New York on November 11.

"Matters are moving on nicely, and I must express to you my heartfelt thanks for your splendid assistance in keeping everything going.

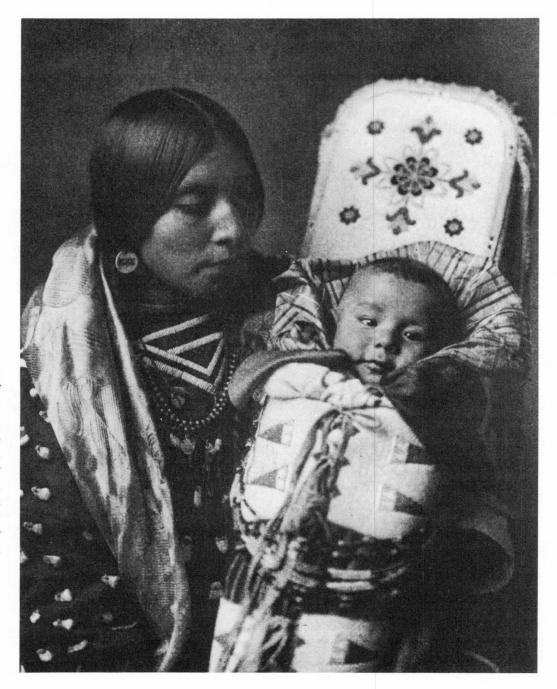

"I shall be in Washington in about ten days and then will have a chance to discuss any little matters that may occur to us."

A matter for discussion occurred to him before he could get to Washington, however, and he wrote Hodge, "By assistance of an influential English friend, I believe that I can secure a review of the book by one or more of the leading English Ethnologists. Would you be so good as to give me the names of two or three of those you believe could do us the most good and from these few names we will let my English friend select the one that he feels closest in touch with. Send me these by return mail if possible."

Hodge moved fast, getting the information Curtis wanted into his hands in just two days. One of the names Hodge supplied was that of Professor A. C. Haddon of Cambridge University.

"Thank you for the English names," Curtis acknowledged. "It happens that Professor Haddon is, I believe, to be a guest in a couple of my camps the coming summer. At least such an arrangement has been suggested by a member of the faculty at the University of Washington, who was a classmate of Haddon's, and I shall certainly be delighted to have an opportunity to extend any such courtesy to him. He will probably spend more time at one of the branch camps, which will be on Puget Sound, than he will with my personal party.

"The party who has offered to assist me in bringing the matter before some of the serious English workers is Lord Northcliffe; he is most enthusiastic over the work, and desires to do all in his power. My idea in securing the English review is not di-

Apsaroke Mother and Child. The women devoted a great deal of thought to dress and personal appearance, that the eyes of the men might be pleased. The hair was worn parted in the middle from front to back, hanging loosely over each shoulder, and tied at the end with a thong and an ornament but not braided. Later, when they saw the Nez Percé women with their neatly braided hair, they adopted that custom.

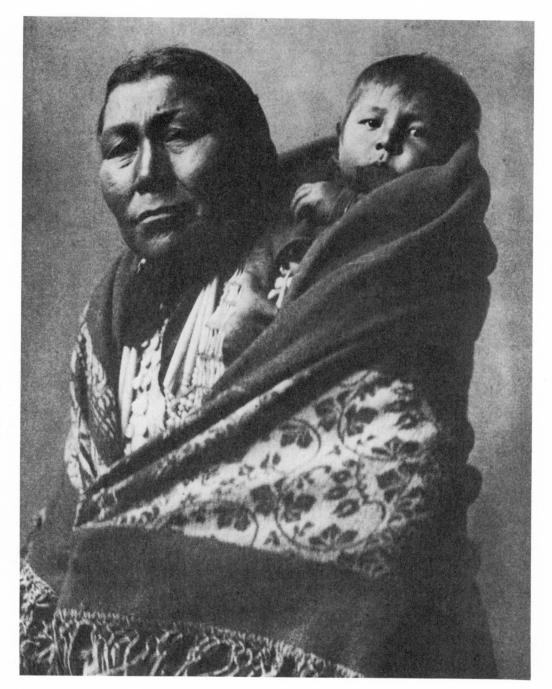

rectly for the effect it will have there, but as an outside endorsement to encourage the hesitating ones on this side. \ldots ."

Lord Northcliffe—Alfred Charles William Harmsworth—was a good man to have in one's corner. He owned most of London's daily newspapers, and this year, 1908, would acquire *The Times* of London.

One of the hesitating ones on this side of the ocean, hesitating no longer but having decided to subscribe, perhaps made it possible for Curtis to reply to Hodge as he did on December 4, "Demands for money are very numerous this month, but notwithstanding this fact you shall have the amount you mention, and I am only sorry I am not in a position to make it many times larger. . . .

"As to the Hidatsa shrine and skulls, yes, I knew *Heye* had them [George E. Heye, a collector of Indian arts, crafts, and artifacts, and founder of the Museum of the American Indian in New York in 1916]. The Rev. Wilson who did the collecting, was a guest in my camp for some days the past season. Incidentally, as you perhaps know, there is a considerable feeling in the Dakotas in regard to said skulls. Understand that I am not saying anything as a criticism but only stating how it looks to some of the people out that way. Wilson was ostensibly gathering information and material for the American Museum of Natural History, and now some of the local people say that there was nothing in that but a bluff, and that he was merely collecting and selling to whoever would pay him the best price. Personally I have no objection to their acquisition by Heyes [sic]. . . ."

Hidatsa Mother and Child. When a child was born the parents made a feast, and some prominent person, an old man or old woman, was called in to give it a name. When a young man reached maturity and had accomplished some brave deed, he was privileged to take the name of his father, grandfather, or other paternal relation. The person whose name he assumed received presents from the young man and was compelled to choose another name for himself.

The push to complete the material for three volumes during 1908 succeeded. But

as Curtis traveled back to the field in the spring of 1909, a haunting problem went with him. It had gotten no better despite Curtis' hope that with five volumes in print the pinch would ease. The aftereffects of the Panic of 1907 lingered. "I received your letter in regard to funds a few days ago," he wrote Hodge apologetically on July 13, from Seattle. "I appreciate more than I can tell your great patience in the matter and will say, in the beginning, that I had expected to have been able to pay you all the money due you long before this, but collections have been heartbreakingly slow.

"Of fifty thousand dollars that should have been paid in during June, I received less than twenty thousand, and just at the present time I am walking the floor trying to keep the banks from growing peevish. Matters are in such shape that I feel it practically impossible to make a definite promise. I will, within a few months, be able to make you a substantial payment, but just at the present moment I am finding it very difficult to keep things afloat. . . .

"Work in the field is progressing quite well. . . . Haddon will get into camp with us by the 20th of this month, and remain until about the 5th of September. The financial worries have seriously interfered with my personal work during the summer, but, notwithstanding that, the progress is quite satisfactory."

Back in New York in the autumn, Curtis had an idea for stimulating sales. He hurriedly submitted it to Hodge. "I am enclosing you a draft of my suggested letter to subscribers and others interested in the undertaking," he wrote on October 30. "It is impossible to go into the subject very much in anything as brief as a letter, and I have carried my statement through in a whirlwind fashion to get the greatest amount of information in the least amount of space. Make any suggestions you like in regard to it. . . ."

In a buoyant follow-up letter to Hodge two days later, Curtis wrote, "I had a splendid chat with Professor [H. F.] Osborn [of the American Museum of Natural History] yesterday and am to write him giving a review of my post-season's work and plans for next year.

"In his case, I will use practically the letter of which you have the outline. Also, if you do not mind, could I have for Prof. Osborn a copy of McGee's review. Prof. Osborn's position just at this moment as being in consultation with Mr. Morgan is a very important one and I need to bring everything within my power to bear. He is now enthusiastic, but I want to increase his enthusiasm if possible.

"Dr. Haddon will secure a set of the books for his personal use through Mr. Morgan, and I will be able to get his review of the work published in the near future. Haddon's letter to Osborn . . . has helped the cause tremendously. Politically, having Haddon with me was the best move yet. All going well, I can start a wave of enthusiasm for the book in the next four weeks, which will completely *swamp* any little antagonism of men like Dorsey, and I will see [C. D.] Walcott [of the Smithsonian] within ten days and encourage his interest as much as I can."

George Amos Dorsey was curator of anthropology at the Field Museum, Chicago, and a specialist in the study of the American Indian.

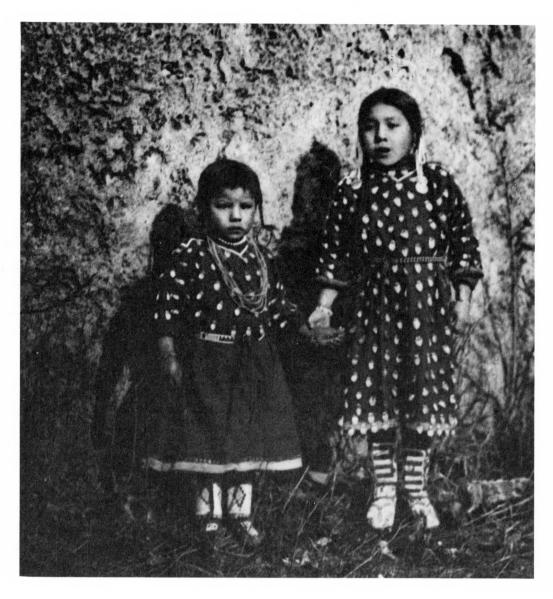

was in the care of her grandmother. Training in household duties began at an early age and by the time the girl was fourteen, she could tan skins and was beginning to make clothing.

Sisters—Apsaroke. The young girl

Hodge had made headway with a Chicago holdout, and Curtis responded, "I am more than pleased that you have had a heart-to-heart talk with Mr. Ayer," who two years before had been doubtful that Curtis would be able to complete such a large project, saying it looked like he was "trying to do fifty men's work."

Curtis went on, "Even if we cannot convert him sufficiently to his becoming a subscriber, it will be nice to win him over, in a measure, in order that he will not work against us. \ldots

"I have just received a letter from Dr. Herman ten Kate of Geneva, Switzerland, which is so good that I will send you a typewritten copy of it and treasure the original that it may be passed down to my grandchildren. It is one of the most complimentary little things that have been written yet."

Dr. ten Kate, associated with the Royal Netherlands Geological Society, wrote: "Dear Sir: I am very grateful to you for sending me the brochure of *The North American Indian*. Although I had read a review of your work before, the idea that I gathered about it was not at all adequate to the reality. You are doing a magnificent thing, building not only an everlasting monument to a vanishing race, but also to yourself. I am sure that if the Indians could realize the value and purport of your work, and perhaps a few of them do, they would be grateful to you. In fact, viewed in a certain light, your work constituted a redemption of the many wrongs our 'superior' race has done the Indian. Some passages you wrote are masterly, in reading them, scenes in the West of days by-gone come back to mind; I felt a great longing and an irresistible regret. That photography is an art in the true sense can no longer be doubted after one has seen those pictures illustrating your text. . . ."

Curtis' stay in the East the closing weeks of 1909 was brightened by his seeing other expressions of approval published within the year.

"A very remarkable and erudite work on the North American Indian tribes by Edward S. Curtis," said the Baltimore *Sun*, April 8, describing the work which had just been received by the Peabody Institute Library. "There is no point of daily custom

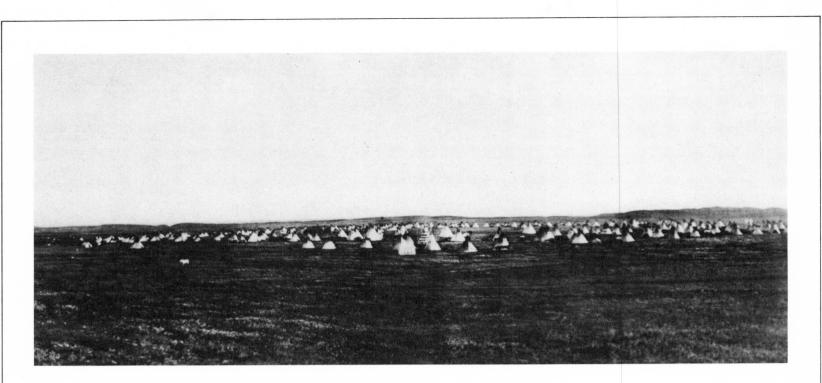

Sun Dance Encampment—Piegan. Curtis first saw the Piegan during the summer of 1898 at the season of their medicine-lodge ceremony. He wrote, "They were in camp on a depressed stretch of prairie, entirely concealing them from the sight of anyone approaching. Suddenly one rode out in full view of their encampment and beheld a truly thrilling sight."

54

about which the slightest details are known that is not presented in an unusual and attractive manner. . . . It will be an incalculably valuable addition to public libraries; and although scientists and anthropologists are more likely than others to be interested in it for the facts it contains, it is not written in the usual dry and unengaging style of most scientific works, but is free and readable and throughout has breadth and charm of phrase and manner."

"The finish, style and perfection of these volumes far surpass anything we have ever seen in this library," said the assistant librarian at London's Guildhall Library, as quoted by the Kansas City *Star*, after the Guildhall had received the three latest Curtis volumes. "These books are of such immense value and unique character that they will not be placed in the shelves of the library in the ordinary way, but students and others can, of course, have access to them upon application being made."

On December 10, Curtis, who had been negotiating with J. Pierpont Morgan for more help, had great news for Hodge. "A couple of days ago," he wrote, "I had a final favorable decision from Mr. Morgan in regard to furnishing further capital in the Indian work. It will be settled up now and the money made available as soon as papers, etc., can be drawn up.

"I feel particularly well pleased with this for several reasons: the added capital will be a tremendous help, and the fact that Mr. Morgan does this proves that he is satisfied with the work so far done and believes in its value.

"He has not, I believe, made this decision without considerable thought and investigation. There is little doubt but what Dr. Osborn's opinion as to the value of the work had tremendous weight with Mr. Morgan. I shall always feel that it was this influence of Osborn's which carried the situation through this time. . . ."

Also in December, Hodge moved up to head of the Bureau of American Ethnology at the Smithsonian, bringing congratulations from Curtis. "I feel it is just as it should be," Curtis wrote, "and I think I am almost as happy over it as you can be. . . ."

At the end of the year, Curtis sent Hodge a check for \$2,037. "I hope that it will do its part on a satisfactory start for the New Year," Curtis wrote.

"Now for another little matter: As you know, I am looking for someone to go into the field work, particularly taking the place of Strong, who will retire in the Spring. Strong writes me of a man of the name of Jeancon of Colorado Springs. He had charge of the Cliff Dwellers at Manitou for a time, and is well acquainted in the Southwest.

"Hewitt knows him, but in considering him for our work it might be wise not to let Hewitt know what we have in mind. Strong tells me that he speaks German, French, and Spanish and knows practically every Indian in the whole Rio Grande country. Unless there is something against the man, it would seem to me advisable to try him for a year at least.

"Let me know what you think and if you have any personal knowledge in regard to him give me what information you have." In the Lodge—Piegan. Piegan lodges of buffalo-skins, and later of canvas, were of common tipi form. The one distinctive feature was the characteristic decoration of the inner lining.

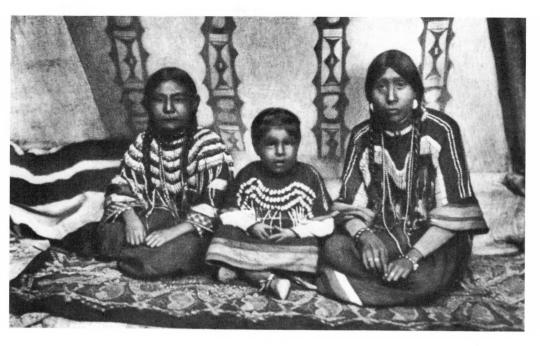

Day-dreams—Piegan. In disposition the Piegan are particularly tractable and likeable. One can scarcely find a tribe so satisfactory to work among.

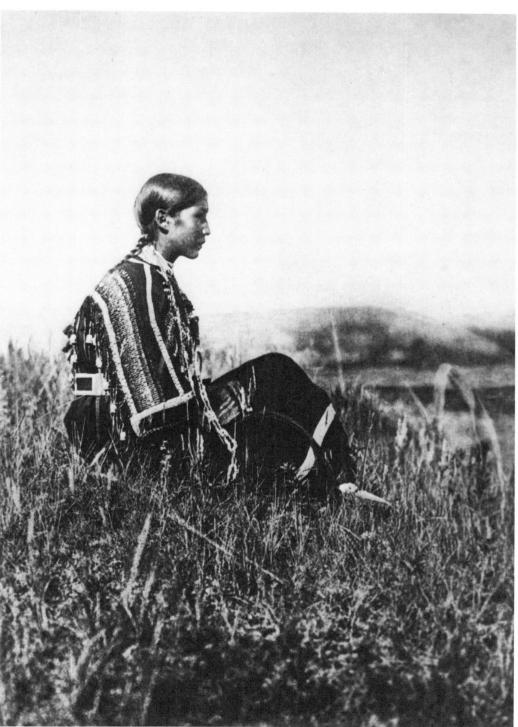

HREE WEEKS into 1910 Curtis was back in the Far West, getting ready for another hard season in the field. "This is my second day of active work in the cabin," Curtis wrote to "My dear Hodge" from the settlement of Waterman, in Kitsap County, Washington, January 23. "We are now getting organized and should be able to make things hum from now on. You will probably hear from us from time to time, as numerous questions will probably come up."

Some of the things on Curtis' mind when he was east were still with him. "While talking with you in Washington," he went on, "you said something of the possibility of getting Mr. ten Kate to review the books. The question in our minds then seemed to be where he would find the volumes. If he would consider writing a review of them, I would be only too glad to go to the expense of sending him, we will say, two volumes and one of the folios. The charges both ways would not be a very serious matter, and a review by him would certainly help us a great deal. I wish you would write and learn his feelings in the matter.

"I wish I could steal you from your office for two weeks and keep you here in the cabin. We are entirely shut off from the world, and our weather is anything but winter from your point of view. Our camp spot is certainly as cheerful as one could wish in this weather, which is the sort well adapted to ducks."

A note from Myers in a few days, written in a neat hand on notebook paper with ring holes, hinted of the nature of the work at the cabin as the rain drummed on the roof. "Dear Mr. Hodge," Myers wrote respectfully, "If Wissler [Professor Clark Wissler, Yale University] has published anything on the Blackfeet later than his preliminary sketch and his Mythology (both of which we have) will you secure a copy and send to us? Sincerely, W. E. Myers."

They were still deep in their homework in March as Myers issued yet another query to Hodge, on March 10, 1910, again in tidy longhand on notebook paper. "Will you write to Chamberlain and find out what he thinks about the word Kutenai? He gives it as a term applied by the tribe to itself. But the Kutenai at Flathead Lake, Montana, insist that the word is used only by other Indians, not Kutenai, and that their proper name is Ksanka.

"If the Tunaha were Salishan, as their language indicates they were, then what looked to me as a pretty certain origin for Kutenai becomes questionable, provided [the anthropologist Alexander Francis] Chamberlain is right in saying it as a Kutenai word.

"I some time ago wrote Chamberlain submitting a number of Kutenai words with probable, or improbable perhaps, derivations, and asked for his opinion, but have heard nothing in reply. Is he inclined to be chary with his knowledge? I should like to hear what he has to say, and if in your letter about the above matter you can incorporate a suggestion that will bring an answer, I shall be grateful to you."

By the middle of June, Curtis and his crew had completed one phase of their field work and were ready to start on another. "We have worked along the Columbia River and Willapa Harbor and Quinault," Curtis wrote Hodge on June 18, like Myers

Author's Camp Among the Spokan. In eastern Washington, along Spokane River below the Coeur d'Alêne, were three small tribes known collectively as the Spokan, and distinguished as Upper, Middle, and Lower Spokan, according to their respective positions on the river. using notebook paper, "and now we will start for Vancouver Island, to be gone some two months. Preliminary information available does not seem particularly illuminating. I take it our hind-sight will be more valuable than our foreknowledge in this case.

"Myers made a trip to Victoria in hopes of getting an outline of the field. Those about that town seem wholly lacking in knowledge or information bearing on the island. . . . They tell us that it is a bad season of the year owing to the Indians all being absent. I trust we will find a little material here and there, and at least have an outline of the subject by our return.

"Myers will go east at once on the close of our Vancouver Island expedition and will be ready to take up the book making, so do your best on manuscripts. We should be ready to begin reading proofs in early September."

Curtis' expedition to Vancouver Island, and beyond, brought no small contribution to his taste for adventure. He followed the turbulent Columbia River route that Lewis and Clark had taken in 1805.

"I wanted to see and study the region from the water, as had the Lewis and Clark party more than a hundred years before," Curtis wrote. "I wanted to camp where they camped and approach the Pacific through the eyes of those intrepid explorers."

The craft Curtis set forth in was rather less pretentious than that of Lewis and Clark: a small, flat-bottomed affair, square at the stern, pointed at the bow, driven by a gasoline engine with barely enough power to keep up steerageway, even though the course lay downstream. As an auxiliary cargo carrier, he used a large Indian canoe.

With him were Myers, Schwinke, Noggie (the cook), and a veteran Columbia River pilot who wanted to make the run just once more "before I fold up."

"As we moved downstream," Curtis wrote, "Myers and I made notes, watched for places to land and checked on old village sites. Schwinke set his typewriter on a packing case and hammered away typing yesterday's notes. Some days swift water and

rapids kept us busy just staying right side up. At night we camped on the shore. Sometimes we picked up an old Indian and took him along for a few days."

At Celilo Falls, where the river plunged over an eighty-foot precipice, they had trouble loading the boat aboard a flatcar hauled by a dinky locomotive, to be portaged to navigable water below the falls. "The track extended down an incline into the river and the car was let down until it was partly under water," Curtis recounted, noting that it was freshet season, complicating the operation.

Curtis worked in the water while the others hauled on lines from shore. They couldn't hear his instructions above the thunder of the falls, however, and he swam ashore to give them directions. There he found Noggie no longer manning his line but sitting on the ground crying. "What the hell's the matter with you?" Curtis demanded.

"You'll be drowned," Noggie sobbed.

Locks got them through the worst of the great falls where the Columbia makes its final plunge through the Cascades on its descent to the sea, but there were several miles of whirling, swollen chaos below, made more dangerous by the spring rains.

"On emerging from the locks we tied up to the side of the concrete spillway for a brief chat with the lock crew," Curtis wrote. "Several of them knew the old captain, and those who did not, knew of his reputation as the most daring and successful of the old river captains. The lock keeper urged him not to attempt the rapids at this season." The river was at its highest stage, the lock keeper pointed out, and as he cast a disapproving eye at the Curtis craft, he cautioned that "the currents have changed since your day."

Meanwhile Curtis was tuning the engine. "I almost hoped the captain would take their advice," he wrote, "but his only answer was a few grunts. He looked at me and wanted to know if I had the teakettle boiling. 'If you have, let's be on our way.' "

As the boat drifted out into the current, the old captain shouted to Curtis, who handled the bowsweep, "Boy, this ain't navigation. This is a boxing match. If the old river gets in one blow we are through. Ride 'em high; keep her on the ridges. Don't let a whirlpool get us."

At the first plunge into the breakers, Curtis wrote, the boat "bucked like a wild cayuse. She stood on her hind legs. She pitched head first into a yawning pit. She shot sideways with a lurch which almost threw me overboard. We rode a long high crest which seemed like a mountain ridge. Whirlpools were to the right of us and while dodging them we barely missed one on the left. As we plunged by it there was another on the right large enough to swallow three such boats. As we sped by, a tree was caught in the swirl. It stood on end and disappeared."

The water calmed and they pulled ashore to rest. Schwinke said the ride had lasted seven minutes. "As a celebration that night we bought a huge chinook salmon from a fisherman and had a feast," Curtis wrote. "It was the fattest, juiciest salmon I've ever tasted. We ate until there was nothing left but the bones."

When the party reached the Willamette River, Noggie quietly folded his bedroll

and quit. And the old captain who had wanted to ride the river one more time decided that while Curtis was working in the vicinity, he would go into Portland and see some friends. Curtis never saw him again.

When at last they reached the Pacific, as Curtis told it, they consigned their "worthy but nondescript little craft" to an ignominious end, cutting it adrift so that "it might float out to meet the ocean breakers and be battered to fragments."

For the tumultuous waters of the North Pacific part of the trip, Curtis bought a larger boat in Seattle: the *Elsie Allen*, forty feet long by eleven at the beam, built by a Skokomish Indian for salmon fishing in the Strait of Juan de Fuca. The new boat was powered by a gasoline engine, backed up by "enough canvas for cruising."

"The personnel of our cruise on the *Elsie Allen*," Curtis wrote, "was Mr. Myers, Mr. Schwinke and Henry Allen, our Indian contact man, and lastly a cook."

Clearing into foreign waters at Victoria, they headed for Cowichan, at the southeast tip of Vancouver Island. "The work at this point held no promise of thrills but formed an important foundation block in the two volumes covering the island," Curtis wrote.

Things became livelier after they sailed back through the Strait of Juan de Fuca, having finished with the tribes on the seaward side of Vancouver Island, and entered Seymour Narrows, one of the labyrinth of waterways that form the inland passage between Vancouver Island and the mainland. Many a ship and canoe had come a cropper on the rock that stood out of the water in mid-channel, taking a heavy toll of lives.

"It had been my plan to anchor south of the Narrows, pick up an Indian pilot and then wait for slack water before attempting the passage," Curtis wrote. The question of where to anchor suddenly became academic as they were caught "in the maw of full tidal flow without sufficient power to retreat against the current. Whatever might be the perils of navigating the Narrows at the worst state of the tide, we were in it and there was no escape."

To Curtis, however, this was heady stuff. "In the inner recesses of my mind," he confided, "I was happy in the thought we had no Indian pilot and that we were to experience the hazardous stretch of the Narrows while the rip tide was the greatest. I took the wheel from our native and told him to go below and nurse the engine."

With Myers trancelike at his side, Curtis fought the wheel as the boat was thrust toward the rock. "Once in the whirl I had little control of our course," Curtis wrote. "At times we spun like a top. Our bow pointed hither and yon; yet on we rushed. Speeding past the great central rock, the breakers and spray poured back on our deck. We seemed to miss the rock by inches."

Wiping the water from his eyes, Myers remarked laconically, "Well, Chief, now that I've lived through the thrilling passage of the Columbia River and now the famous Seymour Narrows at flood tide, I'm convinced that's a potent rabbit's foot you carry."

Farther on, as they continued northward, a thrill of a new kind came one evening as they lay anchored in a narrow, twisting waterway among the mountains.

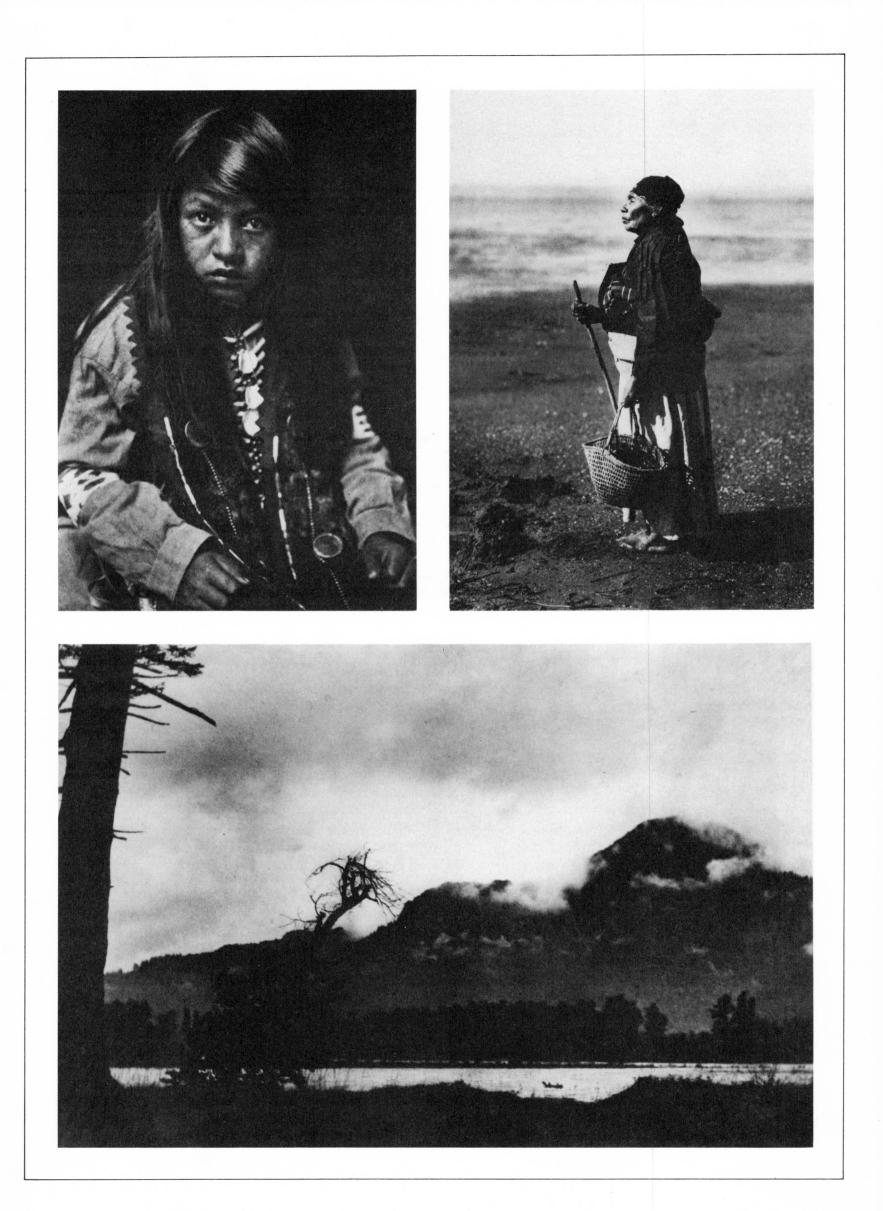

FAR LEFT: Yakima Boy. The most striking psychologic characteristics of the Yakima are obstinacy, arrogance, and a certain moroseness sharply contrasting with the good humor of many native tribes.

LEFT: On the Beach—Chinook. An old Chinook woman with staff and clam-basket makes her way slowly over the mud flats of the southern end of Shoalwater bay, in Washington. Chiish, Burden-basket (Catherine Hawks), is one of a very few survivors of the populous tribe that formerly occupied that part of the state of Washington lying between the middle of Shoalwater bay and the Columbia.

Evening on the Columbia. A spur of the Cascade mountains occupies the background.

"Our boat was close to a sheer cliff," Curtis wrote. "Our evening meal was finished and we were lounging on the deck viewing the eery surroundings. The gloomy, forested cliffs towered toward the clouds.

"Looking up the channel where the waterway gave perspective, there was a break in the low-hanging clouds, and the snow-clad peaks glistened in the crimson afterglow of a northern sunset. It seemed as though we were gazing from a bottomless pit into paradise. Enveloping us was silence so deep that it seemed audible."

From far away came a sound, faint but rising fast. "First it seemed to resemble the crackle and hum of the northern lights," Curtis wrote.

As they watched the upper reaches of the channel, all agreed that the sound came from a high-powered speedboat.

"Then around the bend, perhaps a half mile away came a huge whale and with such tremendous speed it seemed unbelievable," Curtis wrote. "When he was close I recognized him as a sulphur bottom and at least ninety feet in length. From time to time he playfully hit the surface with his tail. The smash of the blow upon the water in that tunnel-like channel was a hundred-fold greater than the back-firing of an automobile."

As the whale disappeared around the bend, the spellbound watchers realized they had witnessed something few others had. Curtis went on: "The extraordinary speed and the repeated high jumps were possible only because the whale was traveling with an exceedingly swift current. The channel was crooked and the bends very abrupt. How the whale in his mad and apparently exuberant exhibition of speed kept from colliding at the turns was beyond understanding."

For Curtis, the ethnologist, there was a special kind of exhilaration in arriving at Fort Rupert, just below Alaska. There he would begin work with the Kwakiutl Indians. "Knowing this group of tribes to possess unusual primitive lore, I was keen with anticipation," he wrote.

"As we dropped anchor in the shoal bay on which is located the Kwakiutl village, we saw below the single line of dwellings comprising the settlement," he wrote. "They were largely rough board structures with their gable ends facing the shore. There were also a few scattered totem poles and carved house posts. Many large and beautifully decorated canoes were drawn up on the beach."

As he stepped ashore, Curtis was met by George Hunt, whom he had arranged for by correspondence to serve as his interpreter. "He proved trying yet the most valuable interpreter and informant encountered in our thirty-two years of research," Curtis wrote. "He was tall, powerful, rawboned, grizzled by the passing of more than sixty years of hard knocks, intrigue, dissipation and the efforts of the 'short life bringers.'"

The son of a hard-headed Scot who was factor of the Hudson's Bay Post at Fort Rupert, and an Indian woman of high intelligence, Hunt had taught himself to write, beginning as a small boy by copying labels at the trading post. He had persisted at this even after his father forbade it and punctuated his prohibition with a paralyzing blow to the boy's head. Hunt had learned so well that he had written a book about the complicated mythology of his people, the Kwakiutl Indians. "Aside from the unparalleled work of Sequoya in inventing the Cherokee alphabet," Curtis wrote, "George's volume of Kwakiutl myths is perhaps the most outstanding achievement of an untutored native."

Hunt was given to mysterious seizures of homicidal rage—perhaps the result of brain damage from the blow by his father in boyhood. "At the beginning of my contact with George, I knew nothing of his extreme irritability, bordering on insanity," Curtis wrote. "I soon learned the signs of approaching brain storms and would at once suggest that we do some fishing or go visit his traps. Yet there were times the rages would occur without warning. On one occasion natives came rushing to tell me that George was in one of his rages and would kill me." They urged Curtis to hide.

"This I could not do," Curtis wrote. "George was my friend. I walked down the beach to meet him. I managed to calm him on that occasion, but realized there would be others. In the study of the Kwakiutl I worked with him for the greater part of four seasons. The results were well worth the patience and tact it required. . . .

"Without his extraordinary assistance," Curtis summed up, "the material for Volume 10 could never have been collected."

It seems likely as well that Hunt once saved Curtis' life, in circumstances growing out of Curtis' bent for doing what the Indians did. In this case, it was to capture an octopus, or devilfish, as the Indians called them. In these waters, off British Columbia, they were the largest in the world; Hunt told Curtis of capturing one that spanned forty feet.

The Indians, who had a deep-rooted fear of these grotesque creatures, told harrowing tales of devilfish reaching into canoes and dragging the occupants into the water, all happening so fast that there was no time for defense. One old Indian told of a devilfish that had grabbed his canoe by both gunwales, clamping a tentacle on each side, while with a third it encircled his sister.

In the face of this intelligence concerning octopi, which would have given pause to most men, Curtis still wanted to capture one and wrestle it into submission the same way the Indians did. The creatures lived in burrows under large rocks far enough from shore not to be exposed at low tide. The Kwakiutl method of capturing them, Curtis wrote, "is to wade in shallow water when the tide is low and locate a burrow, which is easily discovered by the rubbish heap of shells surrounding it," their main diet being shellfish and crabs.

"The hunter, or fisherman, is equipped with a long, slender wand or pole," Curtis continued. "With the burrow located he prods the cavity under the rock. After annoying the creature he withdraws the stick and waits perfectly still. The devilfish, deciding it is better to be elsewhere, slowly creeps from the hole. First the tips of his tentacles appear. Then with extreme caution he moves from beneath the rock. The instant the entire body is free, it is off in high gear. The rapidity with which it attains full speed is amazing.

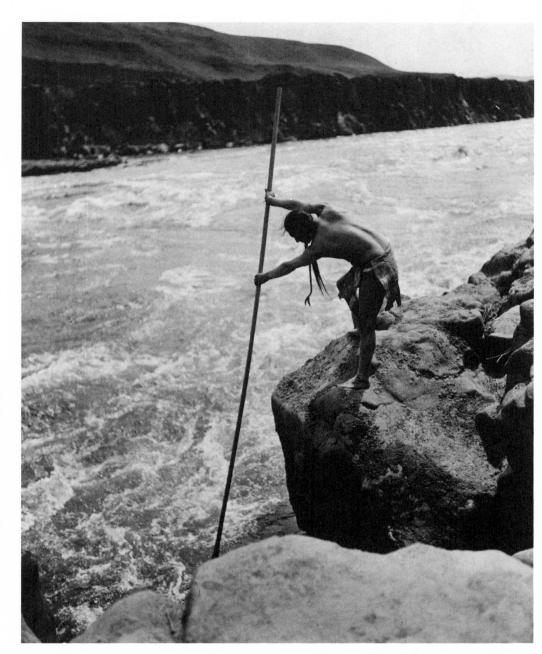

The Fisherman—Wishham. Along the middle course of the Columbia at places where the abruptness of the shore and the up-stream set of an eddy make such method possible, salmon were taken, and still are taken, by means of a longhandled dip-net. At favorable seasons a man will, in a few hours, secure several hundred salmon—as many as the matrons and girls of his household can care for in a day.

Carved Posts at Alert Bay. These two heraldic columns at the Nimkish village Yilís, on Cormorant Island, represent the owner's paternal crest, an eagle, and his maternal crest, a grizzly-bear crushing the head of a rival chief.

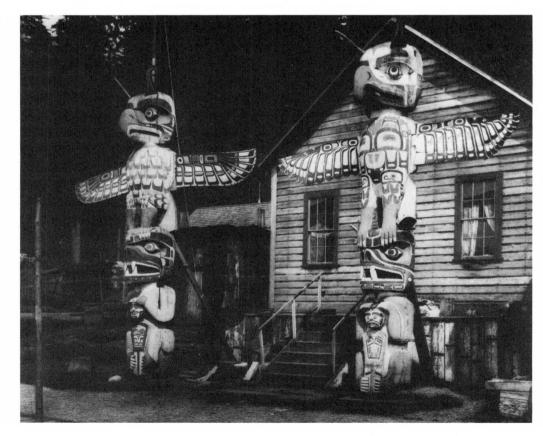

"The catching native, with cat-like movement, grabs the creature and quickly throws it to the beach. The entire success depends upon the quickness of the movement as the octopus must be picked up and thrown before it has time to use its tentacles."

While George Hunt sat on the beach watching, Curtis, wading in water up to his hips—too deep, really—found a telltale burrow. "I prodded with my pole and waited developments," he wrote. "When the octopus came from under the rock, its size gave me a chill, but not wanting a native to think I lacked courage, I made the grab."

Alas, he missed. "The water was too deep and the octupus too heavy," he explained. "Perhaps, too," he conceded, "I fumbled the catch. At least the creature was not thrown and I was caught. Some of its tentacles were holding fast to the boulder and the others wrapped around my legs. I was as securely anchored as though the job had been done with strong ropes of rubber. The harder I struggled, the firmer grew its grip."

For Curtis, would-be conqueror of the devilfish, conditions quickly worsened "I was wearing hip-length rubber boots and on these it vented its rage, cutting innumerable holes through the rubber," he wrote, describing its cutting equipment as being "shaped like the beak of a parrot, with a razor-like edge."

"Help!" Curtis shouted, as the fast-incoming tide rose around him. "This damn thing's going to drown me!"

Hunt, who had been convulsed with laughter from his seat on the beach, suddenly realized the seriousness of the situation and hurried to the rescue.

"By this time the water was rippling over my shoulders," Curtis wrote. "George had not seen the octopus so did not realize the gravity of my plight. He became a frightened and efficient Indian. With his hunting knife he dived into the murky water endeavoring to locate the vital spot. He failed on first and second attempts, but on the third he succeeded in slashing into the body and the vise-like tentacles began to lose their grip. . . ."

Dragged ashore, the octopus measured eleven feet, tip to tip. "And you were fool enough to think you could catch a devilfish that big in deep water!" Hunt scolded.

During his four seasons among the Kwakiutl, Curtis particularly admired the way they captured whales, calling it "the most daring and dangerous of all activities of the American Indian. The capture of a whale, the largest living animal, by natives in a frail canoe is a tremendous undertaking."

Before setting out to face the hazards of whaling, often in the stormiest seas, the Kwakiutl called for the help of the spirits. The whaling season began in May, but they began the secret rituals of preparation, including intensive courses of purification, the preceding October.

"We finally broke through the wall of secrecy and secured not only details of the occult ceremonials attendant to whaling, but what was equally important, the legend accounting for their origin," Curtis wrote.

He had heard that the whalers kept a mummy in the bow of the canoe, but it was

months before someone let slip that this was so, making it necessary to correct a great mass of field notes. Once having got this cat out of the bag, Curtis won permission to take part in some of the ceremonies and to go along on a whaling expedition.

He would need to provide himself with a dozen or so skulls and a mummy. "I had no experience in grave robbing," he commented drily, "but since to learn about such ceremonies it was a prerequisite, I was determined to comply."

Myers was less than charmed by the idea. Enumerating the things he had been through with Curtis, he exclaimed, "When it comes to prowling for skulls and mummies, I draw the line." All the same, when it was time to set out on this "unholy quest," as Curtis called it, Myers was on hand.

"Our craft that night was a small canvas canoe which was ideal for stealthy maneuvering," Curtis chronicled. "Landing at one of the Islands of the Dead, I proceeded to look for a mummy. It was not my plan to disturb well-housed or lately interred bodies, but rather to locate an ancient crypt."

He found many crumbling boxes, but little of what he was looking for. "Skeletons were numerous but mummified bodies were not to be found," he wrote. He explained that in those regions a small percentage of dead bodies dry and shrivel; most simply decay. "Thus the finding of a presentable looking mummy might require the examination of many interments."

Moreover, the skulls, while plentiful, were attached to the spine, and Curtis was finicky about making the separation. "I preferred them not only detached," he wrote, "but well-weathered." Also, many skulls had hair, another disqualification. The night yielded him only two that were suitable.

The second night, with Myers asking to wait in the canoe rather than go ashore, Curtis did better. He returned with four skulls in his bag. More came to him like manna. While he was out taking pictures one day soon afterward, a thunderstorm broke and as he passed under a big spruce, running for shelter at the village, he was showered with burial boxes from its branches, dislodged by the wind.

"In falling they hit other boxes below, and all broke in the descent so there was a veritable deluge of bones and skulls," Curtis wrote. "Like a boy gathering apples, I quickly picked up the skulls, thus adding five more to my collection."

There remained the problem of finding a mummy. Curtis appealed to George Hunt for help. Hunt discussed the matter with his wife, the Loon, then announced with a pleased smile, "The Loon thinks she knows where you can get a mummy and she will help you. It is on the Island of the Dead of her people some thirty miles from here. We should go while the people are away to the fishing village."

The three of them crossed the strait to the burial island, being careful not to be seen. Curtis and the Loon went ashore to visit the "grave houses," Curtis related. "We pried open a few without finding a satisfactory specimen. Then good fortune was ours. We found a beautiful mummy of the female species. I was not sure whether it was a relative or an enemy of the Loon's. It was quite evident she knew the lady well,

65

and henceforth always referred to the mummy by name. Before the removal from the

FAR LEFT: George Hunt at Fort Rupert. Of Hunt, Curtis wrote, "Inherently curious and acquisitive, and possessed of an excellent memory, he has so thoroughly learned the intricate ceremonial and shamanistic practices of these people, as well as their mythologic and economic lore, that today our best authority on the Kwakiutl Indians is this man, who, without a single day's schooling, minutely records Indian customs in the native language and translates it word for word into intelligible English.

LEFT: Octopus Catcher—Kwakiutl. The hunter, finding a den, inserts the end of a sharp stick under the rock, feels about until he touches the hard part of the body, and pushes the stick into it. The octopus, mortally wounded, comes out, and the hunter drags it ashore or into his canoe. It is not permitted to linger, but is beaten to death against the rocks in order that the flesh may be edible.

The Fire-drill—Koskimo. Fire was obtained by means of the drill, of which the spindle was fashioned from a fir branch that had hardened by lying long in water, and the base from very old, dry cedar wood. The spark was caught in yellow-cedar bark floss. While twisting the spindle between his palms the fire-maker kept repeating, "Please come, fire!" box, she talked to it and explained that it was a great honor she was soon to receive."

Thus outfitted with the proper accouterments, Curtis took part in the prescribed rituals. This included the so-called "mummy-eating ceremony," Curtis wrote. "Whether I joined in the eating of the mummy or not I decline to answer. I will hazard to say that I have been asked that question more than a thousand times. Mummy eating was by the British Government classed as cannibalism and if one is convicted of the crime, he is due for a long time behind bars."

For all this, however, the spirits seemed not to be appeased, for when the whalers went out to look for whales, their quarry had left for other waters.

What adventures Curtis was thus denied would appear to have been decently offset by his visit to Devil Rock, to photograph the stellar sea lion, the largest sea lion in the world, reaching a length of thirteen feet and over a ton in weight. Devil Rock, a favorite sea-lion rookery, stood out of the sea amid the Queen Charlotte Islands, some thirty miles off the British Columbia coast.

Setting out from Fort Rupert, Curtis reached the island after a stormy two-day passage, ariving before sunrise but with the light already good enough for taking pic-tures.

"The island was blanketed with the great beasts," Curtis wrote. "At the pinnacle sat a gigantic bull who towered above all the others. We dubbed him the Mayor. The approach of our boat started a restless movement of the herd. The bulls bellowed and the cows barked in protest. I quickly made pictures from the boat. By this time the sea lions were stampeding. They poured off the rock in a waterfall of unwieldy beasts."

The party transferred to an Indian canoe to make the landing. With the steep shores pounded by an open sea, rolling against the rock in thunderous breakers, this was precarious. Stanley, George Hunt's son, was first to make the leap. "At the right instant he sprang, cat-like, landing on hands and feet," Curtis wrote. "Myers followed. On each inshore rush of the sea I tossed them bundles of blankets, food, water, harpoons and overnight necessities."

Curtis threw a line ashore, and on this the cameras and film, wrapped, padded, and encased in waterproof bags sealed by clamp, were sent over. "While my companions were carrying the equipment well above the breakers," Curtis went on, "I watched for my opportunity and made my spring to shore from the canoe."

Making his way to the top of the rock, Curtis made a horrifying discovery: "*Devil Rock was under water at high tide*. The government chart I had consulted was obviously wrong. We were thirty miles off the coast and unable to apprise anyone of our perilous plight."

Myers had run onto the melancholy truth at about the same time. "Chief," he called, "do you realize there is no driftwood on this island?" Both men looked toward the fast-disappearing boat that had brought them from the mainland, too far away to hail.

The chart had shown Devil Rock to be forty feet above water at high tide. "Not a

great margin of safety in a storm," Curtis wrote, "but safe in favorable weather. That the chart could be forty feet in error had not occurred to me. Unwittingly, I had placed my party in this jeopardy. I could hardly find my voice to answer Myers."

They went about their work as if there were nothing to worry about. "Perhaps luck would be with us once more and we would survive," Curtis wrote. "Yet I cannot read about a human being sentenced to death without recalling that awful moment."

The sea lions, filling the water all about, added nothing to the intruders' sense of safety. "At close range the bulls were so incredibly large they dwarfed us as though we were pygmies," Curtis wrote. "These belligerent behemoths resented sharing their quarters. Their dispositions were ugly and the cows equally ill-tempered. This encounter convinced me that natives traveling in canoes on stormy seas to harpoon such great creatures needed all the help obtainable from the spirits to whom they prayed."

Despite the gloom of the situation, Curtis busied himself with his camera, photographing the sea lions as they tried to work up the spunk to come ashore. "The Mayor, bellowing imprecations at us, was the first to arrive," Curtis wrote. "Soon losing courage, though, he plunged back into the sea. Again he approached, his harem barking encouragement. All of which afforded an excellent opportunity for making pictures."

As the hours passed, the tide began coming in. The trapped men watched in growing apprehension as the water crept remorselessly up the rock toward them. When the sun slipped into the sea, their world measured about 200 by 100 feet.

"The restless animals were bellowing and barking in combined protest," Curtis wrote. "Apparently they held a conference and decided upon a mass attack. As though under orders from a commanding general, they literally poured upon the rock from all directions."

Curtis and his two companions fought back by swatting the animals in the face with a pair of empty five-gallon gasoline cans, which had been used for harpoon floats. This was only temporarily effective, and as darkness settled down, man and animal reached a kind of accommodation.

Preparing for the night, the men gathered their equipment at what they called the "Mayor's suite," a small, flat area at the highest point of the rock. "Edging it was a ridge, broken in sections like the vertebrae of a gigantic prehistoric animal," Curtis wrote. "These cracks in the ridge allowed us to make fast our harpoon lines. The cameras were placed in their waterproof sacks, securely lashed to the rocks."

The night was calm, with hardly any wind, and the sea beyond the breakers smooth as glass. The lulling effect of this was offset by the distraction that the area was full of lice. "We began to realize that the sea lion had cause for his irritability," Curtis wrote. "Our flesh itched and burned. As the submerged portion of the Rock grew smaller the lice increased in number. It was now time to adjust life lines. Myers suggested I do the lashing."

68

When Curtis finished with Myers, taking three lines instead of one, Myers hu-

morously complained that he was so well trussed he couldn't scratch. Stanley, when it came his turn to be secured, dubiously wanted to know if it was going to be that bad.

The tide came in swiftly, the breakers aglow with phosphorescence and spraying the huddling refugees with salty spume. "The first wave to carry us off our perch was a terrific shock," Curtis wrote, "but our lines held fast. The uncertainty of what to expect was unnerving. How long could we survive this beating? Finally, I sensed the tide's maximum height, and then it was brutal endurance. In about thirty minutes the breakers no longer hit us."

Drenched, bruised and badly treated by lice, they struggled to loosen their lifesaving lines. "The chill air on wet clothing set our teeth to chattering," Curtis wrote. "Exhausted from the beating we had taken, we dug blankets out of our bags to cover our drenched bodies" and tried to get some sleep.

Curtis was awakened by grunting, puffing, and spittle dripping on his face—the Mayor towering over him. He drove him off with a blow from one of the five-gallon cans, which he had placed in easy reach.

At daylight the boat was back, as arranged, but her crew had been sure it was a waste of time. Soon after leaving their anchorage, they had stopped to palaver with a canoe-load of Haida Indians, George Hunt explaining that they were on their way to pick up his son and a couple of white men who had spent the night on Devil Rock.

"It's no use to go," the Indians said. "No one can live on that rock all night. Some of our people in their canoes have taken refuge there when caught in a storm but they always drowned."

Curtis and his companions had been lucky, for it had been a freakishly calm night. Within hours a violent storm hit, and it took them three days to get back to the mainland. By then they were believed to have perished. One newspaper reported "the tragic loss of the Curtis expedition," accompanying the story with a full page of pictures.

In the course of his adventures in the north, Curtis had anxiously kept in touch with Hodge, apprising him of his own activities and checking to see that he was keeping up his end of things. "It is sometime since I have had any mail so know nothing of the headway you are making on manuscript," he wrote from "In Camp, Alert Bay, British Columbia," July 21, 1910. "I hope all goes well, as we are now nearing the time when Myers will be starting east to take up the winter's work.

"At present we are with the Kwakiutl about Alert Bay and Fort Rupert, and will be here until about the 15th of August, when we will go to Barclay Sound to do a couple of weeks work with the West Coast people and then return to Seattle, and Myers will start east at once."

Curtis was looking ahead to his own activities for the winter. "I take it that McGee has not yet turned in his review," he observed impatiently. "I am writing him tonight, urging that he try and get it out for me. I must make the coming winter a very active one in book-selling, and would like very much to have his review out in

the Autumn number of the *Anthropologist*. Perhaps you can help some by getting McGee on the 'phone and urging the importance of the review. . . ."

Nearly a month later, August 18, 1910, Curtis was temporarily back from the woods, writing Hodge from Victoria, British Columbia. "I have just received your letter and while I feel rather anxious about the late start on the manuscript, I think it will work out all right. I do trust, however, that you will have finished your work on Volume 8 before starting for the Southwest.

"Myers will leave for the East about the 5th of September. He had better call and confer with you, take such manuscript as you have read with him, and start things going at Cambridge. We want to crowd matters along as usual, in order that both Myers and I can get into the field as early as possible another summer, and also for financial reasons."

Curtis said nothing about another project which he started at about this time, in 1910, and carried on piecemeal in later visits to British Columbia during the next two years. With Myers and Schwinke helping, this was the making of a motion picture, *Land of the Head Hunters*, using the Kwakiutl as his cast, enacting the legend of their greatest hero, Motana, and showing them "in their great canoes against the grandeur of tribal country." The film was publicly shown for the first time in 1914.

It was during this enterprise that he received an injury which would plague him the rest of his life. It came while he was filming a whale fighting to escape capture. "With Indians to man the canoe, we drew close," Curtis wrote in his abortive reminiscences. "The creature was immense. Perched as steadily as possible in an Indian canoe in a rough sea, I was getting some incredible footage of this monster.

"I urged the paddlers to move closer. In retrospect I wonder that they obeyed my wish. I wanted a closeup looking into his huge throat. Suddenly I was hurled into the sea and fighting for my life beside that thrashing leviathan. The canoe was smashed to splinters; my camera and priceless film at the bottom of the sea . . . how I mourned that wonderful film made at such close range."

He wrote nothing about his injury. Not until his correspondence with Miss Leitch of the Seattle Library, decades later, is there any reference to it. Referring in his letter of November 29, 1948, to his frequent mention of "my bum leg," he explains, "I acquired that lame leg . . . while making a motion picture of a large whale. He became annoyed and with his tail smashed our whaling boat with a swat of his tail. I came out of the smashing with a broken hip . . . I still limp slightly."

A friend, reading the scenario of *Land of the Head Hunters*, suggested that Curtis put the story into book form, using the declamatory style of the tribal bards. It was published under the same title in 1915 and was still paying Curtis royalties thirty-five years later. So was *Indian Days of the Long Ago*, which Curtis wrote at about the same time and which sold a million copies the first year. When he found time to write books, having found none to keep a journal or diary, is not recorded.

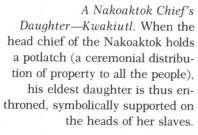

A Bridal Group—Kwakiutl. The bride stands in the middle between two dancers hired for the occasion. Her father is at the left, and the bridegroom's father at the right behind a man who presides over the box-drum.

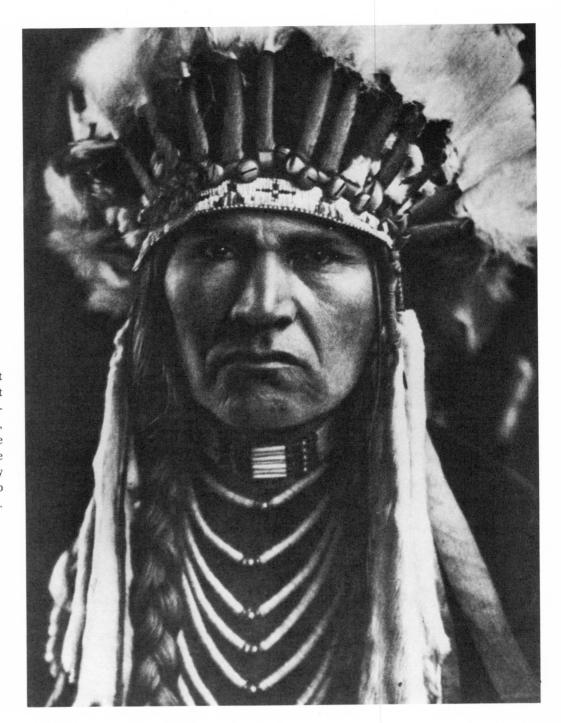

N THE LATE AUTUMN of 1910, Curtis, in Seattle, again wondered about Hodge, who by now should have been back from his vacation in the Southwest. "I trust that you are back in harness and that you are feeling particularly strong, and will be able to pass proofs through your hands at a rate which will keep everything clear of the press," he wrote.

"It is the same old story: I am in a hurry to get the books out. Publication money is now being tied up, and I will need to make a turn on the thing as quickly as possible, and you know that bank paper matures whether anything else is done or not.

"I have been confined to the bed some ten days, but am now out and getting in shape for the work again."

When finally Curtis had word from Hodge, his spirits rallied. "I am more than delighted that you are making such splendid headway with the work," he replied on October 26. "If we can keep up the present pace we will come out in splendid shape and be able to make very early deliveries, which will enable me to get into the field so that I can have a very long summer.

"You suggest that perhaps my illness was caused by overwork. Well, if you can think of anytime in the past ten years when there has not been overwork, I would rather like to know when it was. I have not been able to pull myself together yet, and feel a bit discouraged. . . ."

Typical Nez Percé. The war-bonnet of eagle-feathers, with pendant weasel-skins, as well as the otterfur wrappings of his hair braids, indicates the extent to which the Nez Percés were influenced by the Indians of the prairies, whom they met in their annual pilgrimage to the buffalo country.

72

As spring of 1911 approached, Curtis was deep in sales efforts. "I am sending

you proof of the Hawthorne review," he wrote Hodge on June 7 from New York, referring to a 2,500-word effusion by the son of the famous writer. "The review is in the form in which it will appear in the press on the coming Sunday from one end of the United States to the other, and was considerably modified after its coming from Mr. Hawthorne—modifications being largely in the removal of superlatives and statements which might offend other workers. . . .

"I have to confess that I am face to face with a complete change of plans for the year, and want to go over them with you," Curtis continued, taking up another matter. "Outside of some absolute miracle there is no chance whatever for my getting funds for field work this year. Within forty-eight hours, I will probably have started on my plans for the new order of things, which will be a big and active selling campaign personally conducted, covering all parts of the United States, beginning in October, and ending next Spring.

"I have been face to face with this thing for some weeks, so that I can write now with some degree of sanity. In other words, the worst of the misery is over. The time between now and Autumn will be used in preparation for the winter campaign. I will go to Seattle within a few weeks, and take up the preparation of material and carry on the correspondence for preliminary arrangement of lecture dates. . . .

"It must not be known that this change is forced upon us through lack of funds. We will simply have to take the attitude that it seemed for the best for me to go ahead and sell this work out, reduce our loans, and save the money paid in interest.

"I hope to keep Myers at work in the field. I can, I think, manage for his salary and expenses, provided he will consent to working alone. And then another spring I can take up the coast work and close it up.

"When I start on this selling trip I am going to assume at every point that it is the last possible call for the book, and I believe that I can carry it through. I will at the same time get someone to cover the European ground thoroughly.

"But of all these things I will talk with you, rather than write further at this time."

After his face-to-face talk with Hodge, Curtis wrote him on June 20, optimistic over his new plans. "I have been at work with considerable vigor in preparation for the campaign of the coming winter, and am more than pleased with the interest so far shown. \ldots ."

In October, back from the field, Curtis was ready to start his winter's sales campaign. "The summer has been a very trying one," he wrote Hodge on October 12 from the Hotel Belmont in New York, "and the labor of getting this campaign started exceedingly heavy. However, I think I am in fairly good shape to start in for the lecture work, and trust that I will be able to live up to nine performances a week, and at the same time keep a general over-sight on the campaign and see that we sell books. Everything depends on the success of this winter.

". . . I enclose . . . some material which appeared in the *New York Times*, and it has been suggested that I prepare a little material covering the other side of the

subject. With that thought in view, I have hurriedly dictated a few sheets of material. . . .

". . . Honestly, the number of educated people who presume that the Indians all speak one language is simply appalling. Only a few days ago a man who is a graduate from one of the important colleges, and now the head of a fairly substantial educational institution, asked me if the Indians really had more than one language. . . .

"I enclose a leaflet which is a preliminary announcement of the Carnegie Hall lecture. This promises to be a very successful affair, and I want to make it such, as its effect upon the balance of the winter will be far-reaching.

"I have carefully watched all printed matter bearing on our tour, and have tried in every case to weed out anything that might be offensive to the critical, and the publicity stories which have been prepared for the work have all been gone over by Mr. Schwinke and myself with the same thought in mind. Publicity is absolutely necessary, but I aim to make it dignified; and in writing to acquaintances connected with the different educational institutions I have explained that the tour was not one of lecturing for personal gain, but rather a part of the general effort to further the work. . . .

"I am certain that I have the finest series of slides that have been brought together for exhibition purposes. I have heard most of the music, and I am certain that it is going to be an interesting feature of the entertainment, particularly the bits which are composed to accompany the impressive dissolving views.

"You will be pleased to know that the business organization, in meeting people and in discussing arrangements for these lectures, finds nothing but the warmest interest in the work, the only exception being one of the men coming in contact with Culen's influence. Notwithstanding that, the lecture is booked for the Brooklyn Institute and everything promises a successful affair there. . .

"We leave on Wednesday for Boston, where we will spend a week in rehears als. . . ."

As Curtis honed his show in Boston, perhaps suffering moments of self-doubt because it had been necessary for him to adopt these measures, he could take heart from a review of Volumes 4, 7, and 8 in the *American Anthropologist*, October-December 1911, by William Curtis Farabee of Harvard, noted authority and writer on the Indians of South America.

"The earlier volumes of this work have received well-merited commendation . . . in America and Europe," Dr. Farabee wrote. "It would seem impossible today to improve upon the book-making and techniques of the earlier volumes, but these later ones show progressive improvement in spirit and scope. . . .

"The author has succeeded admirably in his endeavor to make the work one which in fact cannot be questioned by the specialist, but at the same time will be of the greatest interest to the historian, the sculptor, the painter, the dramatist and the fiction writer, as well as the ethnologist. . . ."

The show took to the road, and it went well. "The Carnegie Hall affair was in

The Weaver—Hopi. In the art of weaving, knitting, and embroidery the Hopi are preeminent. Weaving is exclusively a masculine occupation, and the very excellent product includes the ordinary woman's garment, the marriage robe, belts, for daily and ceremonial use, and bed blankets.

Basket Maker—Skokomish. Women of the Skokomish band of Twana are especially skillful in weaving soft, flexible baskets.

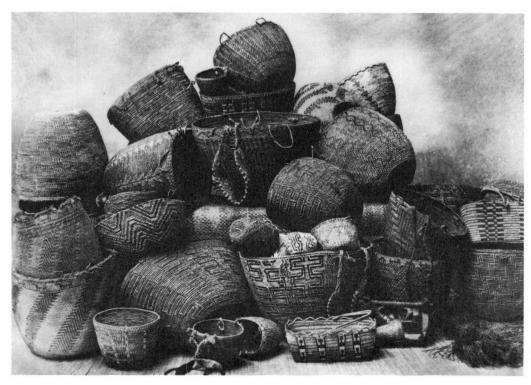

Puget Sound Baskets. Basketry continues to be an important industry of many Puget Sound tribes, the bulk of the product passing into the hands of dealers. every way a tremendous success," Curtis wrote elatedly to Hodge on November 19. "We had a very large audience, and most enthusiastic.

"Last night I was in Brooklyn, where we also had a very large audience. Professor Hooper was good enough to say that they had had no end of lectures about the Indians, but he thought this was the first time the subject had ever been put before them in the right light, and in a comprehensive way. He added that he considered it one of the most successful lectures they had ever given.

"In a popular way the Carnegie Hall evening was so much of a success that the Hippodrome management asked that we give the entertainment there as one of their big Sunday evening affairs. . . ."

But as 1912 began, something went sour with Curtis' stage efforts. The turn of events was revealed in a candid letter by Curtis on January 11, 1912, to Dr. Francis W. Kelsey, at Ann Arbor, Michigan, where, one gathers, a performance had been canceled.

"I find this letter a hard one to write," Curtis began. "My losses during the winter have been very heavy, more so perhaps than I realized until these last few days when my secretary and I have checked up on our outstanding obligations and looked the situation squarely in the face. . . . when talking with my friends, advisors, and supporters, of borrowing further money to continue the tour, they were most positive that I could not afford at this time to take the risk, as to do so and find myself again with a heavy deficit would, to put it frankly, mean bankruptcy. . . ."

On the same day that he wrote to Dr. Kelsey, Curtis also wrote to Hodge, saying nothing of plans to give up the show but answering some criticisms made after the performance at Worchester, Massachusetts. "Cheer up! The worst is yet to come!" Curtis began with irony. "Relative to the comment on the Worcester entertainment, it was our first night. There had not been sufficient rehearsal (you will understand it is a very complicated program) and not being fully experienced on the road, I was foolish enough to let the house manager place our apparatus in the gallery. This brought it to such an incline that the operator could not hold his focus. This gave us much trouble with the pictures, and caused me a great deal of anxiety. In fact, it was naturally one of those very nervous evenings on everyone's part."

On top of all this, something else happened which no man could reasonably be held to account for. "In the midst of the program someone back of me on the stage began to explain that someone in the orchestra was dead and wanted to go to Boston," Curtis wrote.

"This was finally straightened out, and we found it was the father of one of the orchestra men who was dead and the musician wanted to go to Boston. All this time, I was trying to talk to the audience. . . . There was considerable disappointment expressed by the teachers, but this was largely complaint as to the lack of focus and the trouble with the stereopticon.

"As to someone else's statement that he took exception to what I said, and questioned the accuracy, experience teaches me that if a deaf and dumb man who did not

understand the sign language did things on the platform, there would be a reasonable number of people who would take exception to what he said. . . .

"Dr. Gordon came to New York [George Byron Gordon, anthropologist, from 1910 director of the University Museum, University of Pennsylvania] to see and hear the entertainment, and after its close we spent an hour here at the Belmont together," Curtis continued defensively. "I asked him pointedly and frankly to make any criticism he might think of in any way in regard to the entertainment. His remarks were all complimentary, and he immediately went home and arranged for the entertainment to be given there . . . doing all in his power to further it. . . .

"At least I know this, that the Carnegie Hall appearance alone was one of the most important moves that has ever been made in furthering the cause of The North American Indian. \ldots ."

On January 14, 1912, Curtis confided to Hodge what he had written to Dr. Kelsey in Ann Arbor three days earlier, delaying perhaps because his hopes died hard.

"As to the proposed entertainment tour under the auspices of the Institute," Curtis wrote, "I find that I am compelled to give up that plan for this season. . . . I find my losses have been so heavy that I am without capital to go ahead. . . ."

After a lull of several weeks, Curtis was still in New York, balancing on the brink of despair.

"Things are fearfully discouraging," he wrote Hodge on March 28. "But I am always hoping for the best."

T MIDSUMMER 1912, Curtis was back in Seattle and things were somehow rolling once more. "I am sending you a part of MS for Volume 9," he wrote Hodge on July 12. "The balance will follow within a few days. I hope you will be able to go through this before you start on your vacation, as that will put the material in the hands of the printers early in the season, when good headway can be made. . . .

"I will try to get away for the British Columbia country as quickly as possible, and hope to have our Kwakiutl material ready for the publishers as soon as we get this Siwash book off our hands."

Besides making a new trip to study the British Columbia Indians in 1912, Curtis also carried out an important mission among his old friends, the Hopi, in Arizona, whom he had first visited in 1900. This was to take part in their sacred Snake

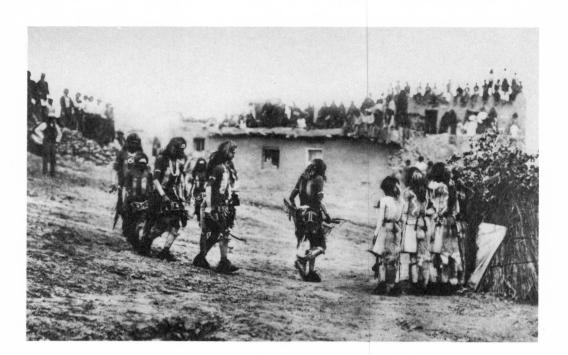

Dance.* He had realized that in order fully to grasp the meaning of this ceremony, which is an invocation to the gods for rain, he would have to experience it along with the Hopi themselves, not simply watch from the sidelines.

Now, after twelve years of going back each year to see the Snake Priest, he was finally initiated into the Snake Order as a priest, so far as he knew the only white man ever to be so honored, and admitted to participation in the dance.

During the sixteen August days the ceremony lasts, Curtis—now in effect an Indian—did exactly as the Indians did, taking pictures and recording as he went.

The serious part of the ceremonial began on the eighth day. "Clad in a loincloth, I entered the kiva with the Chief Priest and followed his orders and directions in every detail. I slept beside him," he wrote. "I fasted through the nine days [remaining], also as prescribed by Hopi priests I had no contact with members of my party and followed the rules of celibacy."

On the tenth day the snake hunt began. "We stripped and smeared our bodies with red paint, which is considered the pollen of snakes," Curtis went on. "At the same time the chief offered a prayer that the snakes would not harm us." They were provided with a stick to dig the snakes out of their holes, an eagle-feather whip, a bag, and a small parcel of food.

"Then we climbed the ladder out of the kiva and proceeded single file down the trail to the land of the north wind. The Hopi understand that on this day no one may go into the valley northward from the village."

At the foot of the cliff they stopped at a spring, saying a prayer and scattering an offering of cornmeal on the water. Then began the search for snakes. "Fortunately, I was the first to see a snake," Curtis wrote. "We surrounded it and threw meal on it." As the discoverer, Curtis "tamed" the reptile with his eagle-feather whip, causing it to straighten out in preparation to escape. "Then I quickly seized it by the neck."

To make sure of the novitiate's brotherly love for the snakes, the Indians had him wrap the creature around his neck before he put it into his bag. There were plenty more to he found—"diamondbacks, sidewinders, bull snakes, whip snakes, but the majority were rattlers. Our sacks soon became heavy with the weight of snakes." For four days they captured snakes, from the four cardinal directions.

The accumulating serpents were kept in the kiva, sharing the quarters with the priests. If any crawled out of the earthen jars in which they were placed, its passage was told by the trail it made in the sand brought in from the desert and spread on the floor. In the days that followed, the snakes were sung to, washed, fondled, and otherwise made ready for the dance which climaxed this long appeal to the gods for rain.

* Writing about his participation in the snake dance years later, could Curtis have been confused as to the date? He says it was 1912. His friend, Professor Meany, writing in *World's Work*, March 1908, refers to an incident during the summer of 1907, when he and Curtis were together among the Sioux, in which Curtis remonstrated with his Indian guides for killing a snake, explaining that he was a priest of the snake religion of the Southwest.

Snake Dancers Entering the Plaza—Hopi. At the right stand the Antelopes, in front of the booth containing the Snake-jars. The Snakes enter the plaza, encircle it four times with military tread, and then after a series of songs remarkable for their irresistible movement, they proceed to dance with the reptiles.

The New York Times, April 16, 1911, tells of Curtis saying he was a member of the snake order.

Awaiting the Return of the Snake Racers—Hopi. The Snake race occurs on the last day of the Snake ceremony. The little boys on this morning are naked and painted white, and they have their hands full of cornstalks, melons, and other plants and fruits. As soon as the racers come in sight, the boys run about the mesa while little girls pursue them and take away their plants and fruit. Thus is expressed the desire and prayer that crops may grow rapidly.

> Curtis described the preparation. "We smeared pink clay over our moccasins and other parts of our costume and corn smut mixed with 'man medicine' (a concoction of root juices and whatnot) over our forearms, calves and the right side of our head. We whitened our chin and blackened the rest of our face. Around our waist we placed the customary brightly woven fringed belt and in the rear, we hung a fox skin, which moves in rhythm of the dance."

> After the snakes were brought to the plaza, the two fraternities, the Snake and Antelope, lined up facing each other. While the one sang and shook its rattles, the other began a dance. Each dancer received a snake which he held in his hands, from time to time placing it around his neck or between his lips.

> "I followed the dancers four times around the plaza, and tossed the snakes aside to be picked up by the 'catcher,' " Curtis wrote, "then received another snake for the continuation of the dance.

> "Dressed in a G-string and Snake Dance costume and with the regulation snake in my mouth, I went through [the ceremony numerous times] while spectators witnessed the dance and did not know that a white man was one of the wild dancers."

> The ceremony was followed by four days of purification, with the chiefs of both clans, as well as Curtis, remaining in the kiva and continuing their prayers for rain. "If it doesn't rain," Curtis observed, "they believe there has been an error in the performance." That error could be Curtis himself, and he added his own fervent prayer. "Thankfully," he wrote, "billowing dark clouds formed over the mountains and the welcome rain began to fall."

Returning to Seattle after his rain-making triumph, Curtis got back the first of his British Columbia material from Hodge, with high praise for it. "Tickled to death to get it," Curtis acknowledged on November 26. "Ran through it last night to observe your red ink marks. Myers and I will get at it today or tonight. Glad you like the material. "We have now decided that we will have to give one volume exclusively to the Kwakiutl. This means that the West Coast and Makah material will go over to form a part of another volume. I realize that this gives a good deal of space to that part of British Columbia, but it was a question of whether we could afford to discard enough Kwakiutl material to make room for the West Coast, and our decision was that it would be better to use a large amount of Kwakiutl material, even if we do have to neglect other less interesting groups. This material is unique, we will probably never be able to get anything like it and certainly it is most important that it be published. . . ."

INETEEN THIRTEEN started on a familiar note, as Curtis back in New York doggedly pursued his star: to record the Indian in words and pictures. "My dear Mr. Hodge," he wrote on January 25, using the formal salutation perhaps to balance any connotation of reproach in what follows, "I just have a letter from the press asking me to do what I can towards prompt return of proofs. Quick action is most important at this time, and for that reason do everything you can to hurry the proof along. I will write to Myers to the same effect.

"I will probably see you within ten days. I am delighted that a set of the books has gone to the Smithsonian."

In a letter on February 19, Curtis wrote, "I see by the press that Wanamaker is getting busy with his monument to the Indians. If he will just busy himself completing his monument and stop spending money imitating my pictures I will be quite happy. . . ."

"Wanamaker" was Lewis Rodman Wanamaker, the Philadelphia department store tycoon, who had sent expeditions to Indian country, led by one Joseph Kossuth Dixon, to "gather historic data and make picture records of their manners, customs, their sports and games, their warfare, religion, and the country in which they live" in short, to do what Curtis was doing.

Knowing a good promotion when he saw one and having the money to see it through, Wanamaker carried his imitation of Curtis all the way. Under Dixon's name, he published his own *The North American Indian*, following the identical format as Curtis' volumes but getting it all between the covers of a single book of 222 pages, with 80 photographs in the same sepia tone as distinguished Curtis' pictures.

Moreover, Wanamaker planned a colossal bronze statue to "the vanishing race" in New York Harbor, larger than the Statue of Liberty, right arm uplifted in the Indian peace sign. Ground for the statue was broken on a hilltop of Fort Wadsworth February 22, 1913, at a ceremony attended by President Taft and his cabinet, top

army and navy brass, and thirty-two Indian chiefs, who signed a "Declaration of Allegiance to the United States Government by the North American Indian."

"You will notice that even the Gods wept," Curtis wrote Hodge, referring to the fact that it rained.

Wanamaker's plans for the statue went by the boards with the outbreak of World War I. The Fort Wadsworth site is now the Staten Island end of the Verrazano Narrows Bridge.

Evidently others than Curtis were displeased with Wanamaker's activities. In writing Hodge about his own movements on March 5, Curtis says, "I had a long talk with Professor Osborn. He is more than with us in our work, and anything but keen about certain other matters. For instance, the Dixon Memorial. A good deal of our chat was rather too confidential to trust to mail. I will talk it over with you when I am next in Washington."

What Professor Osborn's sentiments were in the Wanamaker-Dixon enterprise, and what possibly was being done to counter it, are not told. Perhaps there is a clue in Curtis' closing words: "I am tickled to death that [Franklin K.] Lane [lawyer, conservationist, and friend of the Indian] is Secretary of the Interior. There is nothing like having a strong life-time friend in that position."

In April 1913 J. Pierpont Morgan died, and a memorial page was painstakingly evolved for inclusion at the front of Volume 9, engaging all hands for most of the month. In addition, Curtis wrote a resolution of appreciation to Morgan, read at a meeting of the board of directors of *The North American Indian*, which was printed on sheets like those of the book, for subscribers who might wish to have it as an insert.

At the time of Morgan's death Curtis was in New York and he "at once began an up-to-date financial report on our situation and account of the project which I delivered to the auditors of the Morgan bank. Some time later, I received a call from the bank, saying Mr. Morgan's son would like to see me."

Curtis made the call the following day, "literally numb with apprehension, knowing that practically all of the elder Morgan's explorations in foreign lands had been closed by cable; also I knew that all commitments for purchases of art objects and paintings had been cancelled, and that a great part of his paintings were being sold. Considering all this, I could not see how the North American Indian project could be continued."

Greeting Curtis with a strong handclasp, young Morgan immediately put him at ease. "I can well understand your anxiety as to what's to be done about the North American Indian," Morgan said. "As a family, we have discussed the matter thoroughly and have decided to finish the undertaking as Father had in mind."

There would be some changes. All sales efforts would be discontinued, and all energy concentrated on getting the field work done and the volumes published. The Fifth Avenue office would be closed and the business handled from the Morgan bank. Curtis was to plan his field and text work so that he could spend a few weeks in New York each winter.

"I at once mapped out plans for the field work to complete the twenty volumes," Curtis wrote. "I wrote Mr. Myers of the plans and locations of our coming season's research. We were to start the season among the Mandan and Arikara on the upper Missouri River."

When Curtis reached the field to start the season's work, he found his party already there. The first man to greet him, as he arrived in the early evening, was a recent recruit who had a complaint. "How soon can we get away from this place?" he asked Curtis. "The mosquitoes are eating us up."

"To hell with the mosquitoes!" Curtis retorted. "We are here to work and we'll stay until it's finished. If you can't stand the mosquitoes, it won't take you more than two days to walk to the railroad station."

Late in 1913, the price of the volumes was raised. Since Curtis was in British Columbia, where he had been at work since August, Hodge learned of this from Lewis Albert, Curtis' New York secretary. "At a meeting of the Directors of the North American Indian, Inc.," Albert wrote on November 8, "it was decided that on January 1, 1914, the subscription price on all unsold sets of *THE NORTH AMERICAN IN-DIAN* be increased. An advance in price is necessary in order to more nearly meet the expense of research and publication. On and after January 1, 1914, the regular edition, whether Van Gelder or Japan Vellum, will be sold at Thirty-five Hundred Dollars. Also, if at that time there are any sets of the Tissue edition unsold, they will be increased in price to Forty-five Hundred Dollars. This of course will have no bearing upon your contract, the matter merely being brought to your attention as information. . . . "

Meanwhile, out in Seattle, Curtis lost a key man. A. F. Muhr, the wizard of the darkroom who coaxed *The Vanishing Race* from the plate that was thought to have been underexposed, died suddenly. "It came at the end of the day's work at the end of the week, and without an instant's warning," Curtis wrote on November 24. "I was away at the time in the interest of the book, and returned as quickly as possible and for the balance of the year I must remain at the Studio and get affairs in such shape that I can be comparatively free from the studio burden."

The day before Christmas, Curtis answered a question from Hodge. "Edward Sheriff Curtis is all of the name when you have it spelled out. The Sheriff part of it comes from the maternal side of the family, mother's family being English and bearing that name.

"I have been through a whirlwind of work here at the Studio," he went on. But for the first time in Hodge's memory, Curtis was in no rush. "I will begin to send plates to Andrew [John Andrew and Son of Boston] on Volume 10 at once, but not in view of hurrying the publication. It is only to have them in shape when needed. . . .

"Judging from all-round reports business conditions in the East are something fearful and that fact causes one to hesitate before taking on a heavy financial problem. . . ."

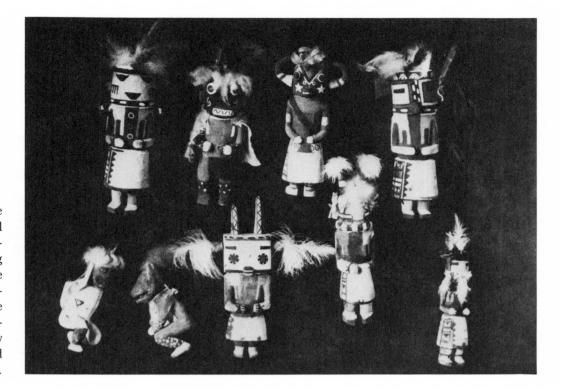

Kachina Dolls—Hopi. The Kachinas, among the principal Hopi deities, are supernatural, anthropomorphic beings inhabiting the water-world that underlies the earth. The first Kachinas were visible beings but because the people did not treat them with consideration, they became invisible. They are now represented by masked dancers.

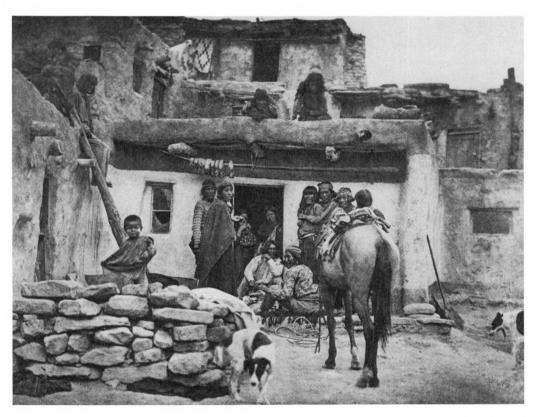

The new year, 1914, was well on its way when Curtis returned to New York, and found trouble with a critic. As usual, he turned to Hodge for help. "At the time you received the manuscript of Volume 9," he wrote on February 3, "I recall your writing a letter in which you expressed yourself as feeling that the material was particularly good, and later you made the same comment while talking with me.

"For some reason Mr. Pegram [perhaps a director of The North American Indian, Inc.] has apparently got it into his head that I did not keep this volume up to the standard. If I am not asking too much, will you let your mind run over the back trail, determine the approximate date that that material was sent you and write me a brief note . . . expressing your opinion as to the material.

"Also, I have your letter of January 15 acknowledging the receipt of the manuscript for Volume 10. Will you mind skimming through this, if you have not already done so, and send me a second brief note as to what you think of this. Of course, the material of the present volume is quite out of the ordinary and this fact gives plenty of latitude for comment. I am particularly anxious just at this time to convince Pegram

A Visitor—Hopi. Affability and sunny disposition are apt to be one's first impression of the dominating traits of Hopi character. Presume on this affability, and you encounter cold reserve, illconcealed disapproval, or outspoken resentment.

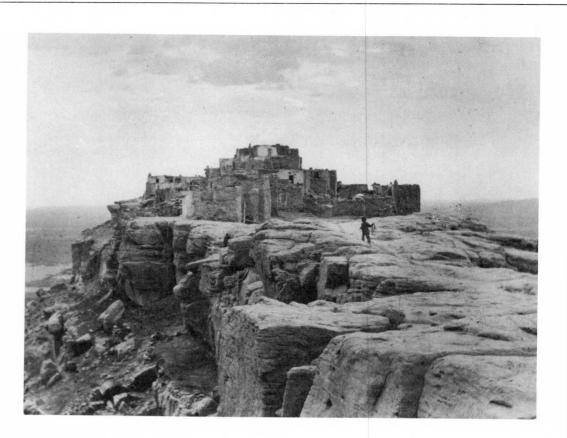

Walpi. Picturesque Walpi, perched on the point of a rocky island in a sea of sand, is an irregular, rambling community-house, built without design, added to in haphazard fashion as need arose; yet it constitutes a perfectly satisfying artistic whole.

A Washo Gem. This remarkable example of coiled basketry was made by Datsolali, an old woman residing at Carson. Her work has rarely been equalled in the fineness and regularity of the stitches, in perfection of symmetry and in the softness and harmonious blending of shades in the straw-color background and the brown and black patterns.

that the work is growing stronger rather than weaker, and if you can help me in this I will appreciate it very much. My annual meeting comes up on Tuesday of next week, so I need to have this quite soon."

Hodge obliged by return mail—partway. "The letter covering Volume 9 is exactly what I want," Curtis responded. "But you overlooked my request for one covering the latest material, the manuscript for Volume 10. This being of such an unusual nature it will give you a chance for enthusiastic comment. Can you send me at once a few words in regard to this so that I will have it for Tuesday?"

Curtis' annoyance with his critic was balanced, a couple of weeks later, by "a little extract from the *Collective Blue Book.*" He seemed to be chortling like a schoolboy who has caught the teacher in a mistake as he wrote Hodge on February 17, "This item would not cause a second thought had it not been for the name, Doctor Hallock and Harvard University. My God! My God! Has the press put one over on the doctor or has he actually taken to drink and had a dream? If Dr. Holmes has not seen this I do wish you would send it on to him but without my flippant comment. . . ."

The item which shook Curtis read: "That North America was the biblical Land of Nod, and that its first city, founded by Cain, son of Adam, was located in the Klamath Lake country of Southern Oregon, is the startling announcement of Charles Hallock, Ph.D., the archaeologist, which he recently filed in the Peabody Museum of Harvard University. Dr. Hallock has concluded extensive researches in the Klamath region and found evidence of a high civilization that flourished at a remote period."

With Volume 10 on its way to press and as Curtis once again prepared to head for British Columbia, poetic justice, unidentified, seems to have been at work on his behalf. "I begin to think that Dixon will eventually get what is coming to him," he wrote Hodge on April 1, 1914. "Rather glad now that I refrained from my desire to make a move towards his extermination. As a matter of fact I think it is better to let other people kill your snakes.

"Have been very much under the weather for a couple of weeks and all going well I hope to be in Washington on the coming Monday. Want to call and pay my respects to Secretary Lane and his new commissioner. \ldots ."

Apparently there was something about the remoteness of British Columbia that caused Curtis to worry whether Hodge was keeping up with his end. In tones used before, Curtis wrote from Port Hardy on June 20: "Myers and I are wondering how you are coming on with work on the manuscript. I hope that you have it practically done. Do let us know. Better write in care of the Curtis Studio, Seattle, as I cannot tell quite how long we will be at this address. . . .

"Our activities here are such that they should be classified as labor rather than work, but all goes fairly well."

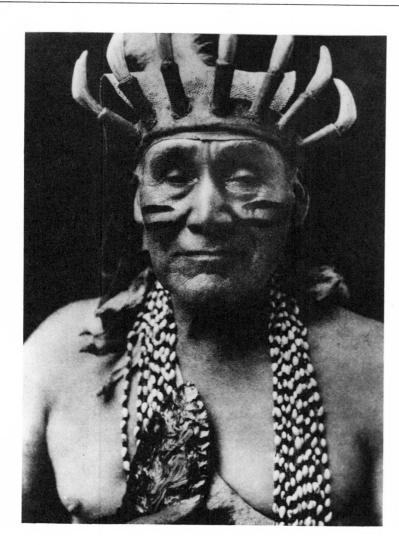

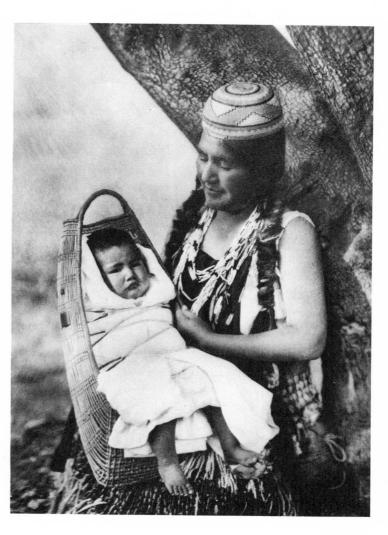

ABOVE: Obsidian-Bearer, White Deerskin Dance—Hupa. The White Deerskin Dance was of a spectacular, but deeply religious, character. At each end of the row of dancers stood a man who carried a large blade of red obsidian. His headband was embellished with nine sea-lion teeth projecting outward and with curving points upward.

> Hupa Purses and Money. Strung dentalia were the Hupa standard of value. The longer dentalia passed for five dollars each. Objects of such great value must be kept in a safe place. A rich man therefore had a very neat purse made by cutting an oblong hollow in a piece of elk-horn six or seven inches long.

ABOVE RIGHT: *Hupa Mother and Child.* Cradle baskets were openwork, and may be described as somewhat resembling a boat with a high, over-decked bow (the foot of the cradle), a narrowing stern cut squarely off (the head), but the gunwale at the stern unimpaired and forming the handle above the infant's head.

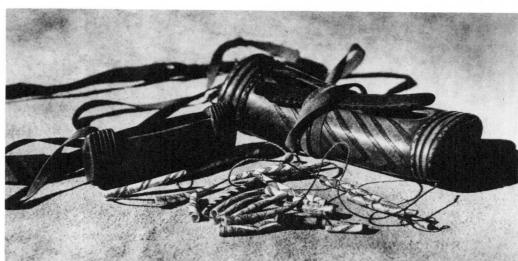

It appears to have been on this new visit to British Columbia that Curtis learned about "she rain" and "he rain." Anchoring his boat in the safety of Port Hardy, near the upper end of the inside passage between Vancouver Island and the mainland, Curtis set out in stormy weather to walk across the island to visit a certain sage of the Koskimo tribe on the West Coast. With him were Myers, Hunt, and Schwinke, each, like himself, carrying a fifty-pound pack on his back.

"We were traveling light with limited food, limited cooking utensils, few blankets and the very necessary camera and film," Curtis wrote, leaving one to wonder about his idea of a decent burden.

"The trail through the heavy, jungle-like forest was rough and deep with mud," Curtis continued. "The depressions were water-filled, sometimes to our shoe tops and sometimes to our hips. The sky was leaking. It was a characteristic 'she rain' of the North Pacific, occurring during the autumn, winter and spring. In that area the natives classify their rains by sex. A 'she rain' is gentle, caressing, clinging, persistent, but a 'he rain' is quite the opposite in all ways but that of persistence." In the "she rain" the four sloshed on, the miles growing longer, pack straps chafing, feet seemingly "encased in divers' leaded boots." "Some days are longer than others and this was one of the longer," Curtis wrote. "Stumbling and falling in the murky, rain-soaked darkness, we came to a deserted fishing shack at the water's edge.

"It was certainly not a palatial dwelling; in fact, its flea-infested interior was filthy and foul-smelling but we couldn't be choosy. At least it was a place to lay off our heavy packs and park our weary bodies. At the center of the roof was a hole for the escape of smoke. Below it we built a fire and soon our rain-soaked clothing was under full steam."

In the morning it was still raining. "We found an old dilapidated skiff and with a few hours' work we patched the holes," Curtis wrote. "Some of us bailed and some of us rowed. Soon the rain changed sexes. The weather gods pulled the plug and we had 'he rain.' In fact I think it was over-sexed. Considering the rain and wind and our leaking skiff we made for shore and shelter, but the only shelter to be found was a large cedar tree with thick low-hanging branches.

"Close around the trunk of this sheltering tree we huddled and for twenty-four hours we continued to huddle. A cataract of water poured off the drooping branches . . . our roof . . . merely kept us from smothering in the downpour. I feared the water would find its way through the oilskin wrapping of camera and notebooks."

The rain changed sexes again and finally stopped. Checking with the government weather station later, Curtis found that during each of the twenty-four hours they were under the tree, nearly an inch of rain fell—twenty-two inches all told.

"I have been in desert cloudbursts where the rainfall per minute was greater," Curtis commented, "but that was the wettest twenty-four hours I've ever experienced."

ATE IN THE YEAR, the Curtis film, Land of the Head Hunters, opened. Among those attending the New York premiere was Francis W. Kelsey, the man in Ann Arbor to whom Curtis had painfully written in the early days of 1912 that he was having to cancel his road tour.

"I must tell you how delighted I was with your picture drama," Kelsey wrote to Curtis on December 8, 1914. "It opens a new world; it is a wonderful creation as remarkable for the beauty of its setting as for the poetic conception that lies back of it and for the dramatic interest and rapidity of movement, rarely united in such a production. . . ."

86

Curtis sent Kelsey's letter down to Hodge in Washington, glumly commenting

only that the picture show "presents problems"—what problems he didn't say. Whatever they were, perhaps he felt better after a further affirmation of the picture's artistic success from the American Museum of Natural History. "Last Saturday night I had the pleasure of attending a performance of your motion picture opera, *The Land* of the Head Hunters," wrote Alanson Skinner, assistant curator. "In all my experience I have never seen anything which so well and beautifully portrayed the life of any of our American Indians. The setting, costumes, and the incidents themselves were all ethnologically correct and the dramatic interest of the play was well sustained. I think you have succeeded admirably in making ethnology alive and of artistic and dramatic interest. Please accept my hearty congratulations."

The year 1915 started out inauspiciously, with a hangup at the printers'. Curtis impatiently jogged them, asking when they would have the material ready for the binder. He sent their reply down to Hodge, which seems to be where the bottleneck was.

"We are not making very rapid progress on the printing of the book because we cannot get the approved proof back," the printer explained to Curtis, "and up to this point I have not dared to go to press until it did come back. In view of your letter, however, I am going to take the bull by the horns and start the press work, hoping that there may not be further changes. It would be a good idea for you to take up with Dr. Hodge the matter of getting all the proofs back to us at once. . . ."

Curtis added his own words to Hodge. "If there is anything we can do to hurry it along, please make every possible effort. The thing is dragging so much that it is proving exceedingly trying in a financial way. \ldots ."

Four days later, March 3, 1915, Curtis followed up conciliatingly. "I suppose the principal delay in proofs and that matter came through the two or three lots which were lost in the mail," he wrote. "I was not in any sense complaining. . . ."

Nothing further was heard from Curtis for more than a year. The silence, unaccounted for, ended when he wrote to Hodge in late May, 1916, from New York and sent him a manuscript he'd been asked to edit for a publisher. He in turn was sending it on to Hodge with the comment, "It looks to me to be pretty poor material."

Money being chronically scarce, it caused considerable excitement when a few days before Christmas, 1916, Hodge was handed the opportunity to add a thousand unexpected dollars to *The North American Indian*'s coffers.

Dr. A. H. Hrdlicka, curator of the National Museum in Washington, D.C., passed along to Hodge a cablegram from the director of the Royal Ethnological Museum of Stockholm, asking him to "secure and send with first Scandinavian steamer a selection of one hundred phonograms of American Indian songs." He added that he was sending a thousand dollars in payment that same day.

Hodge at once routed the request up to Curtis at the *North American Indian* office in New York. "Please let me know at once what you can do," Hodge wrote. "It has occurred to me that you may spare some of the song records made in the field that have already been transcribed and published."

ABOVE: Florence Curtis and two Indian guides at the start of a trip down the Klamath River in the summer of 1923.

ABOVE RIGHT: Florence Curtis at camp near Ukiah, California, summer 1923.

But Curtis was in the Southwest. Lewis Albert, his secretary, replied, "I have telegraphed the information contained in your letter on to him. . . ."

Curtis contacted Hodge directly, writing from Bouse, Arizona, "This matter comes up at a time when it is rather difficult to care for it. Myers is here with me, and our records are still in Seattle. In order to supply these and send them on in a shape that they would be of service, it would be necessary to go over the collection, try the different records, make a selection, catalogue them. And, as you see, it would be out of the question for us to do this on short notice.

"If the records are still wanted, please write me at Bouse, Arizona, giving as much information as possible. Following that I would have the records sent to us and we could make the selection and send it on. It is likely, however, that you will be able to gather up what is needed about Washington and get them off in a shorter time."

N 1920, the sky fell in on Curtis. Domestic problems, which had been preoccupying him for a number of years, came to a head when his wife divorced him, and the court, with what seems to have been an esoteric sense of justice, awarded her virtually everything he owned except the shoes on his feet. It included his precious negatives—his life work. The fact that most of these legally belonged to the North American Indian Corporation gave the judge no pause; and Curtis was too poor to fight back.

Staggered, he moved to Los Angeles and began again, his daughter Beth staying by his side and managing the new studio which he opened on South Rampart Boulevard.

Somehow, despite war, poverty, and pestilence—the Spanish Influenza epidemic of 1918—and the breakup of his home with its aftermath of fearful fits of depression, Curtis carried on determined to complete *The North American Indian*.

If he felt any bitterness toward his wife, he kept it to himself. "Dad never said one unkind word about her," daughter Florence said.

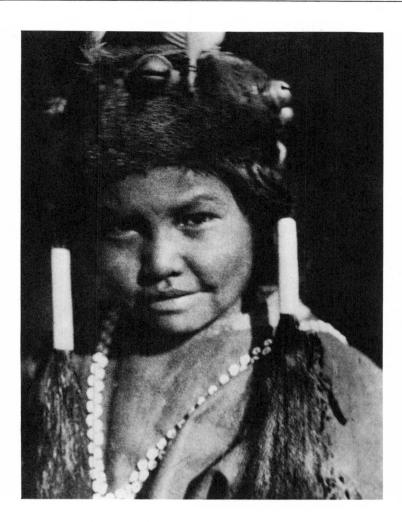

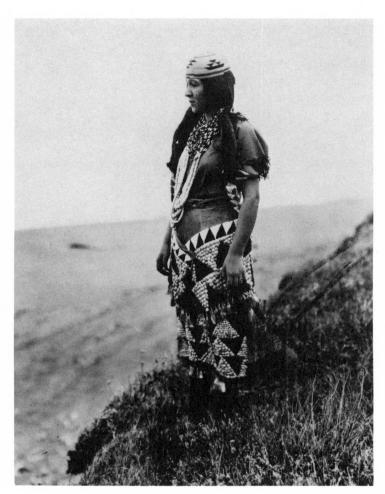

ABOVE: *Klamath Child*. Children were named from some peculiar or noticeable feature or characteristic, and the names of infancy were kept throughout life. Examples of masculine names are "Sore Throat," "Big Mouth," and "Burnt (that is, kinky) Hair."

ABOVE RIGHT: Hupa Woman in Primitive Costume. This is an excellent example of the gala costume of Hupa women. The deerskin skirt is worn about the hips and meets in front, where the opening is covered by a similar garment. Both are fringed and heavily beaded, and the strands of the apron are ornamented with the shells of pine-nuts. Curtis, a reasonable man, likely would have agreed with Angus McMillan, who knew him slightly in Seattle—slightly because "he was never there"—but became a friend in the later times, in Los Angeles. "He came home once or twice a year," Mc-Millan pointed out. "With all due respect to Dad," he commented, referring to Curtis by the name his family and close friends now used, "I can't imagine any woman standing for that too long."

Volume 12, presenting his years of work among the Hopi of Arizona, appeared in 1922; and early the next year Curtis wrote Hodge about "the season's work" from the new "Home of the Curtis Indians," in Los Angeles. It sounded like old times. "I completed pictures for two volumes dealing with Northern California and Southern Oregon," Curtis wrote on February 7. "The pictures for the Northern volume have gone to Boston and all text material is ready. The second volume of the pair will be published as soon as we can clear from the first one.

"I am in hopes of getting into camp long enough to complete pictures for one or two volumes during the coming summer."

Curtis did in fact make it into camp as warm weather came, working in northern California, and for a couple of months his season's stay in the field was graced by the company of his daughter Florence. This was her first opportunity to get to know her father in many years. The last time she had been with him in the field was as a child of six, at Cañon de Chelly in Arizona, when a memorable outing ended in flight from the Indians.

"For all his brawn and bravery he was a gentle, sensitive man and a wonderful companion," Florence wrote. "He had a vast knowledge of and kinship with the outdoor world in which he lived so many months every year. He knew the trees, the animals, the birds and flowers. Camping with him was an unforgettable experience."

And her father seemed to see it all in terms of pictures—as she learned one evening after she had picked a site to pitch the tent for the night. "Not there—over here," he said, indicating a spot a few feet away. When the tent had been set up, Florence asked, with puzzlement, "What's the difference between this place and the one I picked?"

"This one, my dear, makes a better picture," her father explained.

Myers had already gathered material in the area, and Curtis was now suppleg menting this with photographs. "It was interesting to watch him at work," Florence

Grinding Medicine—Zuñi. Medicine and mineral pigments are ground in small stone mortars by means of a water-worn pebble. wrote. "He was friendly with the Indians but never personal. They seemed instinctively to sense his sincerity."

There was no photo tent that summer. Curtis had dispensed with it as an unnecessary frill to make room for the more important things in the Chevrolet coupe in which he and Florence traveled—their own tent, cots, food stocks, Coleman stove, cameras, and film.

"He worked fast," Florence observed. "He was deft and sure—none of the usual fussing. In a few minutes it would be all over. And he was at it all day long. If he didn't have sun, he took pictures anyway."

Then came a gloomy, overcast day, wet with mist from sky and sea alike, when it seemed that Curtis must at last have met his match. "I wondered how father would be able to make pictures that day," Florence recalled, "but he did."

He found a teen-age girl of the Smith River tribe, posed her on a bluff overlooking the ocean, and in two or three quick shots got photographs which betrayed no evidence that they were taken under conditions suggesting the use of undersea techniques. More than half a century later, little basket hat pressed down on her head and wearing her best finery, the young lady looks obliquely out over the water, smiling shyly to be the center of attention. (See the photograph on page 89.)

At the end of the day Curtis impressed his daughter with another skill: his prowess as a cook, cultivated perhaps in subliminal memory of boiled potatoes and muskrat legs as a boy. She remembered how, at Cañon de Chelly, he had served squaw bread, roast Indian corn on the cob, and kid chops prepared over the coals of an open fire. He had gone on from there.

"As a Roquefort salad dressing expert he had established his reputation throughout the East as well as the West," Florence wrote. "It became a tradition in the Teddy Roosevelt family that when he came to dine he must make the Roquefort dressing."

But his abilities as an epicure went beyond salad dressing. "He was an expert on cooking salmon," Florence remembered. "He insisted that it be sliced horizontally, not up and down, leaving the skin intact to keep the juices in. Dad was an expert at making a delicious cheese omelet on our small Coleman stove, with bread toasted in the pan to go with it. He was very particular about the way vegetables were cooked so none of their flavor was lost. I learned about poaching pears in a syrup, and his apple sauce had to be made just right or, he said, it wasn't worth eating.

"He was as much a perfectionist in this as he was in taking pictures."

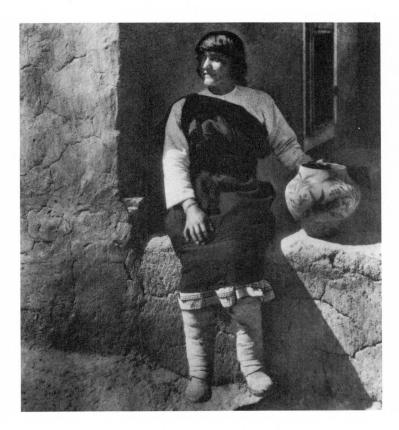

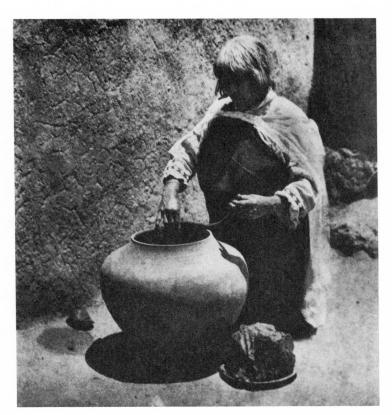

ABOVE: Aiyowits!a—Cochiti. Carolina Quintana, the most mentally alert Indian woman met in more than twenty years of field work in connection with this series, is a shining example of what Pueblo women can become with a little schooling and instruction in modern housekeeping.

ABOVE RIGHT: Tsťyone

("Flying")—Sia. One of the two best potters at Sia, a pueblo noted for the excellence of its earthenware. A vessel of the size shown in the plate brings her the modest sum of ten dollars. OR ALL THE TROUBLES that beset him, Curtis lost none of his appetite for accuracy with the passage of time. In late 1924 he replied to Hodge on a point of information having to do with "Indian ceremonies in the Southwest and the possible objectionable features. Close investigation in the Rio Grande region shows that there are many ceremonies and parts of ceremonies which are decidedly of the obscene type," he wrote, on November 28. "As we all know, education and contact with civilization has a strong tendency to eliminate such ceremonies. Unfortunately, Collier [John Collier, executive secretary of the American Indian Defense League, later Commissioner of Indian Affairs], in his complete ignorance of the subject and desiring some popular angle of the Indian subject to which he can draw support, has done much to encourage the revival of the most objectionable ceremonies.

"As I am to be in New York before any great length of time, I will not at the moment go into this subject—it is too long and too complicated for a letter of reasonable length. Naturally, in *The North American Indian* we are not going into this subject as propagandists; we will touch upon these ceremonies as they should be handled in the work. . . .

"In our season's work we have, I think, secured a great deal of new material bearing upon their ceremonies—particularly at Santo Domingo [New Mexico]; and, as you know, Santo Domingo is the hotbed of all the old ceremonies; and Santo Domingo furnishes the killing committee to care for any offenders regardless of village in question. It was a group of men from Santo Domingo which disposed of the man who told too much to Mrs. Stevenson."

In Volume 17 of *The North American Indian*, Curtis refers at some length to the reluctance of the pueblo Indians to talk about their religious ceremonies. "Most Indians are loath to reveal their religious beliefs, to be sure," he wrote, "yet with tact, patience, and tenacity the student can usually obtain desired information. On the Rio Grande, however, one meets organized opposition to the divulging of information so strong that at Santo Domingo, most refractory of the pueblos, proclamations have been issued against affording information to any white people and at more than one pueblo priestly avengers have executed members who have had the temerity to disregard tribal edicts."

The Indian who was executed was a San Ildefonso man who, about the year 1913, gave Mrs. Matilda Coxe Stevenson, a ethnological researcher, information about the Tewa Snake Worship, especially mentioning the subject of human sacrifice. Mrs. Stevenson published this information in a New Mexico newspaper and her informant was promptly executed.

N THE SPRING of 1926, with two volumes left to go and as he prepared to start field work in Oklahoma, Curtis was jolted to learn that Myers, his faithful wheelhorse since 1906, would not be with him.

"An opportunity has presented itself to make a lot of money in the next two or three years—a real estate transaction," Myers explained by letter. "It is one of the kind that rarely occur and I am getting too old to pass it up in hope that another will be at hand when the Indian work is finished. . . .

"The desire to finish the job," Myers went on, "is what has kept me at it these last few years on a salary that doesn't amount to much in these times and only a very remarkable chance could have induced me to drop the plowhandle. . . ."

Taking up this new problem with Hodge, Curtis added, "Following a suggestion by Myers as to yourself, it occurs to me that you might manage a vacation of a month or six weeks. Join me in the Oklahoma field. . . . From the point of view of *The North American Indian*, this would be the happiest possible solution. . . ."

Hodge shared Curtis' sense of crisis but met it philosophically. "The news you give me in regard to Myers is a great disappointment indeed," he replied. "Of course the reasons which he presents and which to him represent the opportunity of a lifetime, even in California, we must accept as the only balm, yet I am mighty sorry the chance could not have been held off until he had finished the excellent work for the volumes that he has been turning out.

"But all is not thundercloud, for in the first place you say that there is no great haste (and I believe there is not), and there is possibility that Myers will be able to break away from his new duties long enough to go to Oklahoma, and pretty nearly make a killing of the work to be done there with you.

"I wish I could go myself, on your account, but this is out of the question, as I am so overwhelmed here that I scarcely know which way to turn. . . .

"Keep me informed. I am really greatly distressed that Myers is obliged to pull away just now, but of course no one can blame him for embracing a golden opportunity:"

After a month or so, Hodge found Curtis a replacement for Myers, wiring Curtis the news on May 19, 1926. "Mr. S. C. Eastwood of Brandon, Vermont, will accept position to assist you in field and write results. Was graduated University of Pennsylvania nineteen twenty-four and is recommended for ability by Professor Speck and assistants. He took Anthropology course and is familiar with your North American Indian series. . . ."

Stewart Eastwood moved into the breach caused by Myers' leaving and Curtis' plans went forward. At the end of the summer, back from the season's work in Oklahoma, he wrote Hodge from Los Angeles that he believed "we have the material før a good volume. Eastwood is here with me and will settle down close by while we are whipping the text in shape. Owing to Eastwood's lack of knowledge and experience, I will take the long end of the work in rewriting the field notes. . . . While I am working . . . Eastwood can type his vocabularies. . . ."

Drying Pottery. All cookingvessels, food dishes, and water jars are pottery.

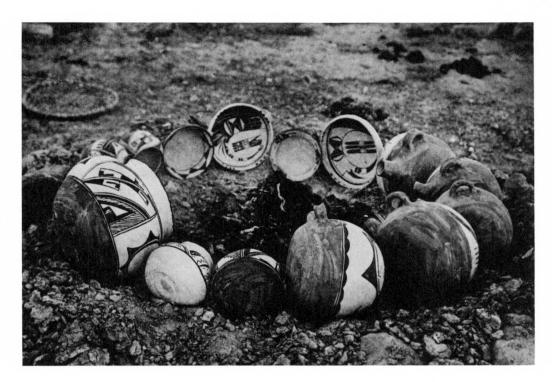

Pottery Burners at Santa Clara. Only with considerable practice can pottery be fired successfully. The vessels and the surrounding fuel of dry dung must be so placed, and the fire must be so controlled that, while perfect combustion takes place, high temperature shall not develop too quickly. Cracked and blackened ware is the penalty of inexperience and carelessness.

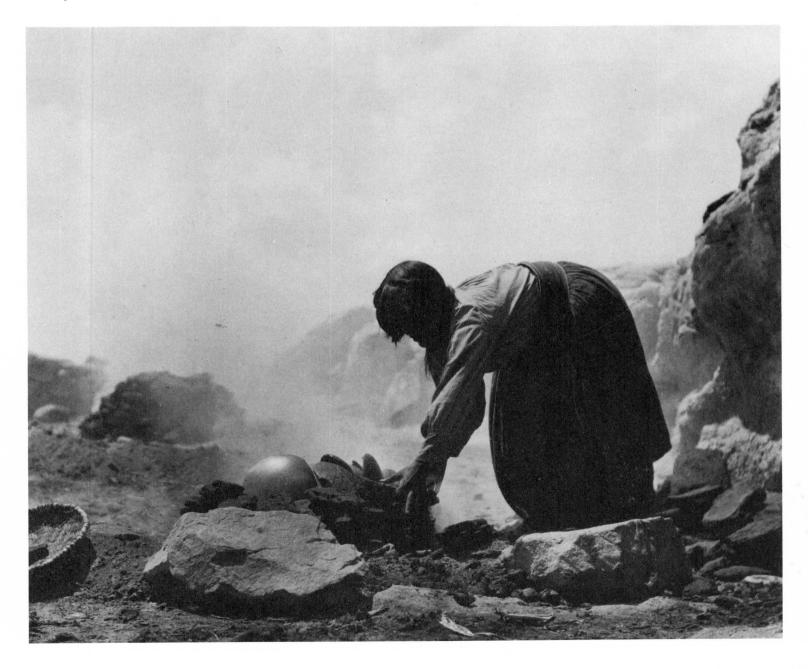

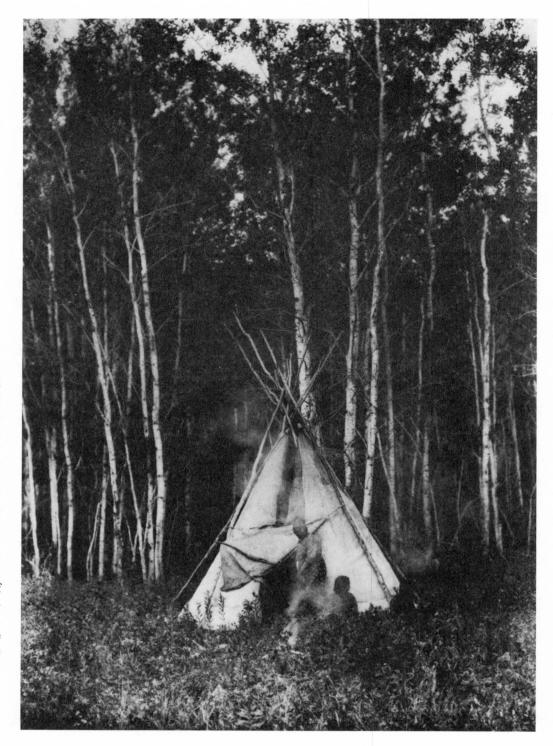

They would "waste no time in rushing the text to completion," Curtis continued, and he suggested that Hodge "be the one proof reader" on the material, saving time and expense.

"As to next year's work," Curtis wrote, "I am rather inclined to think Myers hopes to join us. Whether he does or not is immaterial to me. I am quite satisfied to do the next season's field work with Eastwood as a helper. . . . [He] has a good ear for phonetics and was particularly capable in vocabulary work. . . ."

In another month, on November 17, Curtis reported cheerfully, "Good progress is being made with the text and we are working like a pair of beavers with but a single tree to cut.

"Eastwood grows stronger in the work. We have set February 1st as our goal, but may not quite make the line. I am now thinking of the material for Volume 20. Here is my suggestion: that we make it the Eskimo and one or two of the tribes of northwestern Alaska, including the natives of Yakutat. . . ."

Then Eastwood made a misstep on the copy going to Hodge, who sent it back, along with a strong letter addressed directly to Eastwood, in turn drawing fire from Curtis. "You're a good editor but certainly a bum diplomat," Curtis scolded in a letter on May 11, 1927. "It may seem necessary to wield a club—even so, one might to advantage . . . pad the club. It has taken a lot of quick figuring and hard talking to

Chipewyan Tipi Among the Aspens. The Chipewyan are of several Athapascan groups occupying the territory between Hudson Bay and the Rocky Mountains, from about the fifty-seventh parallel to the Arctic Circle. Much of this area is barren, but the streams that feed and drain the innumerable lakes are bordered by thick groves of the slender, white poles of aspens whose pleasant glades are favored by camps of fishermen and berry pickers. The Chipewyan dwelling, formerly made of the skins of caribou, on which animal these people principally depended for food, clothing, and shelter, was one of the few points in which their culture resembled that of the plains Indians.

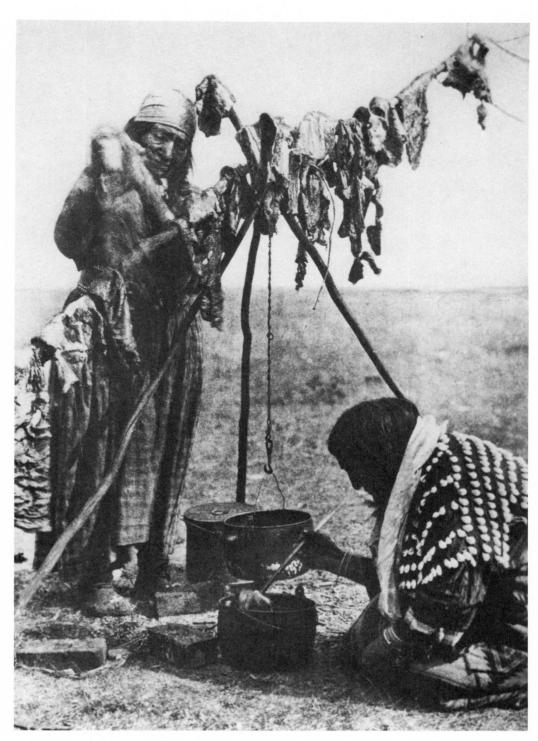

by three allied Algonquin tribes— Blackfoot, Blood, and Piegan, composing a part of what is commonly designated the Blackfoot confederacy.

Blackfoot Cookery. The prairies of southern Alberta were dominated

keep the boy in line. To have him drop out at this last moment would wreck the ship. The office is expecting us to finish Volume 20 this year and to get a new man at this time would be out of the question.

"The manuscript is here," Curtis wrote. "We have so little time before starting into the field that we will put it aside and take it up on our return . . . the next time you feel inclined to wield the big stick, better address me. I have to stand it. Eastwood does not. . . .

"I leave here on the 25th. The steamer *Victoria* sails from Seattle on June 2. We go direct to Nome and take a local boat from there to Kotzebue. Our central address for the first half of the summer will be Nome."

Hodge replied a week or so later. "Yours of the 11th is at hand," he began coolly. "Don't take my criticisms, either of you, in any but the way in which I intended it. It is too late to do any jawing after the book is published, so if anybody has a word of complaint, let it be given now, while there is time. . . .

"There is no point of being thin-skinned in a work of this kind. The manuscript is either right or wrong, and if wrong it should be righted. I have enough confidence in Eastwood to know that he can make a very good job of it. . . .

"I hope you will both have a successful and enjoyable trip," he ended tersely. "Sincerely Yours, Hodge."

95

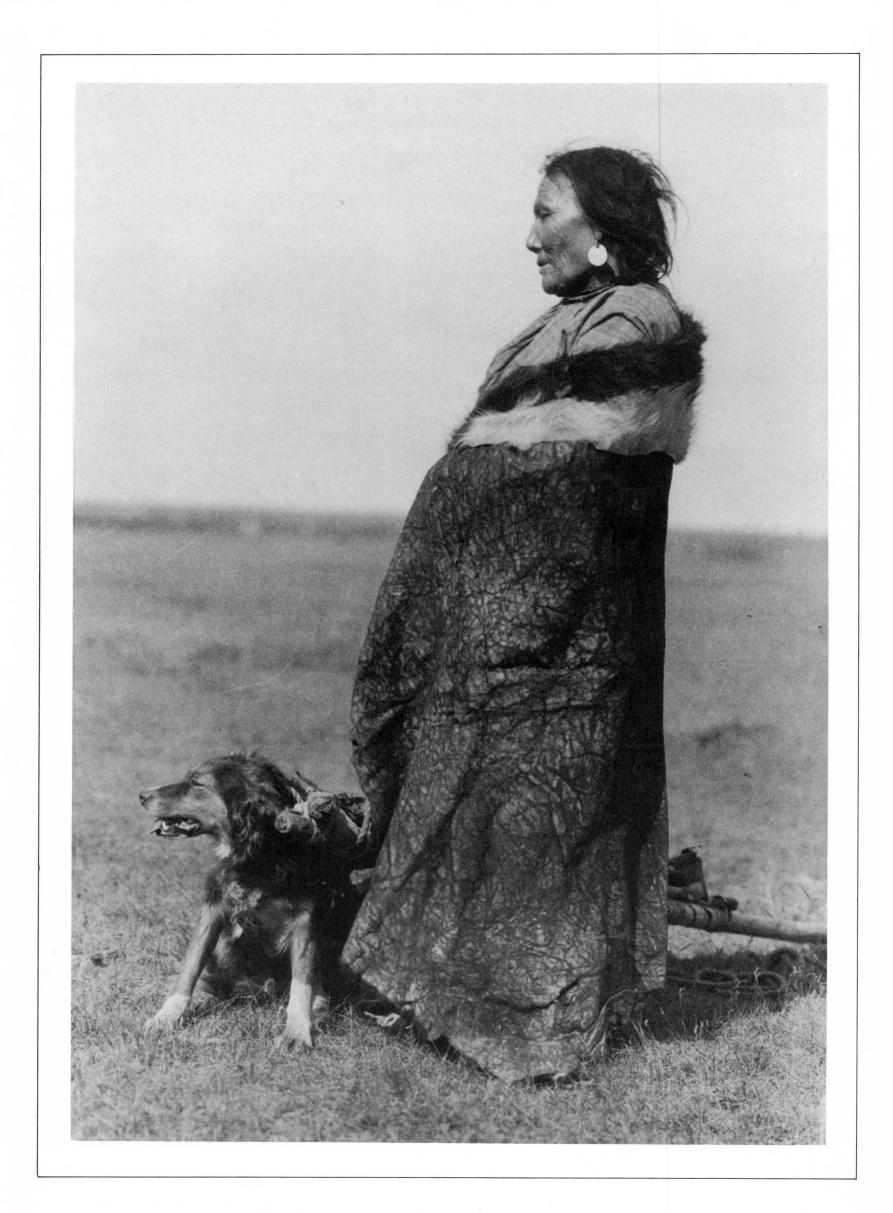

Blackfoot Woman. In the popular press the name Blackfoot or Piegan was continually associated with massacre, outrage, and treachery. This, however, was but a habit without justification in fact. Such crime as they were guilty of was usually the direct result of drink, for which "civilization" was wholly responsible, and such murders as they committed were simply the price we paid for the privilege of debauching them. Successful it was. Enjoyable it must have been as well, in a special, full measure for Curtis, the lover of adventure.

For six weeks, prowling the waters south of Nome in the forty-foot *Jewel Guard* (described by Curtis as "an ideal craft for muskrat hunting in the swamps but certainly never designed for storms in the Arctic Ocean") to visit the natives of the Alaskan coast and those of Nunivak Island, Curtis and his crew were seemingly in constant combat with the sea. His daughter Beth, keeping a log, wrote of towering, gale-driven seas breaking over the deck, of pack ice and icebergs, of fog, wind, rain, and cold, of falling barometers, and of running for shelter.

"The waves are ten times as great as our boat and we are shipping much water," Beth wrote at one point. "We anchor where we are somewhat protected but the storm continues and the rain pours down."

Here's how it was on the night of July 5, 1927: "We do not go to bed and the dinghy is loaded for emergency. Ice pack very heavy. Dad says if we get caught in main pack and carried north our condition will be hopeless; once caught in the heavy ice our boat would be crushed. Barometer falling. . . . The seas break over the deck and everything is awash. . . . We are now headed back, running like a scared jackrabbit, according to Dad."

In a thick fog they hit a shoal and the engine died. The sudden stop brought a tremendous following sea smashing down on the deck, nearly sweeping everyone overboard. "A falling tide found us solidly aground, parked on the floor of the Bering Sea . . . 20 miles from shore."

But all this was gentle prologue compared to what lay ahead for Curtis in the Bering Strait and Arctic Ocean, farther north. As Beth said goodbye to him in Nome to return home, she controlled herself with difficulty. "I was so fearful I would never see him again," she wrote.

There were many times in the weeks to come when Curtis would have agreed with Beth. For the first time, perhaps influenced by Beth's example, Curtis kept a log. "How I managed to keep that log during all the stress is beyond my present understanding," he wrote Miss Leitch in 1948, describing how he had come across it as he "rummaged through a large carton of old scripts. Frankly," he went on, "its reading gave me the shivers and I constantly marveled that at any time in my life I had the strength and endurance to do such a season's work." In one of his first entries, Curtis recorded that his old whale injury was acting up. "My hip is giving me trouble," he wrote. "When it isn't too stormy I can sit down while at the wheel and also do the cooking sitting down. From my stool I can reach the stove, the dish and food locker and table. Thus I often prepare a meal, serve it and do up the dishes without getting on my feet. Thus save myself all I can and give thanks this is the last volume of the Big Book."

Meeting the first boat they had come across on the voyage Curtis noted, "This is a striking illustration of how little traffic there is in the Bering Sea. What a long wait one would have if he fell overboard and was looking for someone to pick him up."

97

At the time, August 7, 1927, Curtis was on his way to King Island, in the middle

Beth Curtis in Alaska with her father.

of the Bering Strait, northwest of Nome. The island, a storm-beaten rock standing steeply out of the sea, lay directly on the route of the walrus herd on its seasonal coming and going from the Arctic Ocean. Among other things, Curtis wanted pictures of the huts precariously perched on stilts on the sides of the cliffs where the natives lived when they came to the island for the kill each spring and autumn, living the rest of the time in Nome. With Curtis were Stewart Eastwood and Harry the Fish, skipper, who set himself apart as a sailor by dourly claiming to hate women, liquor, and tobacco.

Next after King Island came Little Diomede, not far from Siberia. Known along with Big Diomede, two miles away, in Russian waters, as "the storm center of the universe" by mariners of the Bering Sea and Arctic Ocean, the island lay in deceptive calm as Curtis and his crew anchored. Eastwood and Arthur, the interpreter picked up en route at Cape Prince of Wales, "set forth in search of an ancient wise man to give us information," Curtis wrote. "I, along with the school teacher as guide and informant, began making pictures of the dwellings, skin-drying racks, as well as portraits of any natives the teacher could corral. A silver dollar was a great attraction to old and young.

"Since it was a clear day, the Big Diomede Island seemed a good subject for a picture so I quickly changed to a long focus lens and with my tripod standing on American soil, I photographed sections of Siberia."

Next day Diomede became her true self, a storm hitting so fast out of a thick fog that there was no time to move to a safer place. "The anchor dragged for a few seconds, then caught a reef," Curtis wrote. "The chain snapped like a frayed rope. . . . The storm was supposed to come from the northwest. This one came from all points of the compass. . . ."

98

They managed to get the engine running, and their own power plus the drift of

King Island Village from the Sea. The King Islanders occupy dwellings erected on stilts on the cliff side, giving their village an unusual and highly picturesque appearance. In the foreground of the picture is the Jewel Guard, the forty-foot boat in which Curtis and his party sailed the stormy waters off Alaska for six weeks.

the storm enabled them to reach a small cove, where they dropped their remaining anchor. "For four days and nights we swung hither and yon on our anchor tether," Curtis wrote. The shore was only 300 feet away but out of sight in the fog. It wasn't possible to land, and anyway, everyone was needed to fight the storm. The boat was rolling so they could hardly stand.

As the hours passed, the storm increased. "When our boat swings on the anchor chain she comes within 100 feet of the rocks," Curtis wrote. "Our lives depend on that chain. Should it break we would be a wreck in sixty seconds. The seas are as high as the mast."

Above the screeching of the wind and the thunder of the surf, a call from shore was heard. The natives, during a break in the fog, made signals that they must shift anchorage yet again, this time to get in the lee of the southern point of the island. This was somehow accomplished, although the boat was "rolling so we could barely stand and the wind was so strong one had to turn his back to breathe." At the new anchorage two seas met just offshore and piled mountain-high. "It is like sitting on the sidelines and watching a battle," Curtis wrote.

And still the storm grew worse. "We need Beth to cheer us up, but I am glad she is not with us," Curtis entered in his log at four o'clock on the morning of August 13. In the small hours of the fourth day, "Still the same storm and a long night. One cannot sleep even when worn out. It must end sometime. . . . My six by eight camera is ashore. If not for that I think we would try for the mainland in the morning but I must have my camera."

The fifth night was the worst yet. "Cooking is a problem," Curtis wrote. "To eat, the boys sit on the floor with a deep dish between their knees. Land is but 300 feet away but no human could reach it. At this point there is nothing but a sheer cliff 800 feet high."

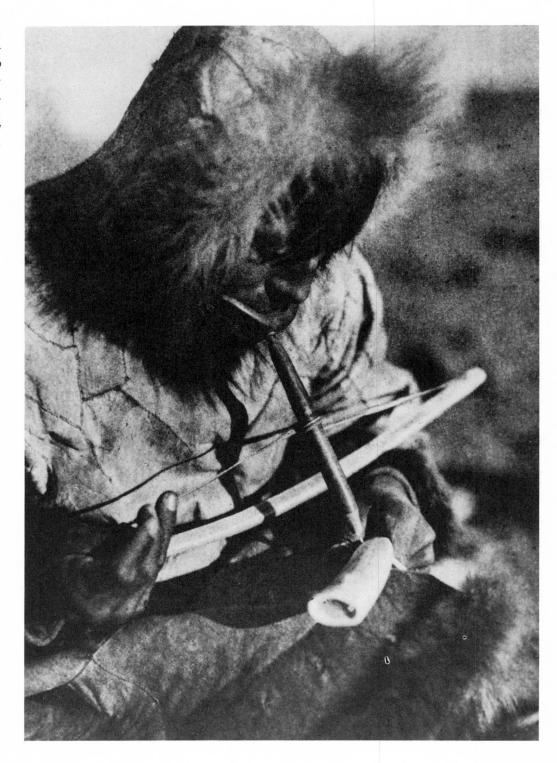

Drilling Ivory—King Island. Among the island and coast Eskimo, ivory is skillfully carved into numerous implements—awls, bodkins, drills, needles, needle-cases, and spear- and harpoon-points. Their etchings on ivory are very well executed. Then the storm eased, and they moved back to their old anchorage at the village. "We surprised the natives," Curtis wrote. "They thought we had been wrecked. Seeing our boat they thought it was a ghost so now they call it the Ghost Ship."

Making up time, Curtis worked ashore from morning until after midnight, pausing only long enough to come back to the boat and eat; then in the night they sailed from the Diomedes for the Alaskan mainland. "Do not want to chance another such storm," he wrote. "Have secured a lot of good material. Heavy sea crossing to Wales. Landed Arthur and pulled out for Kotzebue at once. Wind here unbroken from the Arctic. We are now out of Bering Strait and dealing with the Arctic Ocean. Since noon our course is just about on the Arctic Circle. I am too fagged for words."

Off Kotzebue, a village on a spit jutting into Kotzebue Sound from the Alaskan mainland, well above the Arctic Circle, they picked up a pilot, Curtis wrote, "who insists he knows more about driving dogs than piloting boats. I believe him. We fought mud flats all day, running in every direction looking for water deep enough to keep us afloat. Reached the village at 6 P.M. Sam Magida is here. He is a prince and know he will be a great help with our work. We are anchored in front of his store, about 100 feet from shore. Hope to get a real night's sleep. Have had only 4½ in the last sixty hours. Tomorrow night expect to start on a whaling trip with the natives, the same white whales which they get at Hooper Bay."

But again Curtis' plans to go whaling were foiled, this time by the weather. So for the next several days he worked ashore. Then they pulled anchor and sailed up the Noatak River to get pictures of the Noatak natives, who had left Kotzebue to return to their inland village the day before Curtis arrived.

Back at Kotzebue a week or so later, they started up the Selawik, which came out of the Baird Mountains and emptied into the sound south of the Noatak. Now, besides wind and rough water, they encountered a new hindrance to their work. "Missionary has sent out word the natives are not to talk to us," Curtis wrote. "They are cursed with a vicious breed of missionary. If the natives do not help support them they call them Devil People. . . . Natives cannot even extend aid to any relatives unless they are Christ people; and this in the name of Christ."

Curtis felt constrained to recall for his log that he had run into some people on an island south of Nome who were perhaps "the most primitive on the North American continent. . . . I hesitate to mention it for fear some overzealous sky pilot will feel called upon to labor with these unspoiled people. They are so happy and contented it would be a crime to bring discord into their lives."

As September began, with the weather due to hit anytime, when no man of sound mind would be caught sailing the Arctic Ocean, Curtis lingered to complete his work among the natives along the Selawik. Indeed, he penetrated even further inland. "Moved upstream 3 miles to be near an old informant driven from the village by the missionaries," he entered in his log on September 2. "The old man is a cripple and most deserving but relatives are not allowed to help." He added casually, "A bad snow during the day . . . our first real snow storm and we know that summer is

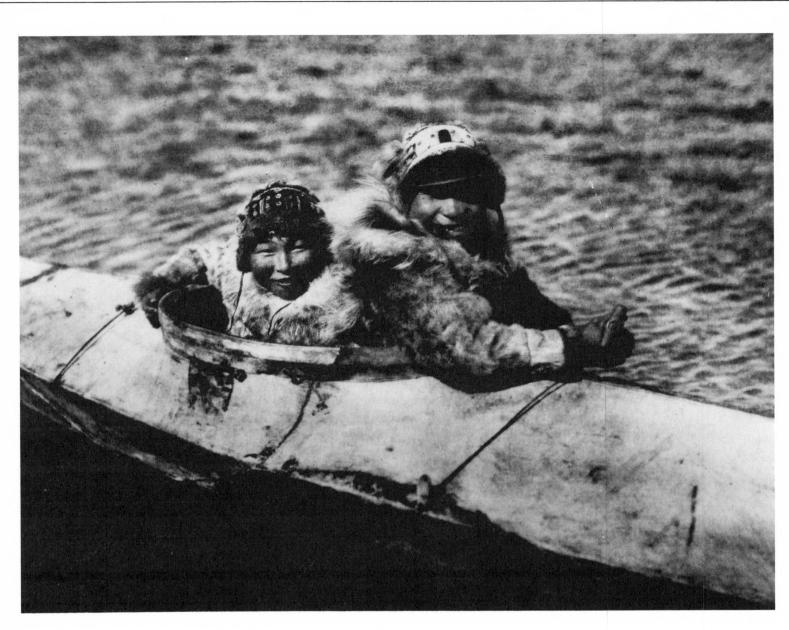

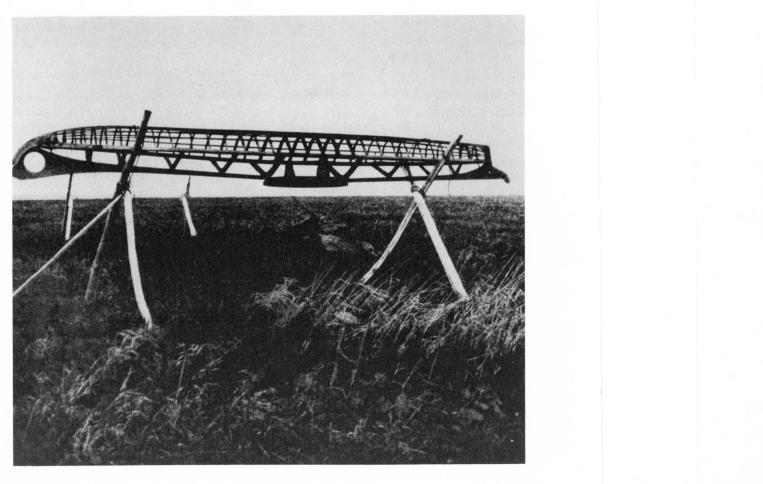

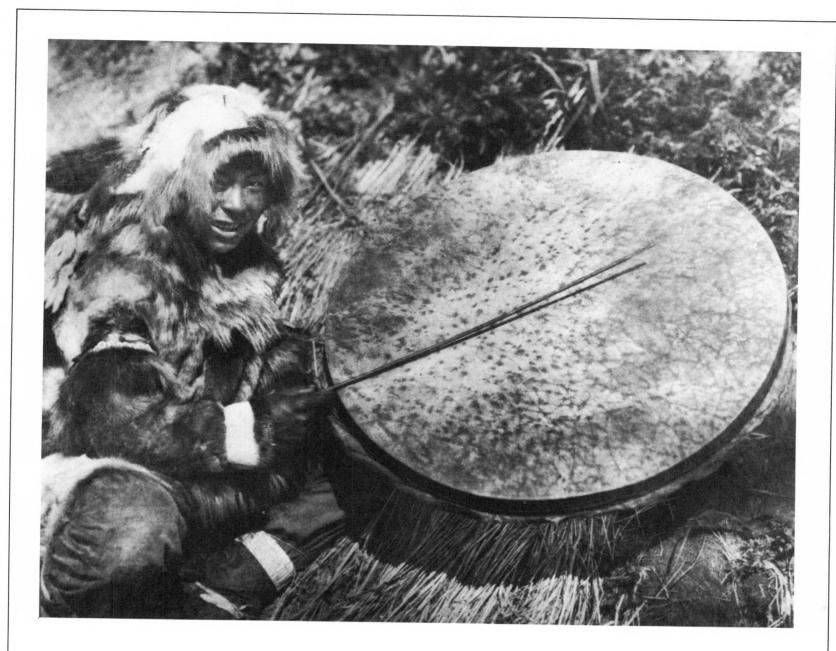

While many of the Eskimo visited and studied by the writer still retain much of their hardihood, they appear to have lost not a little of the rigor observed during his study of the coast Eskimo thirty years ago. As among so many primitive people, contact with whites and the acquirement of their diseases have worked a tragic change during this period. A notable exception was found in the natives of Nunivak island, whose almost total freedom from Caucasian contact has thus been their salvation; and yet within a year of the writer's visit it was officially reported that the population decreased nearly thirty percent. In all the author's experience among Indians and Eskimo, he never knew a happier or more thoroughly honest and selfreliant people.

OPPOSITE ABOVE: Boys in Kaiak—Nunivak. Eskimo boys are trained in manly pursuits from their earliest years and are honored with feasts on taking their first game.

OPPOSITE BELOW: *Kaiak Frame—Nunivak*. New kaiaks are made in late winter or in early spring. Their construction takes place with ceremony in the men's house, usually under the supervision of some old man well skilled in boat-making. The men measure and cut each individual part of the wooden frame according to a prescribed system based on the length of various members of the body or a combination of such members. Thus each man's kaiak is built according to the specifications of his own body and hence is peculiarly fitted to his use.

ABOVE: *The Drummer—Nunivak*. This tambourine-like instrument, its head made of walrus stomach or bladder, is used chiefly in the winter ceremonies. Such drums vary in diameter from a foot to five feet; the one illustated measured three feet six inches. When beaten, the drum is held in a position varying from horizontal to vertical. The drum-stick is a slender wand.

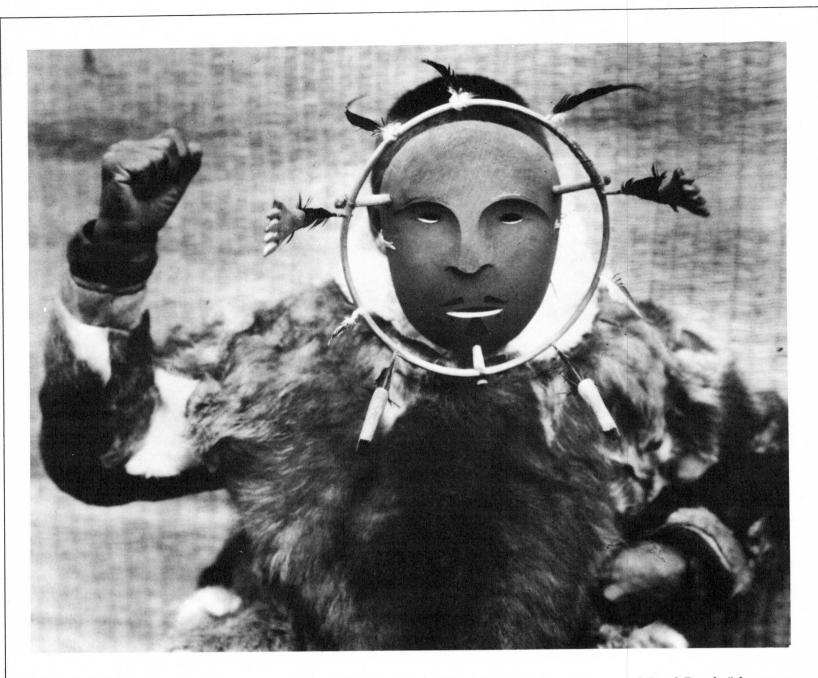

Ceremonial Mask—Nunivak. While the wearing of wooden masks in various festivals and ceremonies forms a part of ritualistic procedure, it is especially difficult to procure any knowledge of their significance chiefly because the customs of the people have become so modified that complete and reliable information as to masks is well-nigh unobtainable. over." "Some fine material here from two who are termed Devil People," he wrote next day.

With the weather growing steadily worse, and threatening to trap them in the Arctic for the winter, they moved to yet a new location, a native camp at the lower end of Selawik Lake—and enjoyed a feast. "Natives brought us a large shea fish, about 40 pounds," Curtis wrote. "Almost worth a trip to the Arctic."

Finally, on September 10, it was time to go. "All the world white with snow," Curtis noted. "Stormy hard head-wind." Then he observed, as if it had just occurred to him, "We must get our boat back to Nome without delay. The run from here to Nome at this season in such a small boat is a risky piece of navigation."

In the darkness of post-midnight next morning, with nature giving abundant portent of what lay ahead, they were on their way. "Growing rough, a hard sea, barometer dropping," Curtis wrote. "The storm is on us. Bitter cold, heavy snow. On the plains this would be called a blizzard. The boat is pounding badly. It is a bitter night. Visibility is ten percent less than pea soup."

Twenty-four hours later, the storm had driven them back to where they started from—and given them an ominous new problem. "Something about the slosh of the boat awakened me," Curtis wrote. "As I jumped from my bunk my feet were in water. I quickly ran aft. The engine room was all awash, a foot of water over the floor. I awakened Harry and Eastwood. While they were crawling out, I started the pump. . . ."

It was found that by keeping the pump going, they were able to stay even with the water. With the full fury of winter closing in, they decided to risk the run to Nome without delaying to make repairs. "I called the boys and we pulled the mud hook," Curtis wrote.

104

But leaky bottoms and pursuing storms did not preclude a stop at Wales, at the western tip of the Seward Peninsula, and about halfway to Nome. "We need to do a few days work there and hoping wind will hold to the northeast," Curtis wrote.

Alas, the weather did not oblige. After allowing them to anchor at Wales, it kept them from getting a boat ashore, blowing up a frigid gale that sent them fleeing to the safety of the harbor at Port Clarence, sixty miles away.

Still Curtis persisted. Nearly a week after they first anchored at Wales, he walked ashore, camera in hand.

Then, the job done, they at last headed south to Nome, racing the weather. "All sails set but the barometer lower than at any time on the trip," Curtis wrote. "Wind increasing. Terrific sea. We are running with it. We are flying like a bird before the gale, merely hitting the high spots. The speed of our chip-sized craft gives the feeling we are a duck being blown from the top of one wave to another."

Eastwood stood with Curtis at the wheel, the pair of them in water up to their waists from the pursuing breakers crashing over the deck. "Chief," Eastwood said, "the storm is growing worse. While I have a chance I want to tell you that my season with you has been the event of my life. Good and bad, I have enjoyed every hour of it."

They shook hands.

"In less than an hour we rounded the Cape and put-putted up to the dock," Curtis wrote. "We had been sighted and every inhabitant of the village was down to the landing to greet us." The last wireless from the north had said they were seen starting for the Diomedes and were doubtless lost in the first big blizzard of the winter.

"A glorious sporting sail if there had not been so much at stake," Curtis wrote. He learned that the storm which caught them as they fled from Wales to the safety of Port Clarence had badly smashed shipping around Nome, killing two men. In the light of this, he wrote: "I think I came out quite well . . . Grant Jackson, my banker friend, said we have the distinction of being the only scientific expedition who did not ask for a loan to get out of the country."

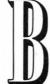

ACK IN THE BENIGN climate of Southern California, Curtis took up the unfinished business of the manuscript for Volume 19, returned by Hodge in disapproval of Eastwood's work just before Curtis left for the Far North. One by one he argued points of information raised by Hodge.

105

"'Wichita Theology'—You seemingly object to the use of the word other than associated with Christian religion. I see nothing in Webster to indicate that Christianity has the exclusive use of the word. However, 'Peace at any price'—so let us compromise on Religious Beliefs.

"'Preachment'-does not suggest flippancy to me, but if the word so impresses you, let us use the word 'Teaching,' even if we do overwork the word.

"The rib matter. You say 'Tribes, for example, which have not been influenced by Christianity.' There ain't no such animal. In my life time I have seen no group of Indians 'not influenced by Christianity.'

"Peyote Cult. In the paragraph which begins 'Indian religion, that is instinctive worship of the divine ones,' you make the comment, 'It is too late to make such a statement in print.' You do not indicate what part of the statement cannot be made. The paragraph as a whole makes two statements, first that 'The instinctive worship of the Infinite does not necessarily include a moral code.' My opinion is that the statement is correct. Like all such matters, the point could be argued as can all matters dealing with religion. The second statement is 'That the foremost teaching of Peyoteism is moral living.' There is no room for argument as to the truth of that statement, so I will let the paragraph stand as it is, and if you feel that it must be changed, let your conscience be your guide.

"I do not think the future of the human race will be seriously affected by the paragraph as it is or as you may change it, but as at the moment I have the last word—I will say that the statements in the paragraph are correct.

"Title of 'Stomp Dance.' Of course, 'Stomp' is derived from 'stamp'; still, wherever the dance is known it is 'stomp.' We might add a foot note telling the reader that 'stomp' is Southern for 'stamp.'

"You say the Comanche material is inadequate. I grant you that it does not make a strong showing, but one cannot make something from nothing. We covered the ground with the most intelligent of the present day educated men as interpreter and helper. With his help, we talked with all the old men of the tribe. Day by day we struggled to get what we thought should exist. Finally, our interpreter, Mr. Tebo, turned to me in some exasperation and stated: 'You are trying to get what does not exist.'

"The only material we could find was countless, meaningless, fragmentary, obscene stories of the camp-fire type; no point to them beyond that of obscenity. Aside from this type of tale, there [were] . . . fragmentary experiences of the old men in hunting stories or stories of war—it was not possible to find comprehensive stories which were worthy of publication. From this personal experience material, I gained some information which was utilized in my brief reference to the Tribe, particularly as to their conflict with the Stone House people. My statement as to Comanche conflict with the Karieso and Pecos I have changed slightly.

"In your comment you state that disease was the particular factor in the decline of Pecos, and, apparently, take exception to my statement that the principal factor was Comanche Raids. As to that, when last in New Mexico I spent considerable time with the old Mexicans of Pecos blood now living near Pecos, and all information is to

the effect that the final Comanche Raid was the big and vital factor. My statement as to that raid is based on personal investigation in the vicinity of Pecos, and that secured from the Comanche. If you will refer to your handbook, you will see that you give the final Comanche raid as the principal factor.

"As to the Monster Serpent—much of my information on that point was the outcome of some days' work with the old Mexicans in the vicinity of Pecos. I had as a helper an interpreter, a most influential Mexican woman who was able to get the old men to talk quite freely. The information came from so many sources that I am convinced of the existence of the final pair of large snakes. The old Mexicans referred to them in all of their stories as 'monsters.'

"Myers was not with me when I did that work and was fearful of going into the subject. I was at that time in favor of devoting a few paragraphs to the Monster Serpents, not claiming the material to be all fact, but giving it for what it was worth.

"If you think best, cut the reference to the snakes in the Comanche material. Some day when I have a little spare time, I mean to return to New Mexico and devote a couple of months to the snakes of that region. \ldots ."

With the manuscript for Volume 19 at last out of the way, Curtis turned to his work from the north, for Volume 20. "We have a fine set of pictures," he wrote Hodge early in 1928, and, a little later, "We have a tremendous mass of material, particularly in the form of folk tales. . . . Inasmuch as so little in the way of folk tales has been

Noatak Child. Almost as soon as a boy can walk, he learns to paddle and maneuver the small but efficient kaiak.

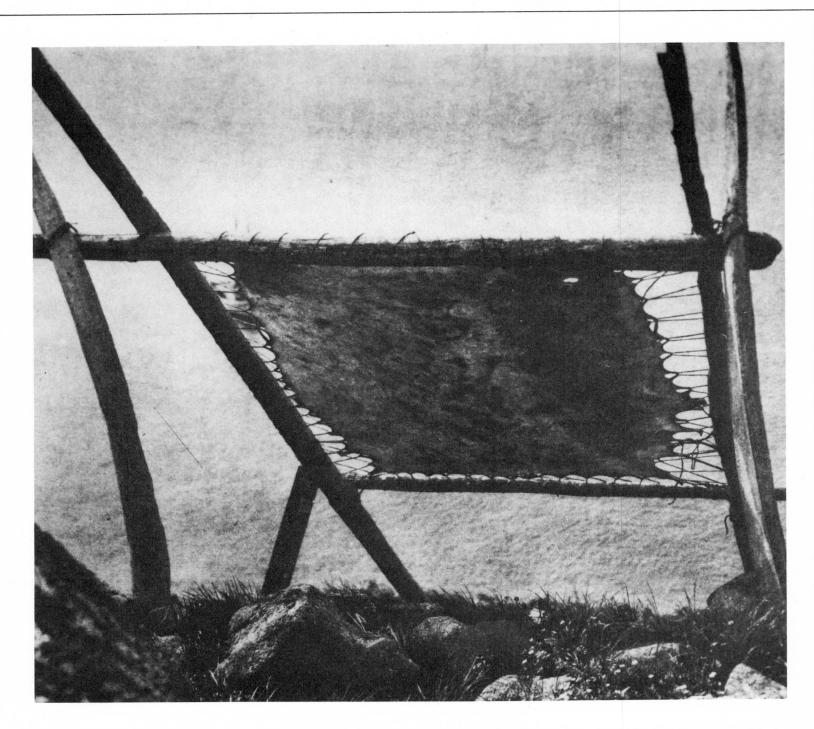

Drying Walrus Hide—Diomede. The chief foods are primarily meat, blubber, and oil of walrus, seal, and whale. The excess hides, meat, and oil are articles of trade with the mainland people on both sides of the Bering Strait. published of the Eskimo, we are inclined to feel we should go as far as possible in including them. After we have prepared our general descriptive matter we can better determine the amount of space we will have for the folk tale material. . . There is a certain sameness . . . yet they practically all give interesting glimpses of the mental processes of the people."

As the end of the long road that began at the turn of the century came at last into sight, Curtis' health problems worsened. "I am in bad shape again," he wrote Hodge on February 20, 1929, informing him that he was forwarding the first of the proofs for Volume 20. "During January I made a good gain and was almost shouting with joy BUT on or during the night of February 1 the trouble came back worse than ever.

"Moving from my bed to my working table is about my limit at present. I have a new doctor and he makes great promises; also I have had my tonsils out. . . ."

For all his disability, Curtis carried on. "Within a few days I will send you a draft of the introduction to Volume 20," he wrote Hodge on March 14, 1929. "As this is the last volume I have added a personal word. . . . After making any changes which you feel needed, please return to me.

"As to the hip, it is again some better and I am most hopeful. I believe the removal of the tonsils helped. Also I have had made a tight fitting straight [sic] jacket which is most uncomfortable to live with, but it does help. In this last mad effort to do something to get the best of the situation, I have resorted to everything which three of the best doctors could suggest. . . ."

108

Curtis got a complaint from an unexpected quarter, relayed by Hodge. "In regard

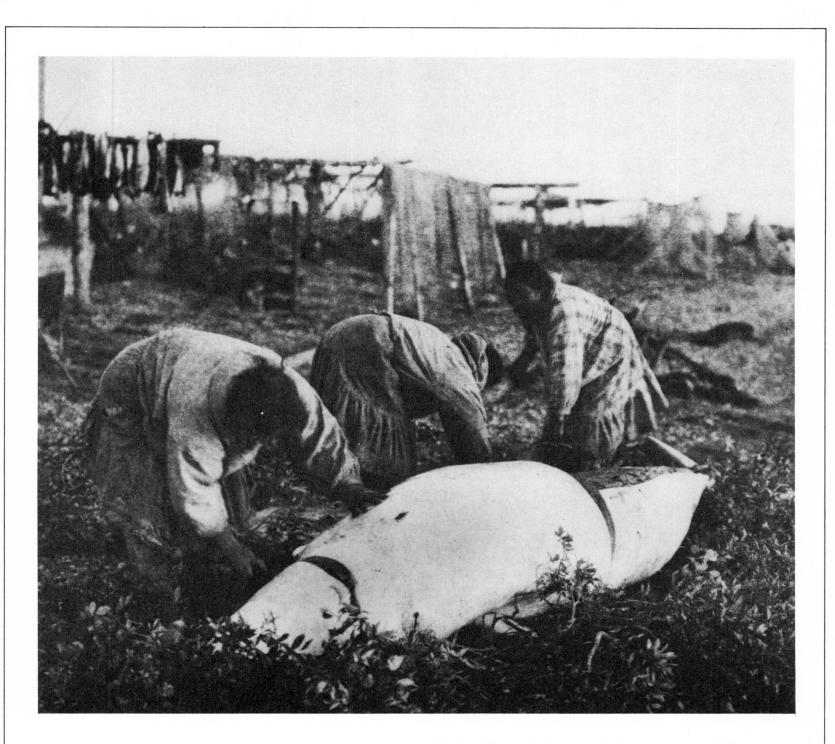

Cutting up a Beluga Whale— Kotzebue. No woman may touch a beluga until her husband gives permission. First the heads are cut off and left in the water in order that the spirits of the animals may return to the sea and enter the bodies of other belugas. When the procedure is properly conducted, the belugas will return again to be killed, it is believed. to pictures promised the Indians," he replied on April 18, 1929, "we mailed prints to all the Indians where prints were promised. In fact we mailed copies of every portrait made.

"Where I made landscape things with Indians included I did not promise pictures as the Indians received more than the usual pay and I did not care to have pictures of that sort out.

"My experience is that pictures often fail to reach the Indians. They disappear in the P. O. or get into hands other than the Indians'. From that season's work we sent enough pictures to plaster the Northwest. I recall one group negative from which we sent 13 copies. . . . As to sending on further pictures that is out of the question as all the negatives go to the plate makers then to the Morgan vaults. I do not see them after they go east.

"The natives of that neck of the woods can have no just complaint. They were all well paid for the sitting for pictures. Also we did our part in sending the promised pictures. \dots "

In 1930 the work of creating *The North American Indian*, the most remarkable undertaking by one man in the history of books, came finally to a close, with the publication of Volume 20.

"Mere thanks seem hollow in comparison with such loyal cooperation," Curtis wrote in his final introduction, referring to those who had stood by him through the years, "but great is the satisfaction the writer enjoys when he can at last say to all those whose faith has been unbounded, 'It is finished.'"

109

Index

Apsaroke Indians, 41 Albert, Lewis, 82, 88 Allen, Henry, 59 Angeline, Princess, 7 Apache Indians, 21, 22-26 Arikara Indians, 34, 82 Assiniboin Indians, 14 Atsina Indians, 49 Audubon, John James, 48 Ayer, Edward E., 36, 53

Black Eagle, Chief, 14 Black Elk, 15-16 Blackfoot Indians, 10, 12 Boaz, Dr. Franz, 28, 30 Borrojo, E. M., 45 Brainard, Erastus, 17 Burroughs, John, 10

Cahuilla Indians, 16 Carson, Kit, 25 Catlin, George, 12, 44 Chamberlain, Alexander F., 56 Christianity, 106 Collier, John, 91 Comanche Indians, 106-7 Crow Indians, 31, 34, 48-49 Culen, Dr. Robert Stewart, 40-41, 74 Curtis, Edward Sheriff: Alaska expeditions, 10, 94-105; awards and prizes, 7; and comparative religion, 15; divorce, 88; early photography, 9, 12-13; exhibitions, 16-17; first camera, 8; first studio, 9; funding, 20, 36, 52, 54, 72-73, 81, 87; hip injury, 70, 97, 108; initiation into Snake Order, 78-79; language and music recordings, 20, 30, 41, 44, 87-88; lecture tour, 73-77; log, 97; marriage, 9; motion picture, 70; relationship with Indians, 12-13, 15, 34; scenic photography, 9; on titles, 43; Vancouver Island expedition, 57-70 Curtis, Beth (daughter), 25, 88, 97, 99 Curtis, Mrs. Edward, 25, 27, 30, 34, 35, 88 Curtis, Harold (son), 25, 30, 34, 35 Curtis, Johnson (father), 8 Curtis Graybill, Florence (daughter), 12, 25, 88-90 Custer, George Armstrong, 31, 34

Day, Charlie, 26 Devil Rock sea lions, 67-69 Dixon, Joseph Kossuth, 80, 84 Dorsey, George Amos, 52

Eastman, George, 7 Eastman, Seth, 12 Eastwood, Stewart, 92, 94, 98, 104, 105 Edison recorder, 20, 30 Eskimos, 94, 108

Farabee, William Curtis, 74 Folk tales, 108

Geronimo, 17 Goes Ahead, 31 Gordon, Dr. George Byron, 77 Gould, Mrs. Jay, 17 Grinnell, George Bird, 9, 10, 45 Guptil, Henry, 9

Haddon, Professor A. C., 50, 52 Hairy Moccasins, 31 Hallock, Charles, 84 Harriman, E. H., 9-10, 17 Harry the Fish, 98, 104 Hawthorne, Julian, 73 Heye, George E., 51 Hidatsa Indians, 41, 49, 51 Hill, David Octavius, 7 Hodge, Frederick Webb: Curtis' correspondence with, 16, 21, 22, 25, 26-30, 34-35, 36, 40-41, 44, 45, 48-54, 56-57, 72-77, 79-88, 91, 92, 94-95, 105-9 Holmes, William Henry, 28 Hopi Indians, 12, 77-79, 89 Hrdlicka, Dr. A. H., 87 Hunt, George, 61-62, 64, 65, 69, 85 Hunt, Stanley, 68-69 Huntington, Henry E., 45-46

Indian Days of the Long Ago (Curtis), 70 Inverarity, D. G., 10 Iron Crow, 30

Jackson, Grant, 105 Jackson, William Henry, 12 John Andrew and Son, 20, 82 Joseph, Chief, 19

Kelsey, Dr. Francis W., 76, 77, 86-87 Koskimo Indians, 85 Ksanka Indians, 56 Kutenai Indians, 56 Kwakiutl Indians, 61-62, 64, 69, 70, 77, 80

Lakota Indians, 41 Land of the Head Hunters (motion picture), 70, 86-87 Lane, Franklin K., 81, 84 Leitch, Harriet, 9, 10, 19, 70, 97 Leupp, Francis, 17, 31, 47-48 Longworth, Alice Roosevelt, 21 Longworth, Nicholas, 21 Lummis, Charles F., 46-47

Magida, Sam, 101 Makah Indians, 80 Mandan Indians, 35, 37-40, 49, 82 Mandan Turtles, 37-40 Mazama Indians, 17 McGee, Professor W. J., 47, 52, 69-70 McMillan, Angus, 89 Meany, Edmond S., 19, 34, 78n. Merriam, Dr. C. Hart, 9, 45 Monster Serpent, 107 Mooney, James, 41 Morgan, J. Pierpont, 20, 21, 36, 45, 52, 54, 81 Morgan, J. Pierpont (son), 81

IIO

Muhr, A. F., 17, 21, 82 Muir, John, 10 Myers, W. E., 27, 29-30, 35, 44, 45, 49, 56-57, 59, 65, 68, 69-70, 73, 80, 82, 84, 85, 88, 89, 92, 94

Navaho Indians, 21, 25, 26 Noatak Indians, 101 North American Indian, The, (Curtis), 26-27, 31, 34-35, 36, 40, 48-49, 51, 81, 88, 91, 92, 109; critical reception, 40-41, 44, 45-48, 53-54, 73; funding, 20, 36, 52, 54, 72-73, 81, 87; price, 20, 82 North American Indian, The (Dixon), 80 Northcliffe, Lord (Alfred Charles William Harmsworth), 50-51

Osborn, Henry Fairfield, 28, 52, 54, 81

Packs Wolf, 37-38 Panic of 1907, 35 Piegan Indians, 16 Peyote Cult, 106 Phillips, William, 27, 28, 29, 35, 44 Pinchot, Gifford, 9, 17 Powell, E. P., 48 Pueblo Indians, 91 Putnam, Frederick Ward, 44

Red Hawk, Chief, 19, 30-31 Ree Indians, 35, 49 Robinson, Mrs. Douglas, 17 Roosevelt, Theodore, 12-13, 16, 17, 26, 27, 28, 31, 90

Sargent, John Singer, 7 Schoolcraft, Henry, 12 Schwinke, Edmond, 27, 57-58, 59, 74, 85 Sealth, Chief, 7 Sheridan, General Philip, 12 Sioux Indians, 19, 29, 30-31, 34, 48-49, 78n. Siwash Indians, 77 Skinner, Alanson, 87 Slow Bull, Chief, 31 Snake Dance, 77-79 Soule, Will, 12 Stevenson, Matilda Coxe, 91 Stone House People, 106-7

Taft, William Howard, 81 ten Kate, Dr. Herman, 53, 56 Tewa Snake Worship, 91 Tulalip reservation, 7 Two Moon, 31

University Press (Cambridge), 20, 45 Upshaw, 37-38

Vanderbilt, Mrs. Frederick W., 17 Vroman, Adam Clark, 12

Walcott, Charles Doolittle, 28, 52 Wanamaker, Lewis Rodman, 80-81 Whistler, James McNeill, 7 White Man Runs Him, 31 Wissler, Professor Clark, 56 Woodruff, General Charles A., 31, 34

Yakutat Indians, 94

THE PORTFOLIO

"While primarily a photographer, I do not see or think photographically; hence the story of Indian life will not be told in microscopic detail, but rather will be presented as a broad and luminous picture."

Edward Sheriff Curtis 1905

1. A Chief of the Desert — Navaho

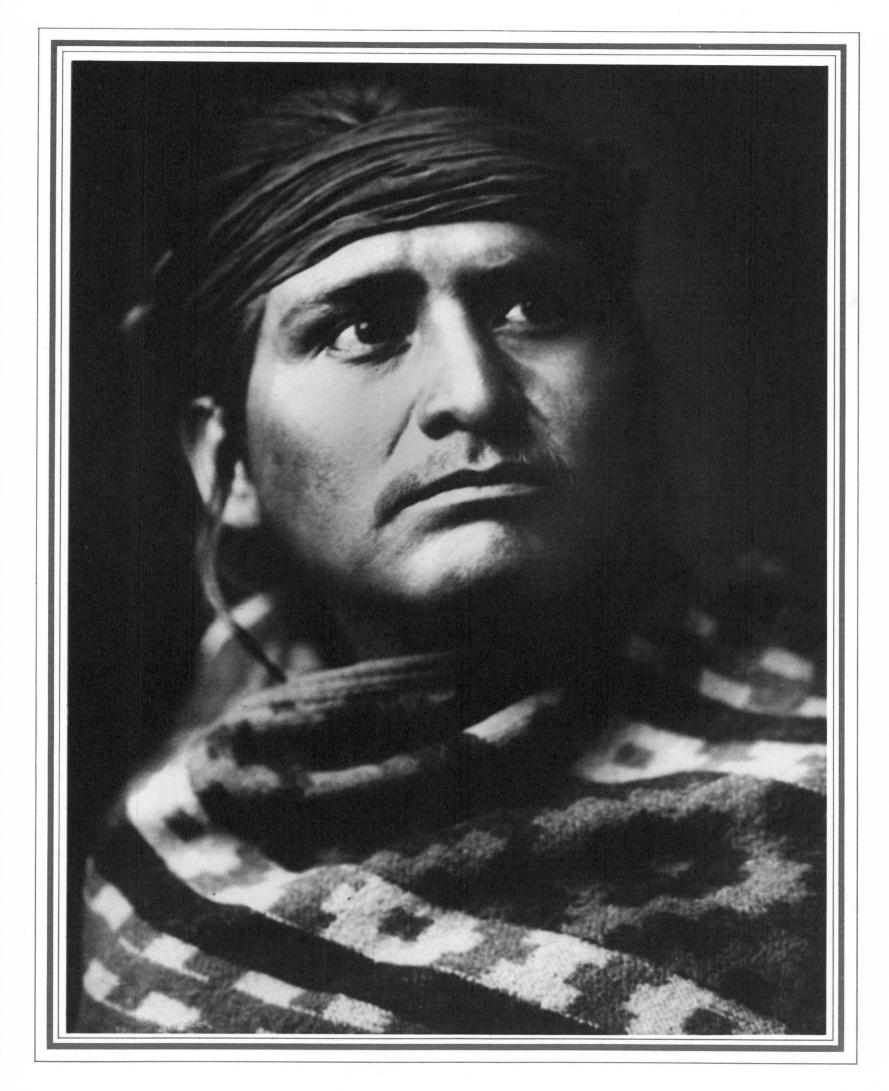

2. Cañon de Chelly — Navaho

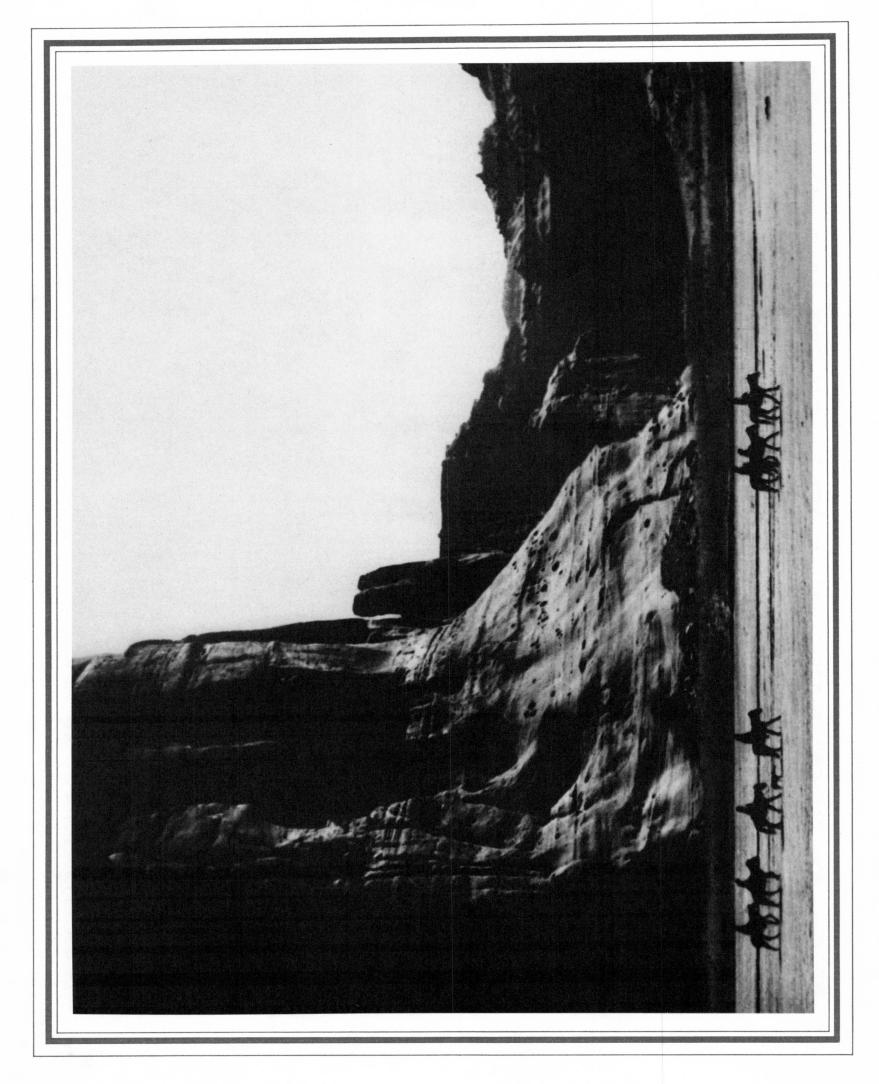

3. A Son of the Desert — Navaho

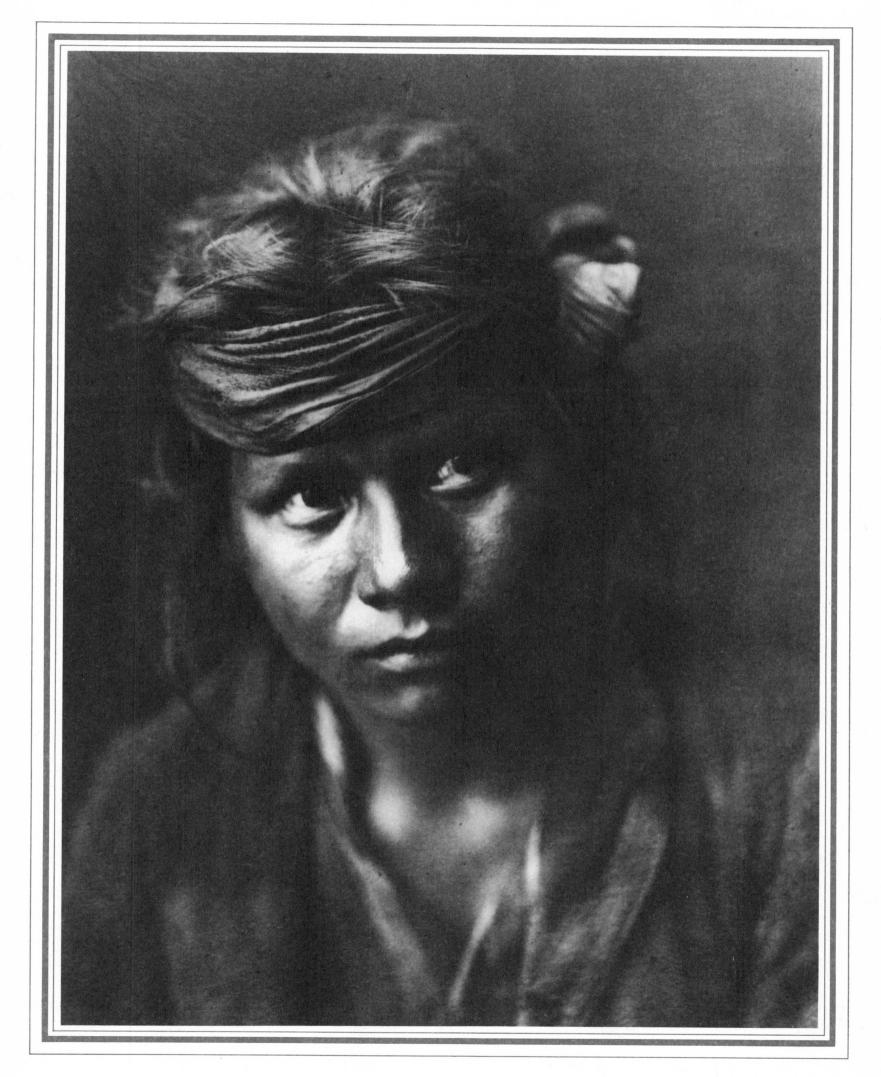

4. Apache Medicine-Man with Sacred Prayer Chart

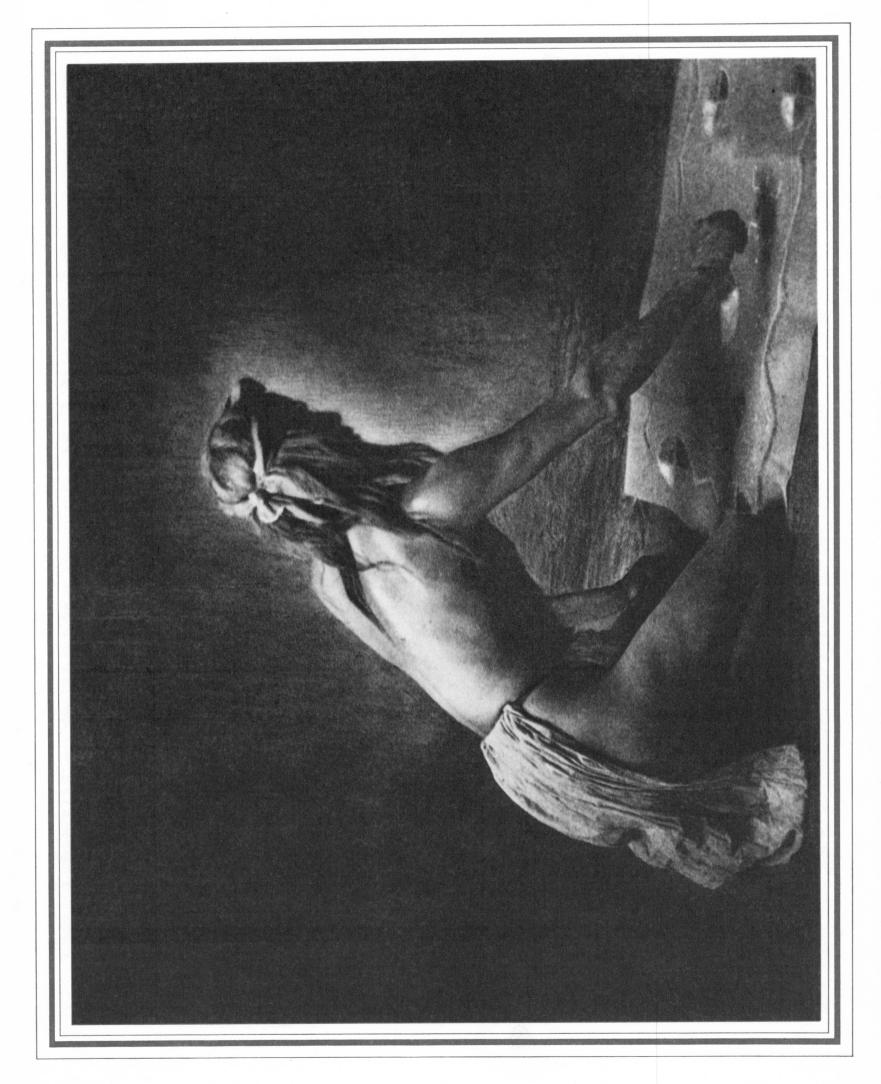

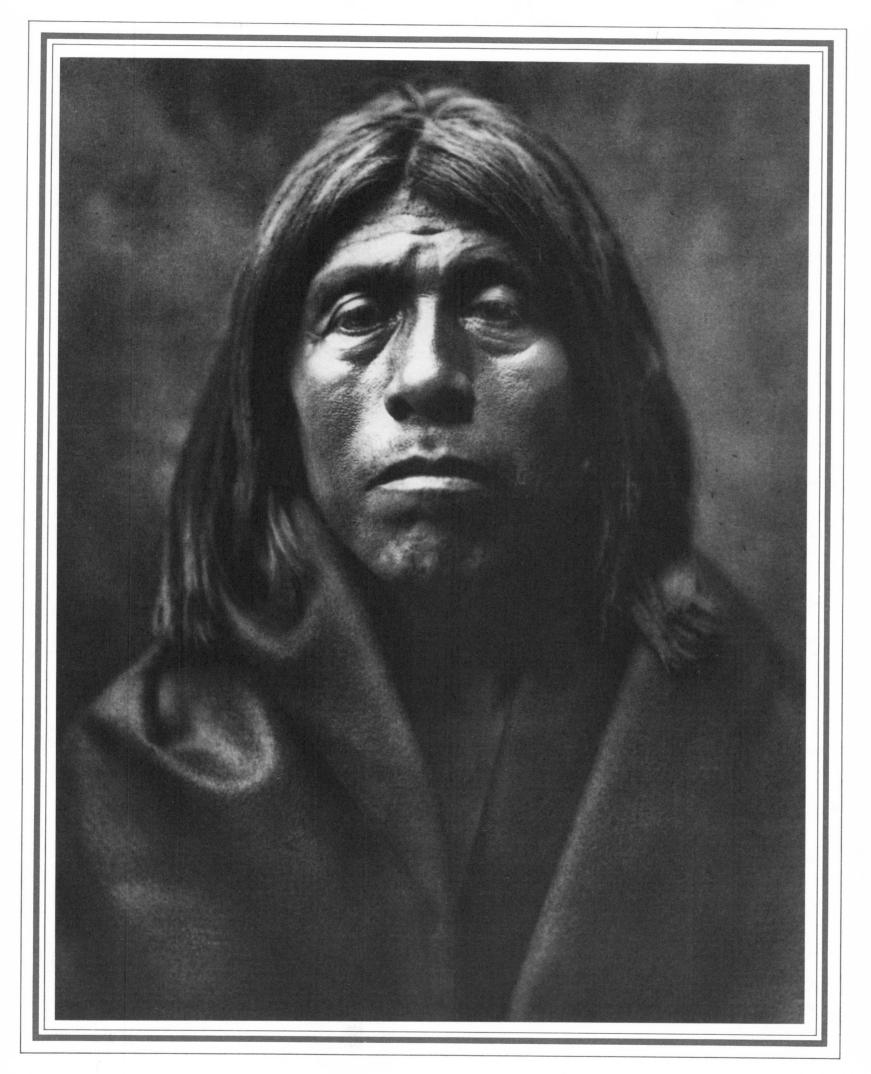

6. QAHÁTĬKA GIRL

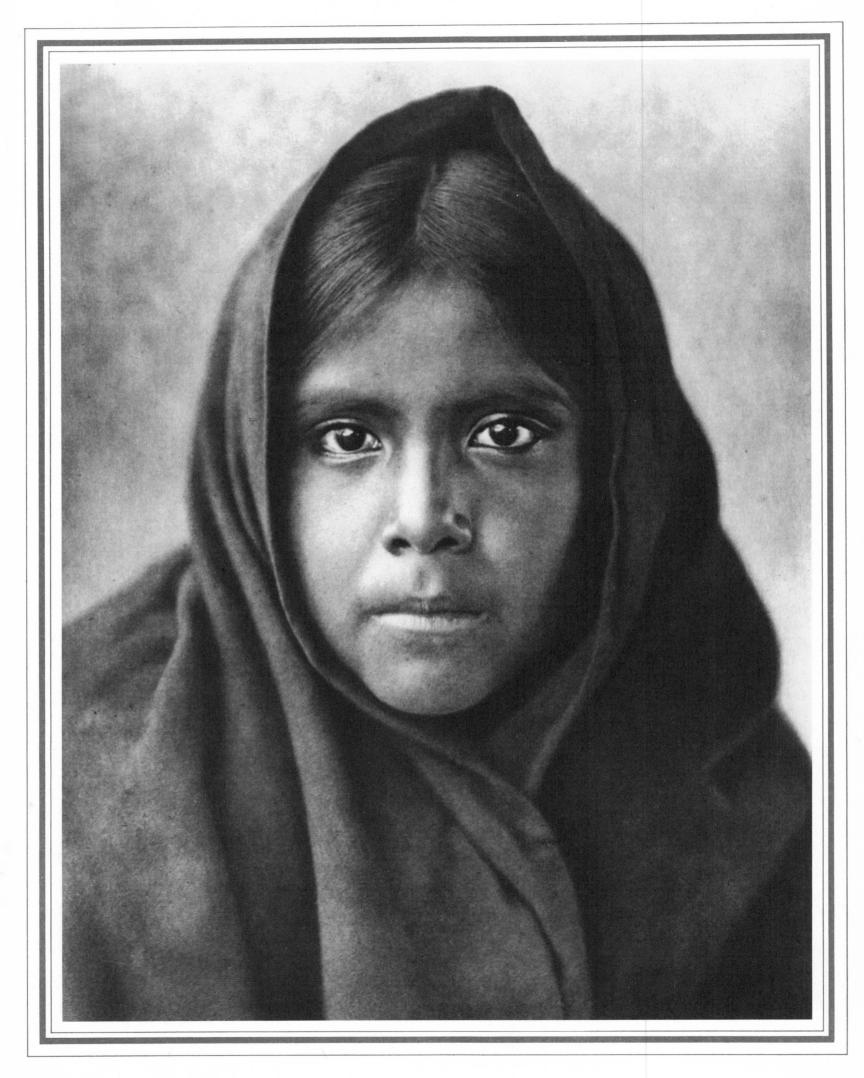

7. Pachílawa — Walapai Chief

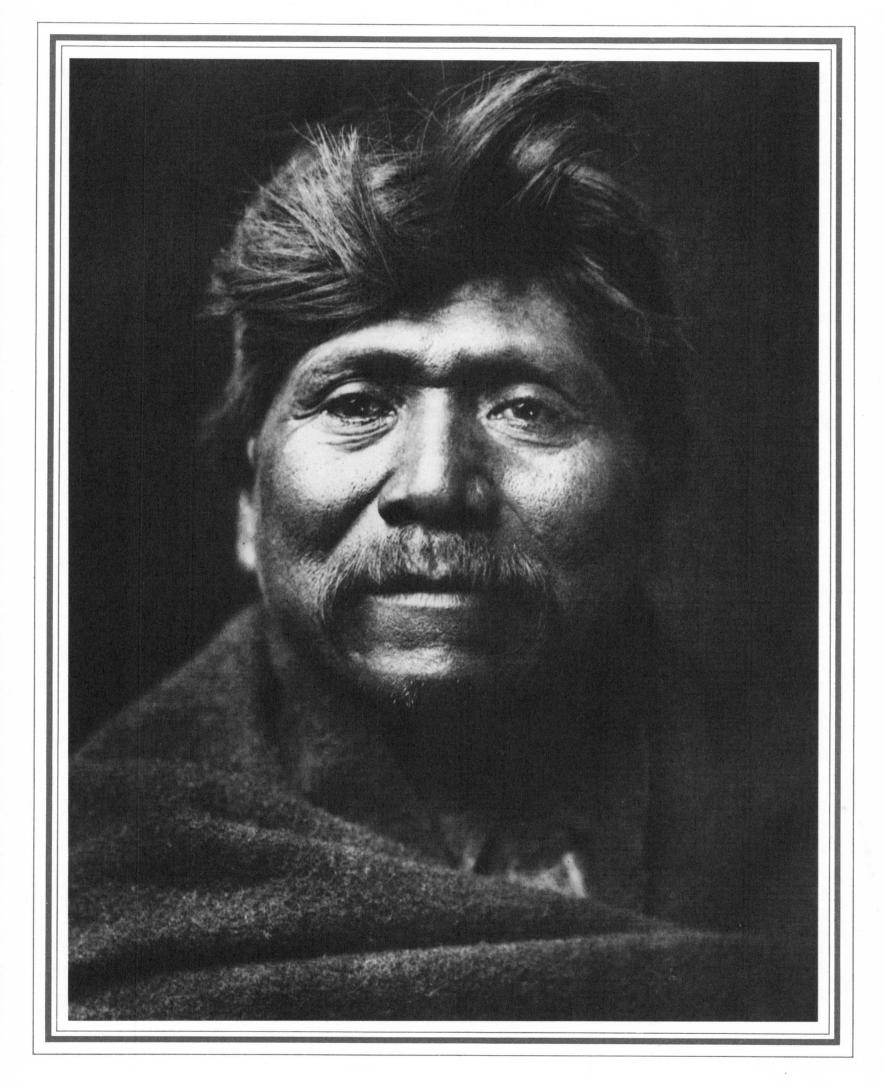

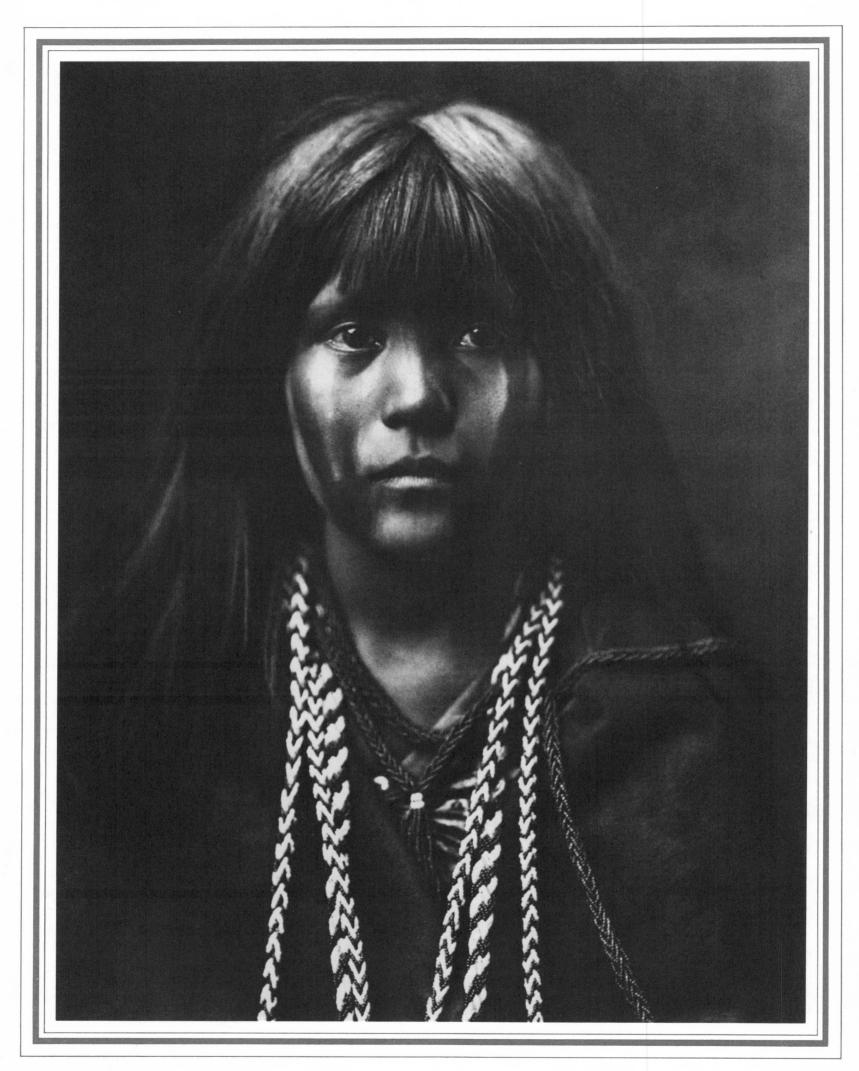

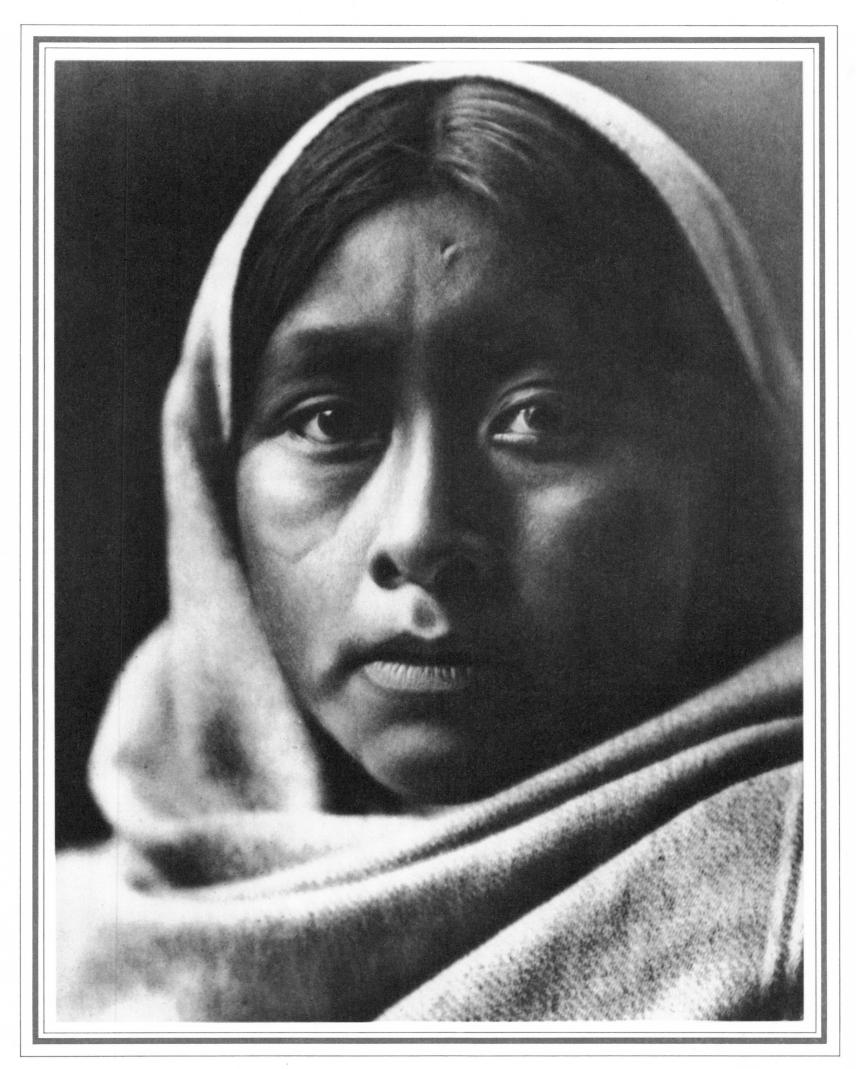

9. Papago Girl

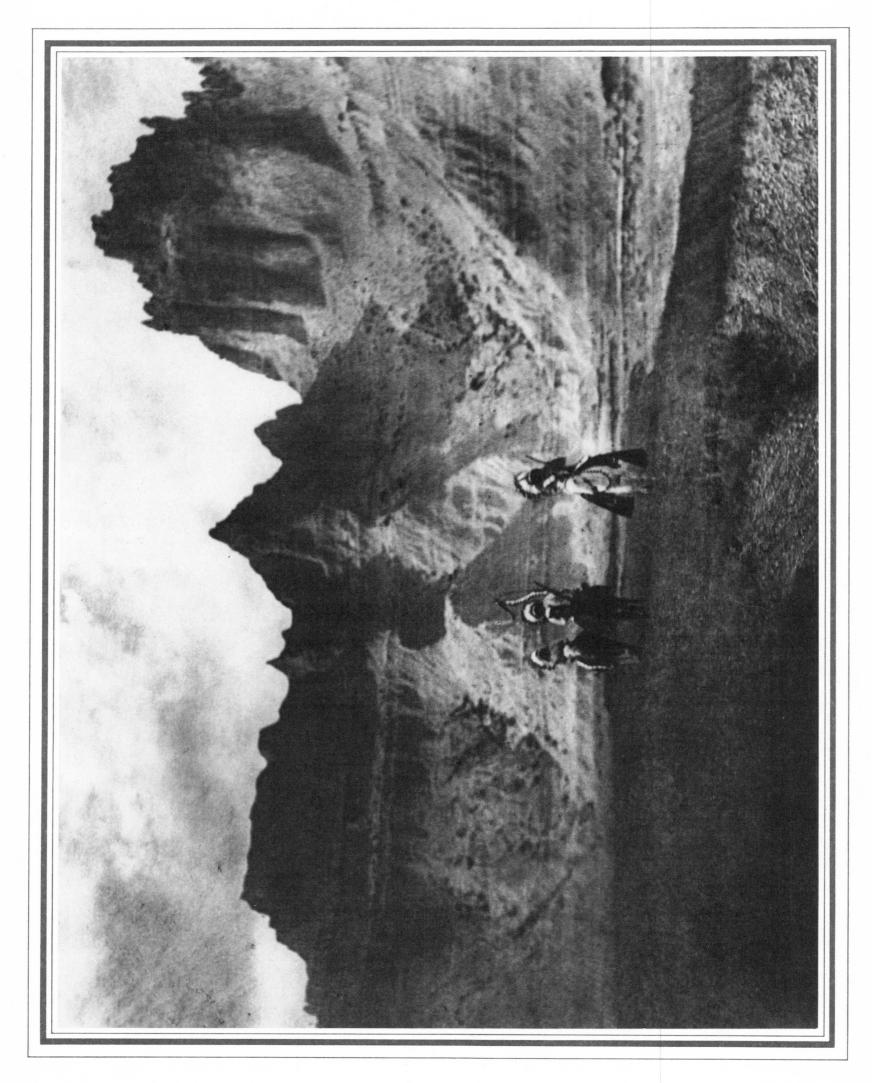

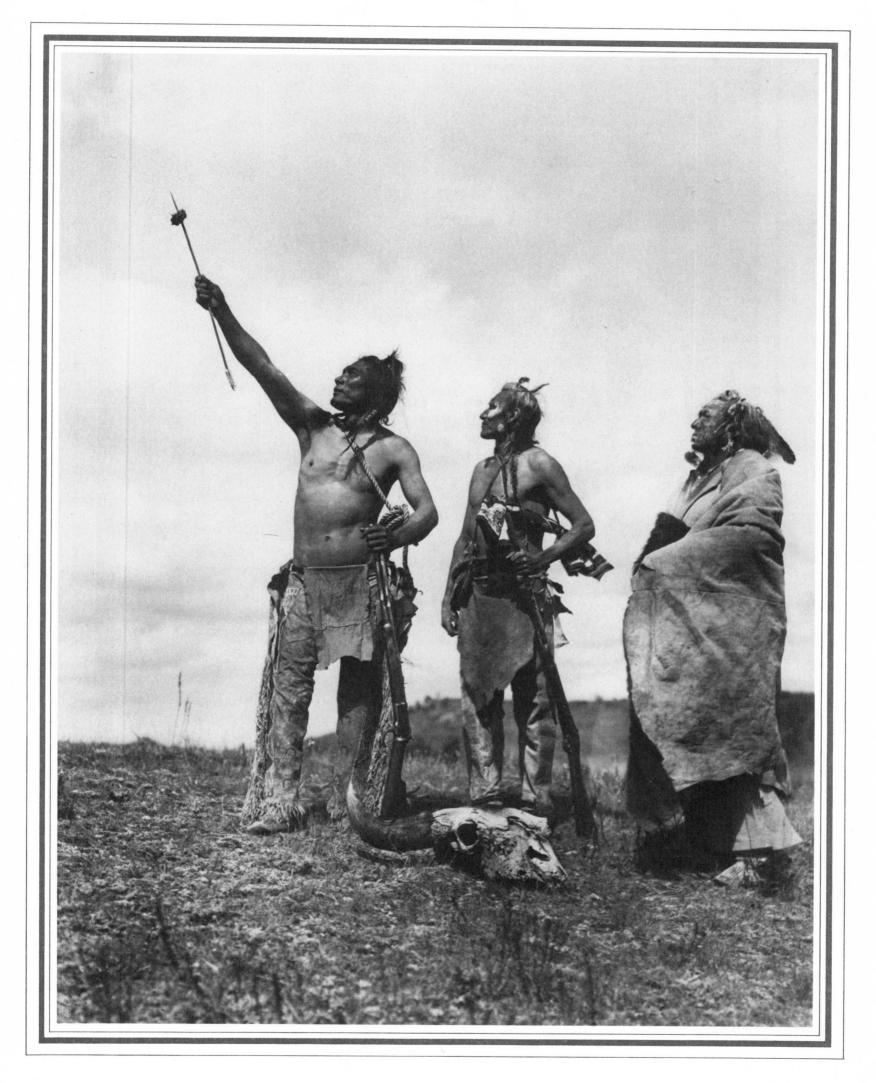

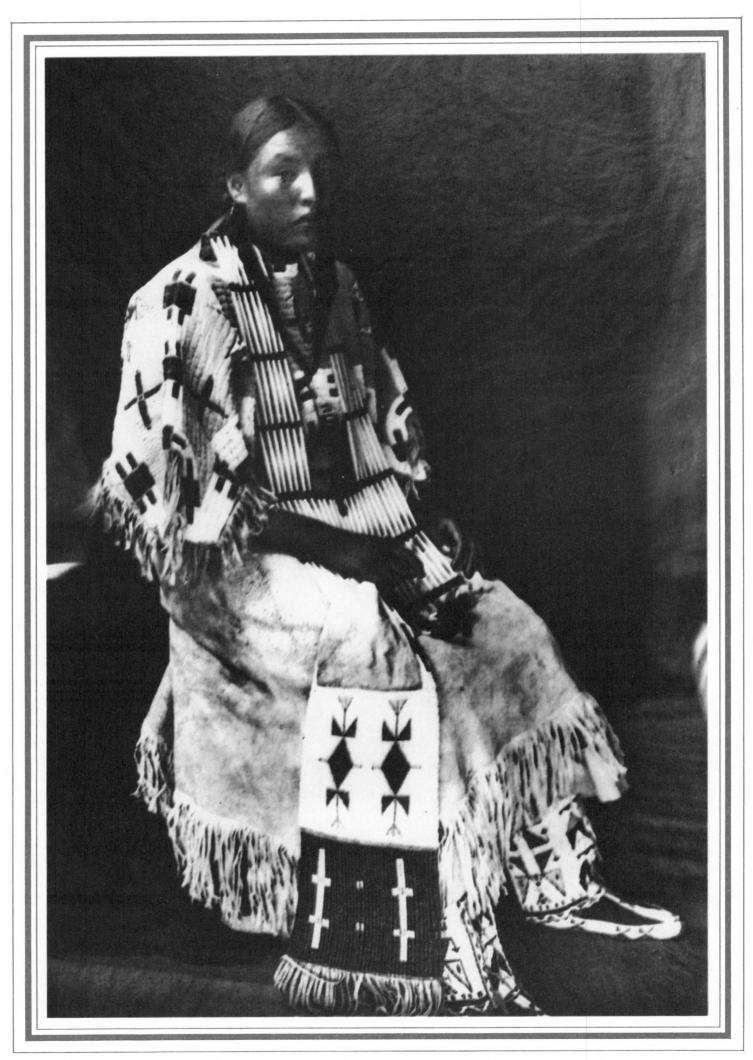

12. SIOUX GIRL

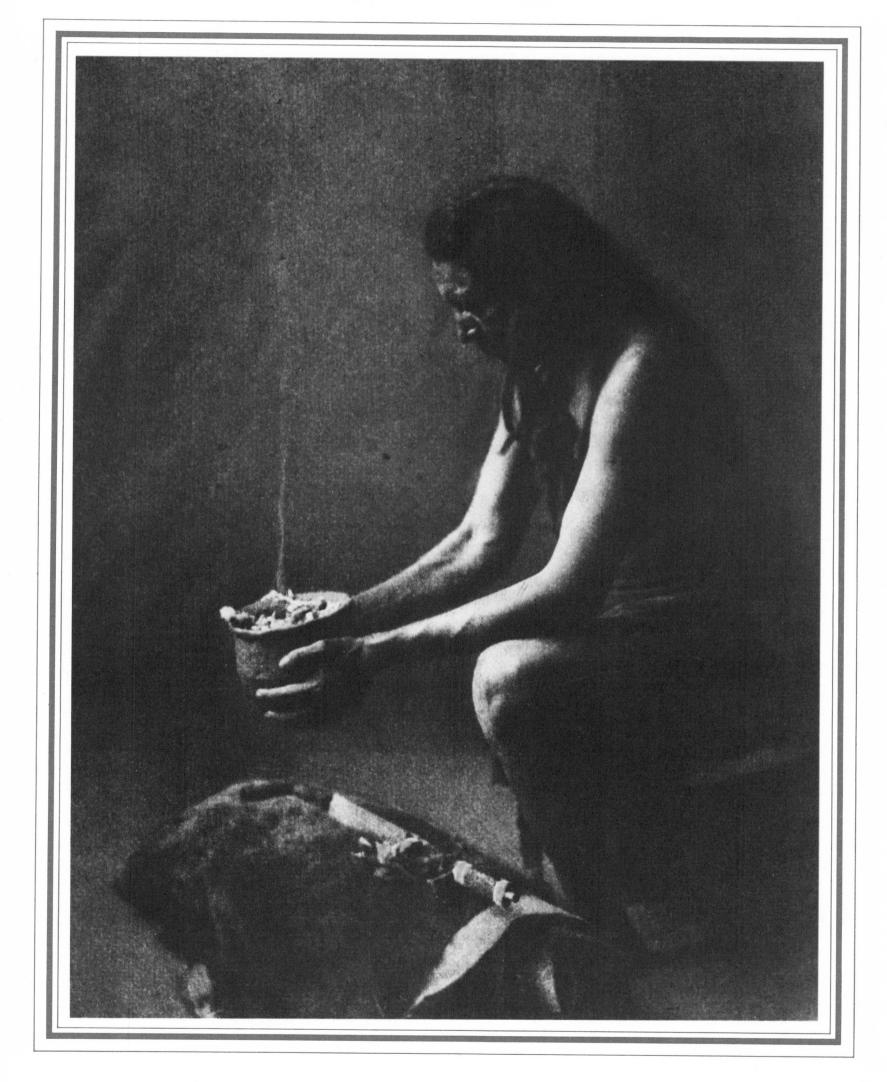

14. Shot in the Hand — Apsaroke

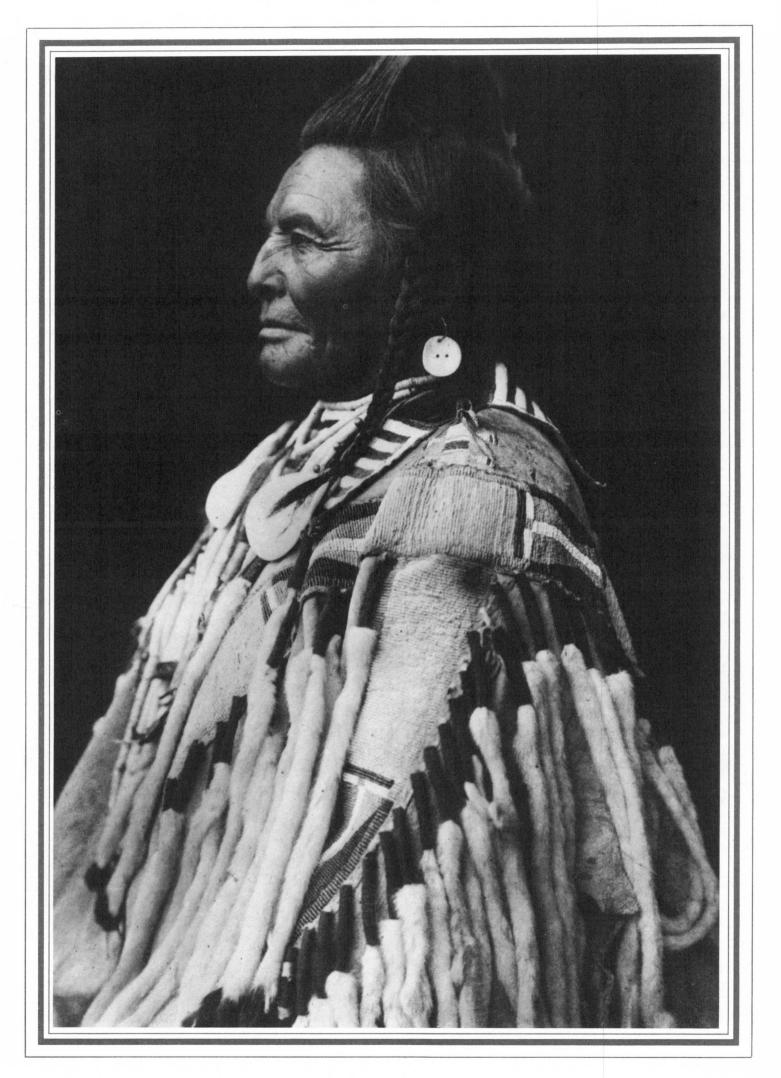

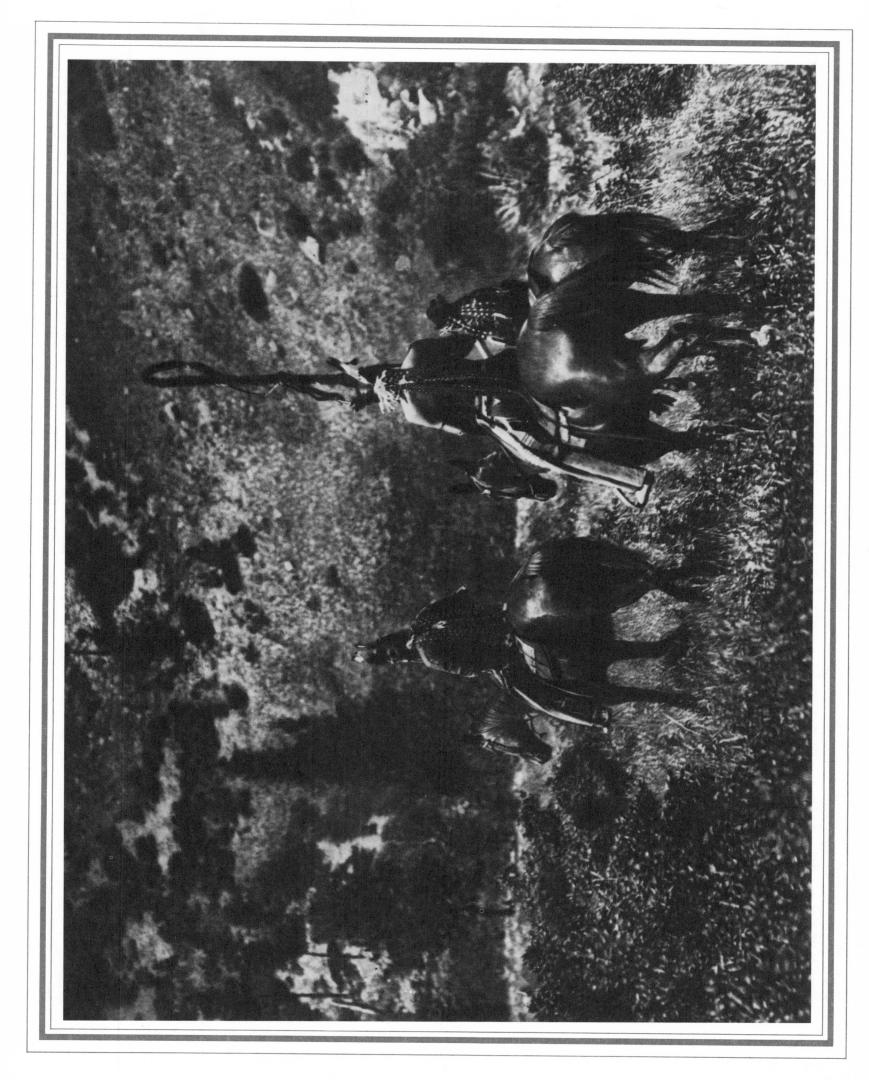

16. Two Leggings — Apsaroke

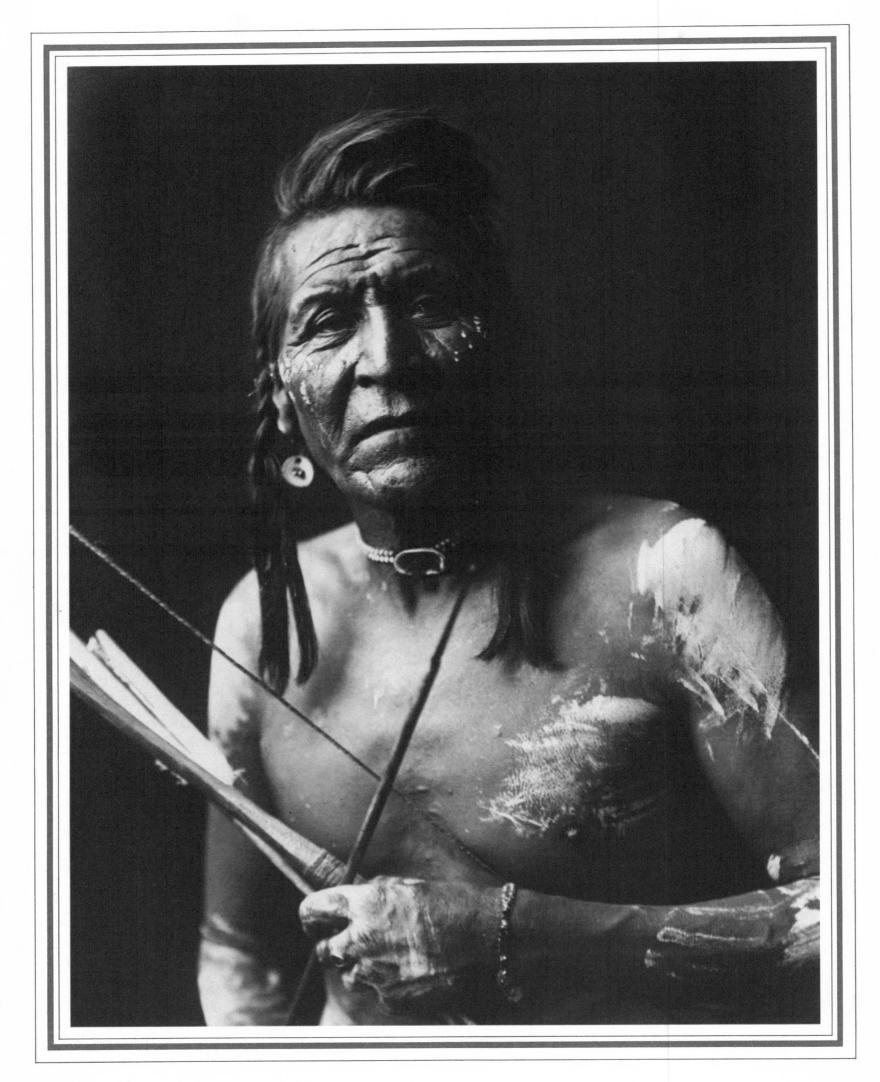

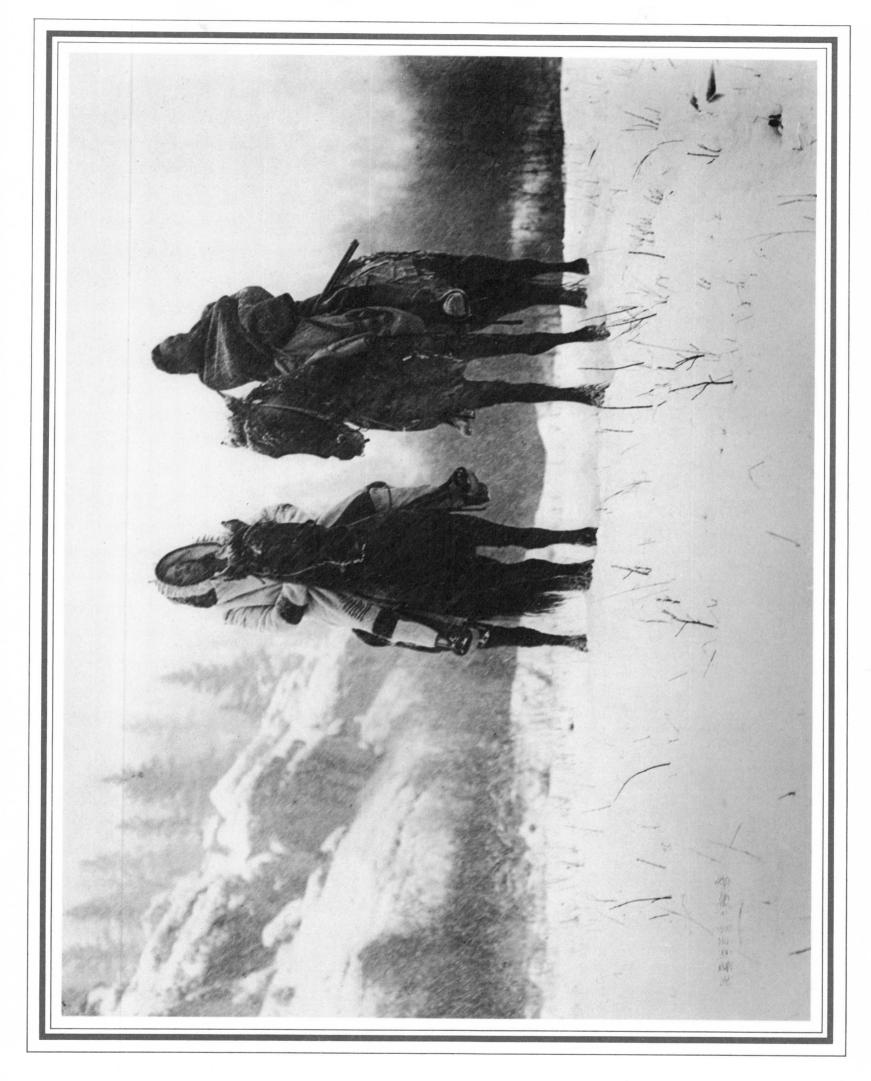

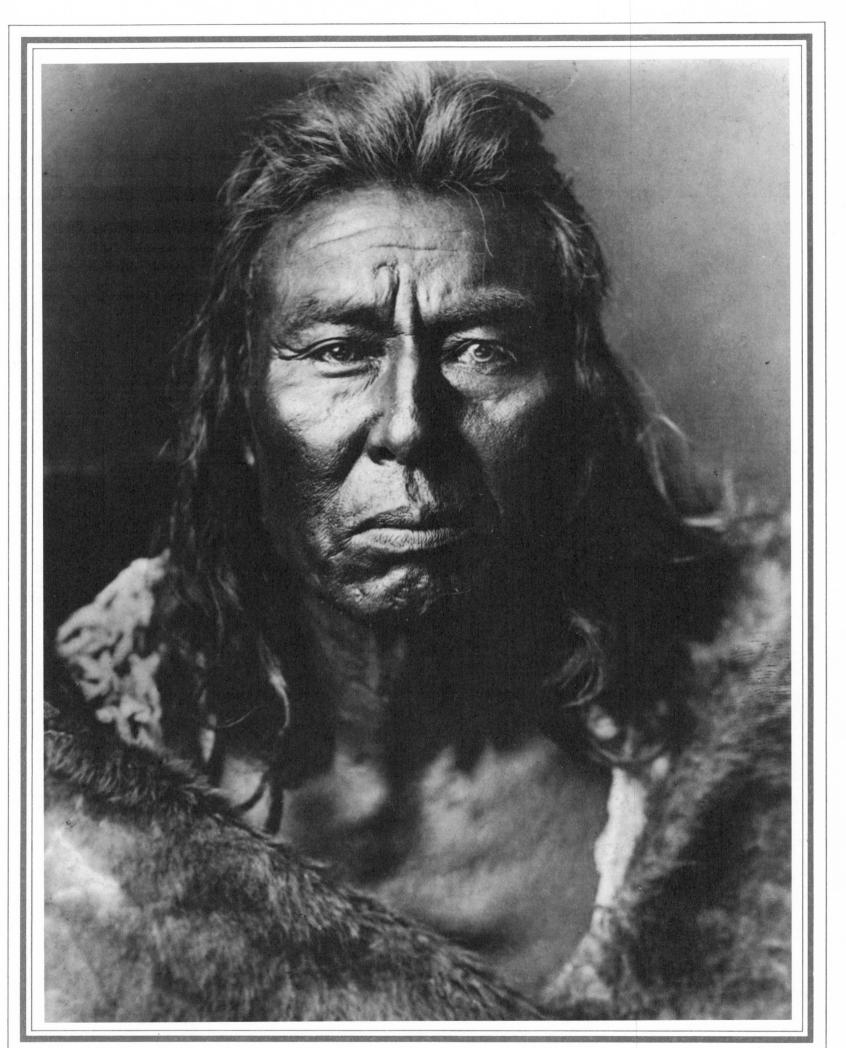

18. Arikara Man

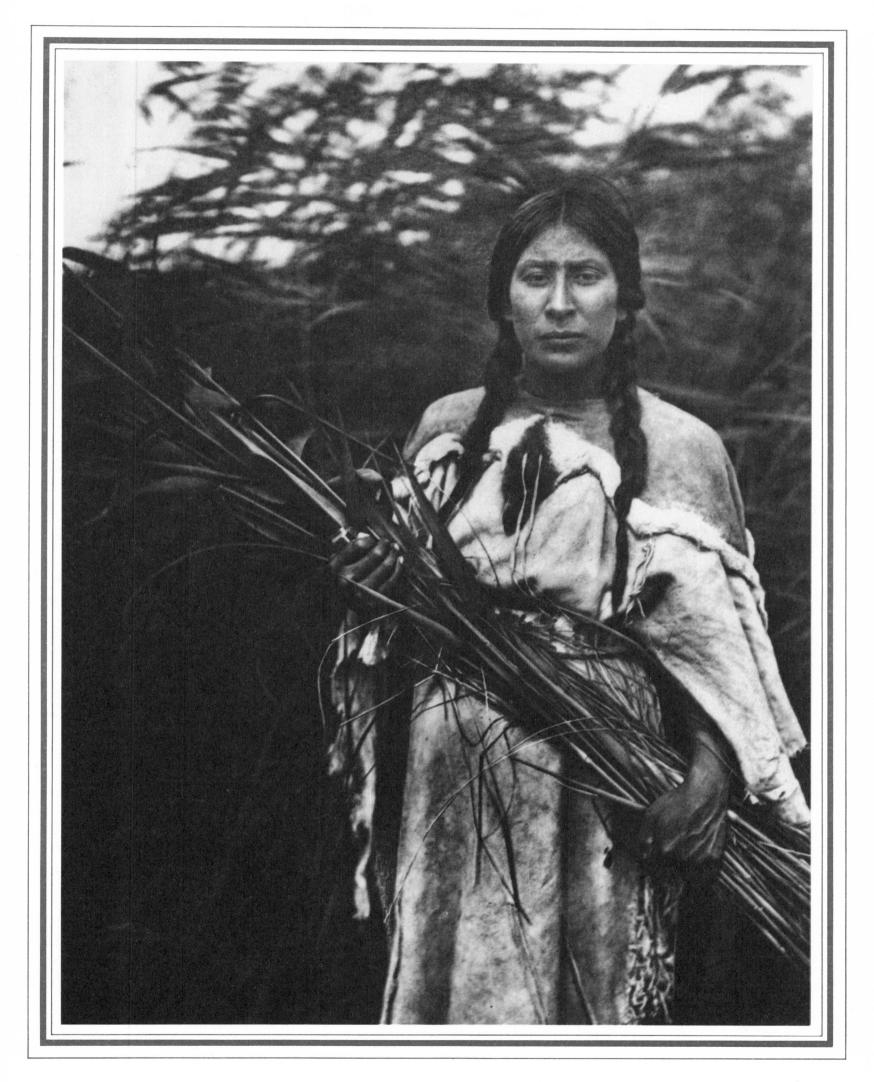

20. Red Whip — Atsina

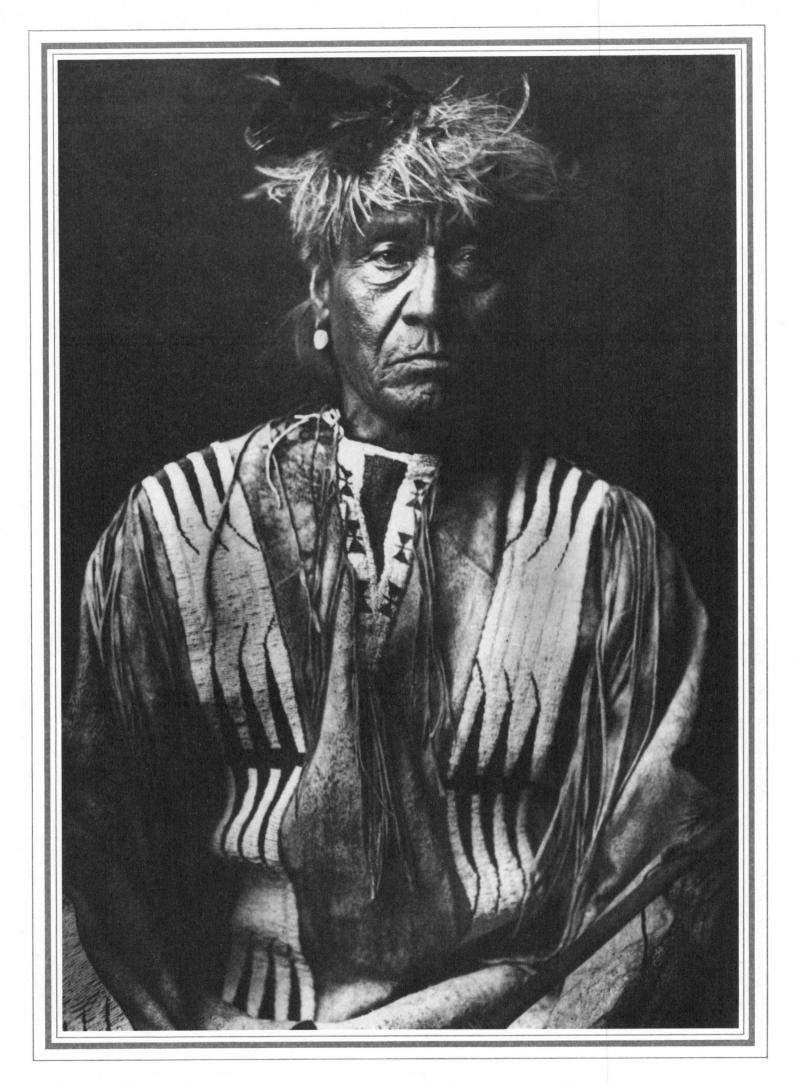

21. In the Medicine Lodge — Arikara

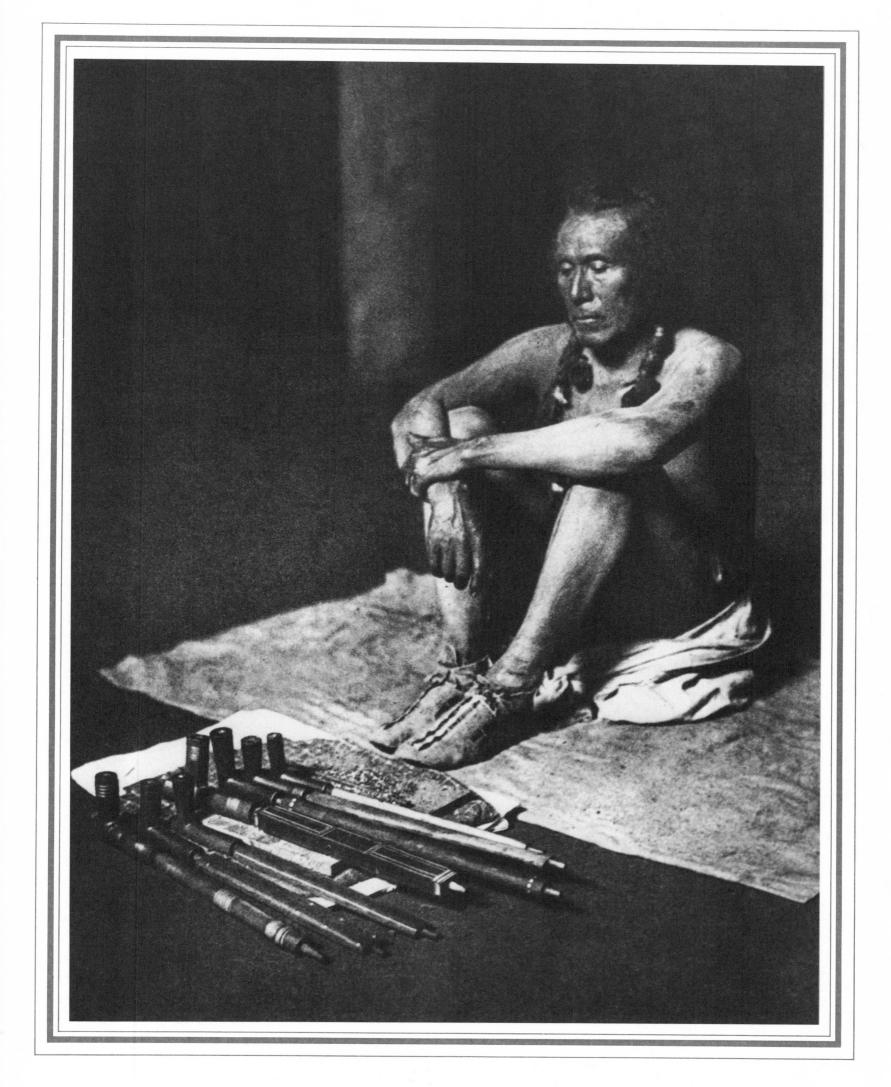

22. BEAR'S BELLY — ARIKARA

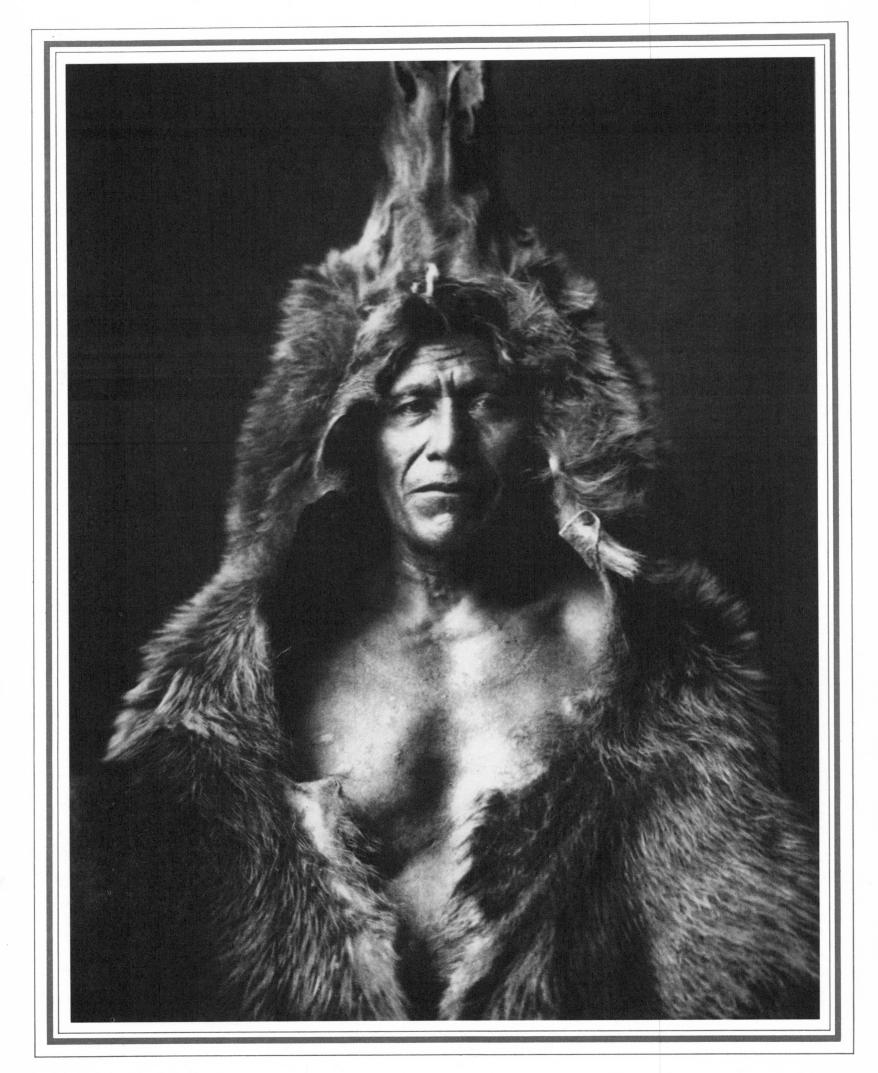

23. Arikara Woman

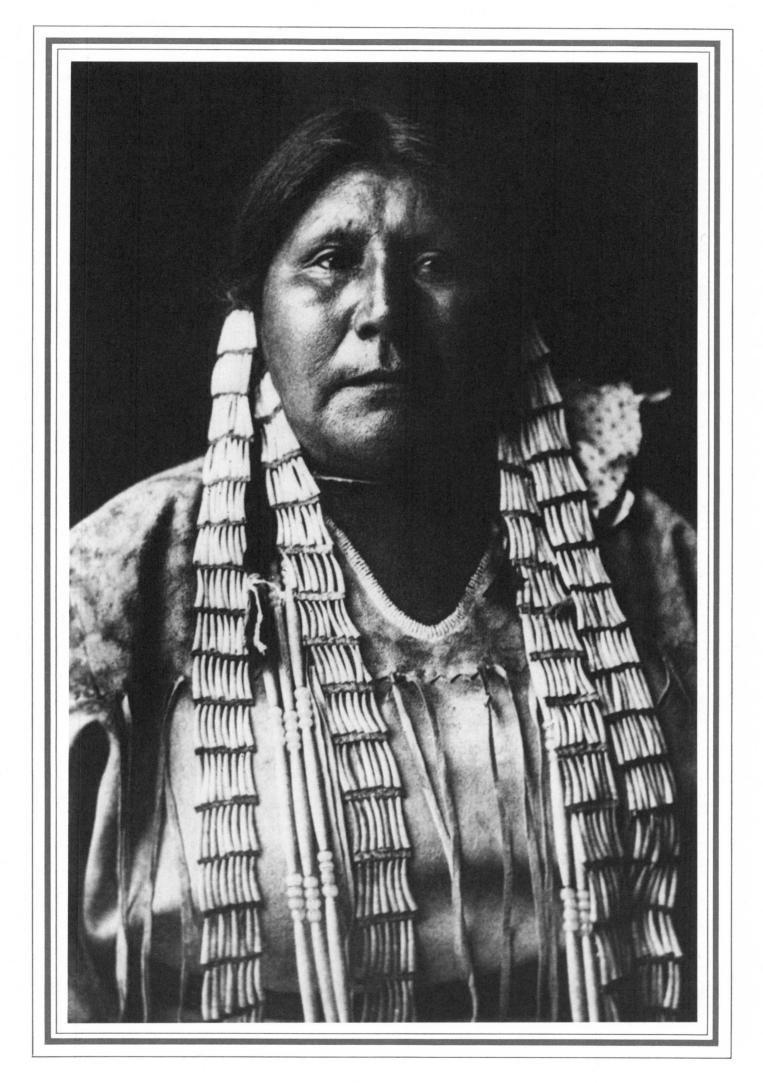

24. Crow Eagle — Piegan

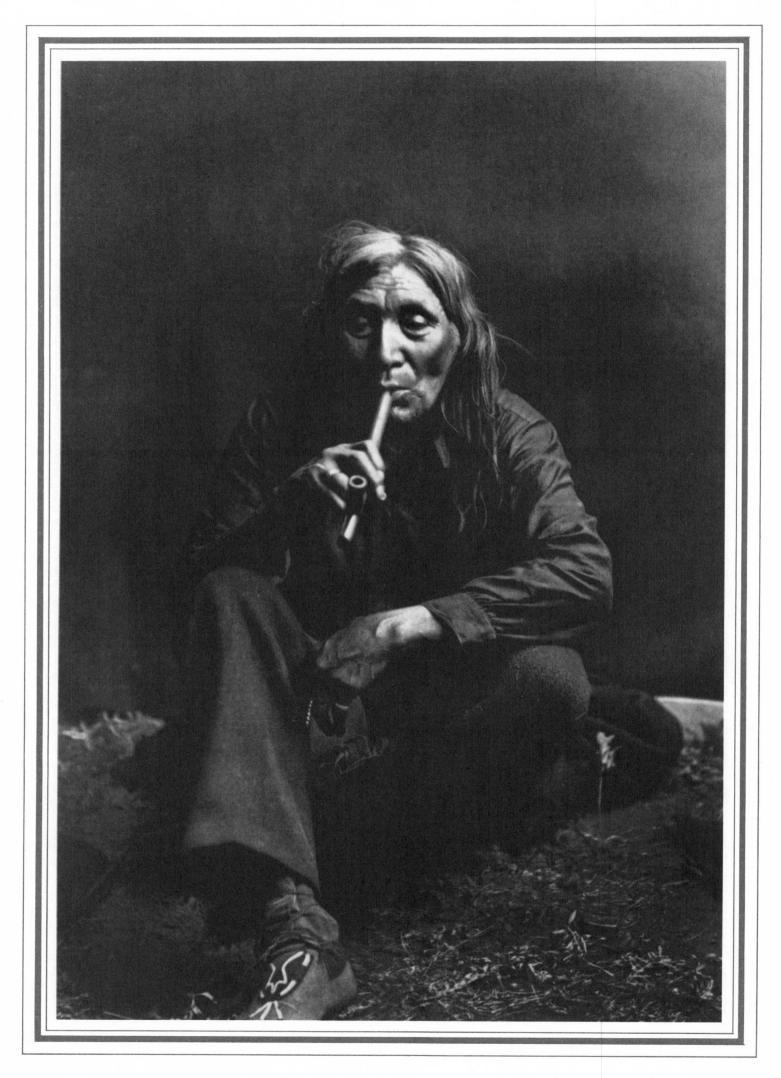

25. Two Bear Woman — Piegan

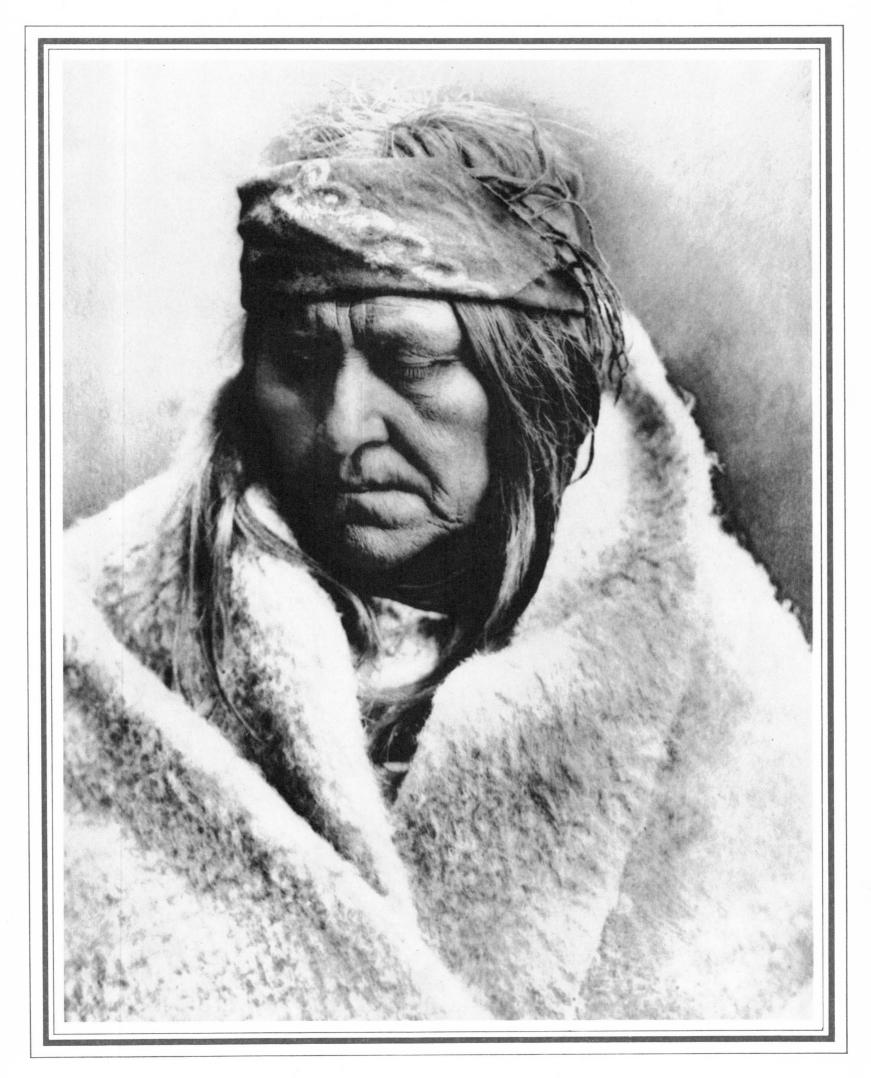

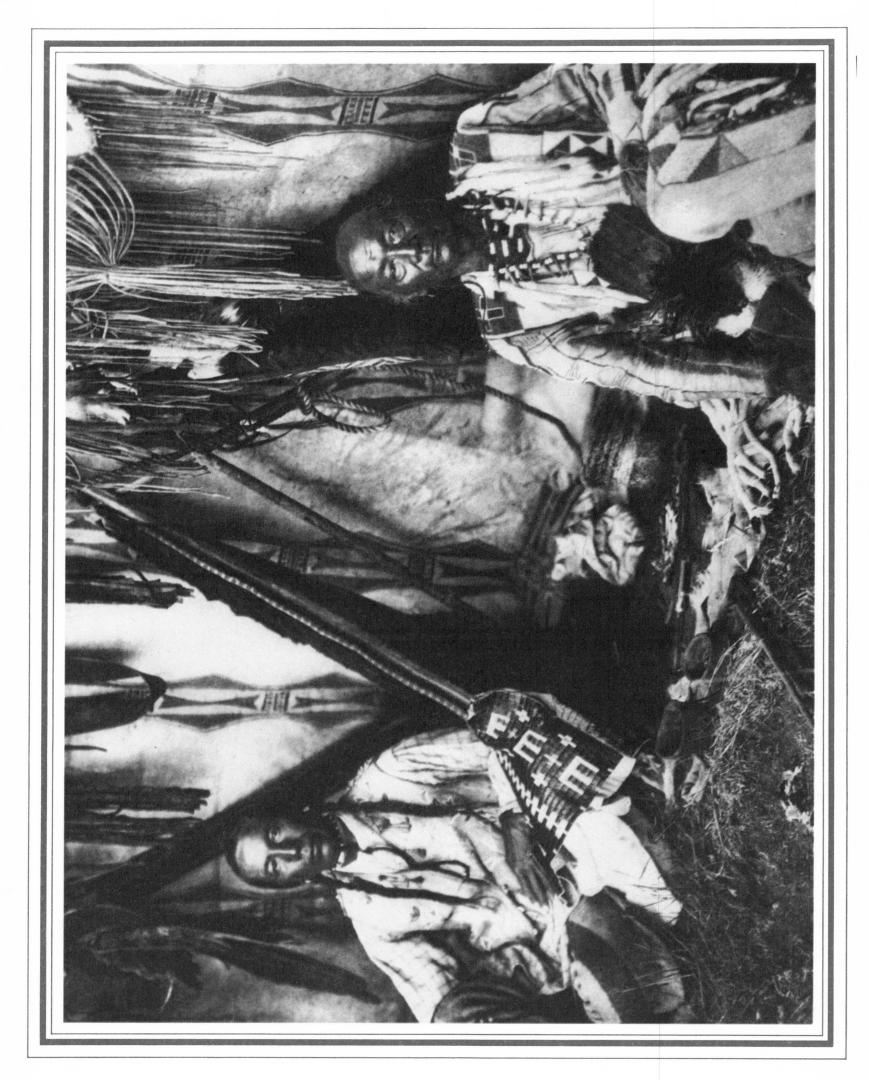

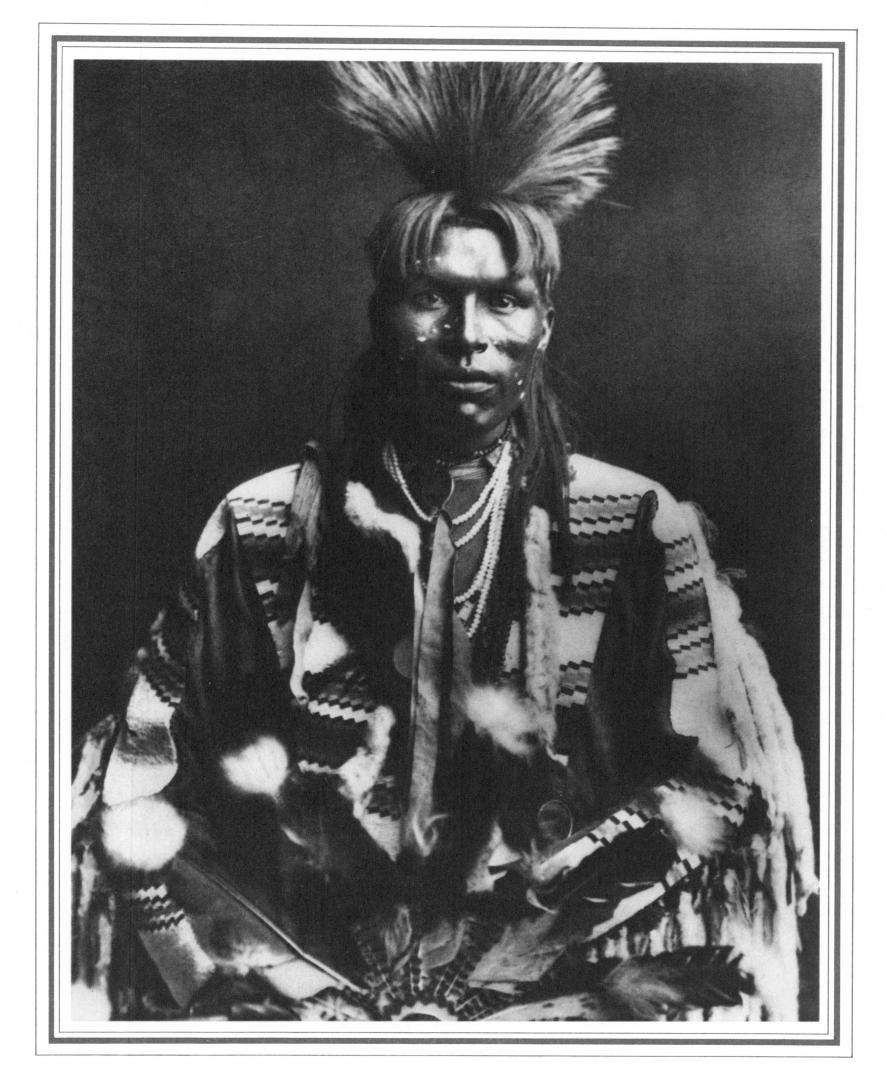

28. Waiting in the Forest — Cheyenne

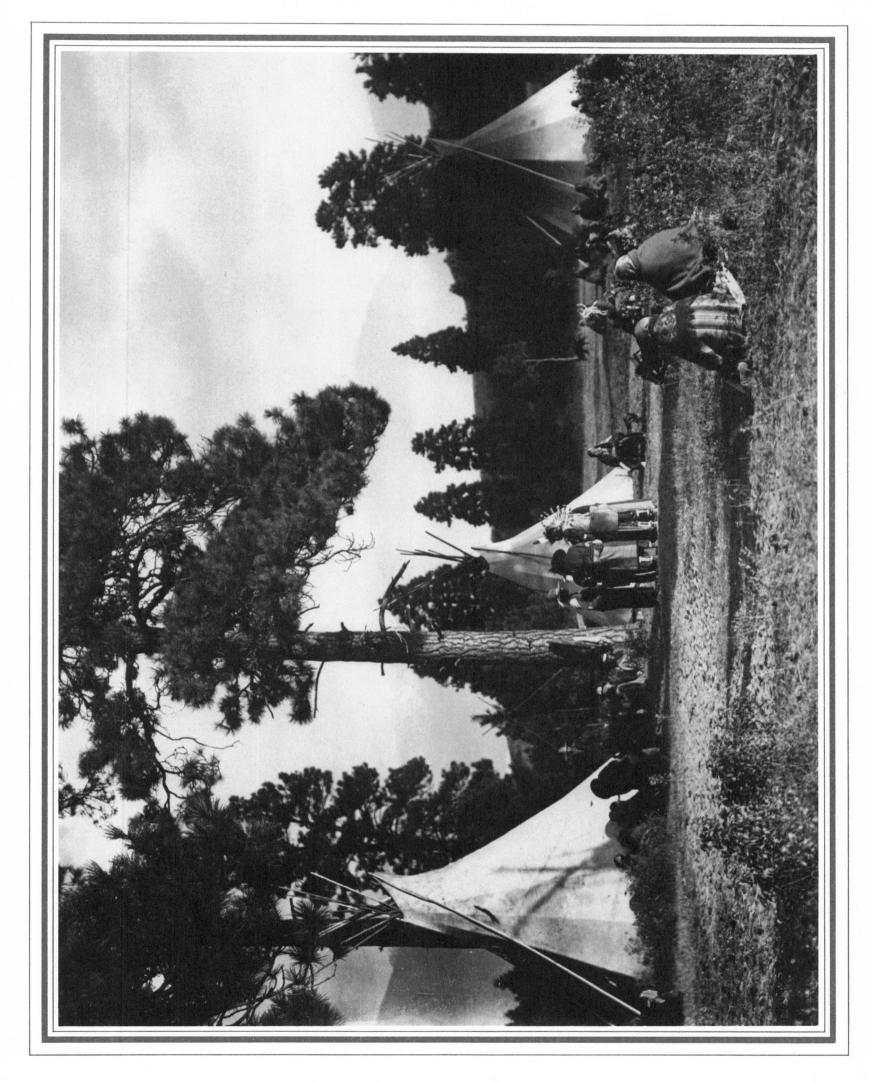

30. KLICKITAT PROFILE

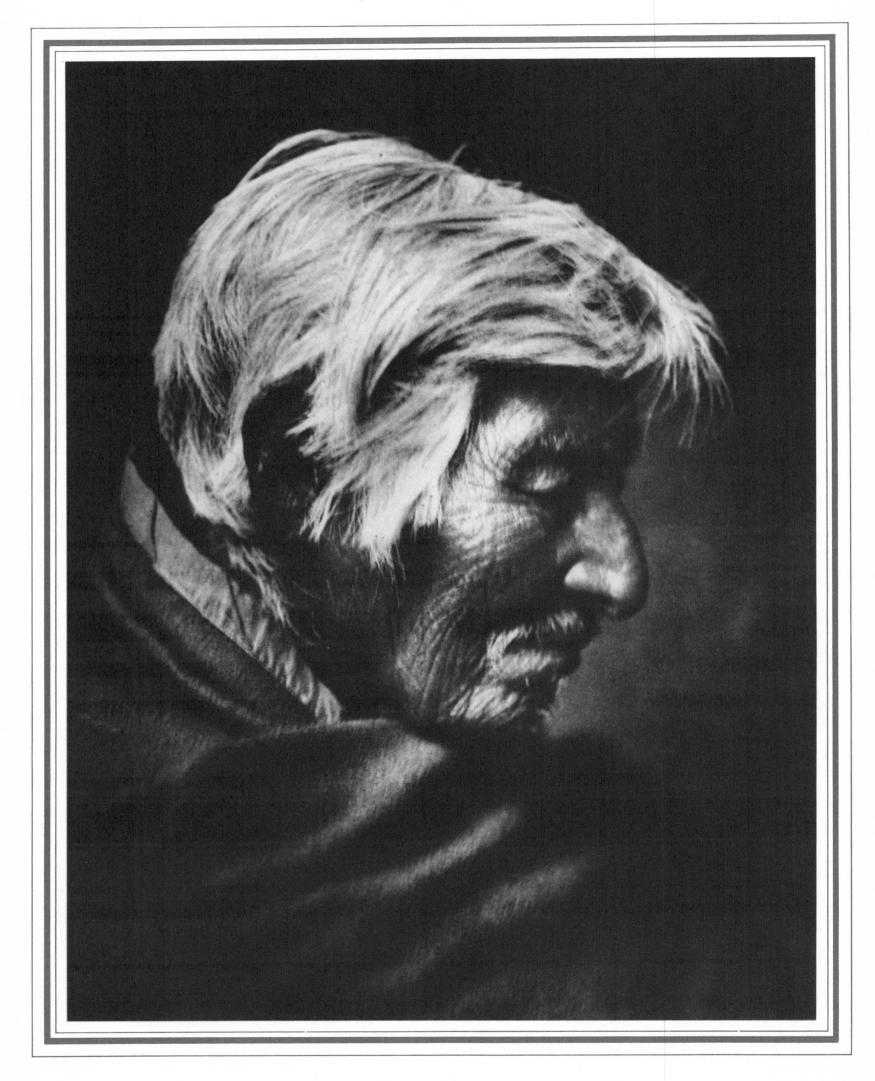

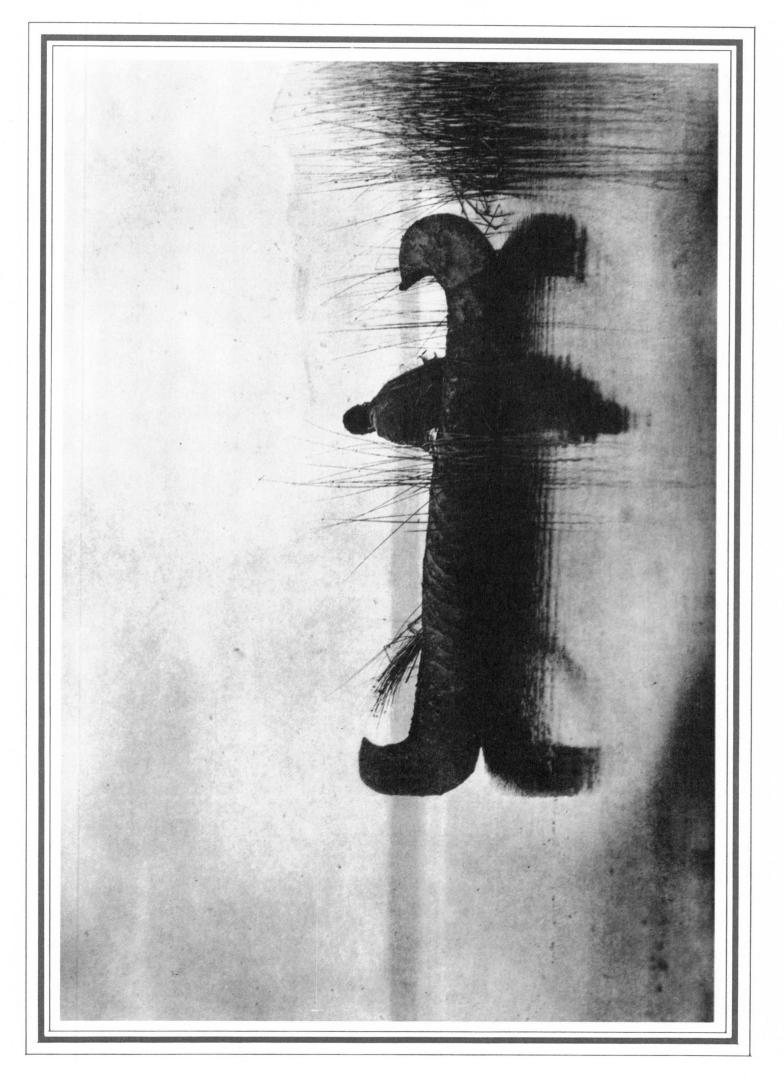

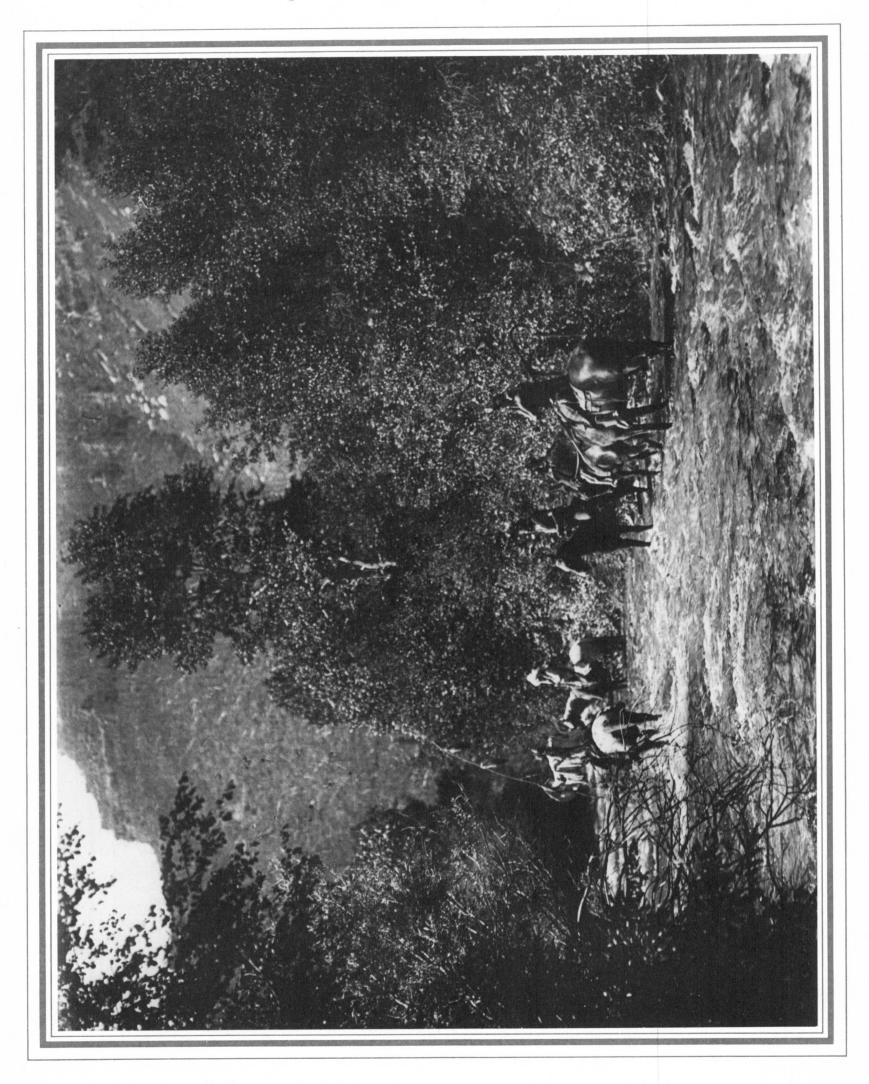

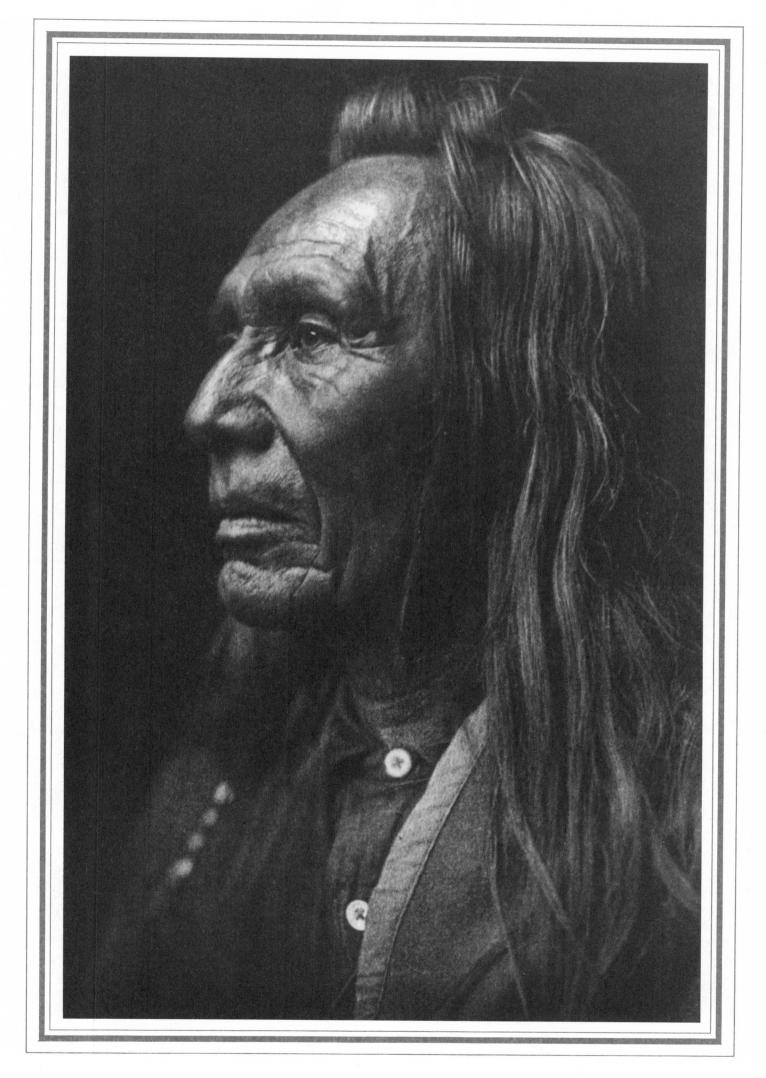

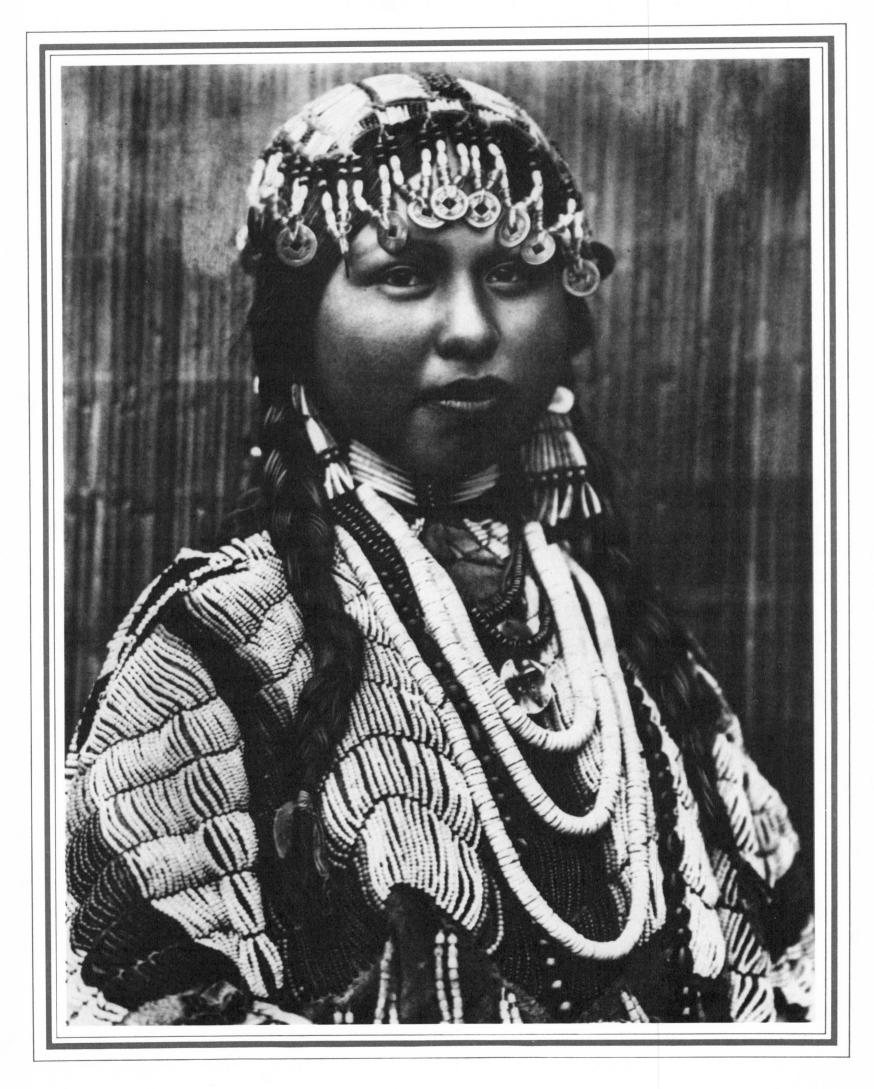

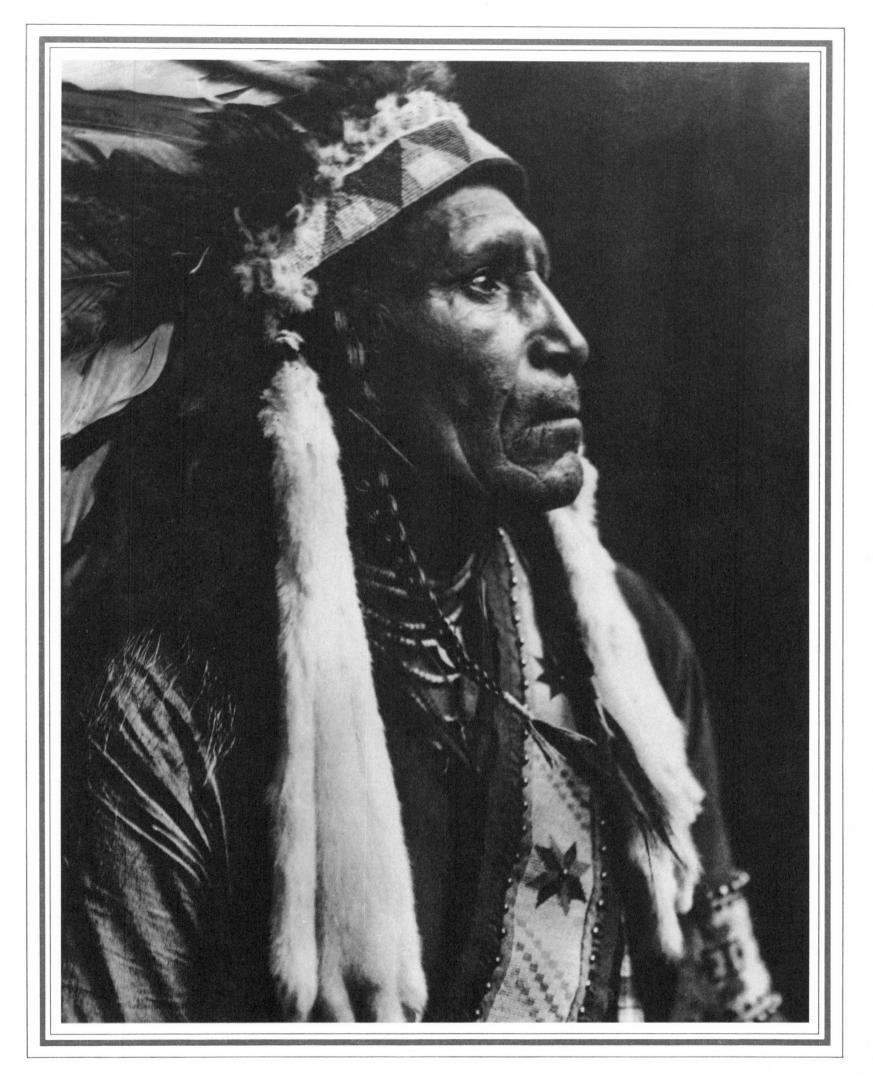

36. Evening on Puget Sound

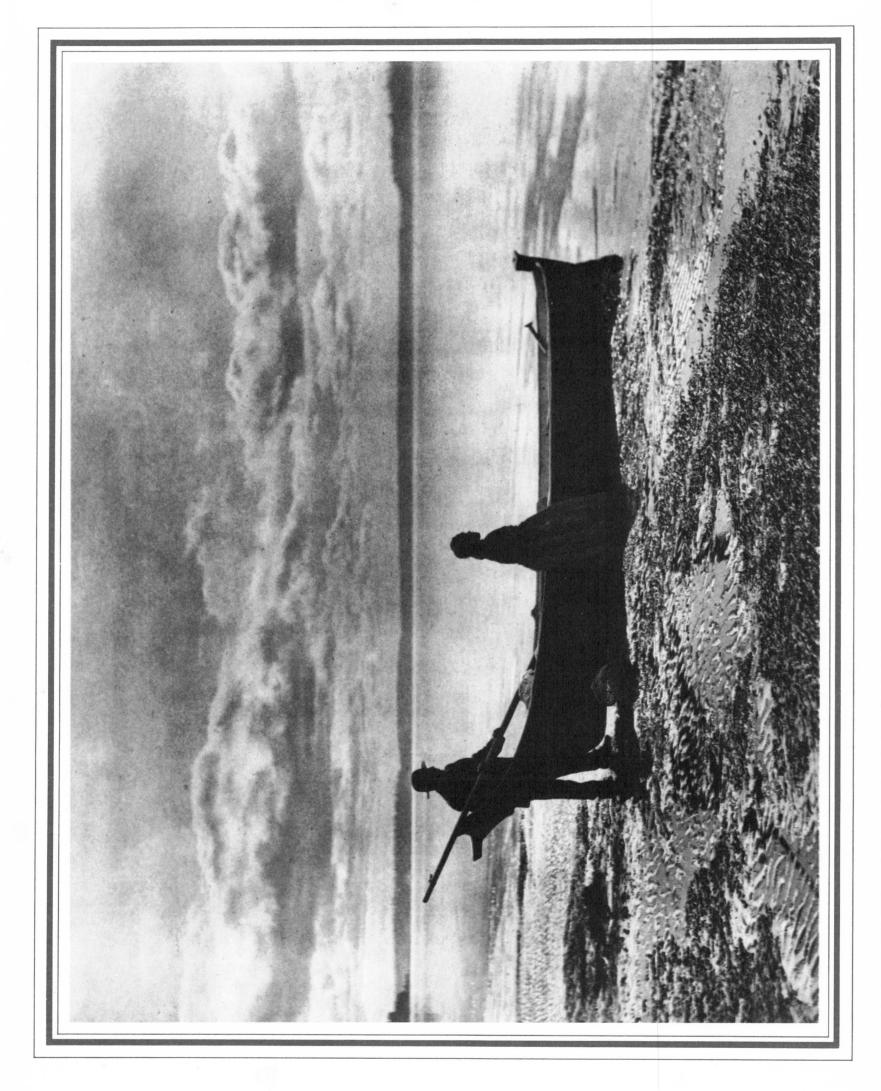

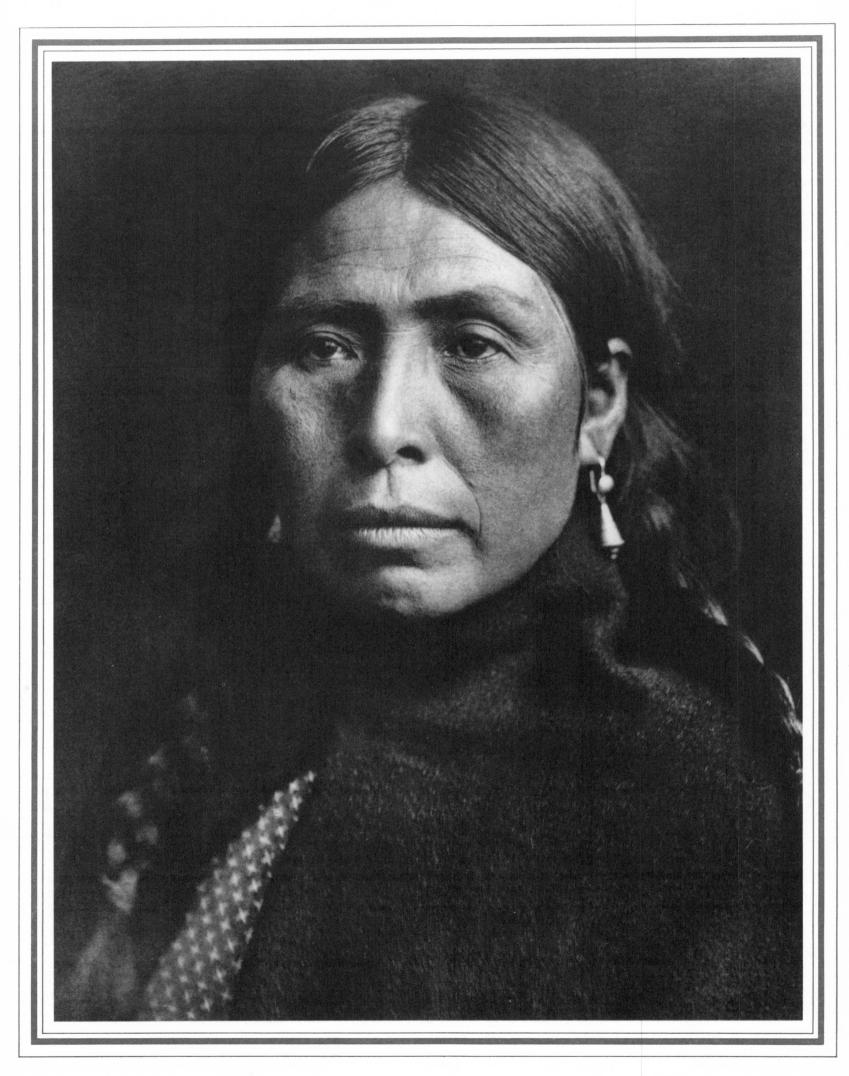

39. Lélehatl — Quilcene

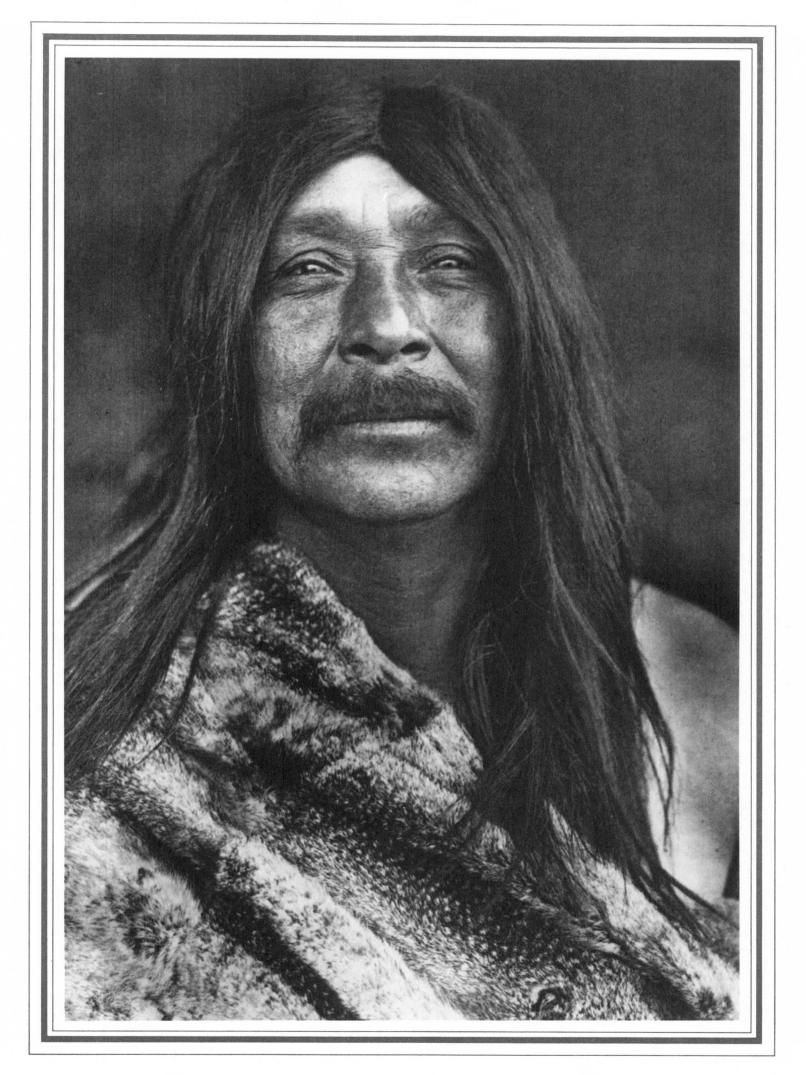

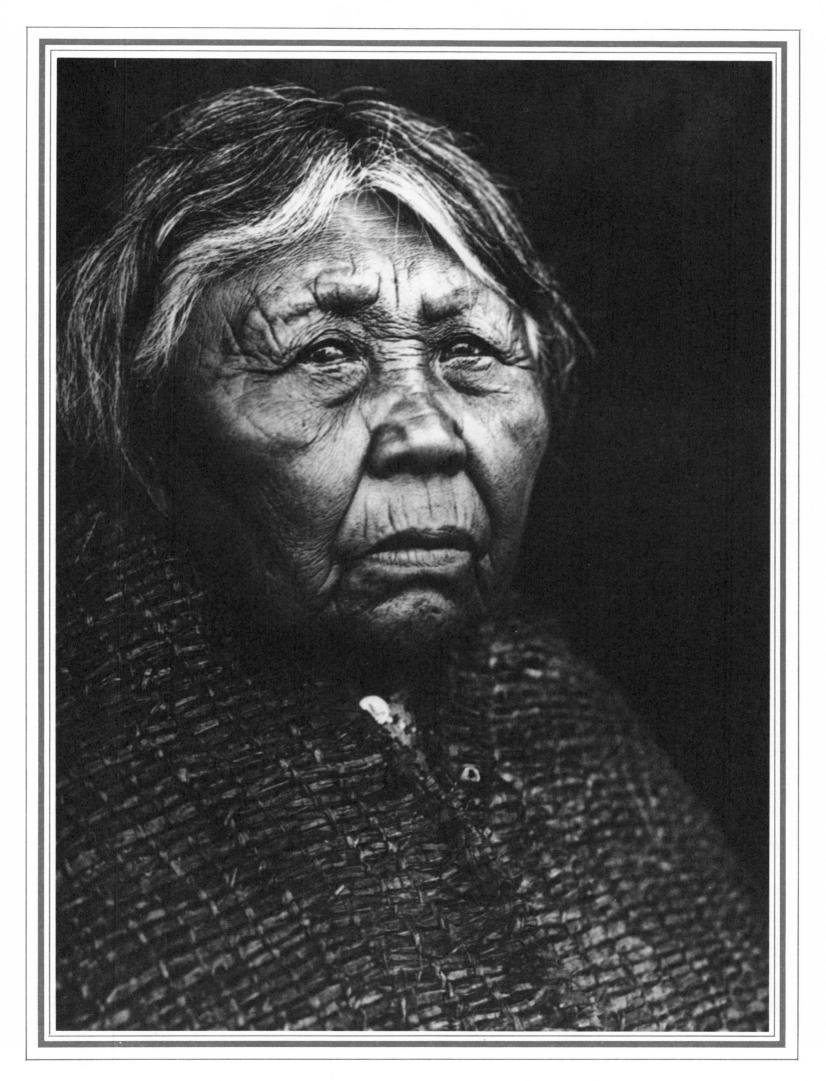

42. Quilcene Boy

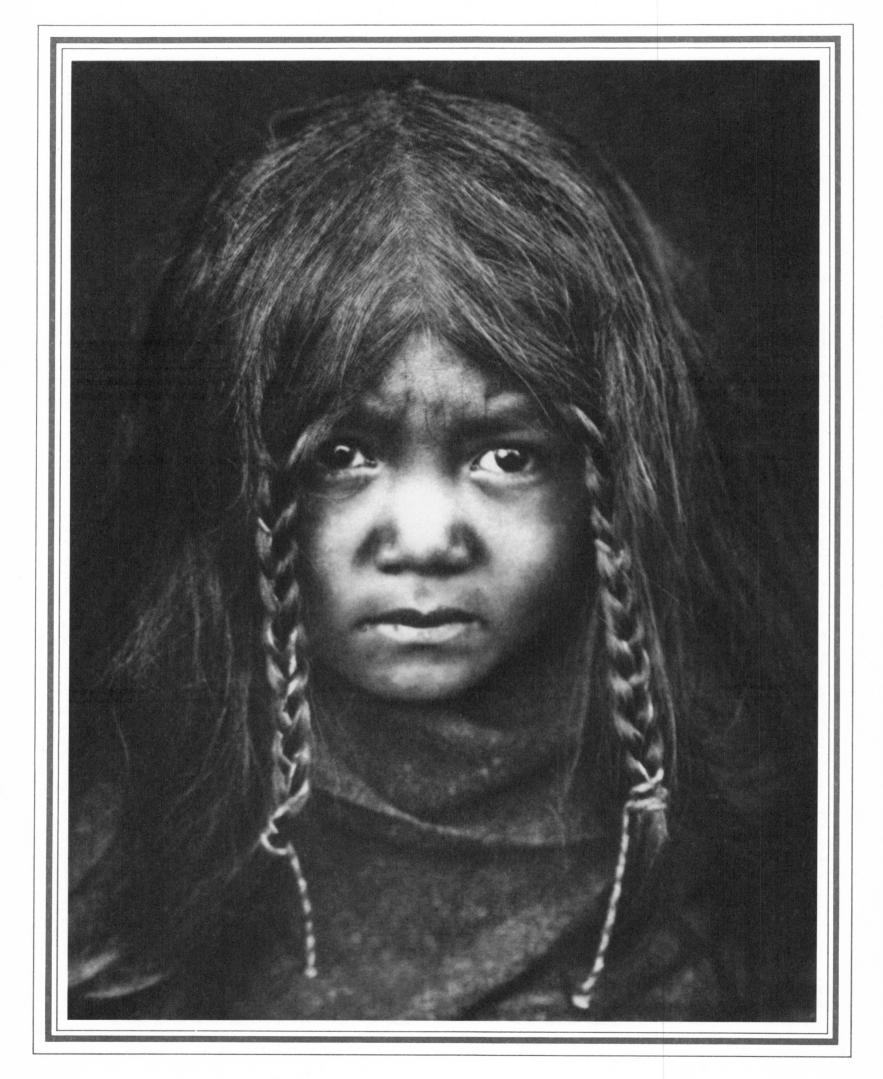

43. Nakoaktok Chief and Copper

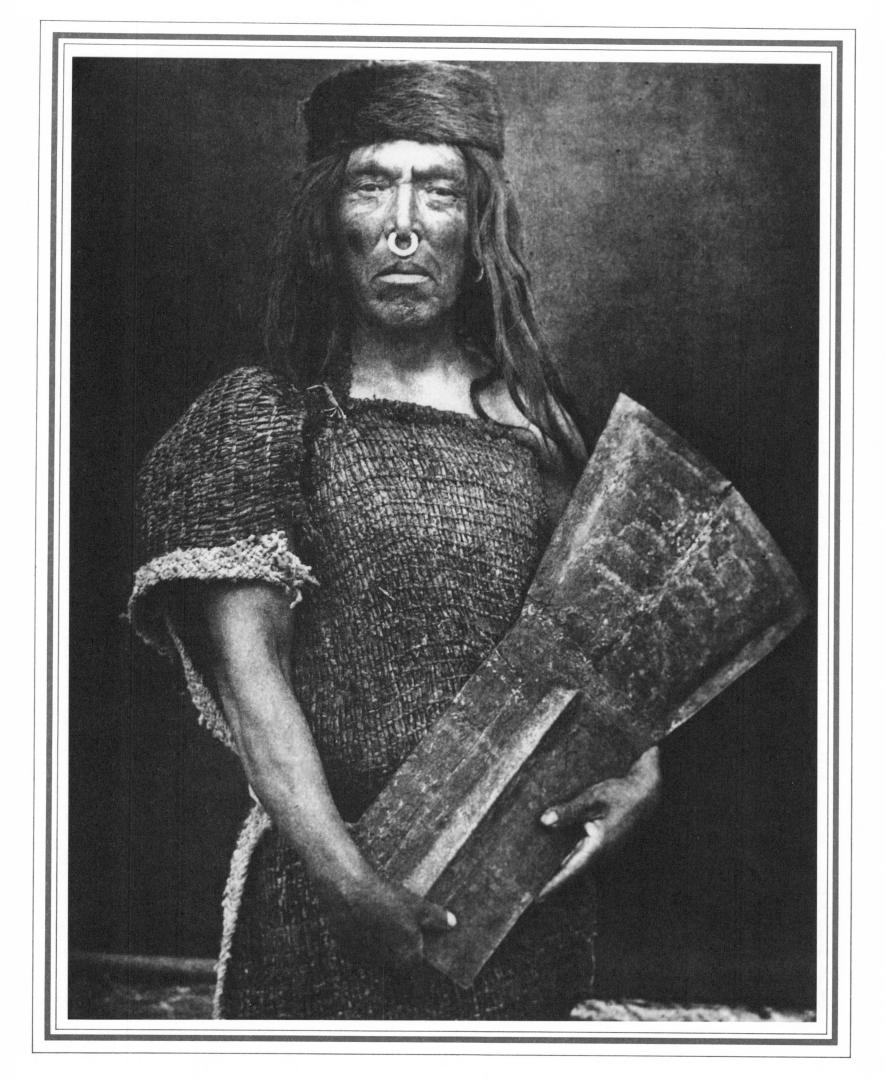

45. Painting a Hat — Nakoaktok

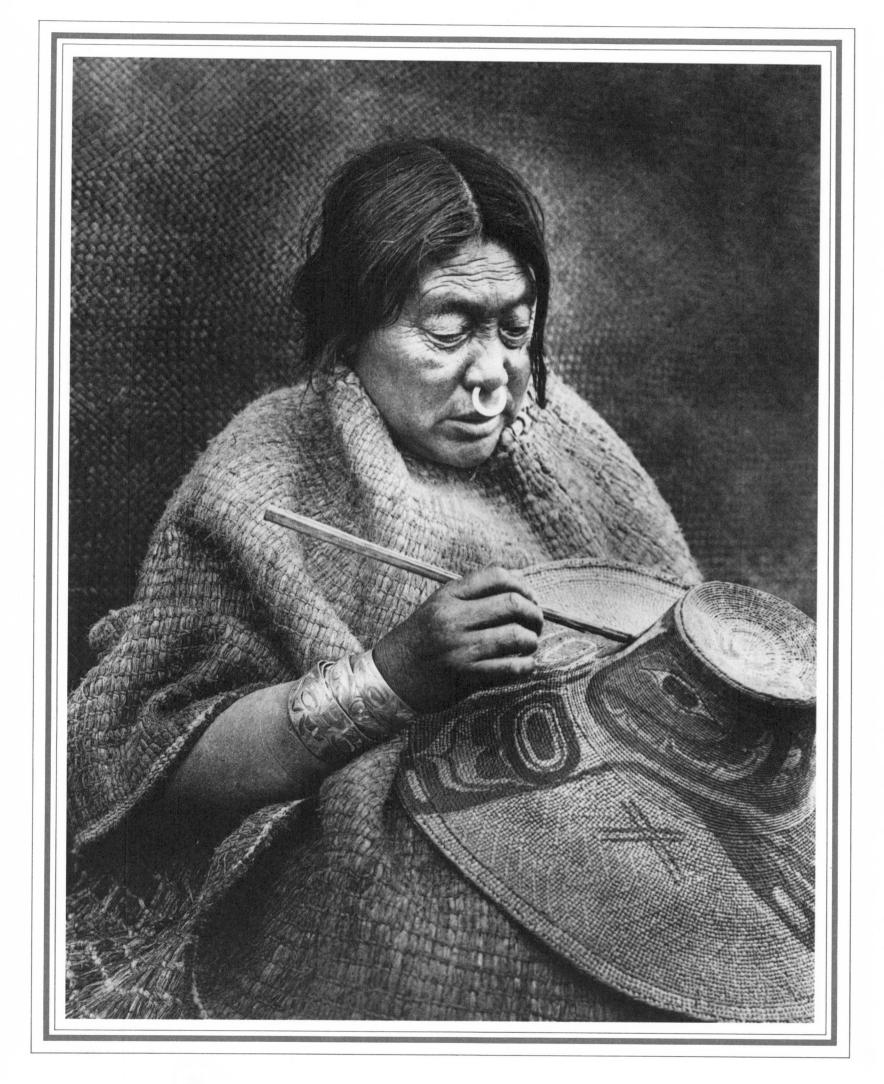

46. A Tlü Wüláhü Mask — Tsawatenok

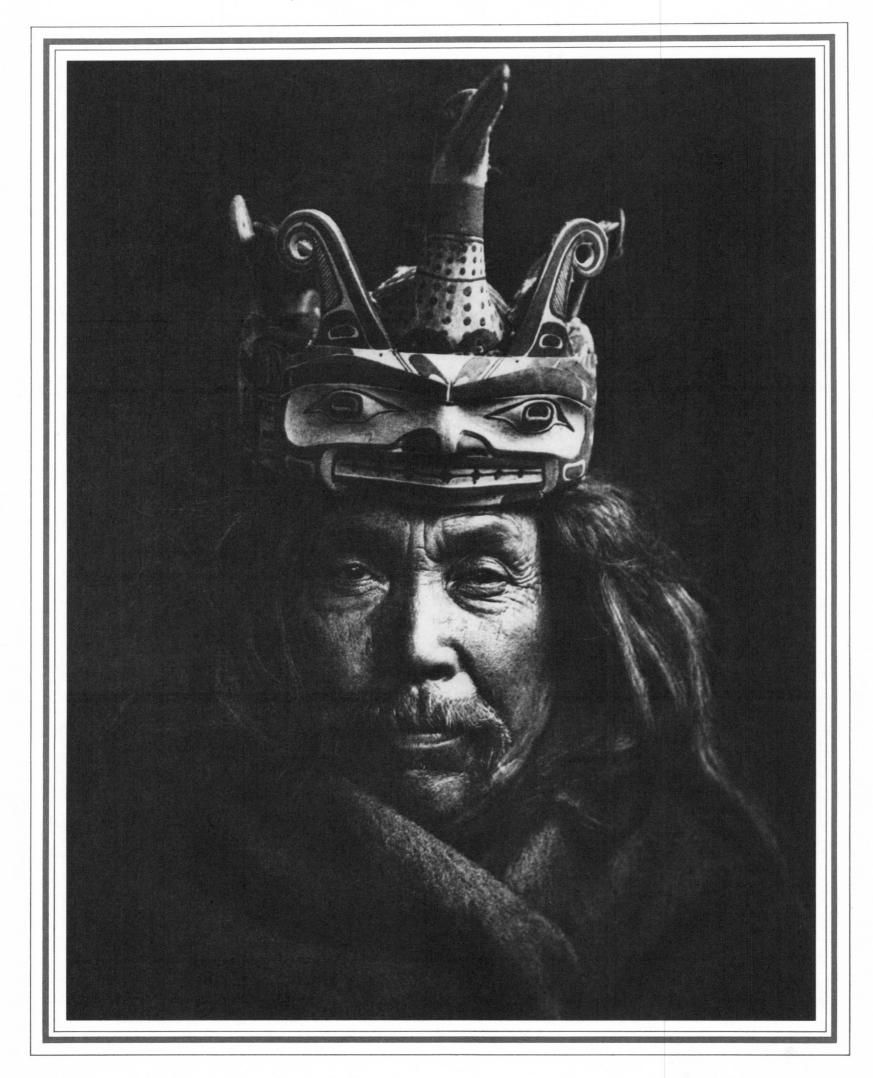

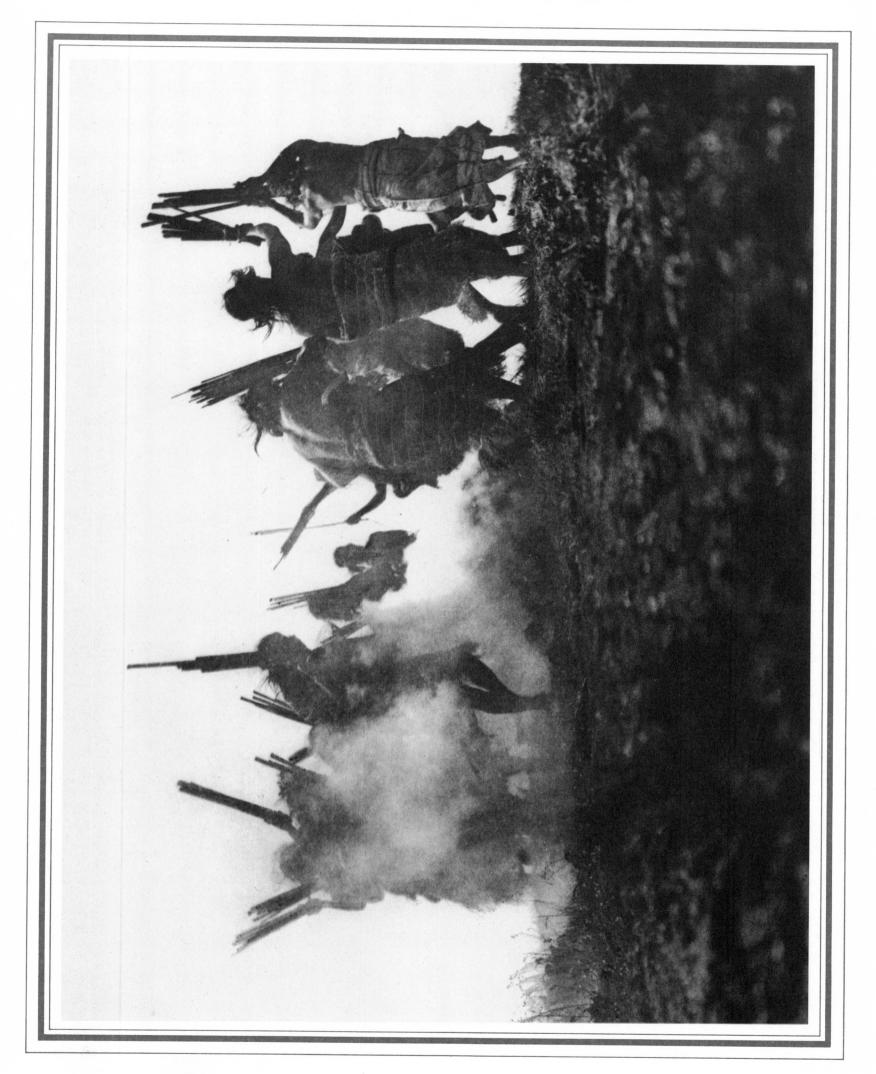

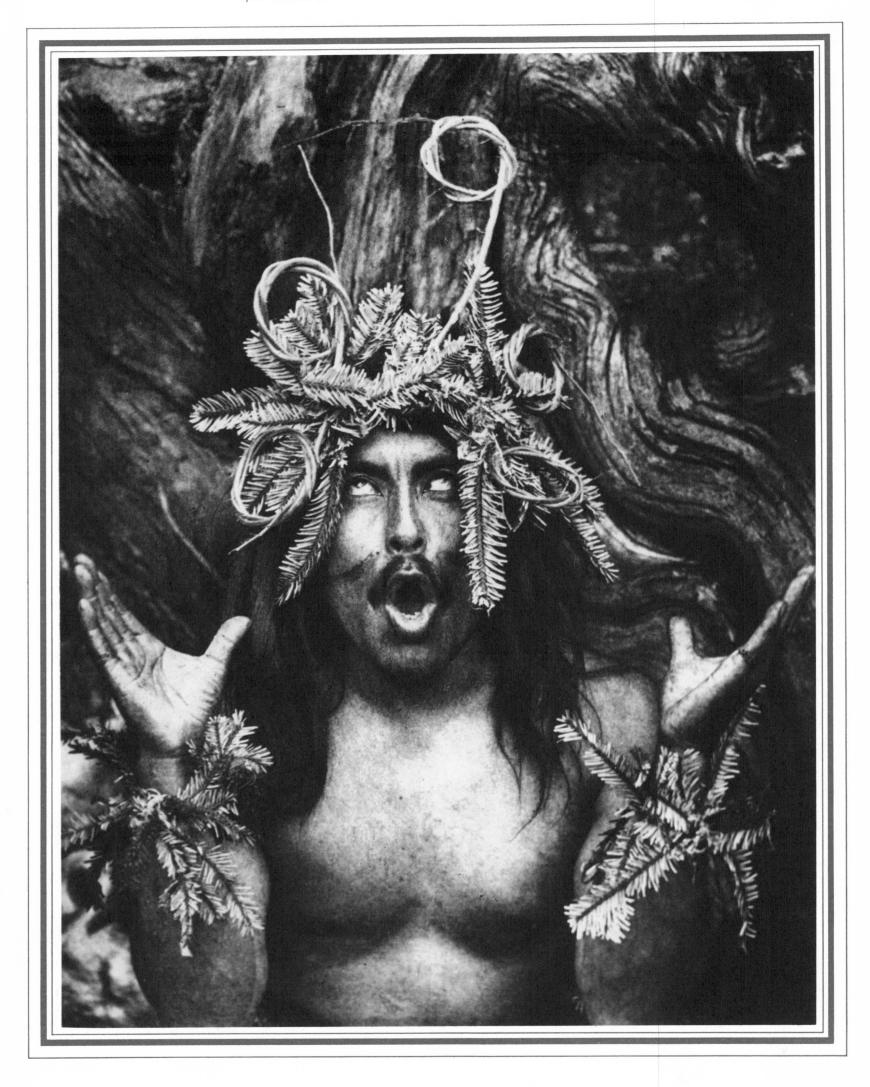

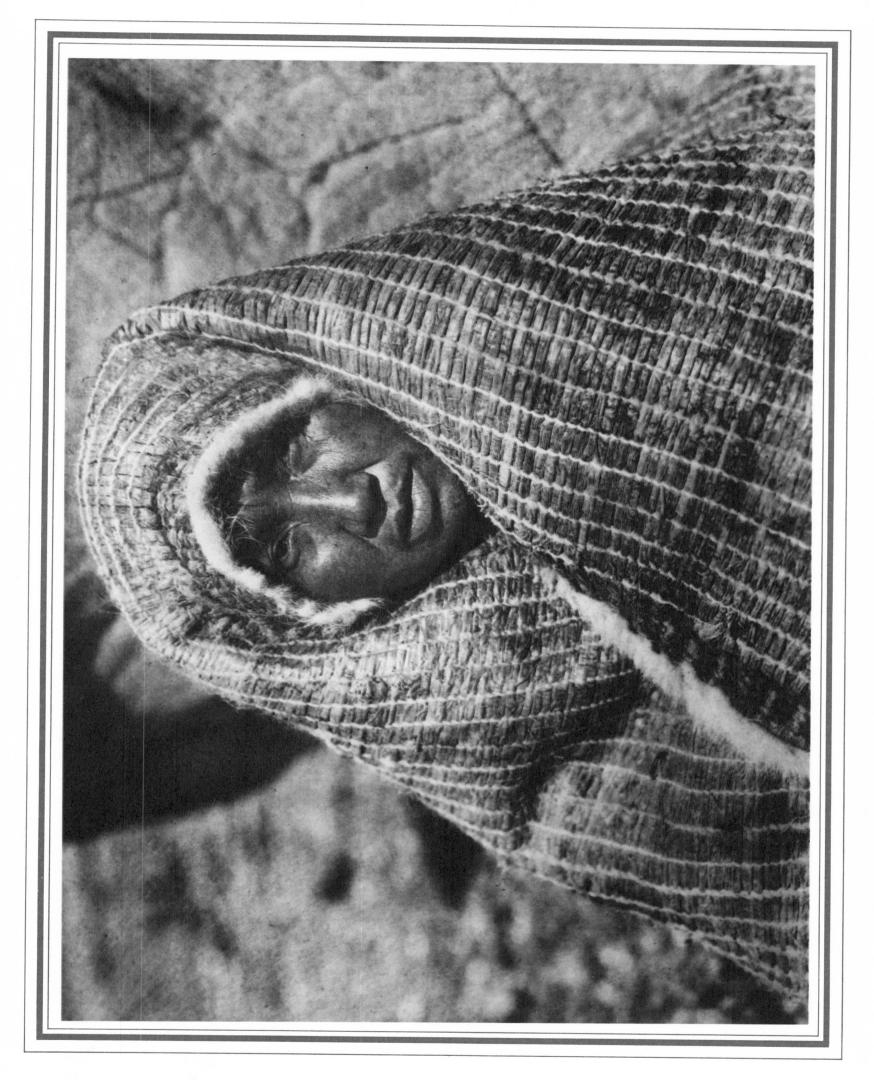

50. A HAIDA OF KUNG

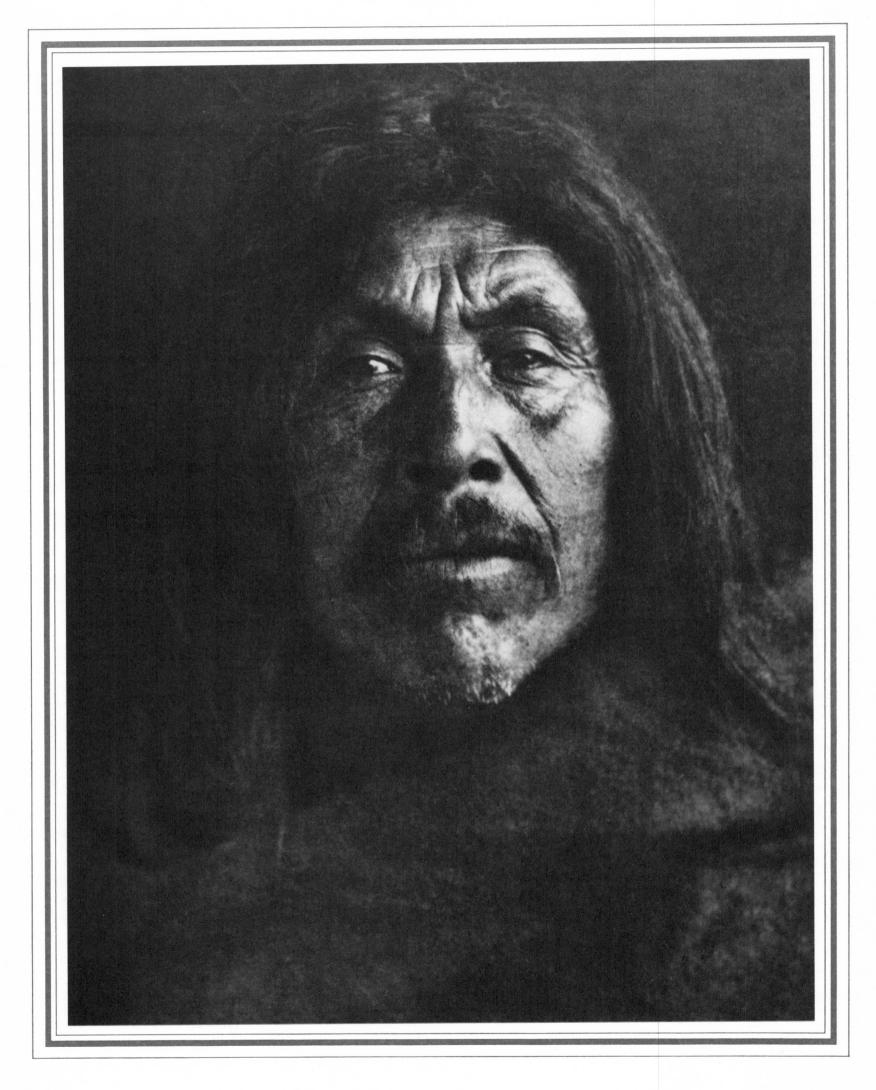

51. Waiting for the Canoe — Nootka

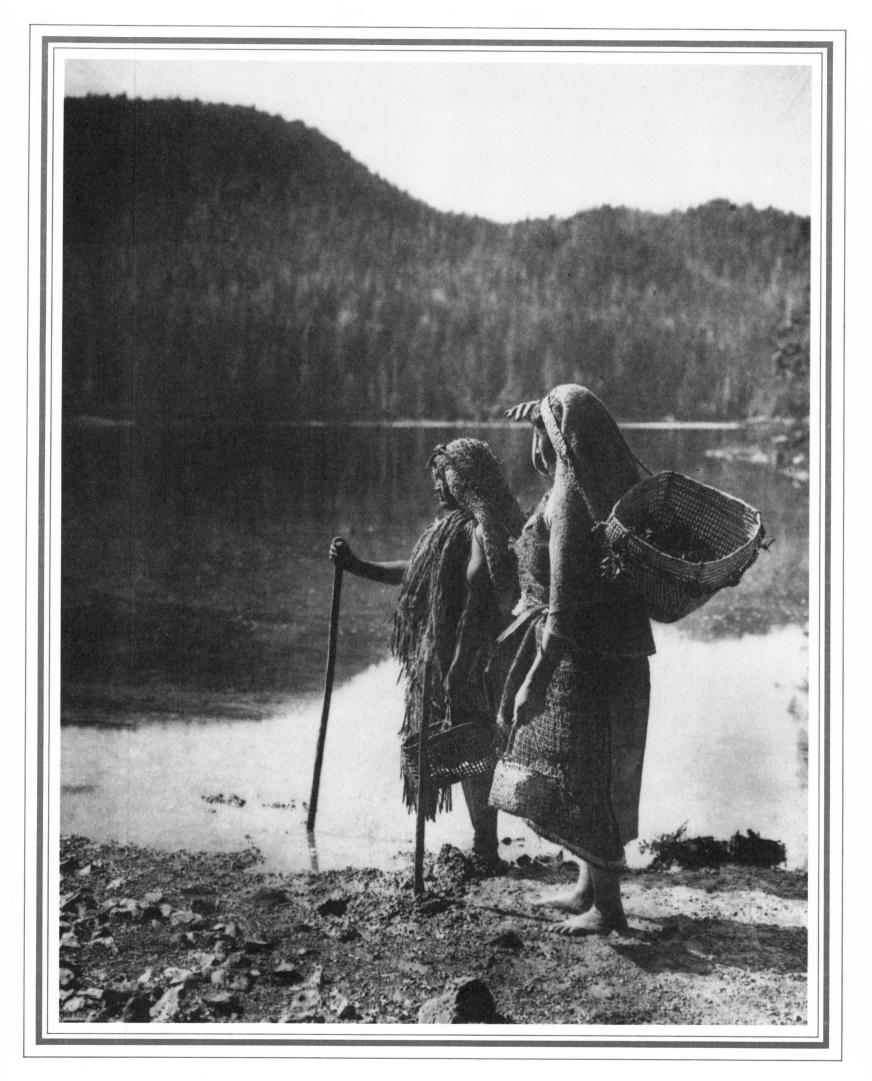

52. Hopi Snake Priest

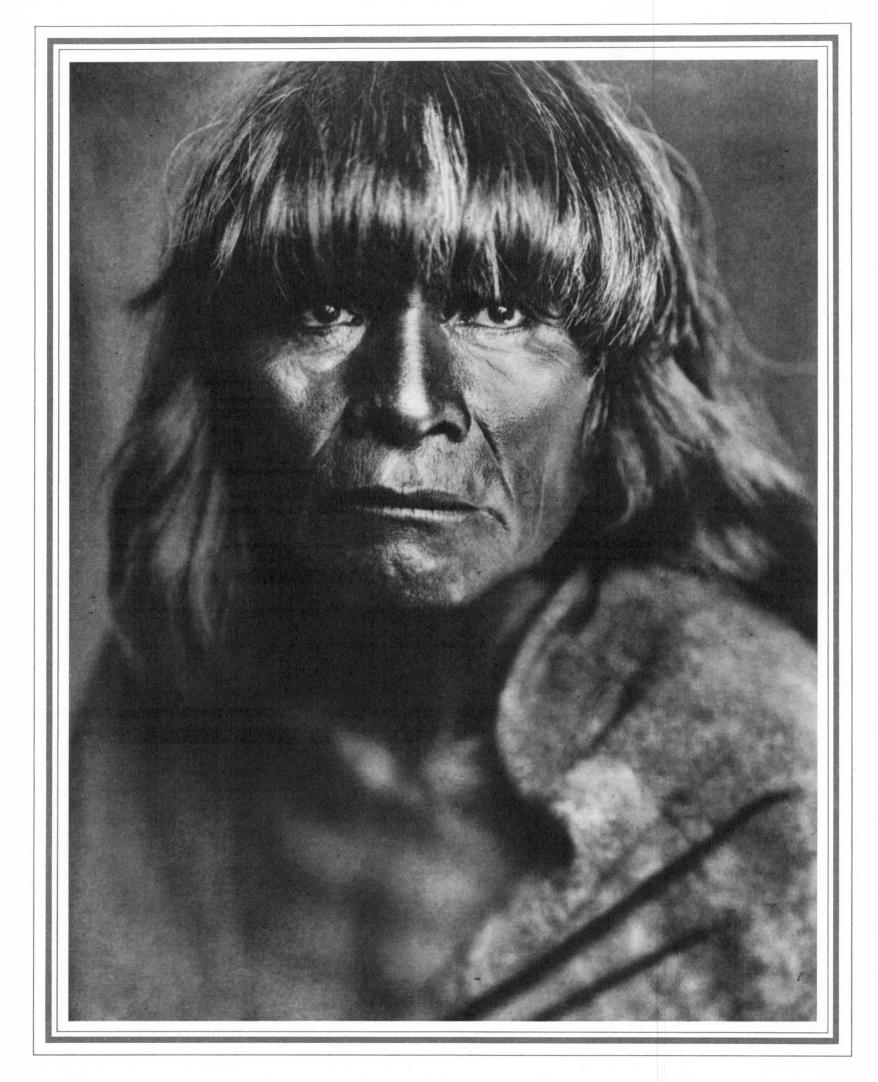

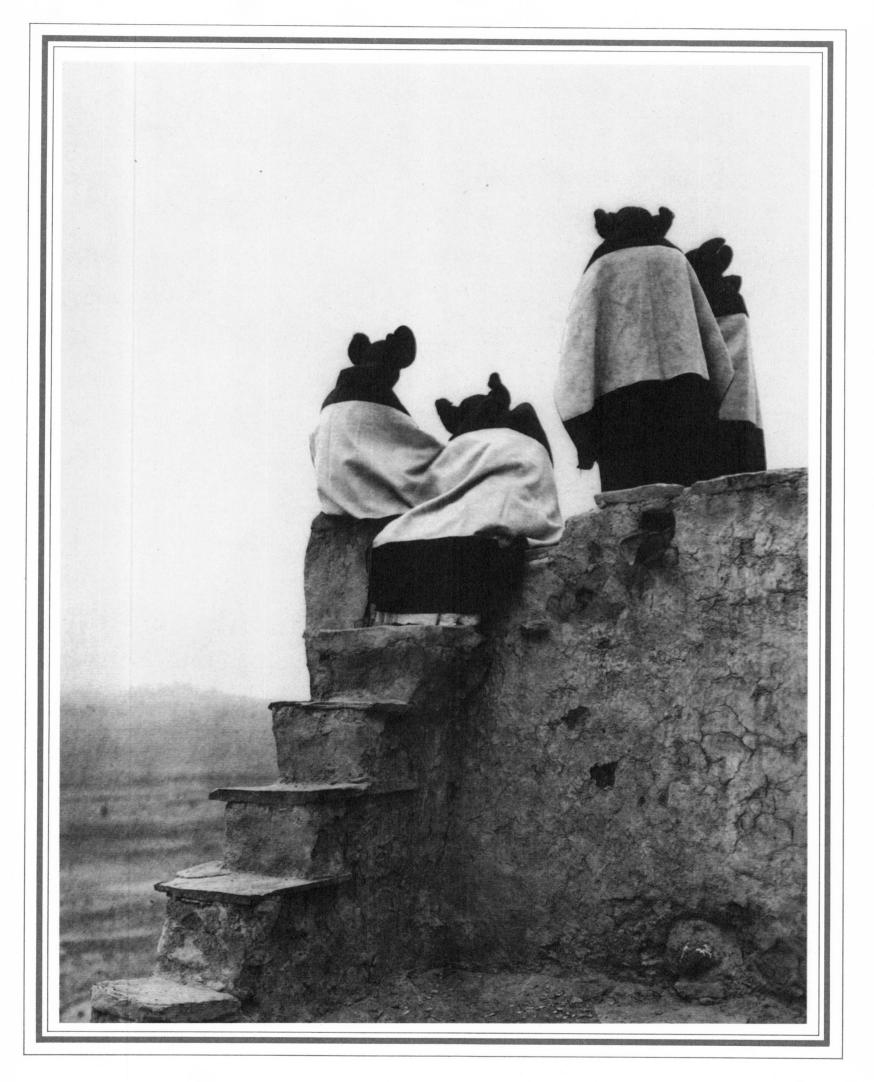

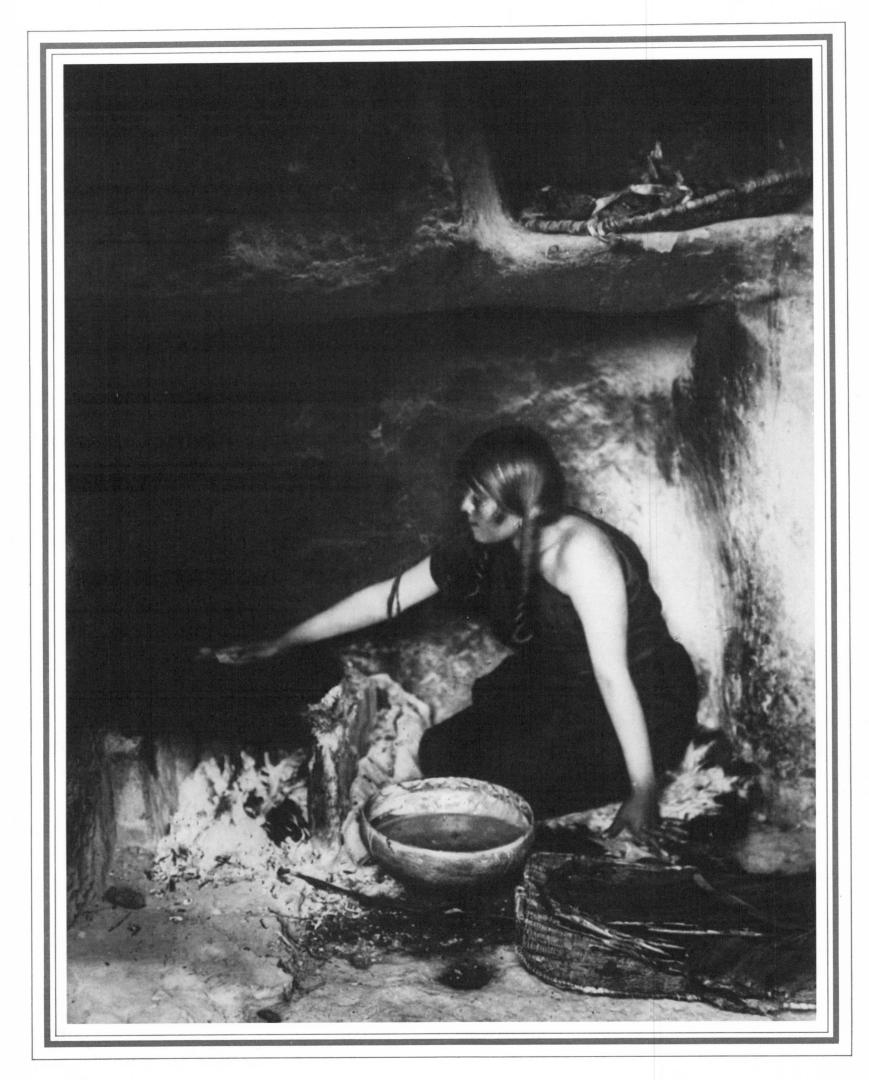

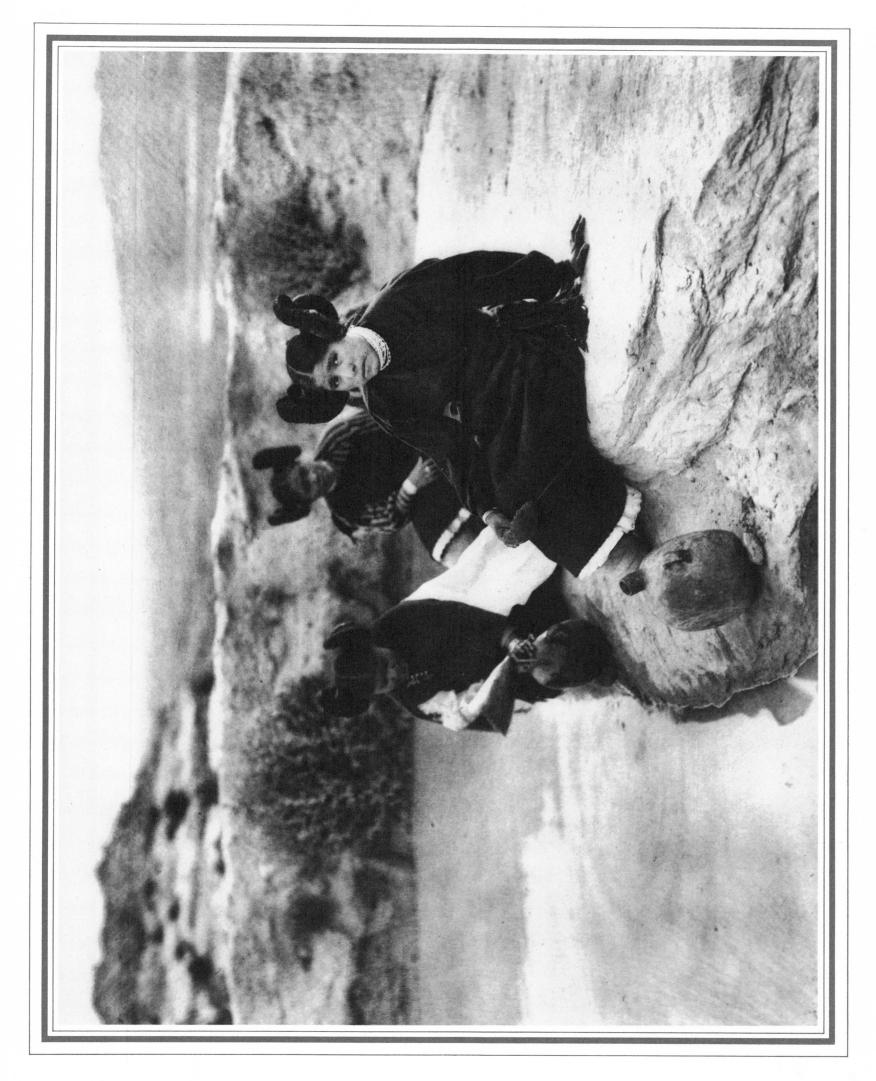

56. The Potter

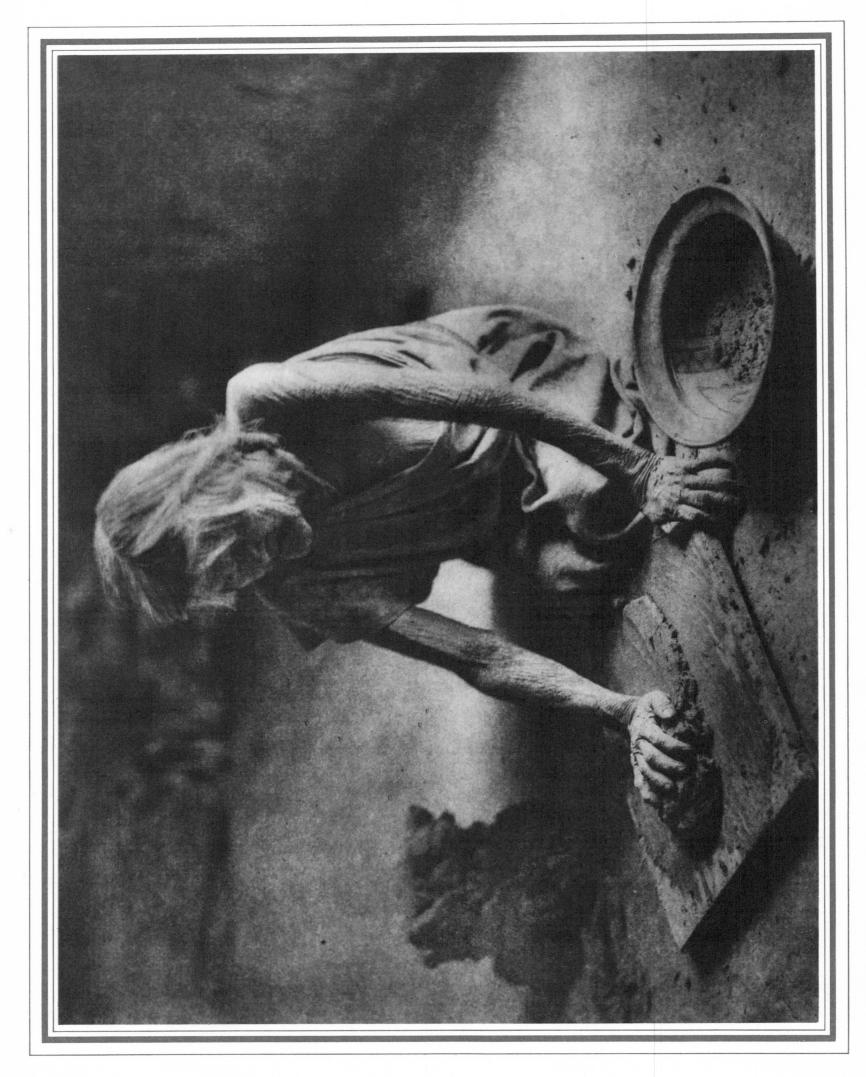

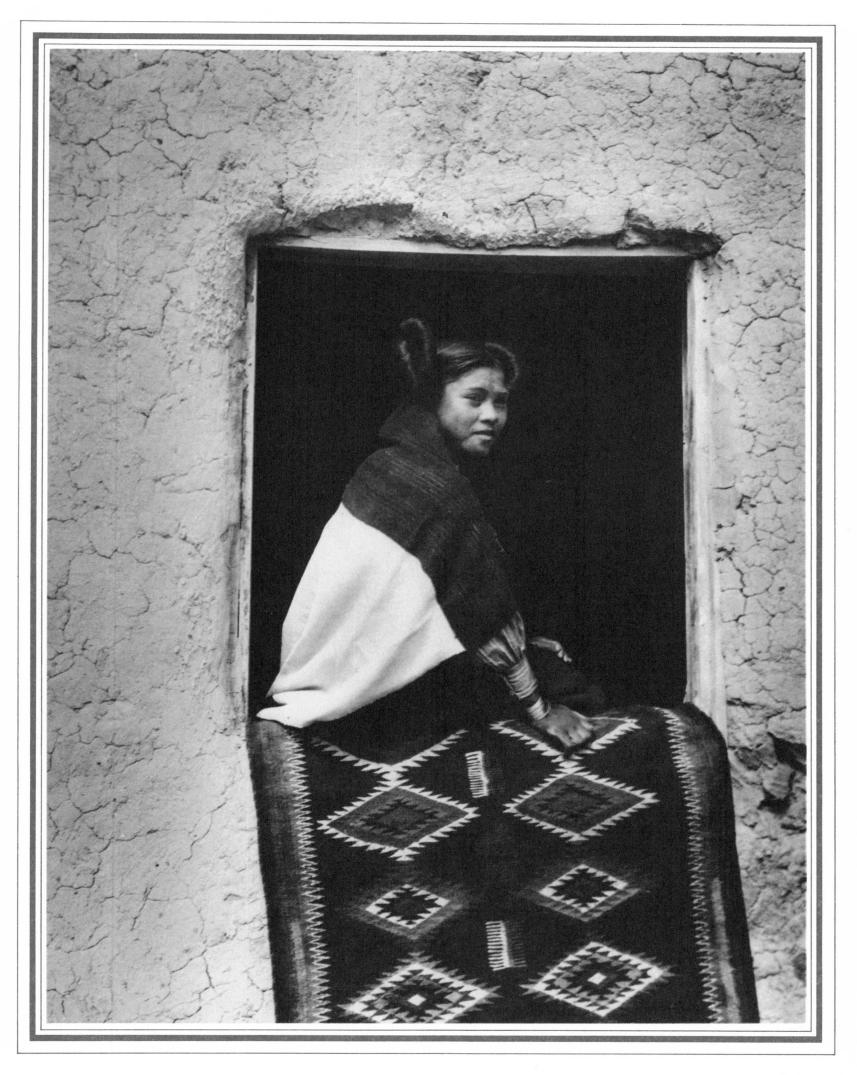

58. Hopi Woman and Child

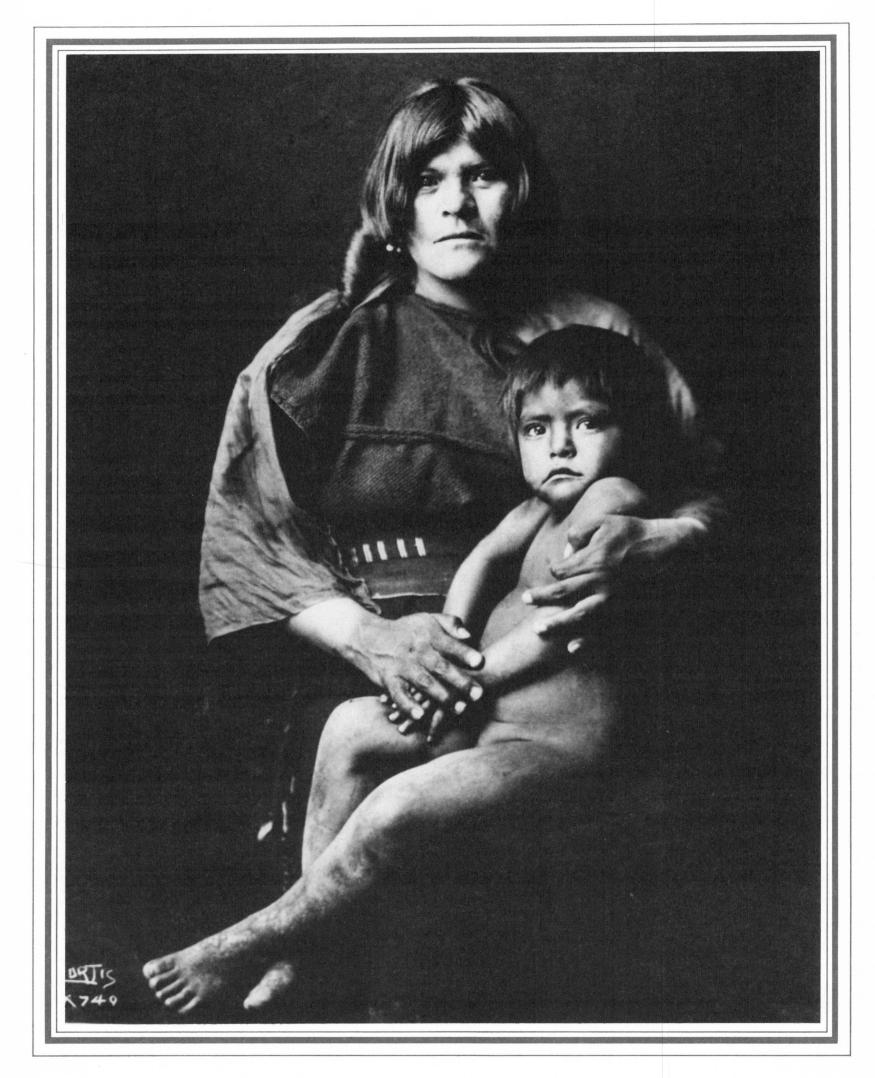

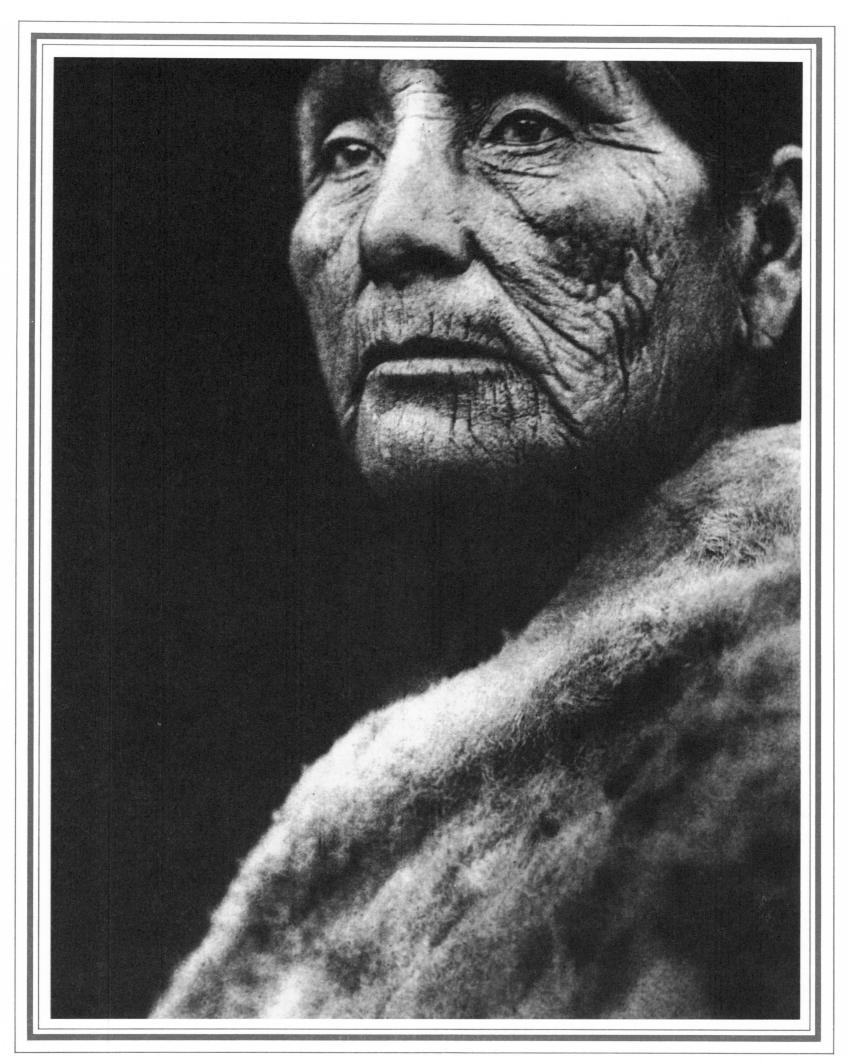

59. Hupa Woman

60. The Smelt Fisher — Trinidad Yurok

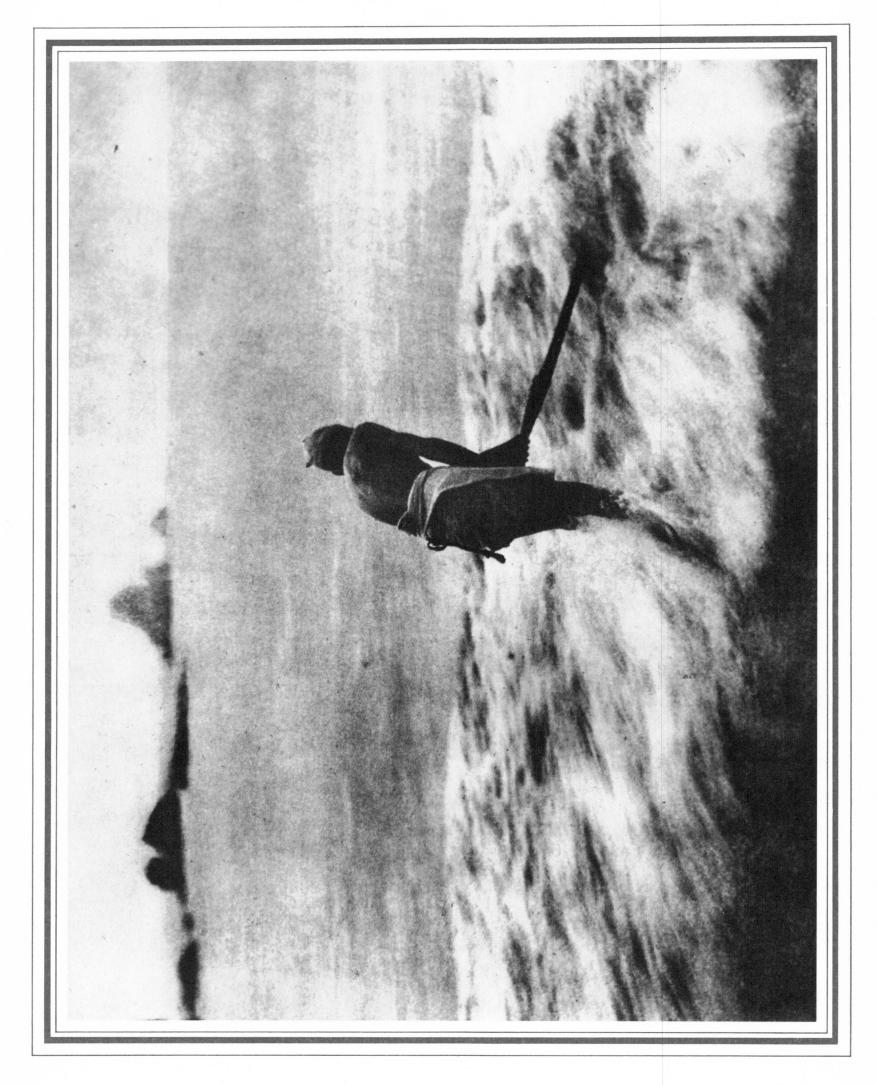

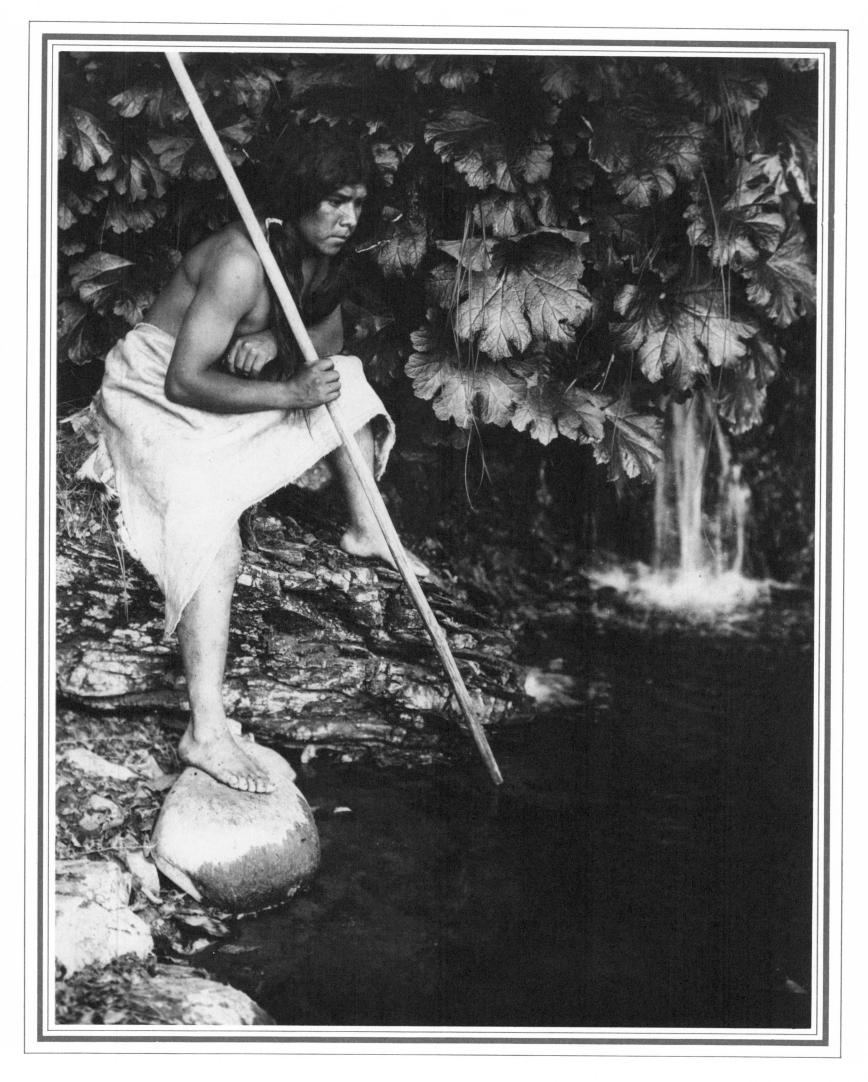

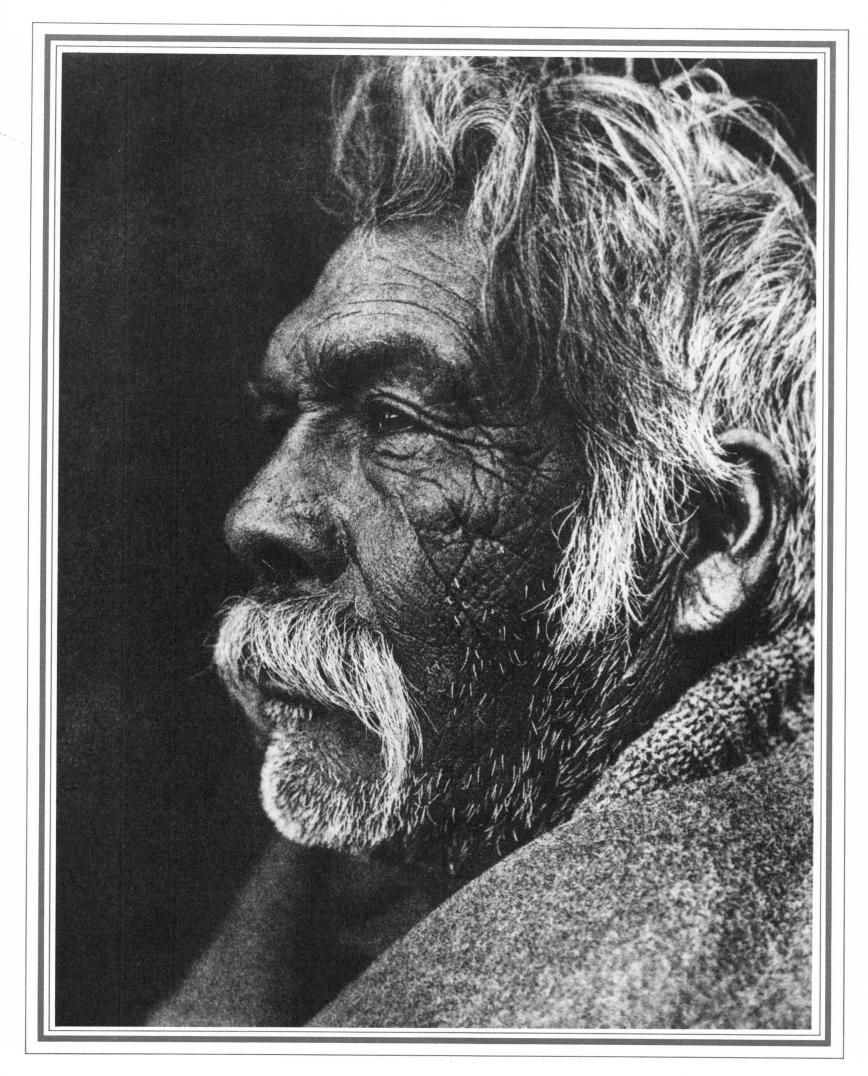

64. A Mono Home

65. A Desert Cahuilla Woman

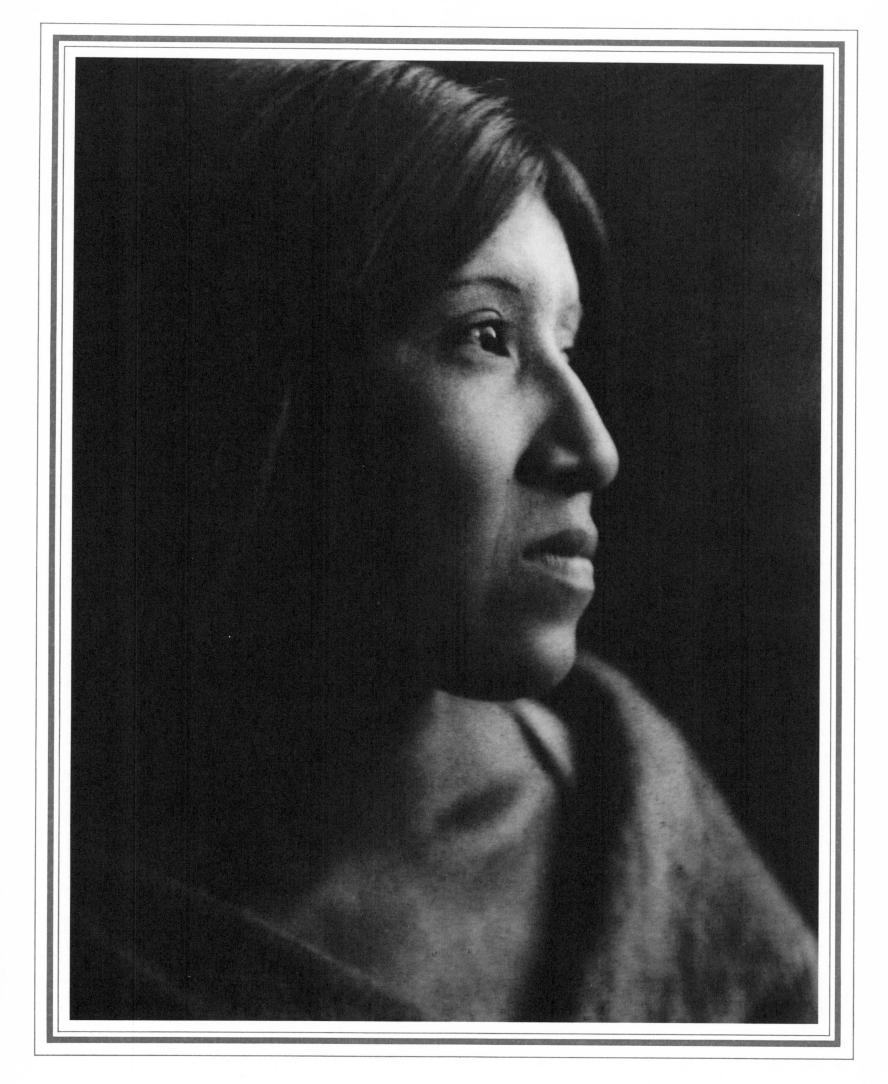

66. Paviotso Basketry

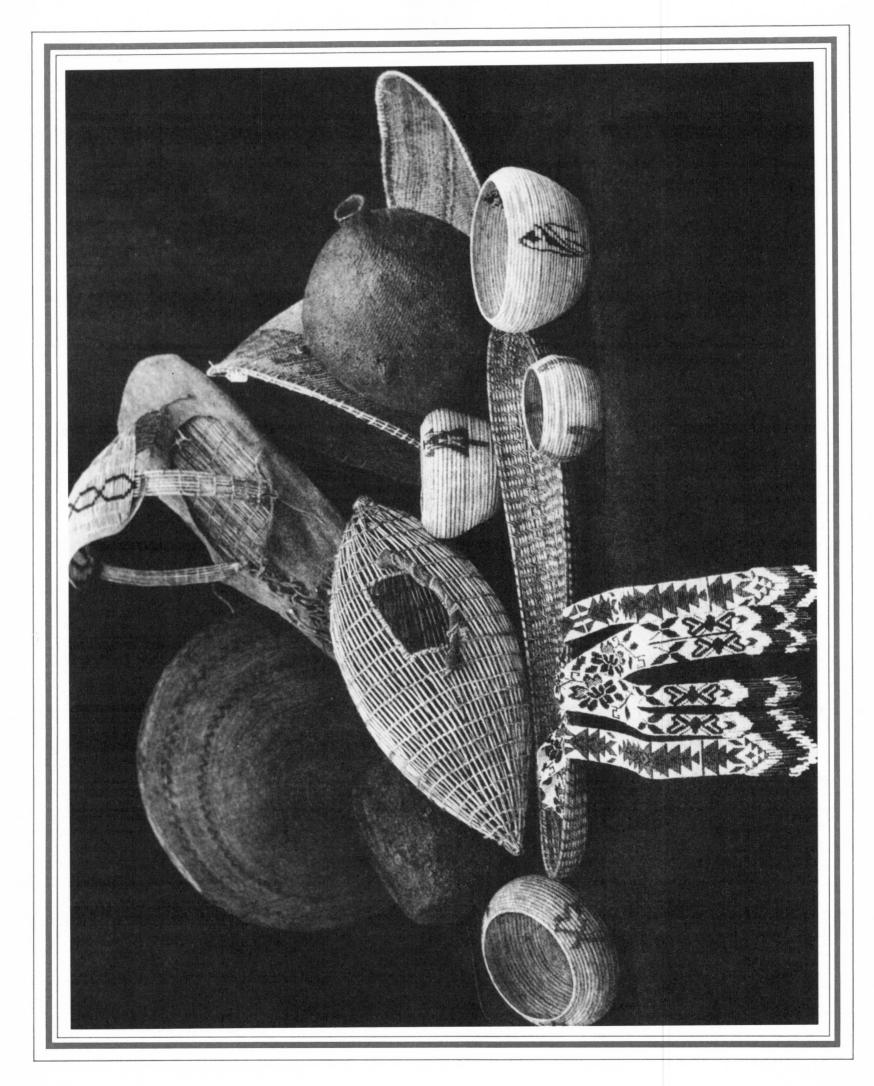

68. At the Old Well of Acoma

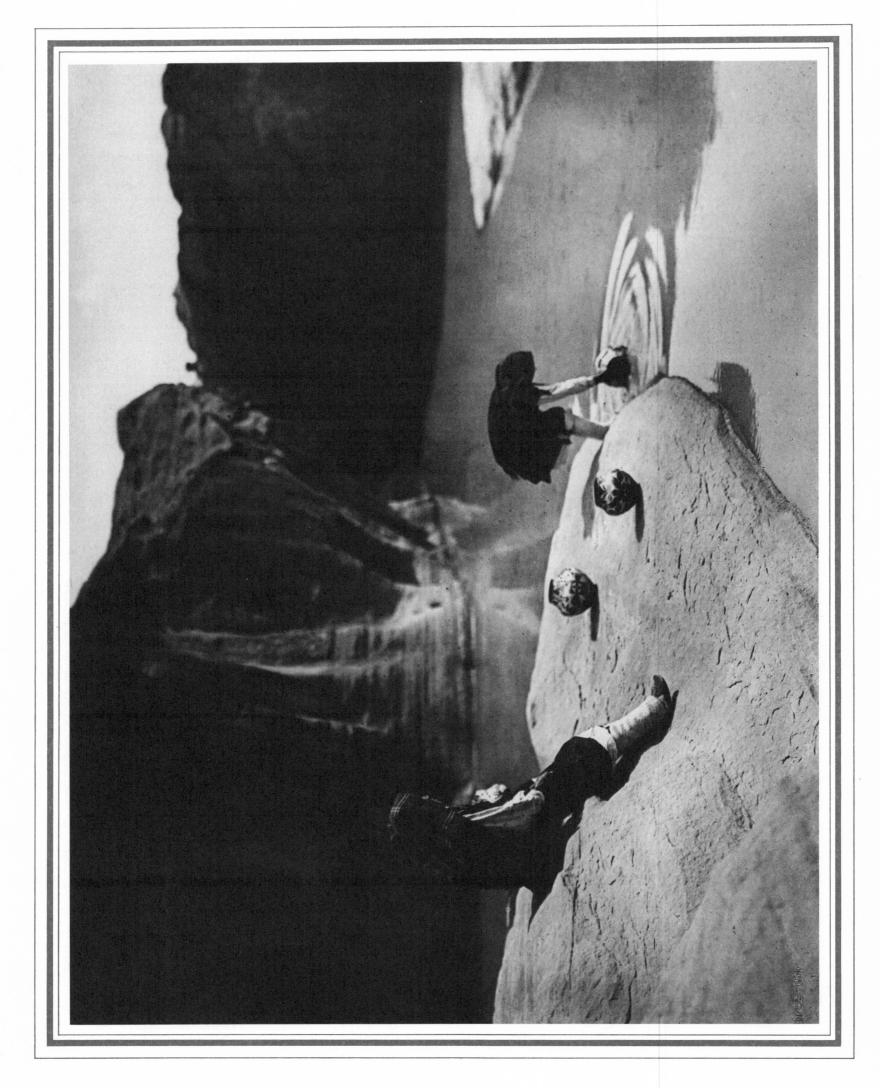

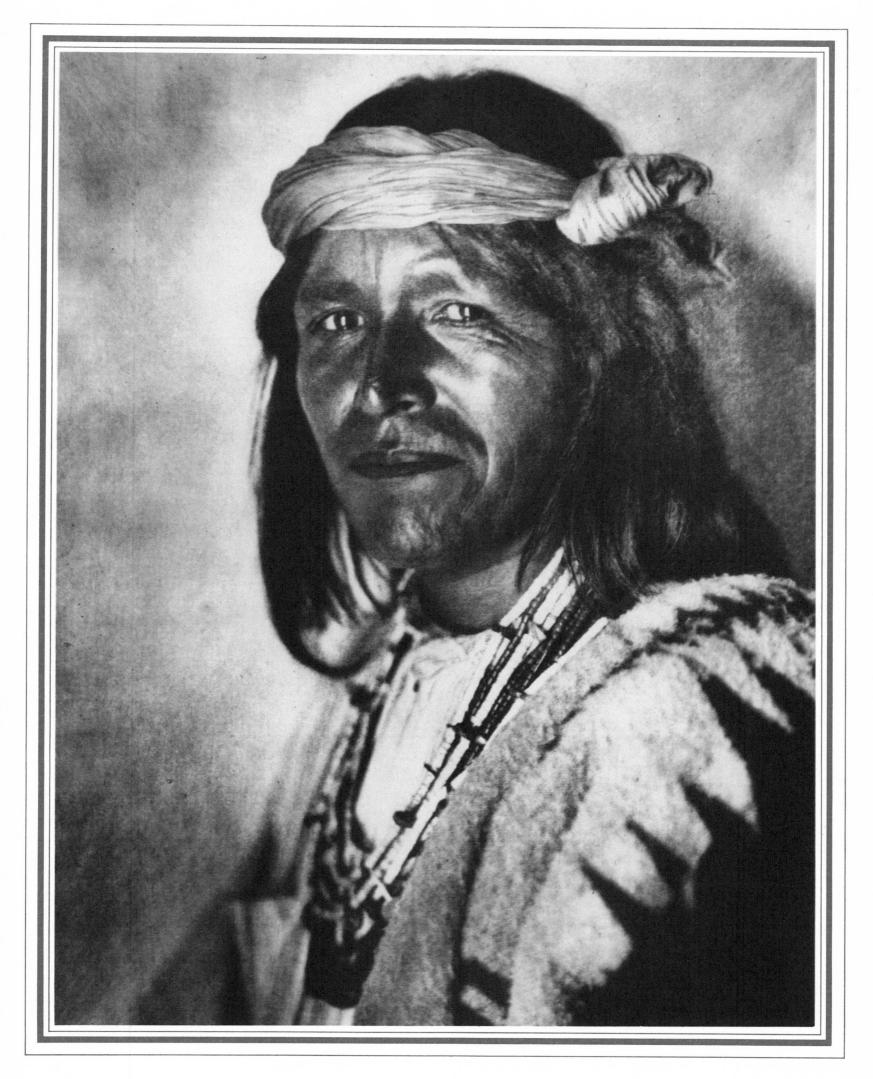

70. An Acoma Woman

72. Okúwa-Tsirě ("Cloud Bird") — San Ildefonso

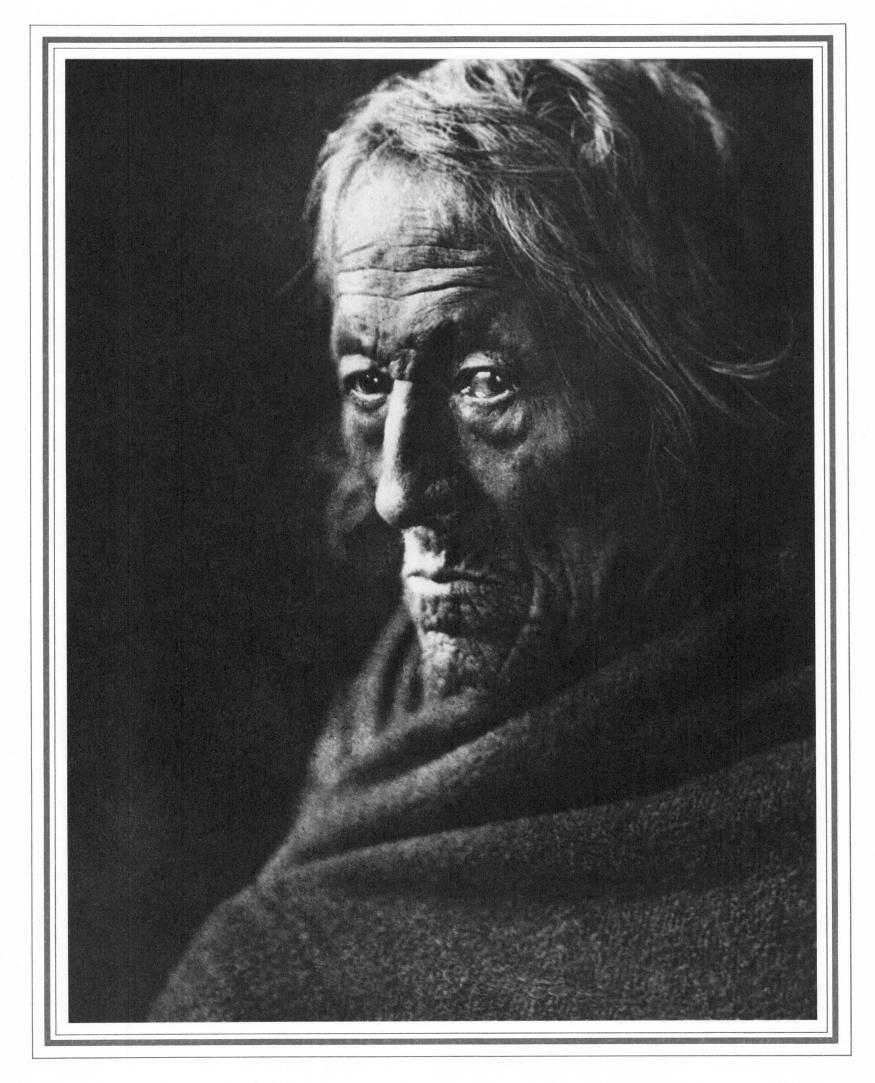

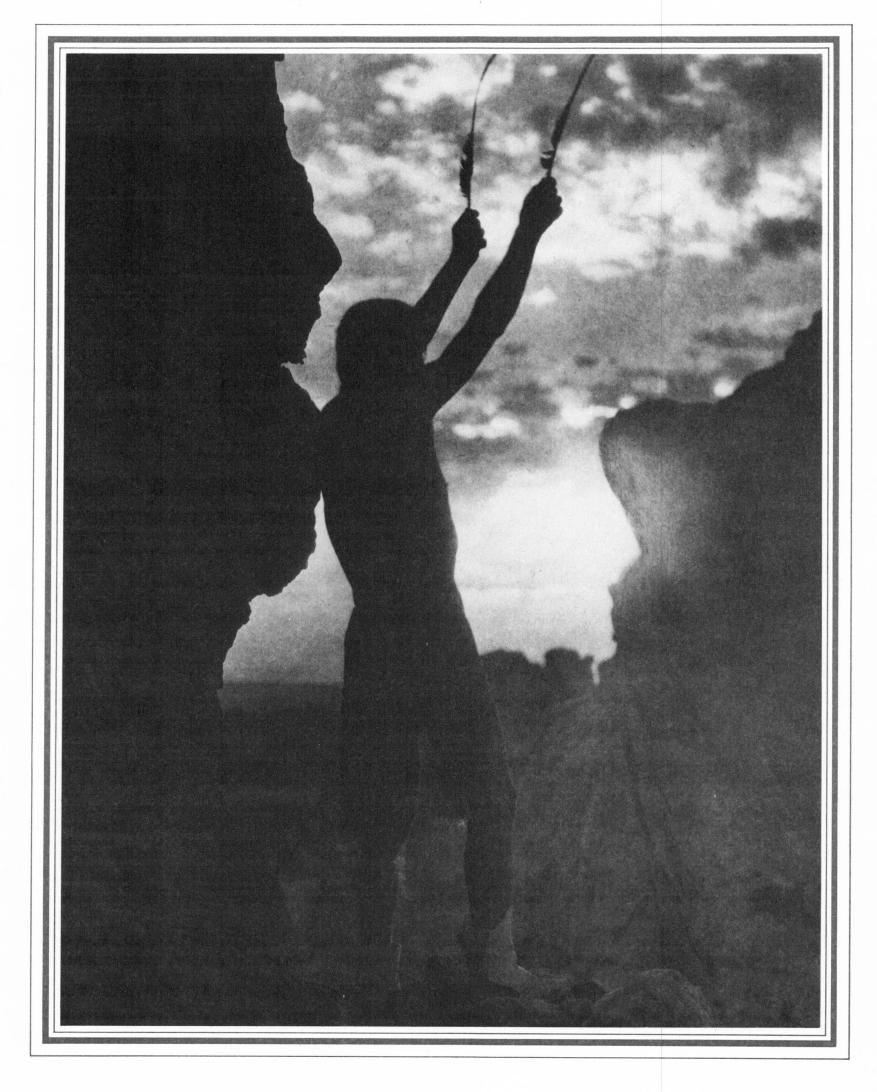

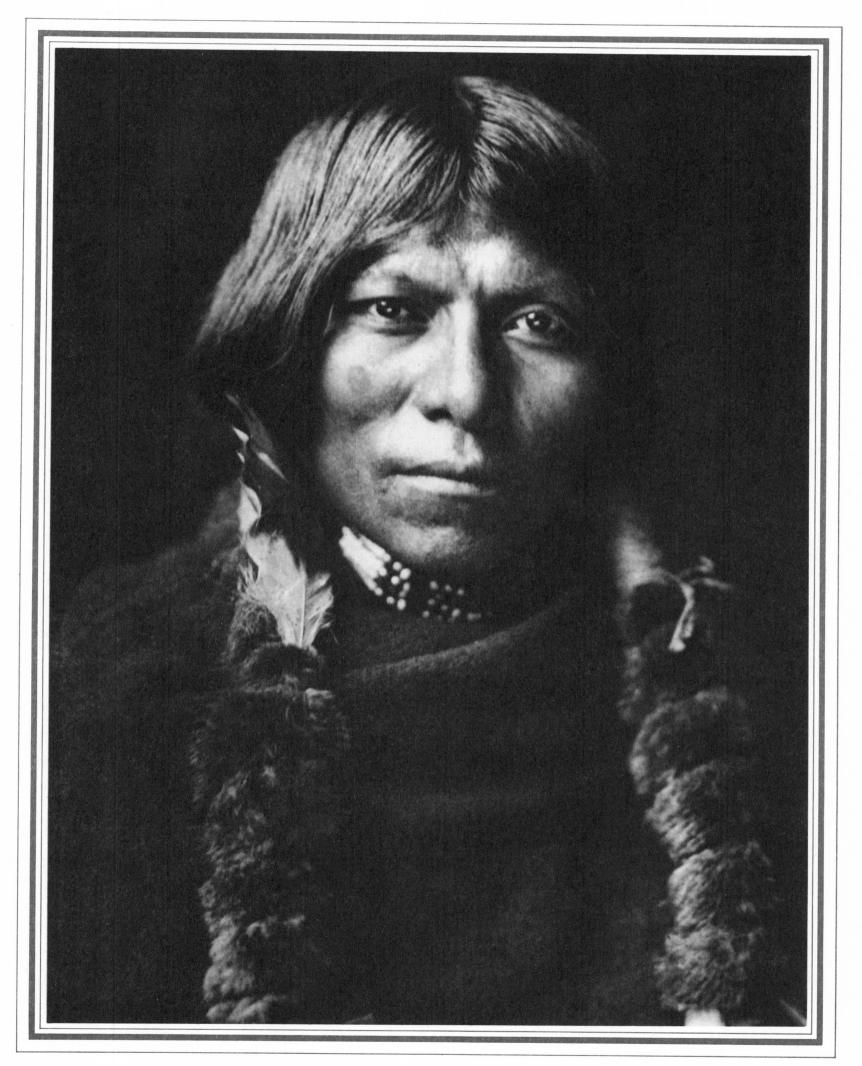

75. Okúwa-Tse ("Cloud Yellow") — San Ildefonso

76. Ah-En-Leith — Zuñi

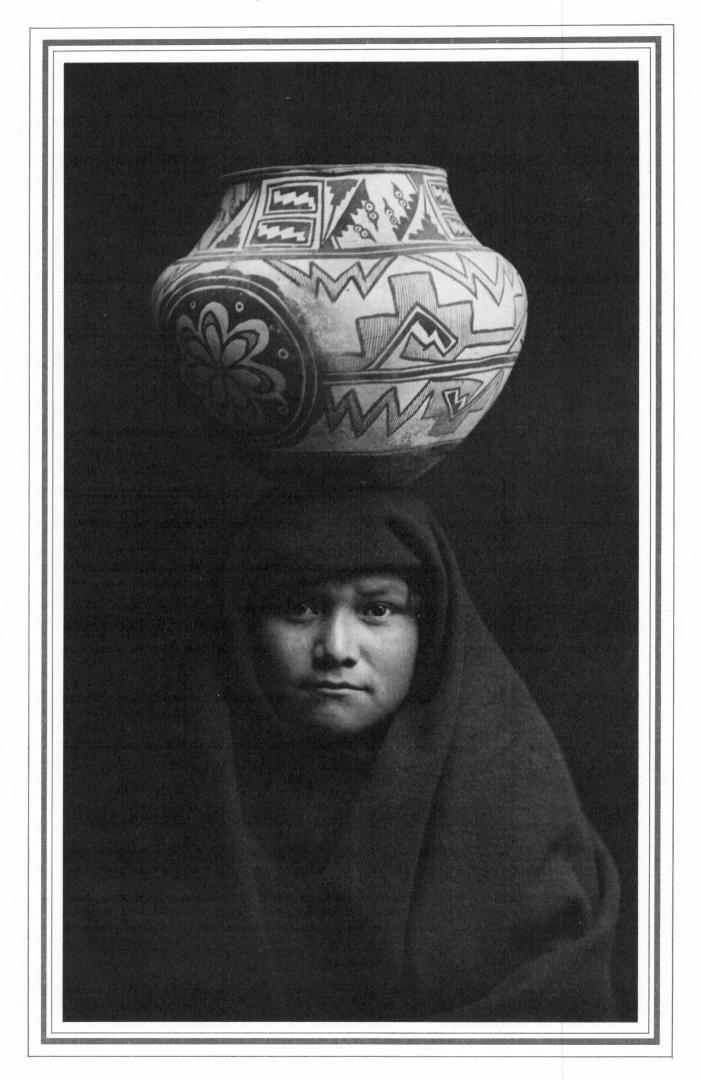

77. Shíwawtiwa — Zuñi

78. Governor of San Juan — Pueblo

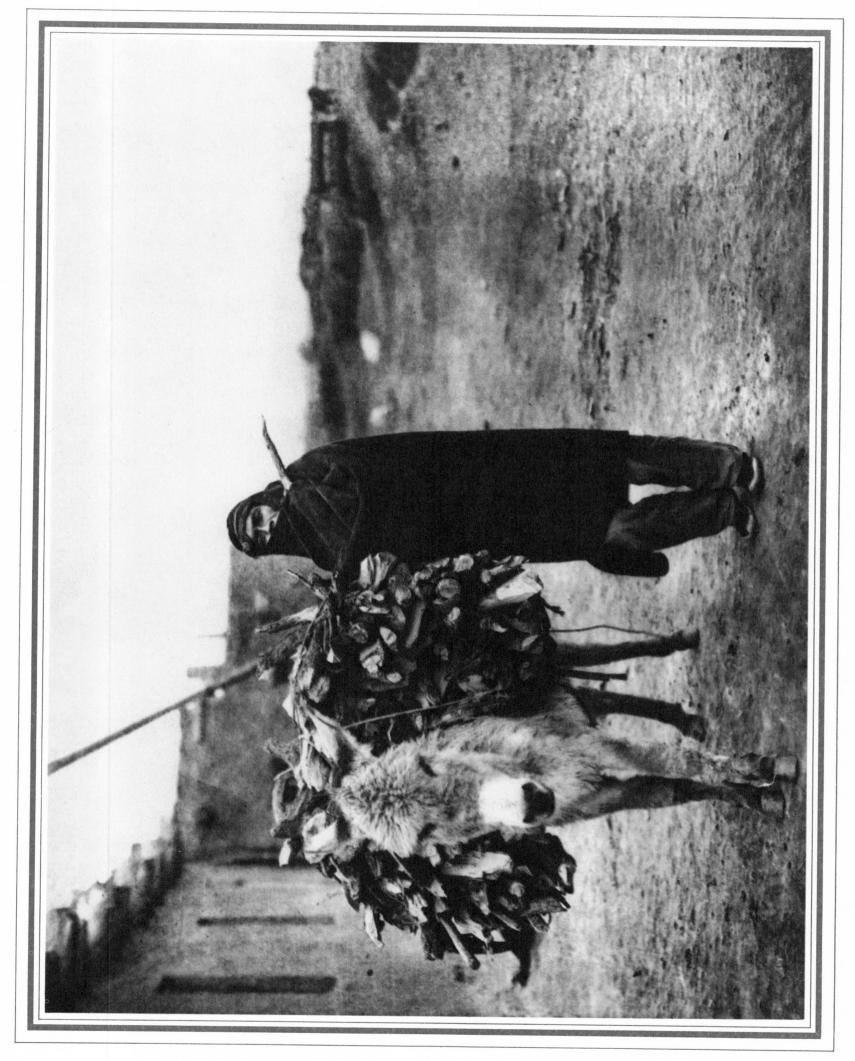

80. "Owl Old-Woman" — Sarsi

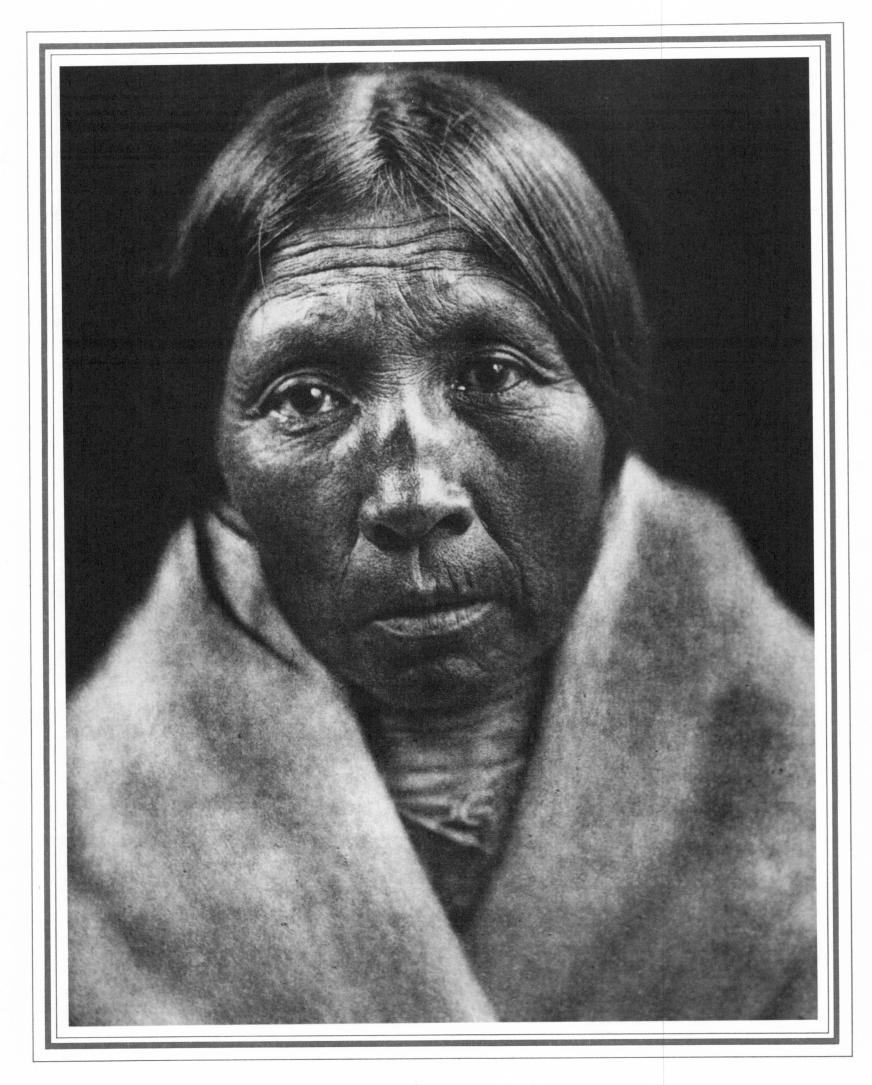

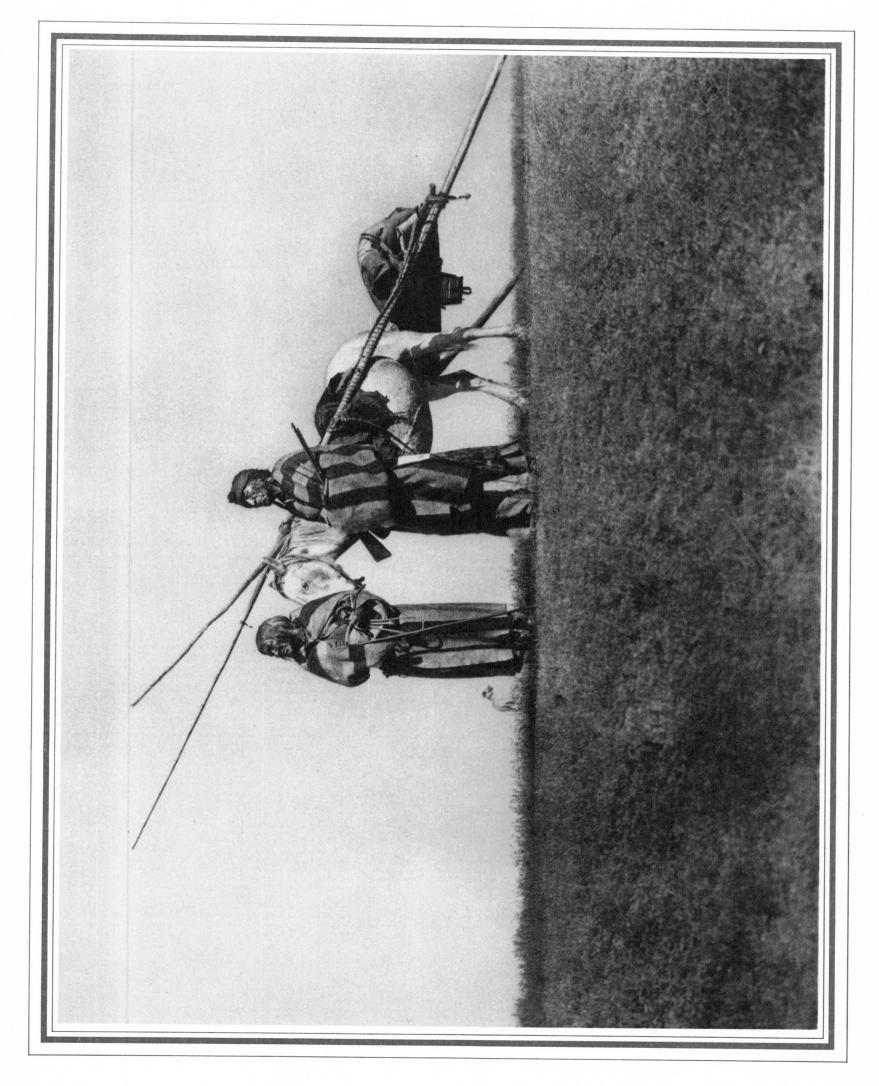

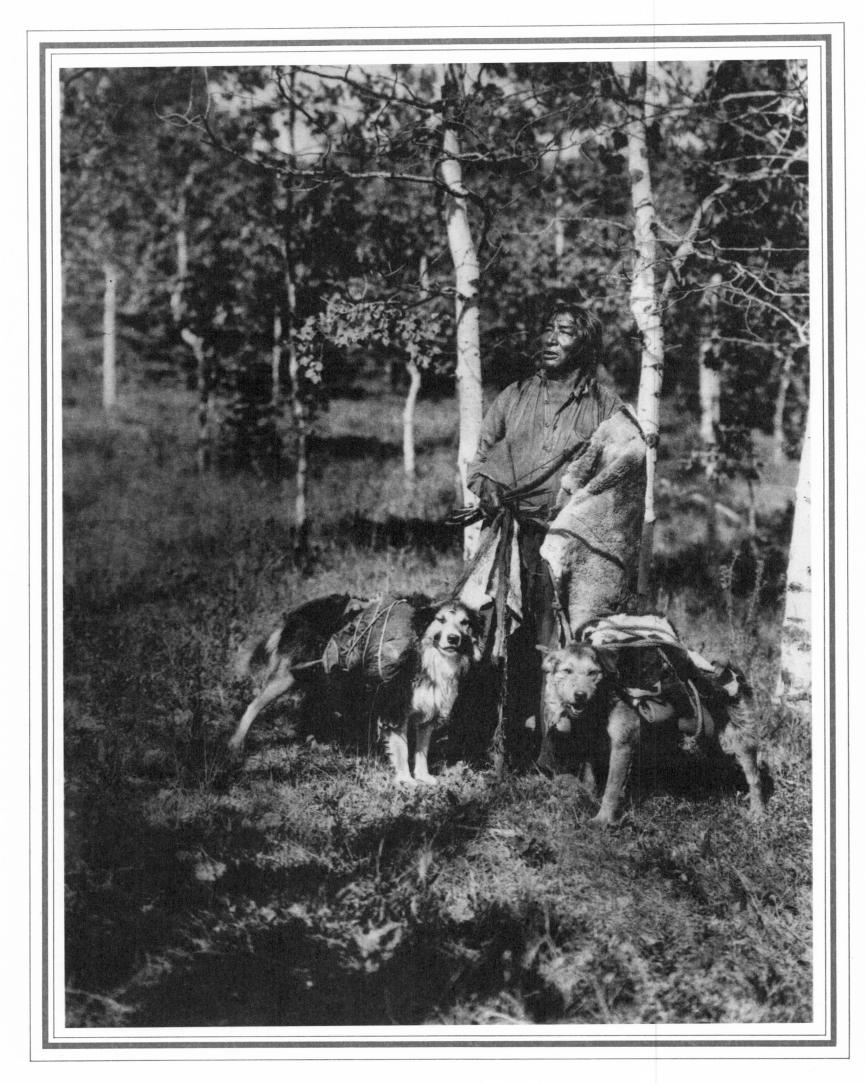

83. A CREE GIRL

84. A PAINTED TIPI — ASSINIBOIN

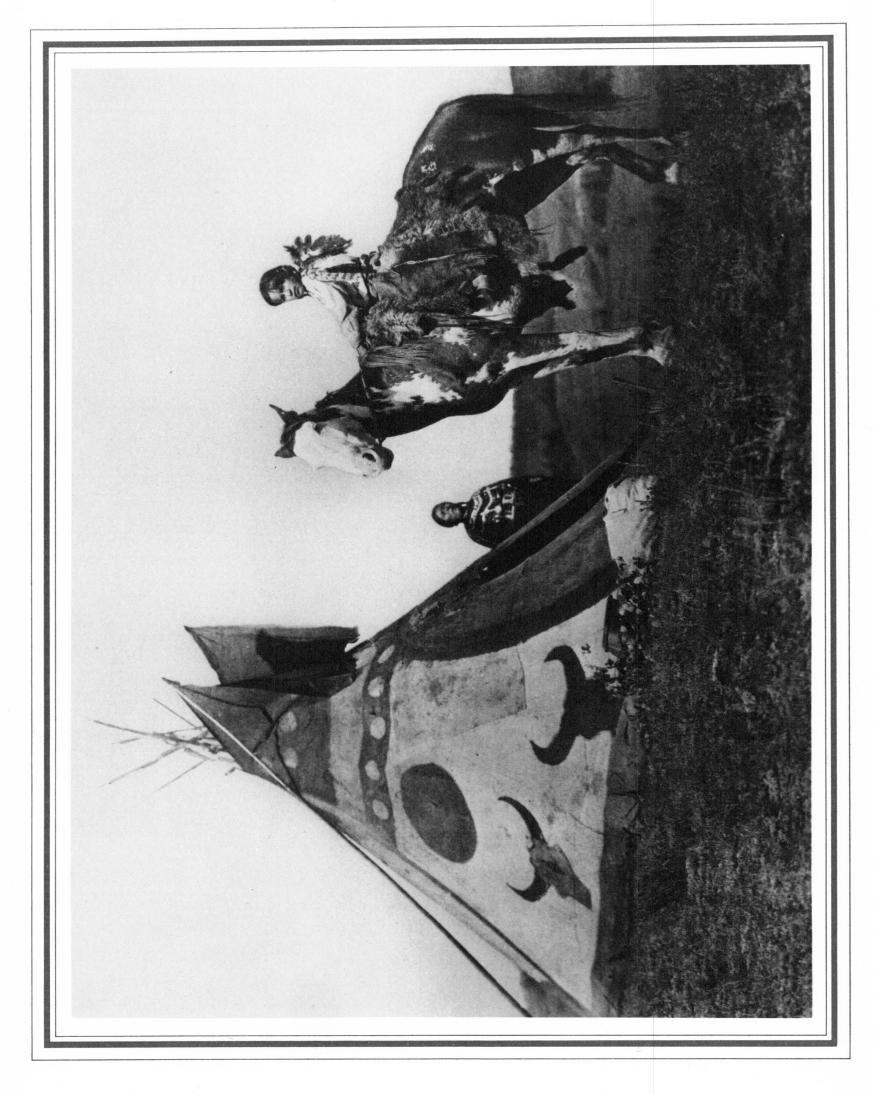

85. Assiniboin Mother and Child

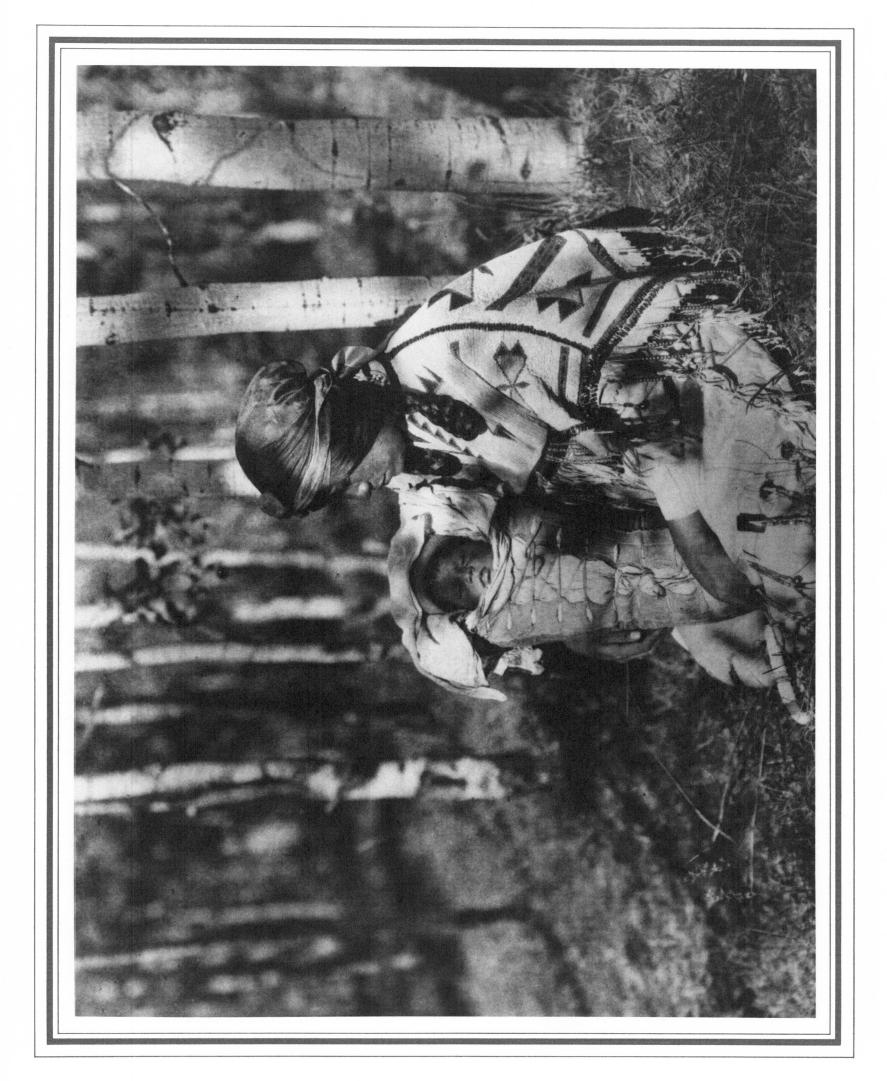

86. Dog Woman — Cheyenne

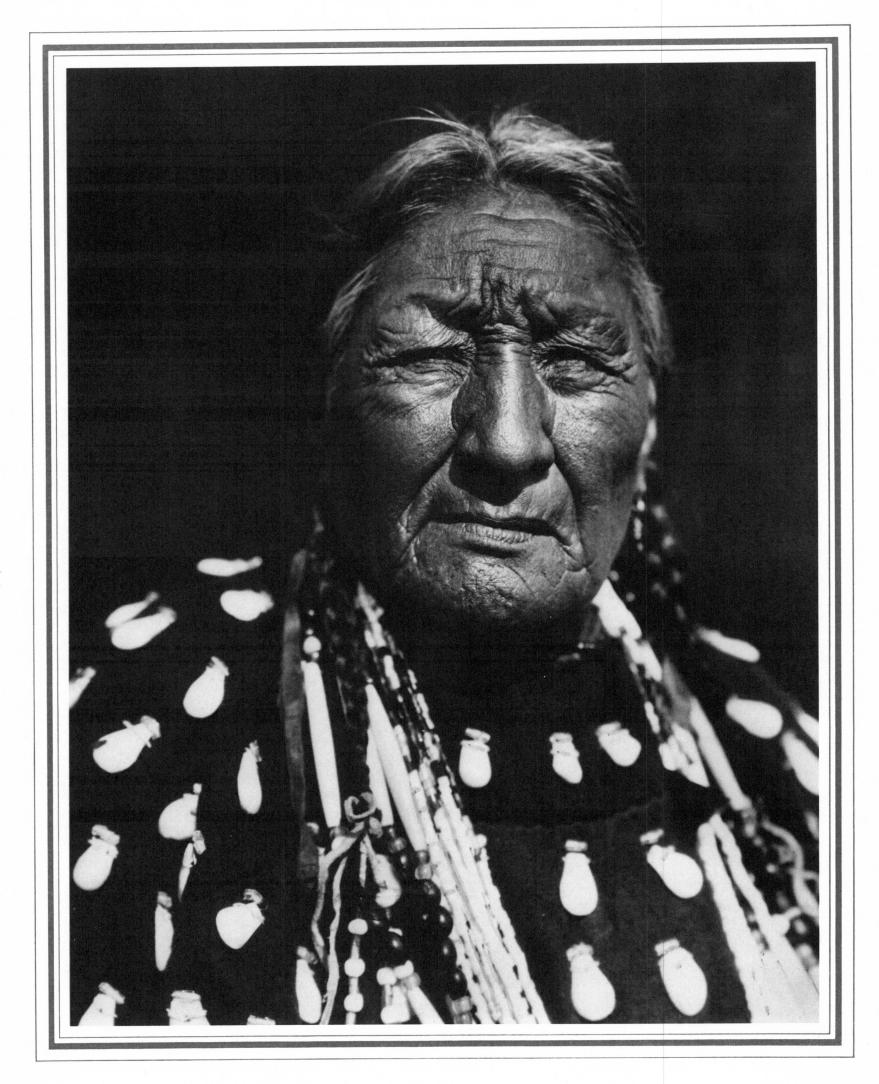

87. Cheyenne Young woman

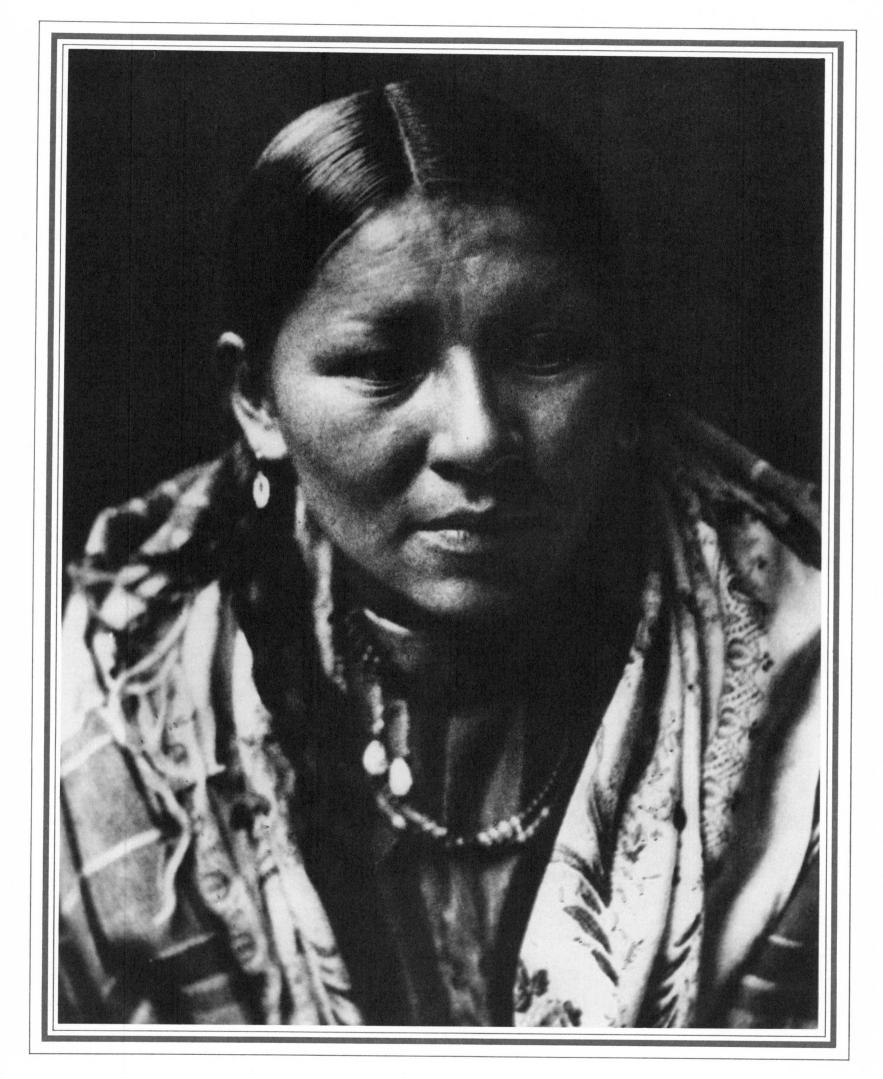

88. Peyote Drummer

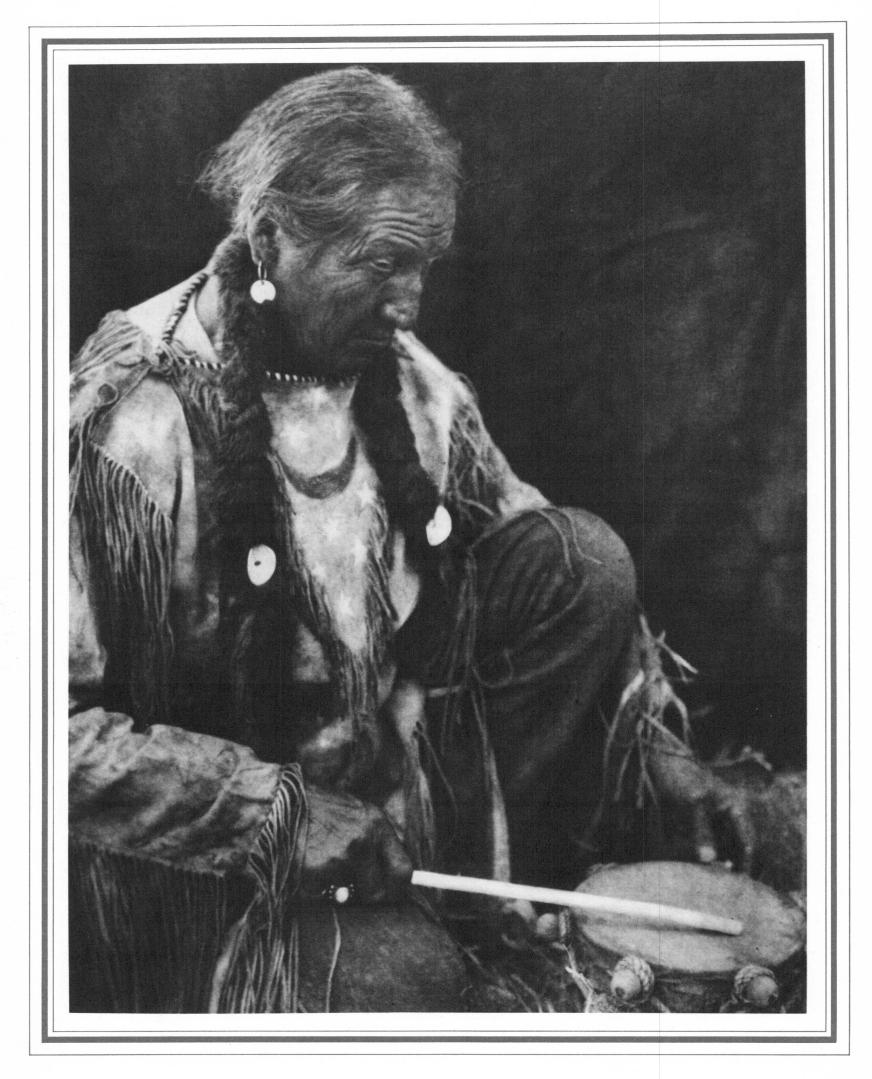

89. Úwat — Comanche

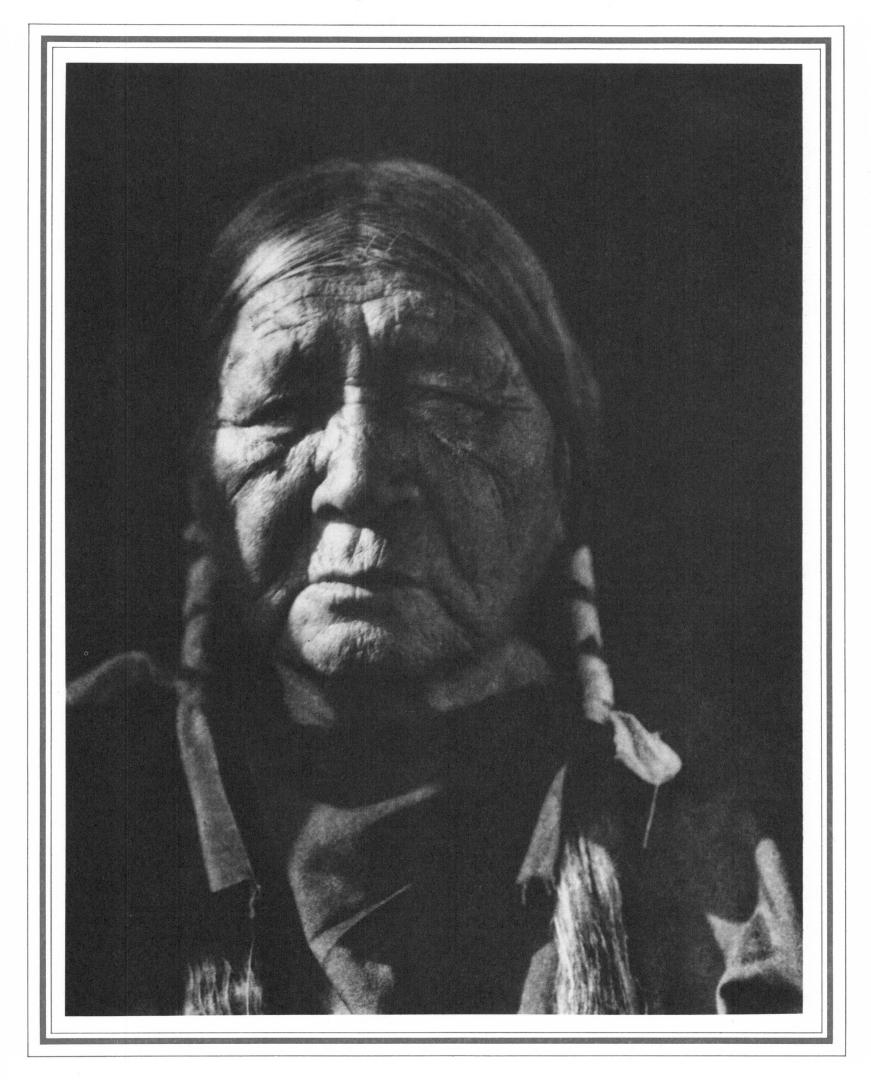

90. A LITTLE COMANCHE

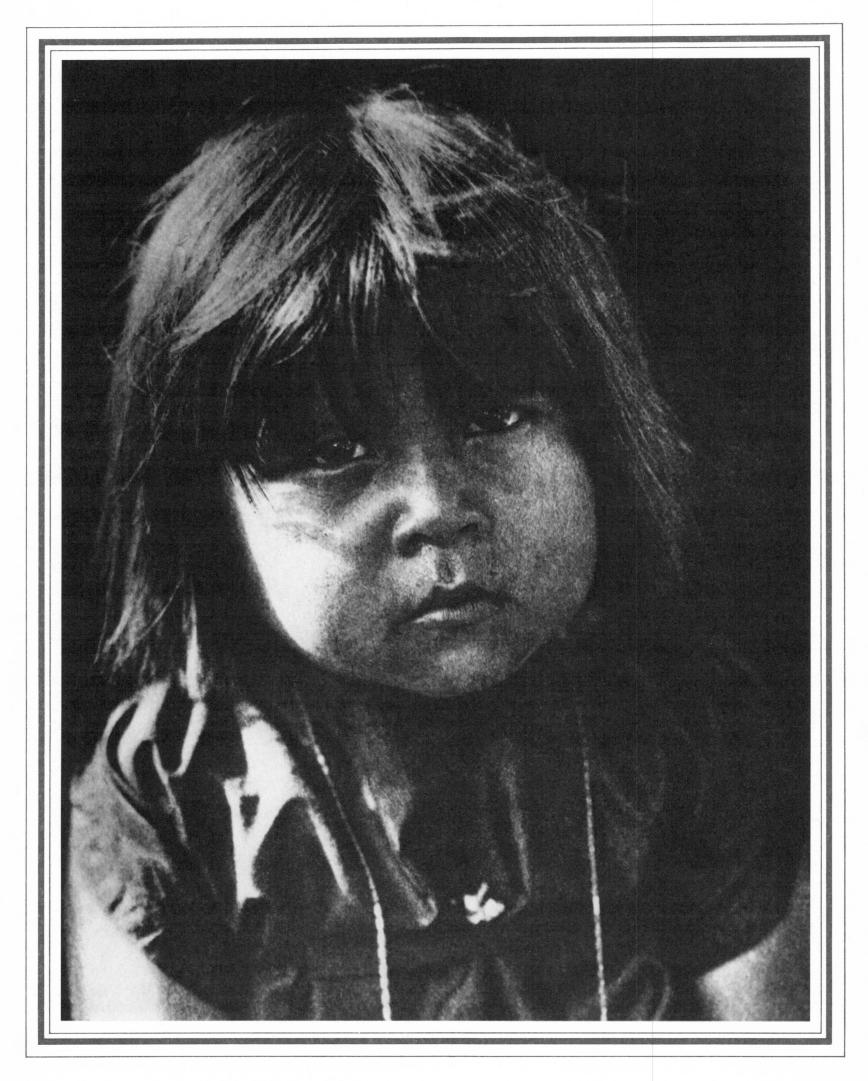

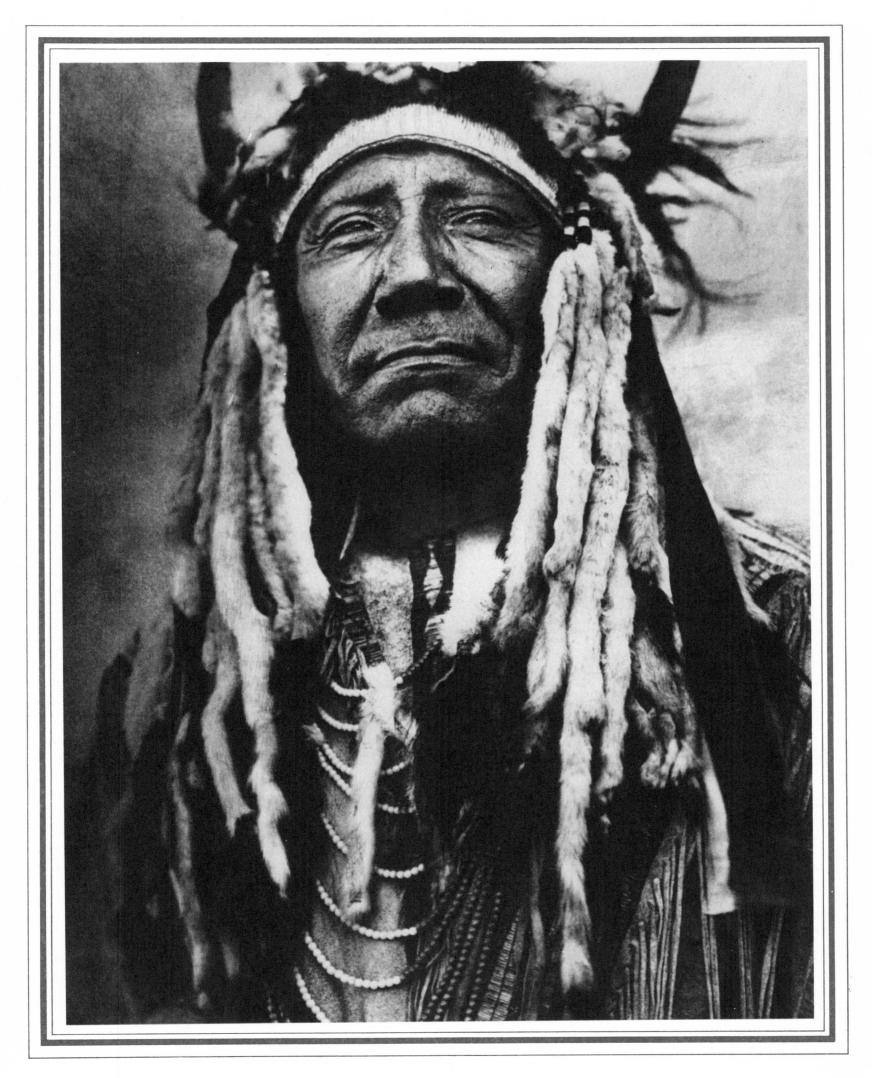

92. A Man from Nunivak — Eskimo

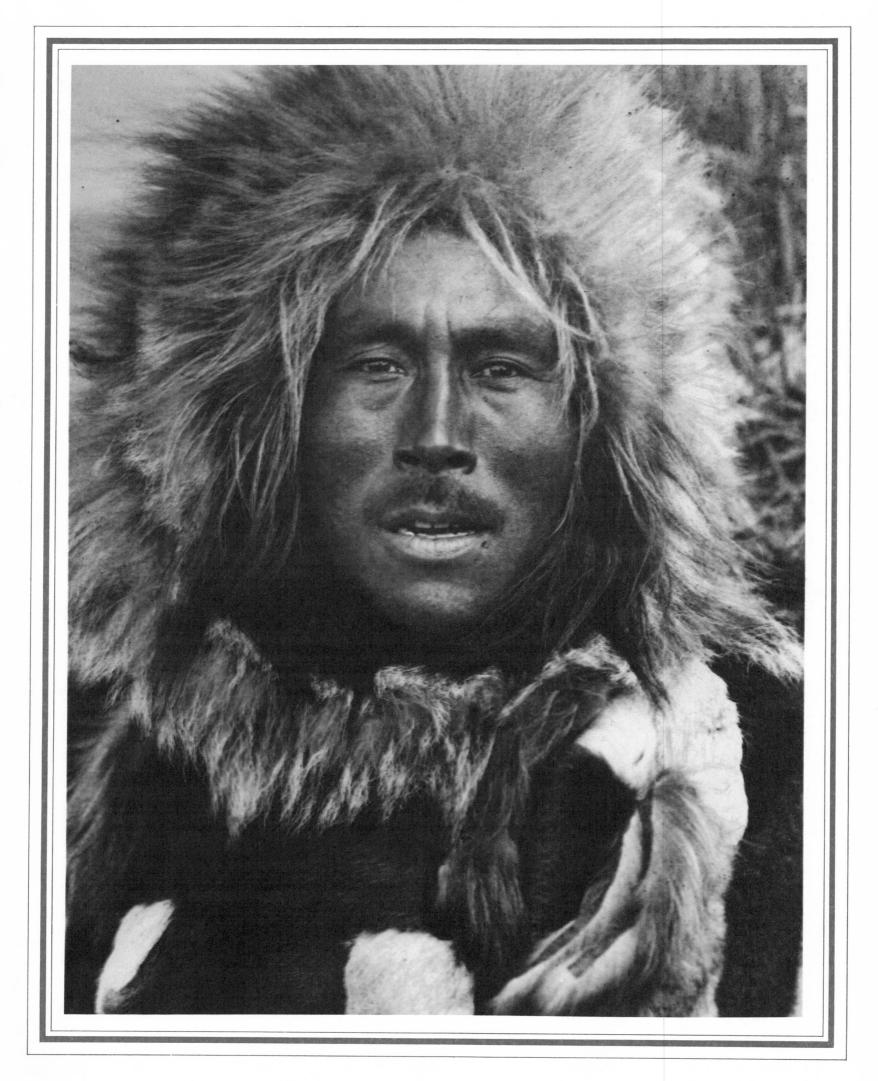

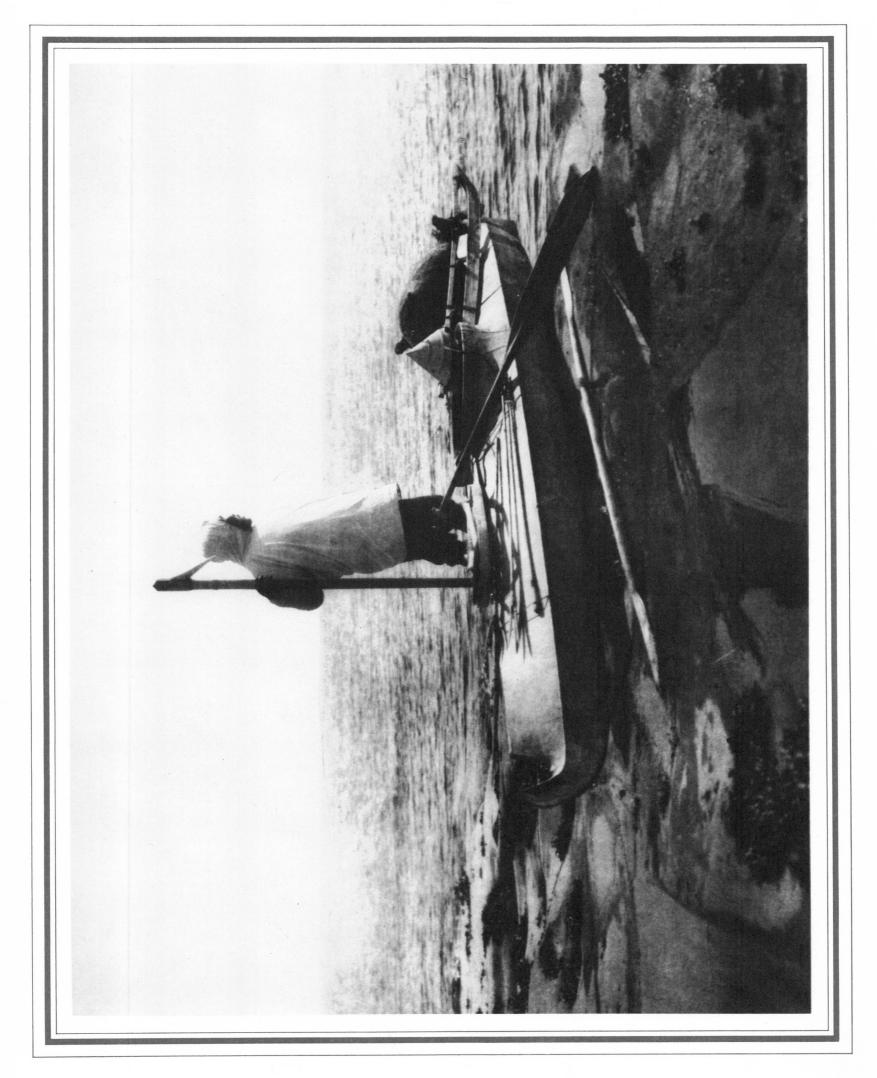

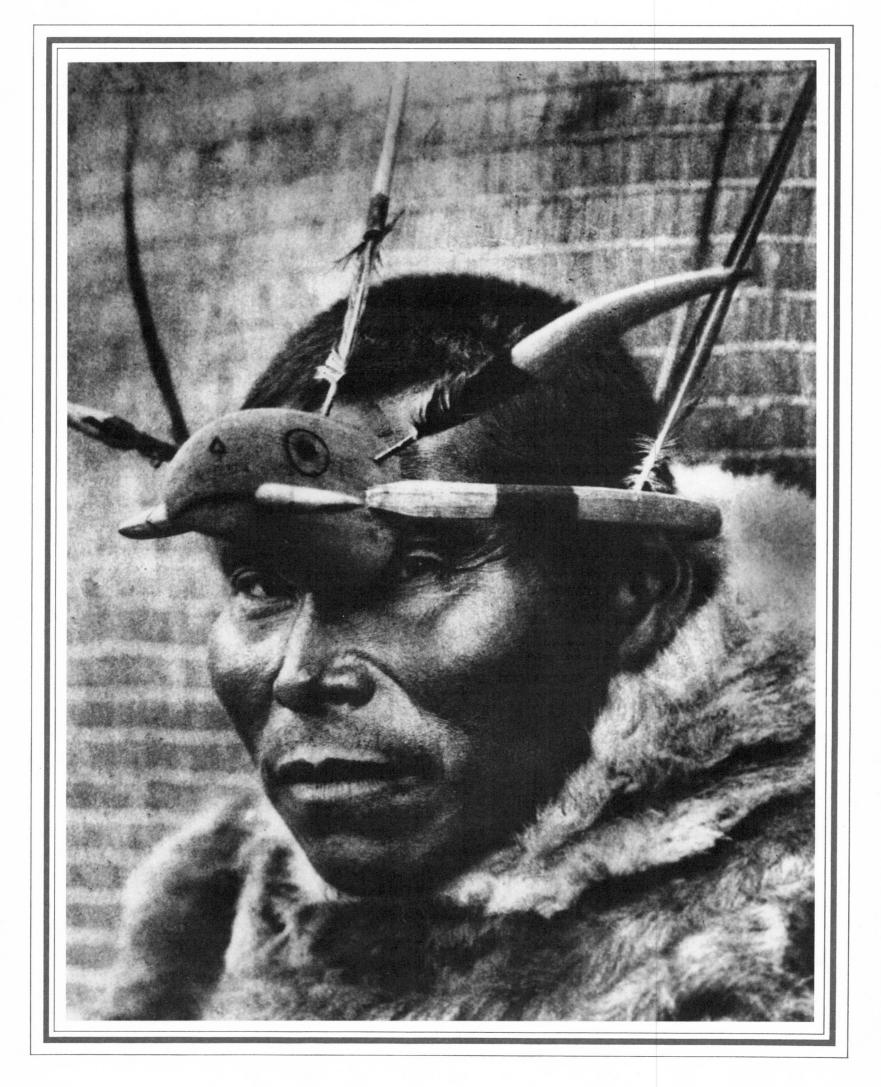

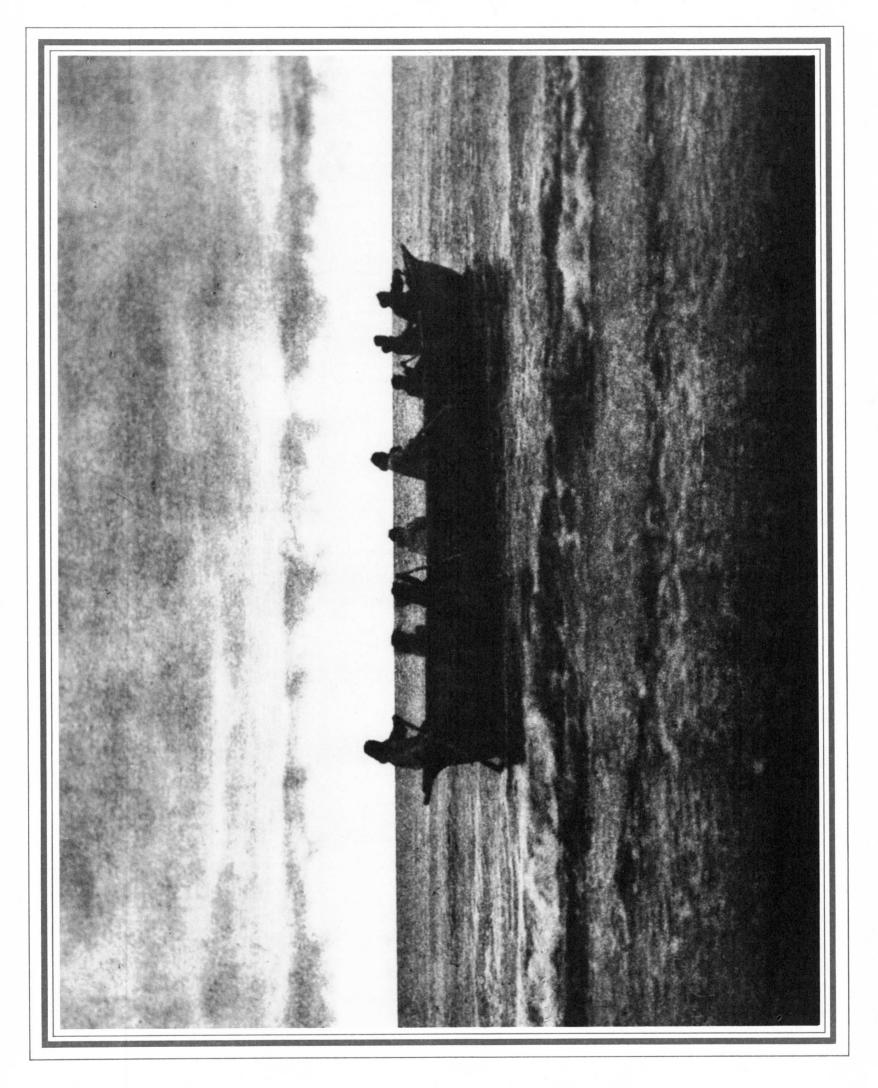

Portfolio Photographs with descriptions by Edward Sheriff Curtis

- 1. A Chief of the Desert Navaho. Picturing not only the individual but a characteristic member of the tribe - disdainful, energetic, self-reliant.
- 2. Cañon de Chelly Navaho A wonderfully scenic spot is this in northeastern Arizona, in the heart of the Navaho country - one of their strongholds, in fact. Cañon de Chelly exhibits evidences of having been occupied by a considerable number of people in former times, as in every niche at every side are seen the cliff-perched ruins of former villages.
- 3. A Son of the Desert Navaho. In the early morning this boy, as if springing from the earth itself, came to the author's desert camp. Indeed, he seemed a part of the very desert. His eyes bespeak all the curiosity, all the wonder of his primitive mind striving to grasp the meaning of the strange things about him.
- Apache Medicine-Man with Sacred Prayer 4. Chart. Every Apache medicine-man has a medicine skin inscribed with the symbolism of the tribal mythology. In his own little kówa, or dwelling, with the painted deerskin spread before him, on which are delineated the symbolic representations of a score of gods comprising the Apache pantheon, a medicine-man will sit and croon songs and pray all day and all night in the hope of hearing the voices of celestial messengers.
- 5. Qũniáika Mohave. Although this pictures one of the best of his tribe, it serves as well to illustrate a man of the Age of Stone
- 6. Qahátíka Girl. About forty miles due south of the Pima reservation [Arizona], one sees a type of the true desert Indian — the Qahátĭka. One traversing this region would have cause to wonder how a human being could wrest from so barren a land the necessities of life. It is only the life of meager requirement that could exist here.
- 7. Pachílawa Walapai Chief. So far as is known [the Walapai] have always occupied the pine-clad mountains for about a hundred miles along the southern side of the Grand Cañon in northwestern Arizona.
- 8. Mosa Mohave. It would be difficult to conceive of a more thorough aboriginal than this Mohave girl. Her eyes are those of the fawn of the forest, questioning the strange things of civilization upon which it gazes for the first time. She is such a type as Father Garces may have viewed on his journey through the Mohave country in 1776.
- 9. Papago Girl. A particularly fine-looking Papago girl of as nearly pure blood as can be found in the region. The northern Piman tribes have been in direct contact with Spanish people for more than two centuries. Much of the early foreign blood, however, has become so blended that its physical influence is no longer apparent. Indeed there are many instances in which the Indians insist that their blood is entirely aboriginal, whereas in fact an infusion of alien blood is traceable for several generations back.
- 10. In the Bad Lands. This striking picture was made at Sheep Mountain in the Bad Lands of Pine Ridge reservation, South Dakota.
- 11. Prayer to the Mystery. In supplication the pipe was always offered to the Mystery by holding it aloft. At the feet of the wor-

shipper lies a buffalo-skull, symbolic of the spirit of the animal upon which the Indians were so dependent. The subject of the picture is Picket Pin, an Ogalala Sioux.

- 12. Sioux Girl. A young Sioux woman in a dress made entirely of deerskin, embroidered with beads and porcupine-quills.
- 13. Incense over a Medicine Bundle Hidatsa. Part of the ritual of the Corn Ceremony took place in the lodge of the medicine maker. The Corn Ceremony was performed in the spring and early summer as a supplication to the spirits to grant bountiful harvests and strength to the tribe.
- 14. Shot in the Hand Apsaroke. He was born about 1841. By fasting he obtained his hawk-medicine; it was his custom to make a powder of a hawk's heart, sweet-grass, and green paint, and to eat a portion of the mixture just before going into battle.
- 15. In Black Cañon. The Apsaroke, although not exclusively mountain dwellers, were ever fond of the hills, preferring the forest shade and the clear mountain streams to the hot, ill-watered, monotonous prairies. The picture illustrates the Apsaroke custom of wearing at the back of the head a band from which fall numerous strands of false hair ornamented at regular intervals with pellets of bright-colored gum. Black Cañon is in the northern portion of the Bighorn mountains, Montana.
- 16. Two Leggings Apsaroke. He was born about 1848. Having no great medicine derived from his own vision, he was adopted into the Tobacco order by Bull Goes Hunting, who gave him his medicine of a fossil or a stone, roughly shaped like a horse facing both ways. Two Leggings thus became a war-leader.
- 17. For a Winter Campaign Apsaroke. It was not uncommon for Apsaroke war-parties, mounted or afoot, to move against the enemy in the depth of winter. The warrior at the left wears the hooded overcoat of heavy blanket material that was generally adopted by the Apsaroke after the arrival of traders among them. The picture was made in a narrow valley among the Pryor mountains, Montana.
- 18. Arikara Man. Tradition and history indicate that at the time of their separation from the Pawnee, the Arikara were a large tribe. War and disease must have dealt harshly with them, for when visited by Lewis and Clark they were occupying three villages at the mouth of the Grand River and then numbered probably twenty-six hundred. By 1871 they had decreased one thousand, in 1888 there were but five hundred, while in 1907 they numbered three hundred and eighty-nine.
- 19. The Rush Gatherer Arikara. The Arikara, as well as their close neighbors, the Mandan and Hidatsa, made many mats of rushes. These were used largely as floor coverings.
- 20. Red Whip Atsina. He was born in 1858. At the age of seventeen he went out on his first war expedition, going against the Sioux. The enemy was camped at Lodge Pole Creek, and the Atsina attacked them at dawn, capturing several horses. Red Whip was in the lead of the charge and took a few of the animals singlehanded.
- 21. In the Medicine Lodge Arikara. The distinctive rite of the Arikara was that of the medicine fraternity, Shunúwanúh,

"Magic Performance." This lasted from midsummer into the fall, with singing and dancing and performance of legerdemain in the lodge afternoon and evening.

- 22. Bear's Belly Arikara. He was born in 1847. He had had no experience in war when at the age of nineteen he joined Custer's scouts at Fort Abraham Lincoln, having been told by the old men of the tribe that such a course was the surest way to gain honors.
- 23. Arikara Woman. Women were clad in a one-piece garment reaching to the ankles and made of two deerskins, one for the front and one for the back. The hair of females, parted in the middle, hung down behind in two braids which were wrapped with deerskin thongs, these being sometimes ornamented with porcupine-quills.
- 24. Crow Eagle Piegan. In the old days of primitive customs and laws, they were fond of formality, especially in their social relations, and these exactions were, of course, largely a part of their religion. A noteworthy phase of such form in their daily and hourly life was the excessive use of the pipe. On lighting it they touched it to the earth and held it to the sky in silent prayer to the spirits. Each serious act of their working day was preceded by similar formal smoking.
- 25. Two Bear Woman Piegan. As to the Piegan of today and tomorrow, one would have to be an optimist indeed to see a silver lining to the overshadowing doubt. The promise long held out to them of better things through civilization has prover worse than empty husks.
- 26. In a Piegan Lodge. Little Plume with h son Yellow Kidney occupies the position of honor, the space at the rear opposite the entrance. The picture is full of suggestion of the various Indian activities. In a prominent place lie the ever-present pipe and its accessories on the tobacco cutting-board. From the lodge-poles hang the buffalo-skin shield, the long medicine-bundle, an eaglewing fan, and deerskin articles for accoutering the horse. The upper end of the rope is attached to the intersection of the lodgepoles, and in stormy weather the lower end is made fast to a stake near the centre of the floor space.
- 27. A Piegan Dandy. About 1855 young men began to part their hair from crown to temples, and to curl the banged forelock on a heated ramrod. Some braided the hair at the sides, others did not.
- 28. Waiting in the Forest Cheyenne. At dusk in the neighborhood of the large encampments young men, closely wrapped in non-committal blankets or white cotton sheets, may be seen gliding about the tipis or standing motionless in the shadow of the trees, each one alert for the opportunity to steal a meeting with his sweetheart.
- 29. Flathead Camp on Jocko River. The scene depicts a small camp among the pines on the reservation of the Flatheads in western Montana, the majestic Rocky Mountains rising abruptly in the background.
- 30. Klickitat Profile. On the Yakima reservation and scattered here and there in the valleys of their old homes, a few aged Klickitat are to be found; but the identity of their tribe has been lost.
- 31. Kutenai Duck Hunter. In the gray dawn of a foggy morning the hunter crouches in

his canoe among the rushes, waiting for the water-fowl to come within range.

- 32. A Mountain Fastness Apsaroke. The Apsaroke lived much among the mountains, and nowhere do they seem more at home than on the streams and in the canons of their forested ranges.
- 33. *Three Eagles Nez Percé*. Three Eagles was the interpreter employed in the collection of material on the Nez Percé.
- 34. Wishham Bride. Polygyny was practically universal among the upper classes, a man of wealth having as many as eight wives. All lived in one house, the impartiality of the husband preventing discord, and the women were nominally equal, although a wife from a family of very high rank was naturally treated with deference and given more prominence in the presence of visitors.
- 35. *Raven Blanket Nez Percé*. Intellectually, culturally, and physically the Nez Percé were the leaders among the aborigines of the Columbia River basin. From the day they were first seen by Lewis and Clark in 1805 to the close of the Nez Percé War in 1877, those who were brought into contact with them remarked them as exceptional people.
- 36. *Evening on Puget Sound*. The photograph was made near the city of Seattle.
- 37. *Puget Sound Camp*. Summer habitations were made by leaning poles from a ridge timber to the ground on each side, and covering this roof and the end walls with matting.
- 38. *Lummi Type*. The Lummi held considerable territory in the vicinity of Lummi Bay, Washington, as well as many of the San Juan Islands.
- 39. Lélehalt Quilcene. Among the Pacific Coast tribes the moustache does not necessarily indicate white ancestry. The earliest travellers noted that many of the men had considerable hair on the face.
- 40. *The Tule Gatherer Cowichan*. The manufacture of tule mats for use as carpets, house-walls, mattresses, capes, and sails is still in many localities an important duty of women.
- 41. Hleástűnüh Skokomish. The dominating cultural influence of this and other Salishan tribes of the coast was their dependence upon sea food. The waters of the Pacific teem with life in countless forms and the dwellers upon the wind-swept shores of the ocean and the more placid waters of the sounds, bays, and harbors drew fully upon this supply. Men, women, and children almost lived in canoes, and possessed most remarkable skill in navigating stormy waters in their frail craft.
- 42. *Quilcene Boy.* The Quilcene, like the Skokomish, are a band of Twana living on Hood Canal, Washington.
- 43. Nakoaktok Chief and Copper. Hakalaht ("overall"), the head chief, is holding the copper Wanistakila ("takes everything out of the house"). The name of the copper refers to the great expense of purchasing it. The copper is valued at five thousand blankets. The price of a copper is not based on its intrinsic value but on the number of times it has been sold; for with every sale the price rises, the greatest rate of increase being one hundred percent.
- 44. *Kwakiutl House-Frame*. The two long beams in the middle are twin ridge-timbers, which are supported in the rear, as in the front, by a transverse beam resting on two uprights. At the extreme right and left are the eaves-timbers. The longitudinal and circular flutes of the columns are laboriously produced by means of a small

hand-adze of primitive form. This frame is at the village Memkumlis.

- 45. Painting a Hat Nakoaktok. The painter is clad in a short, seamless, cedar bark cape which is worn for protection from rain. That she is a woman of wealth and rank is shown by the abalone-shell nose-ornament and the gold bracelets, no less than by her possession of a "Chief's Hat." These waterproof hats, of a form borrowed from the Haida, are made of closely woven shreds of fibrous spruce-roots, and are ornamented with one of the owner's crests — a highly conventionalized painting of some animal or mythological being.
- 46. A Tlü' Wüláhü Mask Tsawatenok. The mask shows the Loon surmounting the face of an anthropomorphic being into which the bird transforms itself at will.
- 47. Dancing to Restore an Eclipsed Moon Qágyuhl. It is thought that an eclipse is the result of an attempt of some creature in the sky to swallow the luminary. In order to compel the monster to disgorge it, the people dance round a smouldering fire of old clothing and hair, the stench of which, rising to his nostrils, is expected to cause him to sneeze and disgorge the moon.
- 48. Hamatsa Emerging from the Woods Koskimo. Of all these North Pacific coastdwellers the Kwakiutl tribes were one of the most important groups, and at the present time theirs are the only villages where primitive life can still be observed. Their ceremonies are developed to a point which fully justifies the term dramatic.
- 49. Nootka Woman Wearing Cedar-Bark Blanket. Both sexes wore cedar-bark or fur robes pinned together at the right side, and the women had in addition bark aprons extending from waist to knees. In rainy weather, bark capes like a poncho were worn. Both sexes wore hats in rain and hot sunshine, those of the common people being woven bark and those of the nobility, spruce-roots.
- 50. *A Haida of Kung.* The Haida are a group of closely related village communities inhabiting the Queen Charlotte Islands in British Columbia and the south end of Prince of Wales Island in Alaska. The Haida, more than almost any other Indian, have been quick to embrace the opportunities of civilization. All of them, even the oldest, speak English well enough to transact business with white men.
- 51. Waiting for the Canoe Nootka. As evening approaches, two women with clambaskets and digging-sticks gaze across the water, anxiously awaiting the canoe that is to come and convey them home.
- 52. *Hopi Snake Priest*. In this physiognomy we read the dominant traits of Hopi character. The eyes speak of wariness, if not of downright distrust. The mouth shows great possibilities of unyielding stubbornness. Yet somewhere in this face lurks an expression of masked warmheartedness and humanity.
- 53. *Watching the Dancers*. A group of girls on the topmost roof of Walpi, looking down into the plaza.
- 54. *The Piki Maker*. Piki is corn-bread baked in colored sheets of paper-like thinness. The batter is spread on the baking-stone with the bare hand, and the quickly baked sheet is folded and laid on the basket at the baker's left.
- 55. Evening in Hopi-Land. There is a subtle charm about the Hopi and their highperched homes that has made the work [of collecting data and making pictures] particularly delightful. This was especially so in earlier years, when their manner of life

indicated comparatively slight contact with civilization. Certainly no other place in the United States afforded a like opportunity to observe native Americans living much as they did when the Spanish explorers first visited the desert land of our Southwest.

- 56. *The Potter*. Every visitor at East mesa knows Nampeyo, the potter of Hano, whose creations excel those of any rival. Strangers wander into her house, welcome though unbidden, but Nampeyo only works and smiles. In the plate her paintstone occupies the central foreground.
- 57. Hopi Girl. Females part their hair in the middle from the forehead to the nape of the neck. Unmarried girls arrange it in a large whorl above each ear, a very distinctive state symbolic of the squash-blossom; the picturesque whorl fashion is so fast disappearing, at least in Walpi, that in three months' observation in the winter of 1911–1912, only one girl was seen with hair so dressed except on ceremonial occasions. To arrange the whorls is too laborious a task for women with a school education.
- 58. *Hopi Woman and Child*. More and more the people are permanently taking up their residence in detached houses in the valleys. They are closer to their fields and sheep ranges, and so the change is a material gain; but it needs no prophet to foretell the eventual and probably not distant abandonment of the pueblos. And when that time arrives, the ancient ceremonies and home customs of the Hopi will be only a memory.

59. *Hupa Woman*. It would be difficult to find a better type of Hupa female physiognomy.

- 60. The Smelt Fisher Trinidad Yurok. The surf-net used in smelt-fishing is a bag suspended on two diverging poles. At the bottom of the net proper is a restricted opening into a long net-bag, which is held in the fisherman's hand. Dipping and raising his net, he allows the imprisoned smelts to fall down into the bag, where they are securely held until he has enough to justify him in going ashore to empty it.
- 61. *Spearing Salmon*. A Hupa youth is waiting with poised spear for the shadowy outline of a salmon lurking in a quiet pool and gathering its strength for a dash through a tiny cascade.
- 62. *Gathering Tules Lake Pomo*. The round-stem tule, *Scirpus lacustris*, was used principally for thatching houses, for making mats by stringing them laterally on parallel cords, and, securely lashed together in long bundles, in the construction of serviceable and quickly made canoes.
- 63. *A Mono.* The culture of the Southern California Shoshoneans, especially of the Mono-Paviotso, was as little developed as that of any tribe within the limits of the United States, if not in North America. In one respect, however, they manifested esthetic taste and ability to a marked degree, for the basketry of some of their women gave and still gives expression to a high artistic sense.
- 64. *A Mono Home*. The Mono inhabit eastcentral California from Owens Lake to the head of the southerly affluents of Walker River. The snow-capped Sierra Nevada rises abruptly on the western border of this inland basin. The wickiup shown in the plate is a typical winter shelter, and the utensils are burden-baskets and sieves, or winnowing-trays. All these baskets were appurtenances of the one wickiup.
- 65. A Desert Cahuilla Woman. The Cahuilla were not warlike. Such fighting as occurred generally grew out of encroachment on the food preserves of a neighboring

group or the supposed sorcery of a medicine-man.

- 66. Paviotso Basketry. The plate illustrates the conical burden-basket (partially concealed), the cradle basket (with female symbol), the basin-shaped receptacle for harvesting seeds, the winnowing-tray (partially concealed in the background at right), two gummed water jars, the fishbasket, several trinket receptacles, and modern beaded belts. The long, narrow piece in the foreground is called a "christening" basket by a local collector. This is a modern form and is probably used as a platter.
- 67. A Cupeño Woman. The Cupeño are a small Shoshonean group of mountaineers formerly residing at the head of San Luis Rey River in north-central San Diego County. Popularly known as Aguas Calientes and as Warner's Ranch Indians, they gained considerable prominence at the beginning of the century when the Supreme Court ruled adversely upon their title to the land of their nativity. In 1903 they were settled at Pala reservation on lands adjoining those of the Luiseños, and their former habitat is now beautiful Warner's Ranch.
- 68. At the Old Well of Acoma. Members of Coronado's army of explorers in 1540 and Espejo in 1583 noted the "cisterns to collect snow and water" on the rock of Acoma.
- 69. A Jemez Fiscal. The office of fiscal, like that of governor and alguacil, is of Spanish origin, and its incumbents are charged with the supervision of activities connected with the church, such as burial of the dead and physical care of the church building. In general the church is an institution superimposed on Pueblo life; it has nowhere become an integral part of it. At Jemez several centuries of effort at Christianization have been without tangible result, except that the presence of missionaries has been a more or less beneficial object lesson in a better mode of life.
- 70. *An Acoma Woman*. The village of Acoma is the oldest continuously occupied settlement in the United States. Perched on top of a mesa some three hundred and fifty feet above the surrounding valley, it is accessible only by difficult trails partly cut in the solid rock of its precipices.
- 71. Sia Buffalo Mask. The buffalo dance is still performed though the original object of exerting preternatural influence on the abundance and availability of the buffalo no longer prevails. The dance is very strenuous and the simulated actions of the buffalo are quite realistic and readily comprehended by the spectator.
- 72. Okúwa-Tsirě (*Cloud Bird") San Ildefonso. The data on the customs of San Ildefonso make no pretense of completeness. Among the New Mexico pueblos the investigator learns what he can, and is inordinately gratified when the outer portal is left ajar for a few brief minutes.
- 73. Agoyó-Tsă Santa Clara. The Pueblo Indians of the Rio Grande Valley in New Mexico, so far as their religious beliefs and practices are concerned, remain the most conservative of all the tribes of North America. One meets organized opposition to the divulging of information pertaining to ceremonial life.
- 74. Offering to the Sun San Ildefonso. Excepting alone the Pueblo tribes of New Mexico and Arizona, no Indians now living within the United States whose ancestors came into contact with Europeans in the sixteenth century have preserved their aboriginal customs with any degree of purity. The Pueblos have changed relatively little

during the intervening centuries, notwithstanding the active efforts made by the Spaniards in early days to lead the Indians towards Christianity by abolishing their native ceremonies.

- 75. Okúwa-Tse ("Cloud Yellow") San Ildefonso. The resemblance of most San Juan men to the Plains type is rendered the more striking by their habit of dressing the hair in two braids wrapped or tied with strips of fur or cloth.
- 76. *Ah-En-Leith Zuñi*. Houses, though built by the men, are the absolute property of the women, who may sell or trade them within the tribe without legal hindrance from husband or children. Daughters are the preferred heirs of the landed possessions of their father and their mother, and sons are only heirs presumptive.
- 77. *Shtwawtiwa* Zuñi. As at all other pueblos, historical tradition at Zuñi is strangely wanting and what little is offered is likely to be a mélange containing a pellet of fact enveloped in a mass of typical native mythology.
- 78. Governor of San Juan Pueblo. The civil officers of the pueblos headed by the governor are a heritage from early Spanish days and their duties are to relieve the real rulers of such details as apportioning water, repairing irrigation canals, announcing community undertakings.
- 79. A Load of Fuel Zuñi. The Zuñi tribe, now numbering twenty-two hundred, has been concentrated in the present pueblo and its farming villages for nearly two and a half centuries, and in the same valley for hundreds of years before. Only a people as frugal as all the Pueblos in the use of fuel could still have an available supply in a region so poorly provided by nature.
- 80. *"Owl Old-Woman"* Sarsi. The Sarsi have the physical characteristics typical of the Athapascans: small features, medium stature, spare lithe bodies. They appear to have great vitality.
- 81. A Blackfoot Travois. The travois is still used for transporting bundles of ceremonial objects. Before, and sometimes even long after, the acquisition of horses, travois were drawn by dogs.
- 82. Assiniboin Hunter. Assiniboin bows were of birch, willow, or service-berry, recurved and backed with sinew. Arrows had shafts of service-berry shoots, three feathers of eagle, partridge, or duck, buffalo sinew wrappings, spruce-gum glue, points of buffalo-rib or flint.
- 83. A Cree Girl. The physical characteristics and dress of the Cree have been described at length by various early observers. Alexander Mackenzie notes that they are of "moderate stature, well proportioned, and of great activity" and proceeds to draw such a picture of feminine beauty that there remains little wonder, if the half were true, that European employees of the fur-trade companies generally selected Cree wives.
- 84. A Painted Tipi Assiniboin. A tipi painted with figures commemorative of a dream experienced by its owner is a venerated object. Its occupants enjoy good fortune, and there is no difficulty in finding a purchaser when after a few years the owner, according to custom, decides to dispose of it.
- 85. Assiniboin Mother and Child. The Assiniboin belong to Siouan stock. The popular name of this tribe is a Chippewan appellation signifying "stone cookers," referring doubtless to the custom of boiling meat with hot stones in bark vessels.
- 86. Dog Woman Cheyenne. The woman's dress is embellished with elk-teeth.
- 87. Cheyenne Young Woman. The story of the

strife between the Cheyenne and the whites is a tragic one of disaster alike to both sides, and anything but creditable to our own race; in fact it records one of the darkest pages in the history of our dealings with the Indians.

- 88. Peyote Drummer. No Indian custom has been the subject of greater controversy or has led to the adoption of more laws and regulations with a view of abolishing it than the Peyote rite, largely because its effects have been misunderstood by white people.... The type of drum used is always the same — a small iron kettle partly filled with water and having a rawhide head. The beating of the drum is continuous throughout the rite, and its rhythmic vibration undoubtedly affects the emotions of the participants.
- 89. Úwat Comanche. Ethnologically the Comanche do not furnish a fertile field of inquiry. The old men, when questioned as to the dearth of ceremonies, folktales, and legends such as existed, for example, with the Wichita and neighboring tribes, made answer, "We were hunters and warriors, and had no time to think of such matters." All information gathered from them indicates that they were so active in warfare, so constantly on the move, that they had little time to give thought to the origin and purpose of their existence; in fact they seemingly took pride in not doing so.
- 90. *A Little Comanche*. Comanche are formal and suspicious to strangers, but hospitable and social to those they consider their friends.
- 91. *Two Moon Cheyenne*. Two Moon was one of the Cheyenne war chiefs at the battle of the Little Bighorn in 1876, when Custer's command was annihilated by a force of Sioux and Cheyenne.
- 92. A Man from Nunivak Eskimo. The most important garment of the Nunivak, and of the Eskimo generally, is the parka. This is a frock, made of animal, bird, or fish skins, which is slipped over the head and reaches about to the knees. Parkas for outdoor wear, for travelling or hunting, and for winter use are provided with a hood which may be drawn up to cover the head, or thrown back at pleasure.
- 93. *Ready for Sealing Nunivak*. The kaiak of this Nunivak sealer is fully equipped with the apparatus required for augmenting the family larder. Sealing is of prime importance to the people of Nunivak island, the seal being sought in spring and in fall during their northward and southward migrations respectively.
- 94. *Maskette Nunivak*. Of maskettes there are very many. Those seen on Nunivak are for wear on the forehead. The common forms are the heads of animals, birds, or fish mounted on hoops or head-bands, of a size to fit the head. One such, a fowl maskette, was the head of a predatory bird bearing a fish in its mouth. The bird's head, fish, and hoop were colored blue. The eyes, mouth, and nostrils of the bird, and eyes, mouth, and fins of the fish, were etched or outlined in red.
- 95. Start of the Whale Hunt Cape Prince of Wales. The boat is launched and allowed to drift out. The crew sing, and the woman [chosen to take part in the ceremonies], left standing on the ice, sings. The boat is then put about and headed towards her, while the spearer makes as if to harpoon her. She then scatters ashes to drive away evil influence, and runs home without looking back. There she remains and fasts until a whale has been killed or the crew returns.